MUSEUMS AND WEALTH

Also Available from Bloomsbury

Between Discipline and a Hard Place: The Value of Contemporary Art, Alana Jelinek
In and Out of View: Art and the Dynamics of Circulation, Suppression, and Censorship, ed. Catha Paquette, Karen Kleinfelder, Christopher Miles
Sociopolitical Aesthetics: Art, Crisis and Neoliberalism, Kim Charnley
Art as Human Practice: An Aesthetics, Georg W. Bertram
The New Aesthetics of Deculturation: Neoliberalism, Fundamentalism and Kitsch, Thorsten Botz-Bornstein
Working Aesthetics: Labour, Art and Capitalism, Danielle Child

MUSEUMS AND WEALTH

The Politics of Contemporary Art Collections

Nizan Shaked

BLOOMSBURY ACADEMIC
LONDON • NEW YORK • OXFORD • NEW DELHI • SYDNEY

BLOOMSBURY ACADEMIC
Bloomsbury Publishing Plc
50 Bedford Square, London, WC1B 3DP, UK
1385 Broadway, New York, NY 10018, USA

BLOOMSBURY, BLOOMSBURY ACADEMIC and the Diana logo are
trademarks of Bloomsbury Publishing Plc

First published in Great Britain 2022

Copyright © Nizan Shaked, 2022

Nizan Shaked has asserted her right under the Copyright, Designs and Patents Act, 1988, to be identified as Author of this work.

For legal purposes the Acknowledgments on p. viii constitute an extension of this copyright page.

Cover design by Ben Anslow
Cover image: The Broad, contemporary art museum, Los Angeles, California, USA. 18th Sep, 2015. (© Ringo Chiu / ZUMA Press, Inc. / Alamy)

All rights reserved. No part of this publication may be reproduced or transmitted in any form or by any means, electronic or mechanical, including photocopying, recording, or any information storage or retrieval system, without prior permission in writing from the publishers.

Bloomsbury Publishing Plc does not have any control over, or responsibility for, any third-party websites referred to or in this book. All internet addresses given in this book were correct at the time of going to press. The author and publisher regret any inconvenience caused if addresses have changed or sites have ceased to exist, but can accept no responsibility for any such changes.

A catalogue record for this book is available from the British Library.

Library of Congress Cataloging-in-Publication Data
Names: Shaked, Nizan, author.
Title: Museums and wealth : the politics of contemporary art collections / Nizan Shaked.
Description: London, UK ; New York, NY, USA : Bloomsbury Academic, 2022. | Includes bibliographical references and index.
Identifiers: LCCN 2021035908 (print) | LCCN 2021035909 (ebook) | ISBN 9781350045767 (pb) | ISBN 9781350045750 (hb) | ISBN 9781350045774 (epdf) | ISBN 9781350045781 (ebook)
Subjects: LCSH: Art museums–Economic aspects. | Art, Modern–Colelctors and collecting. | Common good–Economic aspects. | Public interest–Economic aspects.
Classification: LCC N470 .S53 2022 (print) | LCC N470 (ebook) | DDC 708—dc23
LC record available at https://lccn.loc.gov/2021035908
LC ebook record available at https://lccn.loc.gov/2021035909

ISBN: HB: 978-1-3500-4575-0
PB: 978-1-3500-4576-7
ePDF: 978-1-3500-4577-4
eBook: 978-1-3500-4578-1

Typeset by RefineCatch Limited, Bungay, Suffolk

To find out more about our authors and books visit www.bloomsbury.com and sign up for our newsletters.

CONTENTS

Acknowledgments	viii
INTRODUCTION	1
The study and its methodology	1
World-systems periodization: racial capitalism	8
What is a totalizing perspective?	9
Chapter overview	11
Chapter 1	
THE SAN FRANCISCO MUSEUM OF MODERN ART AND ECONOMIC INEQUALITY: ART AND IMPERIALISM	15
The ambiguous status of American art museums	19
The Fisher collection deal: what we know and what are we asking	20
Conflicting agendas of private and public interest	22
The politics and aesthetics of private interest	24
Art and imperialism	28
Fighting for crumbs: problems with defense of public money in its current form	34
"Grateful for small abuses": diminishing public support	36
Arts funding and diversity	37
Art finance and wealth management: questioning the public merit of private collections	39
Against market criteria	39
Private collections: a curatorial history perspective on the question of quality criteria	42
Neo-expressionism in San Francisco: the conservatism of Georg Baselitz	46
Formulas for beauty: Gerhard Richter's cottage industry of singular-multiples	47
Conclusion	51
Chapter 2	
THE SUBSTANCE OF SYMBOLIC VALUE: MUSEUMS AND PRIVATE COLLECTING	53
Introduction: the private appropriation of public value	53

Institutional value: price advantages for collector/trustees 55
 The private metabolism of a public good 55
 Art's role in the financial growth regime 57
 The financialization of art 59
 "Conflict of interest": and its inadequate applications 62
History and legal theory of the public/private distinction 67
 The nonprofit sector as shadow state 70
 Tax monies: private or public 74
 A brief history of the legal distinction between the private and public realms 77
Symbolic value and ideology 82
 Bourdieu's symbolic capital 84
 An economic theory of art's ideology 87
The substance of art's value 88
 Productive and unproductive labor 92
 The appearance of value in art 93
Conclusion: some immediate solutions 96

Chapter 3
FROM MEDICI TO MOMA: COLLECTIONS, SOVEREIGNTY, AND THE PRIVATE/PUBLIC DISTINCTION 101
The Renaissance roots of MoMA's two audiences 101
 Art's economic character 105
 A few methodological and typological notes 107
Externalizing the collection: a prehistory of the public 108
 From the private *studiolo* to the proto-public Uffizi 110
 Collection as oratory 112
 Secular collections: expanding the audience circuit 113
 Florentine economy, governance, and art 116
 Luxury and abstraction 118
 The origins of capitalism in the sixteenth century: a debate 120
 From city- to nation-state: collections and national identity 124
 The museum: an instrument of social control 127
 The United States: private philanthropy and public collections 129
 American philanthropy and the state 132
The New York Museum of Modern Art 137
 MoMA and the private/public ambiguity 139
 What is the "Public Trust"? 141

 What does it mean that the MoMA is private? 145
 Conclusion 150

Chapter 4
BLUEPRINTS FOR THE FUTURE: DEMOGRAPHIC AND ECONOMIC
CHANGE 151
 Racial capitalism and world system 156
 Is it still capitalism? A neofeudal present 157
 Economic dependency and racial inequality 163
 Museum collections: who will be the judge? 165
 Philanthrocapitalism 168
 The public: abstract and concrete 170
 The limits of nonprofit scholarship and reform 172
 Solutions 175
 Immediate solutions 176
 Collecting solutions 177
 Taxing the secondary market 179
 In the long run 180

CONCLUSION 183

Notes 189
Bibliography 237
Index 267

Acknowledgments

The Los Angeles art scene has been my career and social life for over twenty years, and where I spend numerous hours conversing both openly, and confidentially, with people from all aspects of the art world. I have mostly anonymized my interlocutors, to the extent of omitting most of them from the following acknowledgments. The eagerness of board members, museum personnel, artworkers, and artists to pour out their hearts and share their insights, is testimony to how disturbing the state of the field is to people who are deeply engaged with art. I thank them profoundly for their candor.

My biggest thanks are extended to Rafael Levi, who provided invaluable help with bibliographies, drafts, and endless discussions. Kimberli Meyer continues to be the best colleague, interlocutor, and alternative family, her feedback on this project has been most significant. My colleague Heather Graham deserves special thanks for her generosity and help. Ongoing discussions with Lari Pittman, Liat Yossifor, Dustin Ericksen, Patrick Hill, Jaleh Mansoor, Daniel Spaulding, Matt Cole, Elena Louisa Lange, Craig Stone, Frances Pohl, Gloria Sutton, Simon Leung, Lincoln Tobier, Avigail Moss, Dont Rhine, and John Smith, and others whom I might be forgetting and to whom I apologize, have greatly benefited this project. As usual, all errors in the text are mine. Frankie Mace singled out this book when it was still a conference paper at the London Historical Materialism Conference, where I have been workshopping my ideas for many years, and whose organizers and participants—many listed above and below—deserve much gratitude. Sections of this book have also been presented at the following universities and forums, and I wholeheartedly thank their listed organizers and respondents: Kirsten Lloyd and Harry Weeks, at the Global Contemporary Research Group, University of Edinburgh, where I owe much thanks to Angela Dimitrakaki for also inviting me to be a visiting fellow and for being a dear collaborator and colleague; Adele Patrick and Rachel Thain-Gray at the Glasgow Women's Library, and Kirstie Skinner at Outset, Scotland; Nic Leonhardt and Christopher Balme for the invitation to Philanthropy, Development and the Arts: Histories and Theories Conference, Ludwig Maximilians University and Carl Friedrich von Siemens Stiftung, Munich, where I benefited from the discussion with the participants, especially Inderjeet Parmar, Antonio

Cuyler, Clara de Andrade, and Gustavo Guenzburger; at Le musée face à l'art de son temps, Bicentenaire du Musée du Luxembourg, 1818–2018, Colloque international, Centre Pompidou, Nicolas Liucci-Goutnikov; at Loughborough University, Marsha Meskimmon and Kathryn Brown for multiple engagements and ongoing support; Adriana Turpin and Susan Brackens for Display and Taste in the Modern and Contemporary Periods seminar, Institute of Historical Research, University of London; at Henry Moore Institute, with the Centres for Critical Materialist Studies and the Study of the Arts and Antiques Markets (University of Leeds), Dan Hartley, Mark Westgarth, and Gail Day, who also with Larne Abse Gogarty, Marina Vishmidt, David Mabb, and Steve Edwards invited me to present at the Marxism and Culture series in London; Ben Harker for Wars of Position: Marxism and Civil Society, at the People's History Museum, Manchester; the organizers of the International Initiative for Promoting Political Economy conferences in Berlin and Pula; at the Global Museum: Art Museum Leadership in the 21st Century—College Art Association, Museum Committee session, Toni Guglielmo, Leslee Katrina Michelsen, and Melody Kanschat.

Very special thanks to Elisabeth Thomas at the MoMA Archives, for all her help. Thanks are also due to California State University Long Beach for supporting course release time and difference in pay leave. Special thanks to my legal intern Shevaun Wright for her research assistance and for the contribution of her artwork to my thinking. To Chapter 1 Breanne Bradly contributed research assistance and Jillian Marriage editorial support and discussion. Alanna Carnahan contributed research to Chapter 3. Jeffery Ryan has provided technical support and, as always, has been a pal. Directing Crystal Miette Ferrer's MA thesis on museum deaccessions taught me a great deal. I thank my many students from whom I learned so much over the years. Finally, special thanks to Liza Thompson, Lucy Russell, and the production team at Bloomsbury.

This book has been written in part on the unceded land of the Tongva/Gabrieleño and the Acjachemen /Juaneño Nations. I thank them for their strength, perseverance, and resistance.

INTRODUCTION

The study and its methodology

"You should ask 'who else has collected that particular artist? What museums is that artist in? What curators like the art? Who are their dealers and who else is buying?'"[1] These words belong to J. Tomilson Hill, in an article titled, "Billionaire collector shares his secret to buying great art that turns into even better investment." Tomilson Hill was vice chairman of the Blackstone Group, one of the world's largest alternative investment firms, infamous for profiting from the 2008 financial crisis.[2] He has served on the board of the Metropolitan Museum of Art, the investment committee of the Smithsonian Institution, and is chairman emeritus of the Hirshhorn Museum and Sculpture Garden in Washington, D.C. Beyond privileged access to some of the information he describes above, the experience and knowledge Tomilson Hill acquired by serving public institutions may now also benefit his private art foundation, which recently opened to the public in New York. That based on his own words we can expect the predictable at Tomilson Hill's institution begs a simple question: why would an individual receive public subsidy for exhibiting his private collection?

The contradiction between Hill's public role and private enterprise encapsulates the broad set of questions that this book addresses on two levels: the first challenges the existing liberal system according to its own parameters, and the second introduces a critical perspective that analyzes the system's structural underpinnings in order to change it. Both lines of questioning lead to tackling the lack of diversity in museum collections (touching upon personnel and administration), a problem I argue cannot be remedied without attending to the economic base. The first level makes visible how the American nonprofit system undemocratically allows private individuals to gain financial benefits from, and ideological control over, what is at its core purpose a public system. Collectors serving on museum boards get additional bonuses

beyond prestige and social status, such as access to information and opportunities to enhance the value of their private collections. In this, and several other ways that this book shows, public money for the arts serves private wealth accumulation and sustains the status quo, which is widely understood today as having been, and continuing to be, white supremacist. The escalation in recent years of protest against museum donors and trustees whose fortunes are made by war, prison, and big-pharma profiteering underscores that museums function as part of the public sphere, and therefore the efficacy of claiming them for society at large.[3] A broad constituency of creative, scholarly, and audience communities see the museum as ours and want to see it administered in ways that represent our open-ended vision of a just society, itself a work in progress. Additionally, since the control given to governing boards and donors also translates into institutional aesthetic proclivity, this book discusses shortcomings in the assessment and evaluation of art.

The second level is the deeper analysis of how our social structure is economically and politically (ideologically) governed by the value-form, organized as wage and monetary exchange relations. By examining the economy of private and public art collections, this book makes visible the circuit where symbolic value translates into concrete value, always keeping in mind where the latter gets its substance. Art collections embody the constituting contradiction at the heart of the capitalist economy, where individuals can privately accrue socially created wealth.

Under capitalism art has been cast as a luxury object, deceiving us into believing that it is the prerogative of the wealthy to "generously" share it with us. Yet, art is not a luxury. Art is a necessity. It is a fact of human history that in the worse conditions of slavery, imprisonment, and starvation people have persisted to make art. If we can imagine an egalitarian system for art, we can imagine a better structure by which to administer our lives. Since art and its institutions are a model of civil society, this study is applicable to a broader restructuring of our current essential functions of being, and to inventing new modes of organization for the future. If we can sustain human creativity on a classless basis, we can apply it to health, education, or the development of science and technology for the benefit of all, rather than profits for the few.

In the museum sphere Tomilson Hill is not an outlier, he represents a growing trend of ultra-wealthy individuals that have moved from serving on the boards of public institutions to opening tax-exempt private museums and foundations, such as The Broad or the Marciano Foundation (now closed) in Los Angeles. This is but one example of three main categories, and several subcategories, for the ways in which

private collectors stand to benefit symbolically, informationally, and therefore financially from art collections that are commonly held in public trust.

The first is the benefit of insider knowledge. Trustees and collector-group members may have direct influence on what a museum collects or exhibits. Collectors who serve as trustees or officers can potentially buy artworks with the advantage of privileged access to information. In her exemplary study of corporate sponsorship Chin-Tao Wu confirms that:

> [m]ost American boards are full of collectors, businessmen included, who are buying (contemporary) art. This is not, of course, for a moment to imply that trustees, either individually or collectively, are ever involved in anything illegal or unethical. Yet the fact is that being a trustee allows them inside advantages and benefits, say, over non-trustee collectors, that potentially can result in substantial financial gain for themselves. For instance, they know in advance which artists' works will be acquired or exhibited in the museum, thus affecting the reputation of the artists and their market. If the trustee-collectors purchase or collect for themselves the works by the same artists, the value or prestige of their collection will be automatically enhanced after the museum exhibition, regardless of whether or not any works from their collections are exhibited.[4]

This insider knowledge makes possible the manipulation of symbolic value, our second category. Since inclusion in museum collections or exhibitions can enhance the value of art, short- and long-term loans of private works to museums benefit private individuals at public expense, as this book evidences in several chapters. Gifts also raise the value of the artist's oeuvre in general and amounts to a manipulation of the market. Here, a subcategory is the double-donation mechanism, where collectors buying a contemporary artwork simultaneously donate another by the same artist to a museum, at the very least working to stabilize the value of their privately held work by leveraging the public institution. This also benefits the commercial gallery responsible for the transaction, and can similarly be exploited by auction houses. Since sometimes museum board members own shares in auction house or galleries, there is a potential conflict if the museum they serve does business with the same auction house or gallery. Many practices that are in fact legal are neither ethical nor productive for an objective evaluation of art and its significance.

The third category is subsidy by tax deduction. Donors to museums can reduce their taxable income. The system is set up to advantage the

wealthy and allow them cultural control. Privately collecting art is also advantageous for tax planning, generating capital gains that in turn can be reduced through like-kind exchange (replaced in the U.S. by opportunity zones in 2017), and sales taxes forgiven if the art is exhibited for over three months in a public institution, in some states.[5] Since all of this is anchored in and sanctioned by the law, the line of questioning this book takes leads to deeper scrutiny of legal history, state ideology, and how the hegemony of the capitalist class shapes national culture. By funding arts and welfare under the veneer of generosity, the wealthy secure the loyalty of the middle and creative class. This brings into relief a foundational hypocrisy at the heart of an art world that claims allegiance to the working class and the historically marginalized, but in method of analysis, political strategy, and action in effect supports the status quo of elite dominance.

I approach the arts economy as a model of social organization to challenge the assumptions of current legal and ideological convention that the wealthy are fit cultural stewards. For this I look at a set of American modern and contemporary case studies, insisting that their administrative history begs a comparison with late-Renaissance Europe. Although indeed our modern museums were born along the trajectory that led from monarchies to republics, a significant aspect of the American municipal museum and its private-philanthropy patronage bears similarities to collecting practices in historical periods that were patrimonial or absolutist, in ways that we cannot ignore. Moreover, as European museums are increasingly adopting the privatized American model, we might characterize the larger process as a reprivatization of collections.[6] The various case studies are assembled not to suggest events as a singular continuum, simple cause and effect, or to claim that the same processes unfolded everywhere, but because together they present a larger picture that is characteristic of our present, which can be defined as neofeudal, as I concur with several scholars.

Most museums in the United States are nonprofits organized as either private operating foundations, or charitable trusts. The larger institutions are typically governed, and in part supported by, boards of trustees and officers. Variations on this system are increasingly adopted in other parts of the world, as waning public funding pushes municipalities and nations to emulate the American charity system. But there is a fundamental problem with a system that is dependent on private philanthropy for social welfare. It gives wealthy individuals with private interests political control and economic advantage, and no incentive for change. The change sought by the public entails fair

distribution of resources. The interests of the wealthy and the public are therefore inherently contradictory. Because under capitalism wealth necessitates exploitation, philanthropy is structurally unable to promote social equality. It in effect prevents it. At its best philanthropy can perform some ameliorating triage.

Under this system private/public partnership museums can declare benefit to the public in their tax documents, grant applications, and their interface with audiences, but they are quick to claim that they are private when it comes to scrutiny of finances and programmatic decision-making. Philosophical and legal distinctions between these two categories, private and public, have shifted dramatically over the course of racial-capitalism's expansion. To understand the evolution of the public/private distinction, this book tracks representative case studies and key historical developments in collecting to theorize the contemporary museum as an entity that straddles the private and public dimensions of collecting, wealth, and sovereignty.

Historically, collecting and collections represented mastery over knowledge and statecraft. As collecting turned from an intimate and introverted activity to an extroverted presentation, it became part of the complex that justified the right of the prince, and later elected governments, to rule the people and administer the economy on their behalf. Collecting and collections have since been a major activity of public institutions that shape and sustain the contemporaneous philosophy by which humanity knows itself. This book shows how museums sustain a worldview that mystifies the exploitative nature of the economy. Following a Marxist critique of the political economy, which further developed the basic insight of classical economists David Ricardo and Adam Smith, this book proceeds from the recognition that wealth is only ever created socially and should therefore be distributed accordingly. It culminates with a set of possible solutions: from immediate proposals for changes in practices, policies, and the law, to imagining ideas for a "what if" world.

This book is written out of the love of museums in general, and art museums in particular. Nevertheless, it is highly critical of institutional practices. I hope that my hardworking and dedicated colleagues will understand that I am not necessarily criticizing their daily choices and actions, but rather explaining that structural dependency on limited funding and resources for art constrains the agency of museums to actively support social justice. I am not blaming artists, gallerists, or anyone else for making a living or benefiting from the system. Instead, the criticism aims to show why the current system runs counter to the

declared intentions of most artists, scholars, and institutions, and to offer drafts for the future. That we have inherited this system from history does not mean that we have to accept it. Instead, we can ask what museums were, describe what they are, and what they can be, with an aim to wrestle art away from the role of serving private interest.

The system we have is white supremacist by design. The historical position of the Left has generally been that racism is an outcome of economic relations, where racial distinctions are amplified and mobilized to oppress groups of people into a hierarchy that facilitates better exploitation. According to this logic, racism is best addressed by universal class struggle. Yet today, it is not just economic disadvantage that results in African American, Black and Indigenous People of Color (BIPOC) still being dramatically underrepresented in museum workforce, collections, and exhibition opportunities.[7] A climate of racism prevents retention and advancement of workers of color. Yet we know that protests since the 1960s, identity politics in the 1970s, and the multiculturalism debates of the 1980s and 1990s have so far resulted in insufficient change. Studies quoted in Chapter 4 evince that workforce stratification has a racist character. Therefore, although identity politics has mostly been seen as advancing a politics of representation over redistribution, my position is shaped by a synthesis of ascriptive and class politics. There exists a radical, liberal, and a right-wing version of identity politics. A radical version intersects identity as interpolation, organic formation, or political strategy, with struggles for the abolition of policing, prisons, wage exploitation, gender, and so on. My approach is guided by the work of Angela Davis, Cedric Robinson, Ruth Wilson Gilmore, Barbara Fields, Keeanga-Yamahtta Taylor, and others, whose discussion of racism in relation to the base that determines social relations has shown it to move more on a feedback loop akin to a Möbius strip than to a trajectory of cause and effect. The indisputable ability of Black Lives Matter (here representing the idea and the movement, not just the nonprofit and nongovernmental organizations by that name) to galvanize a coalition of abolitionist causes evidences the power of ascriptive politics to lead an emancipatory struggle. The goal of a radical reorganization of life toward total equality will most likely be reached by diversity of strategies, including direct action and mutual aid as well as reform policy and electoral work.

While racial-capitalism describes the economic system, the main analytical concept I use to analyze it is value.[8] By periodizing when the value-form began to be the key principle organizing the economy and social relations, we can gain a clearer understanding of how value

functions on the cultural and ideological level versus how its actual substance is an outcome of abstract labor power, as explained in depth in Chapter 2. Understanding how art can hold value because of institutional authority gives us a picture of art's place in the political economy. To this end I do not analyze the singular art object, but rather the practice of collecting and the object of "the collection" as a unit. Without collections and display there is no art market. For this reason, in order to understand art's value systematically, we need to look not just at the art object, artistic production, or the oeuvre, but first and foremost at the function of art in the system of collections and display, not as linguistic or representational system, but one of an economic and ideological base and superstructure as they shape the relation of government to civil society.

The book shows how public institutions for collection and display were and are a key factor in establishing art's symbolic value, facilitating its power to play a role in sustaining national, community, or personal identity. It is only due to its common significance that art has monetary potential. In essence, the public institution stabilizes art's capacity to siphon and hold monetary value. In other words, museums stabilize art's value potential. The double role of art, symbolic and economic, interacts such that the symbolic value made collectively is then reaped as money through private ownership. This very fact thwarts museums for enacting any systematic effort to undergo systemic change, including justice for historically excluded groups. It is not only that a history of white supremacy resulted in an economic gap where the top is predominantly white, it is also that attempting to fix this problem from the top down can only function to cover up a root problem, where capitalism is dependent on extreme social hierarchies for pushing down wages and extracting free labor. Diversifying boards or collections cannot solve the fact that wealth relies on inequality and inequality depends on racism to stratify the workforce. To combat this, we need to understand how wealth depends on elastic distinctions between the private and the public realms.

As mentioned above, the distinction between private and public is neither obvious nor absolute. A matter of tax law and policy, it has shifted greatly throughout history. Still in flux, the definitions of the terms and their application are the subject of debates. Looking, for example, at legal arguments about the extent to which foregone tax money is considered public or private, the book will argue that much of what is taken to be private is in fact the outcome of public effort and should be administered accordingly. The historical parts will focus on

the transformation of private collections into public, or semipublic, museums.

World-systems periodization: racial capitalism

Most museum history commences with its modern manifestation from the eighteenth century and on. Our story, however, follows a longue durée arc, because the formation of art as such—its incorporation into formal collections and becoming an expensive collectible—all commenced in the late Renaissance. Therefore, to better theorize the re privatization of collections, we look to historical context in the absolutist, not modern or republican, roots of the museum institution. In this I am instructed by Karl Polanyi's patient description of a transformation that took place over hundreds of years, as proof that the appearances of socioeconomic phenomena are often not an outcome of the immediate past but rather of long and complex processes. I show how our present institutions resemble the private collections that formed before fully-fledged racial-capitalism. The periodization schema that governs my choice of case studies emphasizes the periods before and after capitalism (neofeudalism), rather than the uneven transition to a bourgeois public sphere that took place in between.

Like Cedric Robinson, who solidified the used of the term "racial-capitalism," I follow the logic of Emanuel Wallerstein's world-systems perspective, which locates the origin of capitalism much earlier than its fully-fledged manifestation in the eighteenth century. The study of collecting and collections acknowledges the significance of commerce as the necessary infrastructure for the development of production.

As I will argue in Chapter 2, "The substance of symbolic value," the analysis of art from the perspective of art's so-called production, is metaphorical, since art does not have a capitalist mode of production. The logic of fine art, the social relations underlying its making, is structured by a precapitalist economic order. Its mode of production is one of many forms that have risen in the transition to capitalism but whose making has not been rationalized and systematized to maximize profit. When art gains value, it takes it from a common pool and holds it. Its status has survived alongside capitalism mostly unaltered, a weighty factor in art's investment potential, because art's prices do not necessarily correlate with standard commodities or other markets. Art comes into a relation with total wealth and commodity production, that is, with the system of capital, once it enters the sphere of circulation.[9] Art, even if it is not bought and sold, becomes part of the system through

the participation of artists in the public and private nonprofit exhibition and granting systems, engagement with art schools, magazines, galleries, and so on—the network referred to as the "art world." It is the art world as a whole that gives credence to the symbolic system that establishes the ability of art collections to siphon and hoard value. Most recently, art has been monetized, and financialized—made more liquid by functioning as loan collateral, loans which can then be insured, hedged, and betted upon by newly developed financial tools. Since it is also a means to minimize the tax obligations of the wealthy, collecting art is also rapidly becoming a major part of wealth management. This privatization of art reverses a trajectory, which began even before the Enlightenment, of making collections public. This book describes how art's commercial and institutional circuits are embedded in the capitalist system, even while formed by a different logic, and discusses the consequences and their ethical implications for artists and institutions.

What is a totalizing perspective?

A frequent misunderstanding of the goals and methods of a "totalizing" Marxist analysis accuses it of attempting to theorize everything while ignoring nuance and specificity. Another is that Marxist universalism is based in positivist Enlightenment hierarchies.[10] In contrast, the outlook of this book draws from Black and feminist Marxism that uses analysis of particular relations as a model toward universalist application.[11] The goal for a totalizing approach is to render a large picture by describing, analyzing, and synthesizing how historically specific systems govern and administer social relations, and how they have evolved to be what they are in the present. This method enables us to view a model that demonstrates how things work by zooming very far out onto a broad picture, while alternating with close-ups at specific junctures that show the anatomy of particular interactions. The difficulty of the totalizing description is to identify those instances that are actually consequential. As Evald Ilyenkov explains about the work of historical materialism:

> The whole difficulty lies in the fact that the concrete history of the concrete object is not so easy to single out in the ocean of the real facts of empirical history, for it is not the 'pure history' of the given concrete object that is given in contemplation and immediate notion but a very complicated mass of interconnected processes of development mutually interacting and altering the forms of their manifestation. The difficulty lies in singling out from the empirically

given picture of the total historical process the cardinal points of the development of this particular concrete object, of the given, concrete system of interaction. Logical development coinciding with the historical process of the formation of a concrete whole should rigorously establish its historical beginning, its birth, and later trace its evolution as a sequence of necessary and law-governed moments.[12]

By extracting "cardinal points" and "law-governed moments" and understanding their "system of interaction," it is actually possible to distil and show how a total system works. In this vein *Museums and Wealth* demonstrates the ways in which art objects circulate in an art field, how this art field came to be shaped by institutional structures in their laws and customs, as well as by the economic and ideological interests of patrons and professionals, reflecting an aspect of the social order, itself split into the strata of its appearance and the hidden logic governing its essence. The essence is the extortion of surplus value from abstracted labor. In art this means that art doesn't make value, but art is able to obtain it by circulating on the market. The appearance of price mystifies this fact. This is what Marx called commodity fetishism: the illusion that value is created in the process of exchange, or anywhere else outside the process of production. Only a totalizing view can explain how essence and appearance operate in concert, and show where art gyrates in this orbit.

My goal is to show how the essence of the museum system differs from its appearance. Simply put, while art may appear to be innocent, benign, or a promoter of social justice, we need to understand how, first, it does not itself add value to the general aggregate, and secondly, that it also serves to mask a social reality of imperialism and exploitation. Art reflects Marx's observation about money that, while it appears to be the private property of individuals, the value it holds is in fact only made possible by total social production.

I ask my reader to think about the law-governed moments and cardinal points that generate a system of interaction as a constellation—elements revolving around one another in a greater gravitational concert.[13] The government is the bigger body that shapes the economy, which allows the various elements of the art market, institutions of varying scales, artists of different visibility and desirability, collectors with a range of capacities and influence, and objects from several sets of practice typologies, to gyrate in the broader arts economy. A totalizing view describes a set of typological interactions. While the analogy with a constellation might be a metaphor, the outcome is concrete. As Martin Jay quotes Marx and summarizes:

"The concrete is concrete because it is a synthesis of many particular determinants, i.e. a unity of diverse elements." The totality could be concrete precisely because it included all of the mediation that linked the seemingly isolated facts.[14]

The goal of totalizing analysis is to make sense of concrete phenomena while revealing the mediations that mask or mystify what is actually at work. It is to understand phenomena neither in and of itself, nor entirely from the ground up, but always as part of a larger moving whole in its historical specificity. I am not assuming though that there exists a specific historical subject who has inherent access to such a perspective (as in György Lukács's idea that the working class has access to a total view because of its position in the relations of production). Instead, I use the concept of totality to put into orbit a set of heterogeneous historical moments and developments, each chosen for its applicability to a broader question, in order to extract a picture of the developments that have brought us to our present moment and explain the order that compromises it now. Museums are not just repositories of our collective histories, they are institutions of civil society through which we can ask broader questions about social structure: past, present, and future.

Chapter overview

This book is mostly dedicated to analysis and discussion of contemporary art collecting and collections. For this end it is not organized chronologically. The first chapter introduces the main problems through a case study; the second is a presentation of the theoretical concepts; the third delves into the past to establish the history; and the fourth brings a synthesis to the present where, leading with the question of antiracism, it outlines a set of solutions.

Chapter 1, "Art and imperialism: the San Francisco Museum of Modern Art and economic inequality," looks at the San Francisco Museum of Modern Art (SFMOMA) and its temporary adoption of the private Fisher collection, questioning the ability of the private nonprofit museum to serve the public interest in an equitable way. It describes in detail how the existing administrative structure of museums sustains an ambiguity between what is private and public, allowing the museum to represent itself as benefiting the public while concealing the ways decision-making is driven by the interests of wealthy private

donors. The chapter shows how market-based interests of collector board members are not unrelated to endemic lack of diversity. It also covers the brief moment in the second half of the twentieth century that saw some growth in public funding, which was retreated under neoliberalism as private philanthropy grew exponentially. A critique of the political economy of the nonprofit institution as a whole reveals its role in sustaining extreme inequality locally and globally. In the case of the SFMOMA the connection is explicit and direct. Like many major museums with wealthy donors, the SFMOMA is a conduit between the globalization of production and American welfare. We witness how art, in the name of the public and for the sake of doing good, becomes an agent of imperialism.

Chapter 2, "The substance of symbolic value: museums and private collecting," theorizes the relation of collecting and collections to money and the value-form. It takes public confidence in a stable economy for money to hold value, and it takes collective agreement, sustained by museums, for art to hold value. The museum is an arm of the state by which art gains the status of national and civic patrimony that sediments its symbolic value and its ability to fetch and realize monetary value. That in the U.S. this function is chartered to private nonprofits positions them as third-sector actors performing "shadow state" functions.[15] This chapter argues that nonprofits, including private foundations, should be considered public entities, because the law that determines that the original purpose of welfare money is public is to be carried through to the institutional operations and outcomes. The status of tax money as private or public has been in flux for hundreds of years and is still in debate. I summarize the legal history of the distinction between the public and private realms to challenge some current arguments for donor control over what is done with their donations. It makes strange those ideological dispositions that render private property as a natural order while in fact, even when couched in liberal terms, it is clearly an artificial construct. I then advance Marxist analysis to show how the value of art, like other forms of wealth, is socially created and should be socially distributed. Art can be worth a lot of money because the same object is invested at once with both identity and material value. Whether art is an immobile asset, or made partially and temporarily liquid as loan collateral, it represents the private appropriation of public value. This is the connection of art to the material economic base. Art doesn't make value, but it helps the capitalist class hoard it, but only because of public agreement, which is administered and sustained by museums.

Chapter 3, "From Medici to MoMA: collections, sovereignty, and the private/public distinction," examines the relation of collections to state and government, commencing with the late Renaissance. The Medici incorporated into their statecraft what we today call soft power, in the process of which they "externalized" their private collections, utilizing art as a tool for diplomacy on systemic scale. Although not entirely public in the sense we know since the eighteenth century, a precedent was set in the sixteenth century for what would become museums and government arts programs. This chapter shows how the collection as a whole is a key factor in the ability of art to carry symbolic significance and value, which are together sustained by the relation between collecting and sovereignty. Later, in the transition from the city to the nation-state, museums were used as social technologies to consolidate national identity. In the U.S., where those who came to be known as the "robber barons" funded the formation of civil society under a legal code designed to serve their interests, the function of museums was privatized. Whether the goal was to ameliorate or educate, whether funded by the state or the rich, museums in both Europe and the U.S. could only ever assimilate the identification of the working class, but not their de facto condition, because the working classes were meant to remain poor. If the working class were to be lifted economically there would be no one left to exploit. This is the paradox at the heart of the museum, a creature born from aristocracy and bred under the liberal nation-state and in its ideology: while its mission is to uplift, it does so only to reproduce itself, by bringing all those who are not wealthy under the hegemonic power of the ruling class, but without the benefits.[16] Here, the New York Museum of Modern Art (MoMA), in all its private/public ambiguity, is our case study for an archetypical American model. We understand what it means that the MoMA is private. This history explains why the term "Public Trust" remains a weak theoretical concept with little legal power to adjudicate on the distinction of what is public and what is private when it comes to our common collections.

Chapter 4, "Blueprints for the future: demographic and economic change," arrives at some immediate and long-term solutions for collecting our common patrimony. For museums and collections to reflect the demographics and cultural practices of the public we cannot work from the top down, but rather need to eliminate this hierarchy altogether. Significantly, the concept of "demographic" is basically a placeholder, as it cannot account for a history of colonialism and genocide that would make its literal application unjust. This chapter

contributes to the mapping project of socializing museums by asking how we can combine the work of economic and racial justice. Economic socialization can move hand in hand with antiracist work because antiracist work is the most direct means to organize for economic justice today. As long as the funding and its administration flow from private hands we will not see equity or equality, because the interests of the ruling class will never be the same as that of the public.

Chapter 1

THE SAN FRANCISCO MUSEUM OF MODERN ART AND ECONOMIC INEQUALITY: ART AND IMPERIALISM

In 2019 the San Francisco Museum of Modern Art (SFMOMA) announced that it would be auctioning off a Mark Rothko in order to diversify the collection. As the press release stated: "The museum's primary goal with this deaccession and sale is to broadly diversify its collection, enhance its contemporary holdings and address art historical gaps."[1] With the $50.1 million fetched from the Sotheby's auction the museum bought eleven wonderful works of sophisticated quality.[2] While diversifying the collection is a primary goal, the idea that it can only be done by deaccessioning a rare artwork from the height of Rothko's career[3] is not an unfortunate reality, but a consequence of decision-making processes driven by private instead of public interest, and which distracts efforts from commitment to substantial change. After all, the SFMOMA has just invested an enormous amount of energy and resources on a capital campaign and building venture dedicated to housing the largely undiverse private collection of Donald and Doris Fisher, founders of the Gap fashion enterprise. If, as the press release cited above argues, selling the Rothko was in order to avoid duplication, how is adding twenty-two Gerhard Richter artworks from the Fisher collection to the existing twenty-one in the museum's holding not duplication? There is more:

> Fisher [Robert] also noted that this massive long-term loan inspired other collectors to donate generously—to the tune of three thousand additional artworks. "The Collections Campaign was a story that came across well to the community. People embraced it. SFMOMA was able to approach collectors and say, for instance, 'We don't have a Gerhard Richter stripe painting, so if you give it, it definitely will be shown.'"[4]

Why is it assumed that, in addition to forty-three Richters, the museum must also obtain a signature Strip painting? Why, of all the artists and practices available locally and nationally, does the public need to see work that can be seen in any number of museums internationally, work that has no specific connection to the Bay Area, the United States, or its people? This is not necessarily to advocate for a regionalist perspective, but rather to point out a major flaw in the criteria presumed by museum leadership. That in the past some of the most important collections in the U.S. have come from private individuals does not mean private collections are publicly important in the present.

This chapter uses the SFMOMA as a case study of how the nonprofit system allows a private agenda to drive what museums collect. It shows how the public museum is used to raise the value of privately held art, which, given that art is increasingly an investment vehicle and the scale and stakes of the market for contemporary art have been on a constant rise, is even more problematic now than it ever was before.[5] If the museum is being instrumentalized to stabilize or boost the status of asset-class and other market art, we have a conflict with the museum's claim to public benefit.

The SFMOMA has argued that borrowing the Fisher collection enhances the museum's existing holdings. But this is tautological, because Fisher was one of the trustees who worked to grow the museum's collections in the first place, in the 1990s. Like other donors, the Fishers privately own work by the same artists they gave or loaned to the museum. Driven by businessmen, this logic of collecting and exhibition is oriented to blue-chip art and its scope is limited at the onset by the market. Why is the museum posing this collection as the canon? After all, it is chosen by self-proclaimed laymen, as I will show. When we allow them to steer the publicly subsidized institution in the name of the public it is, at the very least, undemocratic. Although we do know the Fisher collection holds some Californian, as well as women and historically excluded artists, white-male market artists have been repeatedly highlighted when press releases and media accounts were arguing for this collection's significance. As a whole the Fisher collection is methodologically and demographically narrow, too random of a selection, and offers little by way of a thesis about contemporary art.

Exhibiting a ubiquitous set of brand-name artists, drives up a "winner-take-all" market, subject to a "network effect" of self-reinforcing celebrity brand recognition whose goal is investment certainty.[6] The latter is no accident.[7] That museums collect and exhibit the same art as

its patrons is very much related to the fact that the price of the artwork stands to be boosted by merit of its museum inclusion. But this damages museums in the long run. When prices rise institutions lose their purchasing power and are left out of the market, becoming further dependent on collector patrons for gifts, loans, and rising operating costs. With the decline of public funding, patrons gain even more leverage and control. The claim then that the public benefits from private loans or donations is therefore debatable.

By catering to the vision of trustee collectors, the SFMOMA has failed its public promise. Had the museum refrained from adopting the Fisher collection, they would have been much nimbler and more flexible when attending to their recent mission to diversify the collection. There are ways to diversify a collection other than allowing an important and rare artwork to be lost to the public when, most likely, it is sold to private hands. Triage deaccessions cannot resolve the deep-seated problem that our museums do not reflect the culture of the public they claim to serve, or should be serving. Lack of diversity is a symptom of a deep problem of white supremacy that can only be surgically addressed from the ground up. Instead of vanity projects, historical and current exclusions manifesting in the demographics of collections, staff, and programming can be thoroughly and instantly addressed. But the SFMOMA, like most museums today, lacks a systematic approach to inequality, because when private interests are prioritized diversity appears as an afterthought.

To add insult to injury, the Fisher collection has not been given to the museum, but is rather on a 100-year loan (extendable by 25-year increments) that can easily find itself back in the hands of the Fisher heirs after its value has been enhanced by the authority and resources of the publicly subsidized institution. Further disconcerting is that several of the SFMOMA's exhibition of the undiverse Fisher collection have been supported by the meager public funding available in the U.S. Exhibitions partially supported by the National Endowment for the Arts (NEA) include: German Art after 1960: The Fisher Collection; Pop, Minimal, and Figurative Art: The Fisher Collection; Approaching American Abstraction: The Fisher Collection; British Sculptors: The Fisher Collection, May 14, 2016–October 6, 2017; and Alexander Calder, Motion Lab, May 14, 2016–September 10, 2017. From the titles of these exhibitions alone it is starkly evident that the demographic most represented is white-males. We can only speculate why NEA expert panels decided to grant money for the presentation of a private collection of extremely wealthy individuals who operate their own

foundation. It represents either lack of critical awareness, or it proves that public support for private taste is accepted and normalized by the professional arts community. It also means that museum personnel (or contractors) spent their publicly subsidized time asking for public money to support these exhibitions of an undiverse private collection. The ambiguity between the private or public aspects of American museums allows individuals to leverage the public both symbolically and materially to serve their class interest.

My argument has two nesting components. On the first level, I criticize the existing administrative structure of museums that allows institutions to represent themselves as benefiting the public while concealing the ways decision-making is driven by the interests of wealthy donors. I show that market-driven decision-making is not unrelated to endemic lack of diversity.

The second tier is a critique of the political economy of the nonprofit institution that reveals its role in sustaining extreme inequality locally and globally. In the case of the SFMOMA the connection is explicit and direct, as the wealth of its major donors is built on exploitation. Like many major museums with wealthy donors, the SFMOMA is a conduit between the globalization of production and American welfare. We use it here to demonstrate how art, in the name of the public and for the sake of doing good, becomes an agent of imperialism. Here, imperialism is used not in its historical sense of territorial conquest, but as a term characterizing globalized production, as Tony Norfield explains in the context of global banking:

> Under imperialism – by which I mean the present stage of capitalist development, where a few major corporations from a small number of countries dominate the world market – access to finance both reflects economic power and is a means of retaining that power. While poor countries also have banks, and while their companies may also issue bonds and equities, their ability to gain privileges by way of the global financial market is equally poor. This is because they have to operate in a system run by the major powers, one in which they take the prices offered to them and have little say over the terms of the deal.[8]

Beyond banking, this extremely biased system also structures production, generating superprofits for imperialist countries, part of which fund the nonprofit art system.

The ambiguous status of American art museums

Most American museums are structured as nonprofits and as such are neither entirely governmental or otherwise public nor entirely private, the latter because they receive their nonprofit status for the purpose of serving the public good. This allows the organization itself to be tax-exempt and donors to the institution can deduct their donations from their income tax, if they itemize their expenses. Significantly, the latter is a practice reserved for high-income taxpayers only, which is already discriminatory as working and middle classes do not receive any advantage for donating.[9] Generally, museums are organized either as private operating foundations, funded by a single donor (such as The Broad in Los Angeles) or public charities.[10] The SFMOMA is a public charity that meets the Internal Revenue Service (IRS) "public support test."[11] Nevertheless, it can still be classified on their tax return as a private foundation. The elasticity of categories allows the museum to claim the term "public" in publicity, fundraising, grant applications, and tax purposes, but declare it is private when it comes to scrutiny of decision-making, finances, or its partnerships with philanthropists.[12] In his thorough criticism of the SFMOMA/Fisher deal, reporter Charles Desmarais underscored how the museum is shielded from accountability:

> A request for more details, including a look at the loan agreement, was repeatedly avoided or ignored by the museum's public relations team.
> As a private, nonprofit institution, SFMOMA is not technically required to release such information. But even basic facts, such as when the loan term ends, were not forthcoming – until the museum learned this story was planned.[13]

But transparency cannot be left up to the museum's discretion. Because it is funded in part by the city's hotel-tax money, receives donations in lieu of foregone taxes, and has been a recipient of multiple NEA grants, the SFMOMA should be open to public scrutiny and held accountable to public benefit criteria. To ask what is the public benefit of the museum adopting the Fisher collection is to systematically ask broader questions of all such public benefit museums. This is not a criticism of the Fishers and their taste. They are not unique among the top donors/collectors. The criticism here is leveled at the state structure that allows this to happen. The SFMOMA is a model, an example evincing why the

current nonprofit system is ill-suited to democratically serve the museum's public.

The Fisher collection deal: what we know and what are we asking

The first round of talks between Fisher and the SFMOMA in 2005 failed. Fisher wanted a degree of curatorial control that the executive trustee committee and director Neal Benezra decided not to give. Then, San Francisco's Presidio park trust rejected Fisher's plan to build a private museum on the historic landmark. What remains a mystery is why a new deal with the SFMOMA was then heralded in 2009 as a success. Witness the tendency of public officials not only to wax superlatives, but to literally misrepresents facts:

> "This amazing collection belongs right here in the City of San Francisco," said Mayor Gavin Newsom. "Doris and Don Fisher have made an incredibly generous offer, and SFMOMA is the ideal partner and location to house this collection. This collaboration deserves our unanimous support and appreciation. This is a gift for the ages."[14]

Except the deal is neither a gift nor is it for the ages. What exactly is generous about a temporary loan that is also quite short in museum years? Nothing guarantees that the heirs of the Gap empire will not take their loan back when the deal expires.[15] Surely, the SFMOMA knows this happens: recanting heirs and donors have cost them a Picasso, just as it presumably gained them a Calder that was lost to the Whitney.[16] A few years prior, the United Kingdom experienced a dramatic temporary-loan cliff-hanger, when the Duke of Sutherland almost sold two of his Titians that have been on view at the National Gallery of Scotland since 1945, along other works from his famed Bridgewater collection.[17] Luckily, an arrangement was reached, granting the National Galleries in Scotland and London a favorable joint purchase, therefore ensuring that the work remains in the public domain and on display. Significantly, there is a monumental difference between the Bridgewater and Fisher collections. The former includes exceptionally rare historical works by Raphael, Rembrandt, and Poussin, to name a few examples. The Fisher, although undoubtedly containing some important and excellent works by Agnes Martin, Joan Mitchel, or Martin Puryear, to name a few, as a whole is not comparable with the Bridgewater. The urgency of the SFMOMA to borrow the entire Fisher collection remains in question.

The SFMOMA used the Fisher loan to kick-start a capital campaign that supported its 10-story expansion, adding 170,000 square feet of new and renovated indoor and outdoor galleries. We know that a committee of trustees chose the architecture firm and the design,[18] and that the "galleries [have been] tailored to the collection."[19] But since buildings are ideally permanent, and the Fisher is not a gift, we ask: what will happen to the building if and when the collection leaves? Furthermore, will the fact that it has been designed to house standard painting and sculpture dictate the museum's future orientation toward traditional artistic practices?

We know that a single law firm advised and counseled both sides, helping in kind to fundraise for the $305-million-dollar building expansion, and a $610-million-dollar campaign to enlarge the endowment and raise operating costs.[20] But what warranty do we have that our best interests are protected if the same lawyers represent both sides? As Gap Curator and now Fisher Foundation executive director revealed: "From the view of the Fishers, maintaining ownership of the objects is in their best interest."[21] Yet, as this book shows, the interests of the donors and that of the public inherently contradict.

Surprisingly, mainstream press was largely accepting of the SFMOMA's transformation, except for Desmarais, whose sharp criticism outlined the key problems early on, focusing especially on how much of the museum's display space would be going to the Fisher collection:

> It turns out, for instance, that the once-a-decade schedule for showing the collection in what Benezra calls a "monographic" presentation is the tip of a much deeper iceberg. Those huge galleries on the fourth, fifth and sixth floors that carry the Fisher name? Unlike in other spaces designated to honor big donors, which might hold a range of different works and exhibitions, the Doris and Donald Fisher Collection Galleries are required to contain primarily Fisher works at all times. No more than 25 percent of what is on view may come from other lenders or donors.
>
> This stipulation has major implications. It means that something like 60 percent of SFMOMA's indoor galleries (not counting free-admission areas that serve as combination lobby and exhibition spaces) must always adhere – or, at least, respond – to a narrative of art history constructed by just two astute but obdurately private collectors.[22]

Not only are the donors receiving curatorial control and the glorification of their name, they enjoy a set of benefits that transfer public resources to private hands. True, under its broader umbrella, the museum collects and showcases many types of practices and demographics; however, what it does do right cannot be used as justification for giving over 60 percent of the museum to an undiverse collection.

Here, the ambiguity of private versus public benefit is exacerbated by information opacity. The Fishers, who have been regular supporters of the museum, contributed toward the campaign, but the museum has not disclosed who donated what. For example, it is unclear who is paying for the expenses of storage, shipping, conservation, and insurance, although it has been noted that the Fisher pieces "will get the same care, scholarship, and conservation as every other work in the museum":[23]

> Once the transfer has been made, the artwork will be under the stewardship of the museum. In other words, the museum will be responsible for conducting and funding conservation, storage, and security. However, any artwork that is not on display at SFMOMA will be free to be exhibited at Gap or at the Fishers' private residences. Any requests to loan artwork to other institutions would be subject to approval by both the Fisher Foundation and SFMOMA. All of these terms are outlined carefully in the confidential legal documents that solidify the agreement.[24]

Critical information about the deal remains opaque.[25] The Fisher Foundation's tax returns show expenses for the art's upkeep, but we cannot find out which of the loaned Fisher artwork it covers, or who, for example, pays for shipping and insurance when artworks travel between its private and public use.[26] Importantly, the Fisher Foundation itself is also tax-exempt, such that much private-enjoyment expenses are publicly subsidized. We also know that the Foundation lists Doris Fisher and her three sons as trustees, leaving any type of supervision in-house. This is all legal. The problem is with the law itself.

Conflicting agendas of private and public interest

Museum administrators and leadership know that the agenda of private donors and that of the public museum are not the same. As then-director of SFMOMA Neal Benezra explained: "Museums are complicated organizations. We have education. We have conservation.

We do a lot of things besides hang pictures on the wall. Sometimes private collectors are interested in the most basic function – of hanging pictures on the wall."[27] Indeed, it was the latter use of the museum that the Fishers sought for their art collection, in essence, a private agenda that sought to display the collection together:[28]

> According to Gap Curator, and now Fisher Foundation leader, Laura Satersmoen, the Fishers have always had between 90–95% of their collection on view at a given time, divided between the Gap offices, the collectors' private homes, museum loans, or traveling exhibitions … In the agreement with SFMOMA, the Fishers will [be] able to continue to display their artwork in all of these venues if the museum is not using it, which will allow more of the artwork to be on display. When asked if it was an issue of not wanting the art to be in SFMOMA's basement, Satersmoen says, "That's exactly right. Museums have maybe 5 or 10% of their collection up at any time and the rest in storage because they don't have the wall space for it. The Fishers have about the opposite ratio."[29]

But what applies for one's private quarters or business does not necessarily merit neither permanent public display nor subsidy. Ironically, in what is deemed a "partnership" the advantage nevertheless seems to substantially be on the side of the collectors, as Satersmoen confirms:

> Control. That's the biggest benefit. If we gave all the [Alexander] Calder mobiles to the museum and said, "Here you are, no strings attached," then they would undoubtedly sit in storage … that's the primary reason why you'd want to have a partnership over an outright gift.[30]

The collection itself consists of about 1,100 works, which may explain why it was impossible for the museum to commit to exhibiting most of it. We know that museums with substantial collections are only able to show about 10–15 percent of their holdings, due to space and other resource constraints. While of course this is not enough, and 30–40 percent may be an ideal, there are still good reasons why museums do not show everything, like conservation and care. We remember also that museums are not intended only as institutions of display, they are just as importantly storage spaces: for our collective treasures, for secondary and tertiary works that support our understanding of oeuvres and

masterpieces, and for all other research or archival materials. Here we see an obvious contradiction between the interests of the donor who is out to get a good deal, and that of the public that undoubtedly will benefit more from seeing a broader range of artists and practices. As Judith Dobrzynski explained:

> I understand the pressure that SFMoMA director Neal Benezra must have been under to cut a deal with the Fishers. But it seems to me that he and the museum's board were out-negotiated. I–and, I think, others–will have to look at the museum differently, knowing these details. I hope other museums do not emulate Benezra and the museum's trustees.[31]

This paints a disconcerting picture of philanthropists outnegotiating the very institutions they tend to serve. But of course we know that "giving" is an outcome of wealth planning, not a symbol of generosity. As a student of the Fisher case verifies:

> During three separate interviews conducted while researching for this thesis, a collector, a scholar, and a curator all suggested that new tax laws implemented recently may have altered how collectors approach giving their artwork to museums ... Laura Satersmoen has indicated that this law has affected how the Fishers approach their relationship with museums.[32]

The Fisher loan was touted as a breakthrough model, but it sets a dangerous precedent giving collectors tremendous negotiating powers. One can only imagine what smaller institutions might be willing to hand over for the right to show collections of even lesser quality.

The politics and aesthetics of private interest

That the museum—its personnel, officers, and trustees—are acting in good faith and aboveboard according to the existing law is not in question. As stated in the museum's tax returns, it regularly monitors and enforces conflict-of-interest policies. The problem, elaborated upon in Chapter 2, is that current definitions of conflict of interest have limited capacity to address the exploitation of public institutions for private gain. With the SFMOMA case we see how longtime fellow trustee and friend of Donald Fisher, Charles Schwab, brokered the deal, cochaired the campaign for art donations, and procured naming rights

to the new entrance.[33] With his wife Helen, Schwab, an investor and financial executive, is also an underwriter of the named directorship. Since Schwab's influence is heavily felt all over the museum and its programming, we therefore ask: to what degree does the SFMOMA transmit or naturalize his philosophy and politics, which, not surprising for a financial executive, glorify capitalism?

> You have to reward those who innovate and create new products and markets. It's a core American value . . . An executive who has worked hard throughout his career, becomes a successful CEO and makes eye-popping money – I don't want to punish that.[34]

This last sentence is an example of a rhetorical fallacy. A government system that disallows individuals to make "eye-popping money" is not a form of punishment, it is a description of a democratic structure that aims to facilitate redistribution. Schwab wields negative argumentation to naturalize exploitation by rendering "eye-popping money" as a right, which it isn't. We have a right to freedom. There is evidence that wealth is an outcome of a biased system that prevents the freedom of those it exploits and marginalizes, not actually reward for hard work.[35] Logical fallacies aim to conceal the fact that in a capitalist economy, when one entity makes eye-popping money, they do not benevolently create it out of the blue, they siphon value from the total aggregate. This statement is actually not radical, it is based on the analysis of Adam Smith, the father of classical economy. This is not a question of worldview, but one of logic. Under the current system eye-popping wealth can be procured because a winner-takes-all system has been ideologically perpetuated by those for whom it is convenient. To sustain itself it severely punishes entire populations. Besides, it is not "eye-popping money" that is an American value, but equal opportunity. I am not saying innovation need not be rewarded, but I am saying that "eye-popping money" is always a product of collective effort, and should be shared accordingly. The system has been creeping for decades toward ensuring the enrichment of a few.[36] We have an ideological problem when our art and educational institutions participate in the cover-up.

Schwab's political position was revealed when he defended Donald Trump's trade war with China, in an ideological statement that went against the advice of his chief strategist. On March 2018, Schwab's company website published: "[I]t's unlikely that protectionism will turn around the U.S. trade deficit, or reverse the degeneration of U.S.

manufacturing."[37] In a June 2018 interview with Fox News, Schwab made the following explosive statement:

> In my view there is really no free trade as such, every country, particularly people like Russia, like China, like Japan, all have protective type tariffs ... I think what Trump is doing, and it's the right thing to do, we have to have some negotiating positions on these things ... today I think Trump is correct, we want to make America great again, we want to be competitive, stop the giveaways, and start working for ourselves.[38]

By stating that he, too, would like to "make America great again," Schwab does not leave room for much ambiguity regarding his political loyalties, and, whether he likes it or not, it amounts to endorsing the statement's racist implication.[39] Schwab donated $1 million to Trump's inaugural fund and $101,700 to his legal defense fund.[40] Also defending the president's tax cuts, Schwab proudly declared that the excess private money has brought a flow of new clients to his firm. This could be seen as a gauge for entrepreneurship, or it could be understood that Schwab's savviness allows him to make the current system work for him.[41] But does individual success in one sector, in this case business or finance, qualify a wealthy person to orchestrate everyone's culture? These individuals are not objective and neither is their approach to the judgement of art.[42]

The SFMOMA donor class does not seem to share aesthetic proclivities with the creative communities they ostensibly serve. A director of an alternative space tells us about the disconnect of the museum from local art circles:

> [Dena] Beard, The Lab director, said local artists also expect less of large institutions than in New York; they don't move here to be near SFMOMA. "We've seen our art institutions as ancillary to the art scene," she said, adding that local cultural life has been rooted in alternative spaces. "Artists here don't necessarily feel like SFMOMA was ever theirs to begin with."[43]

It is easy for a museum to lose sight of whom its public may be. Especially in a city like San Francisco, where the rapid growth of neighboring tech industries has resulted in a massive inflow of highly-paid creative industries workers and introduced rapid gentrification, causing rents to skyrocket, ultimately hurting artists. Yet, these tech creatives are

not the same as the creatives who had made San Francisco the bohemian city of international reputation that it was. Rebecca Solnit renders this divide:

> One of the curious things about the crisis in San Francisco – precipitated by a huge influx of well-paid tech workers driving up housing costs and causing evictions, gentrification and cultural change – is that they seem unable to understand why many locals don't love them. They're convinced that they are members of the tribe. Their confusion may issue from Silicon Valley's own favourite stories about itself. These days in TED talks and tech-world conversation, commerce is described as art and as revolution and huge corporations are portrayed as agents of the counterculture.[44]

The astonishment of creative tech workers is not that different from that of the Los Angeles art world when it discovered it was not wanted in Boyle Heights.[45] Gentrifiers do not bring business and prosperity for the local residents, they cause rents to rise dramatically, displacing local communities and small businesses. Often enough, art-world participants are unable to register the significance of local contributions, while they impose their aesthetics upon extant cultural production.[46] It is not therefore fear of change that drives antigentrification, but a struggle against the neoliberal privatization that follows the art world. The fact of the matter is that, whether they are commercial or nonprofit, "creative" communities mostly work in support of the ruling class.

The shock of the arts community at the election of Trump in 2016 conceals the fact that this mostly liberal constituency has always been looking the other way on the conservativism of a small but powerful faction:

> Many SFMOMA trustees champion liberal causes, but the board's political profile, measured in donation dollars, skews conservative: Federal Election Commission data show 10 trustees gave mostly to Republicans and 31 gave mostly to Democrats in the 2016 election, yet the 10 outspent the 31 by more than $4 million. (34 of the museum's 75 trustees gave little or nothing.)
>
> ...
>
> Securities and Exchange Commission filings further reveal at least 13 SFMOMA trustees or their spouses, who donate to the museum as pairs, are senior figures at firms invested in military contractors and arms dealers. The holdings include companies such

as nuclear weapons manufacturer Aerojet Rocketdyne, which the government of Norway once deemed an ethically unfit investment vehicle for its public employees [sic] pension fund.[47]

The question is not only how many, but how much—how much power do a small number of conservatives wield? This is the brilliance of this system: it forces those who participate in it, whether they accord with it or not, to work in support of wealth and power concentration.

San Francisco has become an outstanding example of extreme inequality. In 2018 a special UN rapporteur described it as unprecedently cruel.[48] A contemporary class system keeps the upper-middle classes above the fray. The tech sector has been hiring private buses exclusively to transport its workers from the city to Silicon Valley, declaratively excluding the local residents. As Rebecca Solnit explained: "All this is changing the character of what was once a great city of refuge for dissidents, queers, pacifists and experimentalists."[49] Creative industries have been feeding off the culture and reputation of the city, while killing the host.[50]

But what is commonly understood as "artwashing" goes far beyond the local level. If we ask from where does the wealth that funds the SFMOMA—and which is typical of many museum boards—comes from, the larger picture is even more disconcerting.

Art and imperialism

The Fisher's wealth comes from the garment industry. Gap Inc. has been offshoring manufacturing since the 1990s.[51] The company has recorded instances of international labor-law violations, has refused inspection in its Bangladesh facility in 2012, and, along with Walmart, a major supporter of Crystal Bridges museum in Arkansas, has been late to ratify a building and fire safety accord in 2013, which critics argued was not sufficient anyway.[52] With its surplus, Gap raised wages for their American workers to $10 in 2014,[53] which nevertheless can hardly amount to a living income in any of their major urban retail locations, especially in their San Francisco hometown, where $10 looks pithy in comparison with the fights for $15 waged soon thereafter.[54] In this light, the millions or billions in donations and art of the Fisher family foundations can be seen not as giving, but a system driven by profit extraction, which seeks validation by an interlinked system of philanthropy. The amount of power this system affords individuals has been deemed by scholars to be undemocratic.[55]

In terms of his presence in San Francisco and California public life, however, Fisher is all over the lot. He's spending portions of his vast fortune to change the way your kid goes to school, to influence the outcome of your local city hall or statehouse election, to alter the city's skyline, to refurbish your nearby park.[56]

Indeed, it could be argued that by "giving" from their excess wealth the Fishers contribute to the local arts economy, environmental causes, and charter schools with their other foundations. But why are lay individuals, with experience neither in art nor in education, allowed to make critical decisions regarding aspects of civil society and welfare?[57] Moreover, since part of their surplus is made by repatriating value created offshore, the Fishers, and other SFMOMA wealth that draws on offshoring industries, become a conduit by which the population of the northern hemisphere receives portions of their welfare from the exploitation of the global south.[58] Here again, the SFMOMA is a model for other large institutions and the criticism is structural, not particular or personal.

A totalizing view of the economy is necessary to understand the function of the arts within the larger system. A capitalist economy is a whole within which nonproductive sectors distribute value made in production. The understanding that there are sectors or activities that distribute or store value, rather than create it, comes from the father of modern economics, Adam Smith (who modified it from the insights of the French Physiocrats), in his foundational *The Wealth of Nations* (1776).[59] Marx applied this revelation critically, distinguishing the functions of labor power and money in the commensurability and equivalence that facilitates the economy (discussed further in Chapter 2). Both still provide a way for us to recognize that price does not represent value, but is a different type of category altogether. Evidencing its implication in great detail, he exposed how capitalism generates an inverted picture of the economy so vast that it is hard to spot, resist, and overthrow. Yet, once we understand that value in the economic process is first accrued in a general pool and only then distributed, we see that what appears on the surface as profit, is actually what different firms are able to pull from the general aggregate. When one product is more expensive than another it means that a firm is able to gain a larger share, which can be due to labor-saving technology, innovation, or brand monopoly, allowing it to capture more profit from the sector as a whole during the process of circulation. This is a fundamental aspect of the Marxist critique of the political economy. This is why anyone who is making "eye-popping money," is not creating it from naught, but always

making it at the expense of someone else. The creative process that went into making one product more expensive than another—coding, design, packaging, advertising, etc.— doesn't create surplus, but rather distributes it. Significantly, even Adam Smith has clearly emphasized that this is a technical economic matter, distinctly separate from the question of what is useful or not for society. Productive and unproductive labor will be further discussed in Chapter 2. For now, we direct our criticism at the conventions and power structure that result in extreme overcompensation of work in some sections of the production chain over others. That the creative, executive, and investor classes reap disproportionate parts of the surplus created by labor is an outcome of the state structure and global imperial relations. It is not natural or organic. Moreover, while Adam Smith was right about productive and unproductive labor, his conclusion that the invisible hand of the market will balance the two is empirically wrong, because there is no such thing as a free market. Markets have always been regulated. The existence of borders alone is already a regulation of labor prices, just one example of the ways the markets are categorically subject to forms of regulation that are authored by those who stand to gain.

Although production is now global, networked nation-states fragment the economy of a world system into national accounts. This masks the extent of the contribution of (globalized) productive labor to the final prices that are measured toward Gross Domestic Product (GDP) in the rich countries. The problem with GDP, as John Smith shows, is that when it measures the profits made by transnational corporations in the northern hemisphere, it measures what it perceives to be "value added," which should instead be called "value captured."[60] In his comprehensive study *Imperialism in the 21st Century: The Globalization of Production, Super-Exploitation, and the Crisis of Capitalism*, Smith uses three case studies of prototypical commodities: the T-shirt, the iPhone, and the coffee cup, to show how, since the 1990s, transnational corporations gradually shifted foreign direct investment to manufacturing in developing countries with low organic composition (more manual labor and less automated machinery), forcing local producers to push wages below their value in order to facilitate greater surplus value, most of which is captured by high price markups in the northern hemisphere. This makes the way nations now measure GDP (generally speaking, the combined final value of all goods and services produced within a national economy) wrong.[61]

The contemporary use of the term "imperialism" describes how economies of leading nations exploit weaker nations through arms-

length manufacturing, forcing local producers into conditions of superexploitation, where a (gendered) workforce works inhumanly long hours in squalid conditions. That this population is much larger than production can absorb allows pay to be pushed below a living wage. Andy Higginbottom shows how the depression of labor value below its actual value (the cost of its own reproduction) amounts to the superexploitation of labor, which results in superprofits for the capitalist.[62] The term "superexploitation" was largely developed by the Brazilian economist and sociologist Ruy Mauro Marini in the 1970s, to describe capitalism's dependency on indirect forms of exploitation throughout the system as a whole. In Chapter 3 I will show the longer arc of capitalist dependency, the world system as defined by Immanuel Wallerstein who demonstrated how, as early as the sixteenth century, the nascent forms of early capitalism in England could turn profit enough for accumulation only because, rather than consume pricier local grain, what fed workers was imported cheap wheat from eastern Europe.[63] Without this type of arbitrage, early systematic production would have never been able to turn enough profit to allow the development of what became fully-fledged capitalism.

Today still, the labor force in dominant nations generally enjoy better conditions because they benefit from the importation of raw materials and cheap foodstuff from weak nations, where exploitation takes place not only by extending the working day (absolute surplus value) in combination with wages that do not suffice workers to reproduce themselves (socially necessary labor time), but without investing in productivity-enhancing technologies (relative surplus value). Local populations survive by relying on informal economies to keep their communities afloat. Arms-length manufacturing ensures that when disaster happens, or labor violations and abuses are exposed, plant and sweatshop operators get blamed, while northern companies continue to profit with very little accountability:

> The full meaning of this was brought out by the rapid succession of catastrophes in Bangladesh: the Tazreen Fashions factory fire in November 2012, the Rana Plaza factory collapse in April 2013 and the November 2013 fire, all in Dhaka. Wal-Mart was implicated in all three. Besides Wal-Mart one can find in garments and apparel, sportswear and even fashion brands like Adidas, Christian Dior, Hugo Boss, Nike, Marks and Spencer's, Gap and H&M, which all thrive on workers, mostly women, paid wages far below even other sectors locally.[74]

Local factory owners (and owners of sweatshops in the northern hemisphere) have been squeezed by the brand companies that outsource the labor, and who repatriate the value-added from their seats at the oppressor nations, themselves complicit with such imperialist relations as they reap taxes and tariffs to fund the public purse.

Launched in 2013, the Bureau of Economic Analysis Arts and Cultural Production Satellite Account has been measuring the creative economy as part of the GDP. What these numbers do not consider is that portions of the values distributed by unproductive labor (design or retail, for example) come from the value registered by wealthy Western nations on their national accounts, despite the fact that it is actually produced offshore.

The same misconception of value is common sense in the arts field. According to the NEA Guide to the U.S. Arts and Cultural Production Satellite Account: "Value added is industry output minus intermediate inputs (i.e., energy, raw materials, semi-finished goods, and purchased services)—i.e., value added is the industry's contribution to the national GDP."[65] Yet, a Marxist perspective shows that value is only actually created by the transformation of inputs in the process of capitalist production, when abstracted living labor transforms raw materials into commodities that are then pooled into a common aggregate from which all other profits thereafter derive. The rest of the economy functions to distribute the value created in production.

Indeed, capitalists, whose doctrine is inherently based on the work of Adam Smith, are well aware of the difference between productive and unproductive labor. As the economist Brian Green exclaimed: "[F]irms know this very well. It is evidenced in their balance sheets!"[66] But, somewhere between the balance sheets of firms and the claims that they make on the political scene, the ideological system of capitalism has suppressed its own intellectual underpinnings:

> However difficult it may be to conceptualize or solve what has come to be called the 'transformation problem', values, which are prior to prices, *must be transformed into prices in a really existing process.* The consequences of this are profound. Once we open our eyes to the fact that, as part of the process of price formation, value generated in one firm may be transferred or reassigned to competing capitals, we are obliged to radically redefine value added to signify not the value it has added but *the share of the total value created by all firms* competing within the economy as a whole that this firm succeeds in capturing.[67]

Skeptics may argue that innovation and efficiency contribute to creating more value. I raise the clear and accessible analysis of the Great Depression by Joseph Stiglitz and Linda Bilmes, who are not Marxists, yet prove how the making efficient of agricultural production led to a chain reaction that contributed to the collapse of the American economy in 1929.[68] This is because prices do not reflect value but are rather determined by multiple factors, including the market. Since the economy operates as a whole, efficiency at one end may seem to contribute to the GDP, but might also throw the system into an imbalance that results in collapse. Crisis capitalism has survived since 1970s stagflation because of deregulation, globalization, and temporary phenomena such as the dot.com boom. Underneath these corrections lies an endemic crisis of production that results in the tendency of the rate of profits to fall, the latter a fact also plainly evident by any accounting of capitalism's long and short histories.[69] Capitalism can survive only because it is dependent on the free (gendered) labor of social reproduction and care work, the plunder and destruction of common natural resources, and the simultaneous existence of precapitalist economic forms.[70]

Two of the commodities John Smith traces around the globe, the iPhone and the T-shirt are especially pertinent to SFMOMA, which grooms the tech industry as collectors, by which it expands its pool of donors.[71] The creative industries benefit directly from these forms of exploitation, which, as we have seen, essentially means investors and executives are taking a disproportionate share from the value pool. With these excesses they can support the art market and the institutions that are networked with it. Under liberal logic, creative workers are deemed more productive and are therefore also paid much more than laborers. A creative worker or executive in Silicon Valley enjoys the fruits of this world system, just as the entire welfare and nonprofit system benefits recipients of imperialist nations.

The point of this comparison with the workers producing the cheap commodities we all enjoy is to say that we owe these people our solidarity. Most significantly, a struggle for public funding for the arts should take the problem of imperialism into account. For this reason, we might want to take a longer perspective and reconsider the default left or liberal common assumption that a fight for government money for the arts is necessarily the best strategy.

Fighting for crumbs: problems with defense of public money in its current form

Like Ronald Reagan in the 1980s, Trump has attempted several times to eliminate the NEA or to severely cut its budget.[72] The antagonism of both Republican presidents to public funding for the arts reflects their ideological inclination to small government, privatization, and the conviction that arts should be supported solely by the private sector. However, as organic as it may seem, we ought not assume that rightwing politics inherently entails a belief in the privatization of art. Quite the contrary is seen in "A Conservative Plea for the National Endowment for the Arts," an opinion by Mike Huckabee, Arkansas governor from 1996 to 2000, and a staunch Trump supporter, imploring the president to preserve the federal granting agency. Huckabee's argument is economic:

> The arts are a $730 billion industry, representing 4.2 percent of our gross domestic product—more than transportation, tourism and agriculture. The nonprofit side of the arts alone generates $135 billion in economic activity, supporting 4.1 million jobs ... The American arts generated a $30 billion trade surplus in 2014, on the strength of $60 billion in exports of various arts goods.[73]

Huckabee's perspective and sources are echoed in the advocacy of groups as varied as Americans for the Arts, or the College Art Association.[74] That a defense articulated by a conservative aligns with the ongoing attempts of liberal arts activism to save the little public support that the U.S. has for the arts reveals a core similarity between the two worldviews—neither is a critic of capitalism.

There are conservatives who recognize that meager arts funding not only sustains the system, but can be leveraged in support of private accumulation. The received knowledge on both sides of the isle is that the arts contribute to the economy:[75] "NEA grants provide a significant return on investment of federal dollars with $1 of NEA direct funding leveraging up to $9 in private and other public funds, resulting in $500 million in matching support in 2016."[76]

So far we have witnessed two major problems. The first is that public money, here NEA money, is used to support institutions driven by private interest, and they end up further enriching the rich as discussed above. The second is that these private individuals, toted as entrepreneurs, are becoming ultrawealthy by exploitation. Significantly, this system

serves both a right-wing agenda and a democratic establishment that assumes it to be structurally unchangeable and therefore engages the battle only on the ground of reform. Reform is a slippery slope. Those who believe that the system has the capacity to evolve toward more social justice end up fighting harder and harder for less and less.[77] The recent history of public arts funding in the U.S. is a story of such compromise and decline.

In "Reagan's Revenge," a 1990 analysis of diminishing NEA appropriations, Carol Vance recalls how the arts community set differences aside to mount a forceful defense of public arts funding, where the liberal constituency found itself in alliance with the (at the very least) fiscally conservative:

> [P]hilanthropists and donors to cultural institutions testified that federal funding for the arts was essential, rejecting Reagan's contention that private philanthropy could take up the slack. Paradoxically, the boards of many major institutions seemed thick with supporters of supply-side economics who nevertheless wanted continued subsidies for their museums and symphonies.[78]

It is not lost on conservatives that their contribution to public investment enriches them; they would not be doing it otherwise. It is therefore not surprising that conservatives align with arts advocates on the issue of public seed money for the arts. Government funding provides a basis for the operation of the nonprofit system, and the nonprofit system is, in part, how the government subsidizes the economy that benefits the wealthy.[79] Ample critical research, a substantial portion coming from people that work within the system, forcefully argues that the nonprofit system is not making good on its promises.[80] Throughout the neoliberal period, as cuts to public services increased, the nonprofit system carried more and more of the burden foregone by the declining welfare state. In many ways the nonprofit system became a vehicle for the privatizing of the welfare state and of civil society.[81] As the wealthy get wealthier,[82] they gain more tax advantages through philanthropic giving,[83] in some cases supporting their business agendas directly with tax money that the public has essentially foregone.[84] They receive from the public a combination of tax advantages and influence in areas they see fit, on top of which the wealthy are also rewarded with abundant gratitude. Conforming to the given structure, the arts community has time and time again defended the interests of the wealthy, and ignored, if not occasionally attacked, the interests of the working class.

Let me be clear, I do not mean to discourage advocacy. Advocacy is a means to consolidate community, have people's voices heard, and nurture political participation. But it is also important to point out when advocacy is set up as a means to ensure obedience and prevent more consequential activism. For example, arts funding based on competitive grants pits institutions one against the other, ensuring that they remain divided, entrenched in the exhausting battle for funds, public and private. We have watched how competition for funding affected conformism at critical moments. As Vance identifies, George H. W. Bush (president, 1989–93) used the sex panics generated around AIDS to help further Reagan's original defunding agenda. In the aftermath of the culture wars waged around NEA funding, Vance tells us that fear of losing funding discouraged risk-taking.[85]

Given the circumstances, it is understandable that arts advocacy activists fight for preserving the little we have, and that they do so within the parameters and means set up by the system itself. Yet, such reactive strategy has allowed conservatism to dictate the terms of the struggle, pushing advocates into a tighter and tighter corner, demarcating the parameters of possibility by the logic of capitalism and subjecting us to its mercies.

"Grateful for small abuses": diminishing public support

Despite resistance, Reagan was ultimately able to significantly reduce funding for the arts, and the National Endowment for the Humanities (NEH), nominating conservative personnel to key agency and council positions, which further influenced content selection:

> In fact, the 1982 cuts were severe. The arts appropriation dropped from $158.8 million in fiscal 1981 to $143.5 million the next year. The NEH lost close to 14 percent of its $151.3 million budget in 1982 and would not regain its 1981 level of funding until 1989. In an era of double-digit inflation this represented a real dollar cut of approximately 50 percent over the course of the 1980s—an amount consistent in the end with the Reagan administration's original objective. The NEA, which had a more effective lobbying network in well-known performing arts advocates and a large and dedicated institutional base of arts organizations, did return to (and exceed) its 1981 appropriation by 1984; however, even that did not keep pace with inflation.[86]

Significant cuts also took place under Clinton's Republican-dominated congress,[87] such that between 1978 and 1998 appropriations for both endowments declined by roughly 85 percent in inflation-adjusted dollars.[88] The promise that philanthropy would fill in the gap was also a fallacy, keeping the U.S. per-capita support dramatically under that of Europe.[89] Cynthia Koch tells us about the Clinton years:

> But like the strange sense of relief experienced by arts people five years earlier, when the final 1990 appropriation legislation carried a compromise version of the original punitive Helms amendment on obscenity [consequence of the "Culture Wars"], the $5 million rescission seemed more a relief than an assault. Or, as it was put in a retrospective memo sent to humanities councils: "By March, a lot had happened. We avoided a serious rescission, and the councils were fortunate to take no cut at all. Did we dodge a bullet, or the bullet?" Like the arts advocates who had faced years of vocal attack that threatened their core purposes, now the humanities constituency was grateful for small abuses.[90]

"Grateful for small abuses" is a cautionary tale. Since then, the support for arts has continued to decline in real dollars.[91] Diminishing public support for the arts resulted in intensified advocacy efforts, which meant more energy spent on obtaining funding from a declining pool:

> Substantial staff cutbacks and wholesale program reorganization have cut into its expertise and its ability to systematically affect entire fields or disciplines. Persistent political criticism and a bureaucratic siege mentality have diminished its capacity for program innovation, policy entrepreneurship, and national leadership.[92]

The fight to preserve diminishing public funding is inherently defeatist. It functions as a topical solution to a deep-seated problem of programming and collections homogeneity, itself an outcome of a long institutional history of concessions to private interest.

Arts funding and diversity

Diminishing public support always hurts historically excluded groups first. Moreover, since what we see diminishing was already inadequate, we need to reconsider struggle strategy altogether. In the larger picture, meager and unequal subsidy for the arts perpetuates a system that, as a

whole, extends the conditions of disenfranchisement. It leaves historically excluded communities in a state of perpetual dependency, competition, and emergency. It is ironic then, if not cynical, when the advocacy by historically excluded groups is front and center in the defense of public subsidy for the arts, because in the larger picture they remain so underfunded.[93] Exclusion has also been enacted historically by the classification of art forms into hierarchical categories such as craft, folklore, community arts, art therapy, or social welfare, skewing an objective assessment of merit and significance, and under this pretence blocking entire demographics of artists and professionals from fair representation in the field. From the late 1960s on, excluded groups were gradually given the chance to participate in national culture and be collected by and exhibited in major institutions, but nevertheless, heavily biased notions of quality continued to determine what institutions collect. Signed into law in 1965 by Lyndon Johnson, the NEA was to remedy historical imbalance, and like many other initiatives, it was successful just as it was limited.[94] Thus, even if the NEA has given seed money to smaller organizations and helped lift some underrepresented artists from total marginalization, at the end it overwhelmingly supported mainstream art institutions that tended to be demographically white.[95] The NEA budget grew roughly ten-fold under the bipartisan appeal of the legendary Nancy Hanks (NEA chair 1969–77). The expansion was mostly directed to large-scale, mainstream, cultural institutions producing hegemonic art programs, serving a predominantly white, middle to upper class demographic. In effect, during the years that the NEA was more robust, its support was heavily allocated to mainstream metropolitan culture. While later it saw a broader set of cultural forms and geographic localities supported, this also coincided with reduction in real dollar funding. But the point is not to argue that the NEA be abolished because it is elitist and discriminatory, as some conservatives have.[96] The point here is to find a way to transform the system into a vast egalitarian public arts economy, by changing its structure, not by pushing or pulling it back and forth in its current form.

Under Jimmy Carter, Livingston Biddle (chair 1977–81) attempted to democratize and regionalize the agency. This was seen by conservatives to be promoting social programs rather than art. Then Reagan, for all his claims to base criteria on merit, chose not an arts professional but rather a career bureaucrat, Frank Hodsoll (1981–9), who aggressively intervened into the agency decision-making process, overturned competitive peer-based choices (even those approved by the National Council), appointed conservative personnel, and invited collectors and

dealers to sit on panels.[97] Radical, community, or identity-based manifestations were seen as political and propagandistic.[98] "Merit" became a code word for measuring art by so-called universalist criteria, led by market preference, traditional canon, or a claim to formalist objectivity. In essence, it was the deskilling of criteria and assessment.

Complex outcomes emerged in the late 1980s and early 1990s. Since the broader project of multiculturalism was well on its way, giving a degree of visibility to art by underrepresented groups—just enough to instill a dread that it was taking over—it evoked a backlash on all sides of the aisle. In contrast to perceptions, art outside a Western-centric canon remained underrepresented and underfunded.[99] The reasons are evident in the conduct of our case study—the SFMOMA—where the bigger commitment to donor will and a market-based taste in art overwhelm the attempt to balance the collection.

Art finance and wealth management: questioning the public merit of private collections

Against market criteria

The SFMOMA's publicity and the media repeatedly named Georg Baselitz, William Kentridge, Roy Lichtenstein, Cy Twombly, Willem de Kooning, Richard Diebenkorn, Ellsworth Kelly, or Brice Marden as the major focus of the collection, in addition to those listed in the press release:

> The Fishers' collection is a perfect complement to SFMOMA's already strong holdings of artists like Gerhard Richter, Andy Warhol, and Philip Guston, and gives us new strength in our representation of major figures like Alexander Calder, Anselm Kiefer, Richard Serra, and Chuck Close.[100]

But this is a self-fulfilling prophecy. It is true simply because of the fact that the same people influenced the museum's holding when the new building opened downtown in 1995:

> Almost immediately, Schwab and Fisher set out to find great art to fill it. As entrepreneurs the two men had a natural rapport, which they had bolstered by serving on each other's corporate boards. "Our shared quest for contemporary art was an important part of the

relationship," Schwab says. Adventures together included a jaunt to Japan. "We went to buy art from a Japanese bank that had a vault full of art that had been securing debt," he recalls. "A lot of the art we collected on that trip would eventually go to the museum."[101]

Lack of transparency prevents us from knowing what these collectors bought for themselves, and what they gave the museum.[102] It is though implied that there is overlap, such that beyond impacting what the museum will hold for the public or for posterity collector-patrons are potentially guaranteeing, or enhancing, the value of the art that they themselves collect. The museum they govern as public service is providing public significance to the art they privately own.

We also need to ask why a present-day museum is collecting the type of art held in a bank's vault? Indeed, we know that this is the art that is highly priced, but other than this can we really say that this is the most significant art? The equation of quality with price is artificial. Posterity does not measure quality or significance by the price art fetched at its time. Dramatic historical fluctuations in price is evidence that prices may rise and fall according to taste, and that contemporaneous fashion does not always ensure lasting significance.[103]

Everything said above is exacerbated in the twenty-first century, when the attempts to corral art collecting in the service of the finance industry has reached a maturity that puts it at obvious odds with the public institution. Much of the art market's unprecedented growth is intimately related to the relative liquidity granted to it by the monetization and financialization of the art object, which has made it an easier means to both store and (partially) liquidate capital, incentivizing investors and an influx of new collectors. As Business Development Director for Christie's France explains:

> The safe-haven status, attributed to works of art and collectibles (including wine, jewelry, watches, etc.), their inclusion in wealth investment and diversification strategies, or also the development of the online art market, highlight the nature of these structural changes. The accumulative effects of these drivers of growth have allowed the art market to rapidly recover from the 2008–2009 financial crisis and reach, in the intervening years, both historically unprecedented global sales totals and price levels.[104]

This expert opinion is published in the Deloitte report on art and finance, where one of the world's largest accounting firms that has also

expanded its services to private and public art consulting and wealth management brings specialists to analyze the state of the field. Made abundantly evident throughout this document is the assumption that the role of the publicly subsidized museum is to support the health, if not growth, of the market.[105] Repeatedly, numerous art-market experts testify that information is one of the most sought-after resources and which is sorely lacking. The museum not only has information to offer, it generates it. What is not said in this report is that it is *not* the role of the publicly subsidized institution to be an agent of inequality by supporting the financial industry.

Although the type of museum and donor relations I am describing do not constitute conflict of interest in strictly legal terms, in any other industry such a relationship, giving individuals a business advantage over the public, would be illegal.[106] Individuals serving in governance or committees have access to information and influence on collecting and programming at the same time that some are privately involved in buying art, advising clients on collecting, and/or wealth management; owning shares in auction houses with which the museum does business; or borrowing or lending capital against art with past or future museum display record. This does not happen just at the SFMOMA:

> "Like investing, collecting is about pattern recognition; it's about doing your due diligence, it's about assessing intrinsic value, and it's about knowing what and when to sell," said Anne Dias, a trustee at the Museum of Modern Art and the Whitney Museum trustee and former hedge fund manager who now runs her own family office, speaking at the Deloitte conference.[107]

The museum has been cast into the role of stabilizing the art and finance industry not only indirectly, through the total system, but directly, by virtue of owning, caring for, and displaying the same art on both the public and private sides. Why is it the job of the publicly subsidized art institution to offer stability for art driven to bubble prices by acting as collateral in a lending and insurance market?

Significantly, art collateralization is becoming a major vehicle in financial management and, as experts have identified, it is "not a minor phenomenon either, considering that in the U.S., art collections come in a close fourth as the most common collateral loan after commercial real estate and merging securities."[108] To be worthwhile collateral art must be expensive. This ties the criteria for quality assessment that the museum can provide to speculative debt leveraging. While in many

cases the connection between quality and price is inevitable (as with the market for singular and rare historical works), with contemporary art the need for verification is higher, and hence the stakes of its institutional dependency. When financial stakes are this high for museum donors and trustees, it compromises the ability of curators and directors to objectively assess art's significance.

The problem of judgment is exacerbated with art by living artists. Not coincidentally, some savvy artists have designed strategies to produce high volumes of signature-style work that can nevertheless be cast as singular, thus justifying high prices. But we need to remember that it is not the role of the museum to generate the symbolic backing to make this type of work expensive.

Private collections: a curatorial history perspective on the question of quality criteria

There are also qualitative reasons why institutions should be unlinked from the task of sustaining or raising art prices. The Fisher collection is unabashedly lay:

Don Also, I don't think I'm smart enough to be able to pick out the emerging artist who is going to be great.

Benezra So you don't consider yourself a talent scout.

Don Correct. Although I think we have put together a wonderful collection, it's difficult to determine what makes an artist great. History will be the judge.

Doris Yes, but we generally veer toward work that we find more aesthetic.

Don That's right. That's a very good description. We bought works that were visually appealing to us.[109]

As the Fishers themselves attest, they collected art that was not "too tough in terms of content."[110] So now approximately 60 percent of the SFMOMA display is subject to what was visually appealing to individuals self-described as not smart enough to objectively judge art. They nevertheless seemed smart enough to have fashioned the institution into supporting the art they own. The nonprofit institution should do exactly the opposite of what the SFMOMA did, that is, serve

art that *is* difficult in form and content. In order to experiment with new, radical, marginalized, or otherwise unmarketable forms and ideas, museums have to be sequestered from the pressures of populism, ratings, and individual personal taste.

When helping the Getty Museum in Los Angeles implement a collection policy, Otto Wittmann, legendary for having put a small museum in Toledo, Ohio, on the international map, explained in a memorandum: "The basic reasoning behind developing such a policy was that there is a difference in concept between collecting by an individual and collecting for a museum in order to enhance public knowledge."[111] A student and mentee of Paul Sachs, time and again Wittmann underscored the need to acquire masterpieces and the finest examples—quality stressed over quantity. On the limited availability of quality art Wittmann advised the board to practice "acquiring art in areas that were at that time weak or nonexistent in the museum and that were neglected and out-of-fashion in the market."[112] The idea to collect out-of-fashion art is profound. It can be both a means to enhance diversity, and balance the power of the market. It also demonstrates in retrospect that price does not represent significance. The ostentatious declaration that "the best art is the most expensive, because the market is so smart" is a fallacy, historically incorrect, and I would hedge my bets that the speaker knows this very well.[113]

James Soby, who directed the Department of Painting and Sculpture at the MoMA from 1943 to 1944, strongly advised against acquisitioning entire private collections. In a report to the trustees, Soby contrasted the rare and outstanding instances of the Frick and Wallace collections, as he outlined the fundamental distinction:

> As Professor Sachs so eloquently pointed out at the Trustees meeting of Jan. 11, 1945, there is a great natural difference between the collector's viewpoint on acquisitions and the Museum curator's. This was said then and is repeated here, not to minimize the importance and function of private collections, an altogether valid preparation for the responsibility of making acquisitions for a public institution. But I believe, too, that it is valid only in so far as the collector is able to keep in mind the contrasting problems relating to private collecting on the one hand, museum acquisitions on the other it is not always easy to keep these problems in mind—I know that it was often difficult for me to do so, as director of Painting and Sculpture, after fifteen years of private collecting in the Museum's own modern field.

For that reason I would like to list here some of the contrasts in approach.[114]

Soby goes on to contrast the two types of collecting in parallel columns.

Collector:	Museum curator:
1. The gratification of private taste and love of the arts.	1. The broad educational program of a public institution.
2. Absolute freedom of choice within financial limits.	2. The necessity for covering all significant aspects of a given field.
3. Expenditure of one's own money.	3. Expenditure of somebody else's money, given in faith and confidence to a public institution.
4. A free hand in changing the contents of a collection through sale, disposal or trade, following the dictates of personal taste.	4. A professional responsibility in making sure that personal changes in taste do not lead to eliminations which will a) Be hasty and perhaps a mistake b) Break the continuity of a public collection which should <u>illustrate</u> changes in taste, with reasonable limits, rather than be reconstituted entirely according to these changes.
5. Freedom from public pressure and from responsibility toward living artists.	5. The need to consider carefully pressure from public groups, to refute it if ill-founded, to weigh it if it appears fair.
	6. A tremendous moral responsibility toward living artists whose careers and fortunes can be drastically affected by the Museum's support or lack of it.[115]

Soby concludes that, while they each serve a different purpose, "The standards of the first cannot be applied to the second without attendant limitations of function which are of the utmost seriousness."[116]

It is clear that the Fisher collection cannot live up to this standard, since it represents a limited range of individual taste. Naturally, only some of its pieces are truly distinct: "Museum director Neal Benezra identifies a 'core collection' of 400 especially important works, about 90% of them created since 1960."[117] Even by conservative standards it seems hard to justify overall "quality" because Benezra's assessment roughly leaves only 36 percent of the collection as "especially important." There is no reason to doubt Benezra's appraisal, yet a nagging recollection persists: his position is handsomely endowed by Charles and Helen Schwab. In other instances of named positions,

universities, for example, scholars holding endowed chairs or professorships do not have such close and extensive contact with their benefactors, and even under these conditions, the objectivity of persons receiving endowed positions are rightfully questioned.[118] For this reason, it is impossible to ask Benezra to remain objective under such circumstances. Thus, if we consider that he might have given the Fisher collection a generous assessment, this means that at least 66 percent of works taking up 60 percent of the museum are not so important.

But, must a museum like the SFMOMA only display important works? The answer is: absolutely not. A museum should definitely display experimental and controversial work, works of quality yet unknown, revisionist perspectives that are still in question, etc. But the Fisher collection does not meet these criteria either, because as Satersmoen identified: "There's no Piss Christ in the collection. Or Anything made with Elephant dung, or anything like that. It's kind of classic, blue chip."[119] In contrast, the display of the SFMOMA's own permanent collection boasts fantastic treasures of California art, the Bay Area figurative movement, works by Joan Brown, Jay DeFeo, Wallace Berman, Bruce Nauman, and many others that one would like to see in depth in the major Northern California institution, some of which are rarely seen elsewhere. When traveling to San Francisco one can imagine rooms full of work by legendary artist and Black Panther Emory Douglas, or artists of the California Clay tradition, to give just two key examples. Instead, a limited selection of local work is on view, the permanent collection display is overcrowded in a marginal set of galleries, while a temporary private collection dominates the institution. Where are the iconic local contributions of Beat culture, experimentalism, the Black Panthers, Berkeley's radical past, the gay and queer and universes developed above and underground, or the complex and imaginative works of art and activism that responded to the AIDS crisis—all the histories that have made the Bay Area unique? Why not continue in the legacy of the first museum to have shown Judy Chicago's "Dinner Party" (1979)? Where is the West-Coast emphasis Henry Hopkins focused on in the 1980s?[120] We know the museum has collected Bay Area video and performance art; wouldn't it make much more sense to build a museum around this legacy? An attempted cosmopolitanism seems misplaced.

The SFMOMA was never set up to build a canonical collection:

> For the most part, old line San Francisco families did not collect art. They lived with a few pieces that helped create a pleasant environment, and when they died, their heirs tended to sell the work. That's why, in

comparison to New York, Chicago, Boston and Philadelphia, local museums had such weak collections.[121]

This could have been an opportunity to build a different museum. Instead, wealthy patrons chased a vision of generic internationalism.[122] The SFMOMA could have taken a cue from the Tate Modern, which has managed to turn a weak collection into a strength, emphasizing local and peripheral Modernisms. Even before announcing that it would revamp, the permanent collection display at the Tate Modern in London foregrounded examples of South American and North African Modernism, alongside artists such as Gwen John or Meredith Frampton. This is not to necessarily elevate the Tate over the SFMOMA. The Tate suffers its own ethical compromises in terms of funding and is a pioneer in the museum branding trend and its emphasis on the marketing of experience and the homogenization of culture.[123] It is simply to show another mainstream model that does not overemphasize artists central to the art-finance nexus.

Neo-expressionism in San Francisco:
the conservatism of Georg Baselitz

The SFMOMA holds at least six works by Georg Baselitz, all of which belong to the Fisher collection with dates ranging from 1965 to 2007. What does it mean for a museum that purports to advance diversity to promote the work of an artist who continuously repeats that women are inferior?[124] Speaking with Kate Connolly from the *Guardian*, Baselitz said: "If women are ambitious enough to succeed, they can do so, thank you very much. But up until now, they have failed to prove that they want to. Normally, women sell themselves well, but not as painters."[125] Gasp. The proposition that women "sell themselves well" is nothing short of verbal violence. If Baselitz's opinion rings familiar it's because he made nearly identical comments in 2013: "Women don't paint very well. It's a fact." He backed up his claim by saying that women don't pass "the market test" or "the value test."[126] The tests Baselitz doesn't pass are history and critical thinking. Market success is not a consequence of fair competition or assessment of quality, but compatibility with contemporaneous taste and a lot of luck.[127] Surely Baselitz knows that Van Gogh was not passing any market or value tests in his time. While we can attribute the offensive opinion of historical figures to bygone worldviews, it would be hard to argue that we should also do so in the present. Herein the differences in the public and private collection of art

make themselves starkly clear. If the Fishers wish to collect the work of an artist famous for his conservative practice and out-of-touch worldviews, so be it. If the SFMOMA chooses to endorse it, they, as a public charity, elect to perpetuate a discriminatory culture.

In art historical circles it is commonly understood that the success of neo-expressionist artists such as Baselitz is part of a conservative backlash.[128] In the chapter "The Postmodern Museum," from his landmark study *On the Museum's Ruins,* Douglas Crimp distinguishes between a progressive postmodernism rooted in critical practice, and a reactionary one seeking to return to the modernist mythologies of artistic genius and self-expression.[129] Crimp's Foucaultian analysis of the museum as a space of exclusion and confinement has "subjected the reigning idealism of mainstream modernism to a materialist critique and thereby showed the museum—founded of the presuppositions of idealism—to be an outmoded institution, no longer having an easy relationship to innovative contemporary art."[130] Crimp shows how such institutional practices underrepresented, or altogether excluded, a range of radical practices (and we can extrapolate demographics), essentially falsifying art's history. In adopting a collection heavy in art reliant upon outmoded notions of originality or artistic genius, the SFMOMA is perpetuating again those very mythologies that have been criticized since the 1960s and 1970s, and again by the critical analysis of race, gender, and sexuality in the 1980s and 1990s. The practices collected by the Fishers, and most museum supporters, usually represent but a narrow range in decades bursting with new forms of making and critical thinking.[131] Crimp wrote about the 1980s and the shift to neoliberalism, which since its rise in the late 1970s has exacerbated economic inequality and resulted in the recent global resurgence of authoritarianism, misogyny, nationalism, racism, and xenophobia. Museums promoting such outmoded perspectives without proper context are failing the education of their audiences.

Formulas for beauty: Gerhard Richter's cottage industry of singular-multiples

As opposed to Baselitz, the significance of Gerhard Richter's contribution to art's history is not in question. I do though, as does he, question his prices. This is evidenced in an interview:

> "How do you feel when a Gerhard Richter painting [sells] for tens of millions of dollars?" Richter answers: "Ambivalent. On the one side, I

am proud that they pay so much for this little painting I did that was extremely cheap. And on the other hand, I think that's not good … They shouldn't pay 30 million for a painting. Even for a Picasso that's too much."[132]

Something has changed in the logic of art. Usually rarity is a weighty cause of art's high cost. Yet, the fact that Richter has produced thousands and thousands of artworks has not adversely affected his market.[133] The problem here is that his prices are connected to a publicly subsidized system, which has been corralled by private interests and is part of an agenda to keep prices soaring.[134]

The argument is that the only way for his works to live up to their conceptual significance is if they were cheap. As the painter Liat Yossifor concludes, "Richter is for the masses."[135] One artist can perhaps make thousands of artworks, but technically speaking, the vast majority of them are simply not masterpieces.[136] Major aspects of his practice, from his turn to abstraction and on, are based on device-produced multiples. They are not singular historical works, but parts of series whose conceptual significance is in many ways derived from this fact. When Richter stopped making his Strip Paintings, a series of digital prints produced by photographing, scanning, stretching, and mirroring slices of an earlier abstract painting to form a stripe pattern, he announced: "After 4,000, you can't see the difference. You'd have to look through a microscope. It wouldn't make any sense."[137] It also doesn't make any sense, neither from a conceptual standpoint nor from a formal one, to make 4000, or even 40. In series where the art-historical significance relies on a conceptualist logic, the only works that are truly important are the first, the last, and the ones where consequential transitions took place. The only reason to make 4,000 is to sell them. What makes even less sense is for so many museums to own so many of these works.[138] All the important issues this work raises about history, photography, or memory; figuration versus abstraction; or about painting's death and resurrection, do not justify more than a few key examples in museum collections. The rest might be stunningly beautiful, but they are not publicly significant. They ought to stay in private collections or on the market.

Richter himself is the first to admit that his paintings are not masterful. He has clarified that his smudging techniques are a means to overcome flaw, lack of detail, and to ensure the paintings are easy on the eye:

> I'm never really sure what that word means, but however inaccurately

I use it, 'classical' was always my ideal, as long as I can remember, and something of that has always stayed with me, to this day. Of course, there were difficulties, because in comparison to my ideal, I didn't even come close.[139]

While the artist cannot be held accountable for his market, he can be for his practice. On the one hand, claims that his is a critical practice rely on comparing his work with the serial strategies developed by minimalist and conceptualist artists, on the other, they are sold for the price of singulars as products of a fetishized genius, which would contradict the conceptual underpinning. The significance of Richter's paintings is anchored not to the modernist logic of the painterly practice, but rather to Andy Warhol's postmodernist print production, where the techniques, and therefore the scale of output, were more akin to an artisanal cottage industry.[140] Warhol, who referred to his studio as "the factory" and declared intensions to mesh art and business, was working in defiance of modernist conventions and their emphasis on the unique artwork.[141] Warhol's was clearly a critique rather than an embrace, especially when viewed in light of his overt queerness, nonconformist lifestyle, and reverence of pop culture.[142] His deliberately off-register prints established a critical tension between the artisanal multiple and the singular masterpiece. Clever use of catchy design, camp, and celebrity recognition set the stage for the posthumous assent of his secondary-market prices. In contrast to Warhol's acerbic humor that informed his circuit and its context, Richter is surrounded by a mythologizing reverence.[143] The outmoded ways in which art is dealt with in popular media support the perception of virtuosity and singularity, necessary for the art market to continue and fetch skyrocketing prices. With his ratcheted serial production Richter is intellectually double-dipping in both conceptualist and pictorial traditions. I echo Jaleh Mansoor's observation:

> Having taken the assertion of the totalizing determination of everyday life in which all creativity is replaced by product innovation as a point of departure, I would like to explore an emergent lining in the economy of the work, a negative space in which, to put it idiomatically, Richter 'has his cake and eats it too'.[144]

If Richter intended his color-chart paintings to be, in his words, "an assault on the falsity and the religiosity of the way people glorified abstraction, with such phony reverence,"[145] they nevertheless end up

being and selling as exactly that which was meant to be placed under attack. Richter's output mimes the logic of mass-produced fashion, where a House that has gained its reputation by creating couture is now manufacturing prêt-à-porter on a sliding scale of price and availability. This can be seen in how some of his major works are sometimes accompanied by series of derivative prints, available in various sizes. The difficulty is that his prices are not retail. Since this art's status is dependent upon its publicly subsidized sector verifying the significance of his "couture" pieces, we should be able to regulate Richter like we regulate any other type of creative industry.

As Benjamin Buchloh points out, we can no longer sustain the assessment of Richter within the singular logic of the modernist paradigm:[146]

> Further reflection on the differences between Richter's and Stella's paintings reveals quite a bit more about the precarious conditions of abstraction in the period of transition from gesture to spectacle, from critical modernist self-reflexivity to a seemingly inescapable terminus in which all of the structural, chromatic, and gestural forms that abstract painting can conceive in the present end up as corporate decoration.[147]

T. J. Clark, who has referred to some Richters as "shrieking abstractions," confirms:

> The word 'glazing' comes up; but glazing – that precious resource of oil painters from Burgundy on, in which colour was given depth and intensity by being made to shine through a foreground translucency – now botched, magnified, hypertrophied, presented to us as 'device'. ('Glazing' as in eyes glazing over.) The paintings, alas, have a corporate glossiness.[148]

The use of device, a strategy used critically by Jasper Johns to mock the idea of the "artist's hand," has been emptied of its critical potential, and leveraged instead to produce contradictory singular-multiples.

Richter is repeatedly raised as an example of a contemporary artist against which art-finance services are happy to loan cash. It leaves a lingering sense that such artists are being promoted for reasons other than the work's significance, that this is because it is easier to obtain funding for shows or donations because of the role brand-name art plays in wealth management.[149] For these reasons, the argument that

viewing this work benefits the entire arts community and society is questionable. Trickle-down economy, even if it is supported by arts philanthropy, is a myth.[150] If collectors were removed from decision-making and influence we might see a more equitable distribution of opportunities and concomitant price.

As simultaneously a living artist, the name brand behind an asset class, and because his work is collected by some museums by the dozens, Richter is a case to reinforce the argument that it is not the role of the museum to inflate or sustain artificial prices for a single artist—a model for why and how such a market can be regulated. In Chapter 4 I will discuss the idea of taxing the secondary market, such that the prices of an artist like Richter would potentially be evened out, and better reflect the mass appeal of his product. This is not an argument against populism. Populist art can be excellent. Television, for example, has produced monumentally important social realist work like *The Wire* (2002–8). Wrong though is the condition where publicly subsidized institutions, and the professionals salaried by them, are part of the cycle that makes these works overpriced.

Conclusion

The institutional structure of museums today facilitates inequality by its economic organization, governance choices, and concomitant aesthetics. That deals cut between patrons and the museum are made to appear desirable or inevitable does not make them ethical or acceptable. Savvy collectors negotiating museums to serve their personal desires is an outcome of an economic system in which a starving public sector has been replaced by the rapid growth of the nonprofit system. This is funded by philanthropists with their excess earnings or assets in return for tax deduction. The argument is not that individuals abuse the system, although some of them certainly do, the argument is rather that the ability of private interests to leverage the public sphere are structural, and individuals manipulate the system because they can. Professionals in the field— artists, dealers, museum personnel, grant panelists, art writers, and so on—collaborate with the system because it is their means of livelihood and career. Nevertheless, if we are to work our way out of this predicament, we must face the place and role of art in the broader circuits of the political economy.

Examining the SFMOMA and its sources of funding is one example of art's relation to global value chains and their exploitative outcomes.

Surplus appropriated through superexploitation of labor in the global south is used, through the nonprofit system, to support welfare and leisure in the U.S. When it is repatriated and distributed where products are consumed, value transformed into profits is taxed, or donated for the purpose of tax reduction (hence it is a form of public money since it was earmarked for this purpose), as I substantiate in Chapter 2. Through the nonprofit system, public tax money and tax foregone in lieu of donations (in other words, what should have been public tax money) is revolved and used to support the further accumulation of private wealth, as seen when museums involve donors in activities by which they can gain beneficial information, ideological control, and even monetary advantages, all the while enhancing the value of private collections.

While significant, current struggle for public funding for the arts is a fight for declining resources. It also ends up using public resources to fundraise for what ends up supporting private interests. Historically, public funding has been discriminatory of underrepresented groups. Advocacy for declining public funding keeps weak constituencies in service of the system that serves the wealthy and promotes a market-driven taste in art. Diversity is introduced as an afterthought rather than being a driver for social and economic justice at the base.

The anxiety of the art world that without philanthropists there will be no arts funding is a narrow perspective ignoring what could be done, for example, with a massive increase of marginal tax, as well as substantial taxation of capital gains, dividends, business income, and the idea to introduce a special resale tax for art. Yet, while there are necessary and important steps ahead, they ultimately can address only part of the deep-seated problems that can neither be measured, nor resolved, within national economies. The conventional understanding of the economy predominant in the art world is that art adds value to the economy, which supports the conclusion that some vocations are owed more than others. A just conception of a fair distribution of resources and income go hand in hand with recognizing that art distributes value, it does not make it, as will be discussed in the next chapter.

Chapter 2

THE SUBSTANCE OF SYMBOLIC VALUE: MUSEUMS AND PRIVATE COLLECTING

Introduction: the private appropriation of public value

"A museum retrospective can often boost the value of an artist's work, particularly when the piece at issue is included in the show," Carol Vogel tells us in a 2008 article about a shaky auction season following the financial crisis:[1]

> That may explain why Jennifer Stockman, president of the Solomon R. Guggenheim Foundation, is parting with "Pine House (Rooms for Rent)," a 1994 painting by the Scottish-born artist Peter Doig.
> The canvas, which was featured in a show of the artist's work at Tate Britain in London earlier this year, is expected to bring $4.5 million to $6.5 million.
> "Talk about timing," Ms. Stockman said of the consignment. She said she secured a guarantee, so "it became almost impossible not to take advantage of the sale."[2]

A guarantee means the auction house, or a third party, assures the seller a minimum price above which the extra profit is usually split between the selling parties.[3] Based on Stockman's insinuation it was presumably a high minimum. In a volatile and competitive art market, auction houses have been actively seeking out desirable works, and offering incredible deals to potential sellers.[4] By 2014 the price of this work shot up to $18 million.[5] This is intimately related to the artist being included in museum exhibitions and collections.[6] Jeffrey Deitch, art dealer and former director of the Los Angeles Museum of Contemporary Art (MoCA), confirms this common understanding in a conversational example:

> The irony is—we were working together at MoCA, Carolyn [Clark Power] was on the board—in a museum show it's all supposed to be

non-commercial, however, for example, when we did the Urs Fisher show, it wasn't really a commercial show, a lot borrowed from collectors, but then I calculated: just on the pieces that were available, I think Larry Gagosian made 10 million dollars. So that's the crazy irony: the museum show, that the tax payers pay for all this, and art dealers use it as a show room. That's the system.[7]

Yet in a self-perpetuating cycle between museum exhibition and the market, when museums are complicit in serving the wealthy patrons, they ultimately undermine their own ability to purchase work and collect on behalf of the public. As former J. Paul Getty Museum director John Walsh revealed in 1989, "[T]he irony here is that museums have mostly been put out of the acquisitions game partly by what museums themselves have been doing to create art consumers."[8] The current mandate of museums to self-regulate is therefore here under question.[9]

Museums are state-chartered institutions that administer collections on behalf of the public. The public is the categorical justification that grants the institution subsidies, tax-exempt status, public funding, and of course the public is also a direct source of revenue. Although most American museums, whether they are charitable trusts or nonprofit corporations, are technically "private" institutions, in this chapter I refer to them as public because that is how they actually should be defined, and because, from a legal standpoint, the charitable purpose of the foregone tax money is designated for public purpose and should therefore carry it throughout its journey to its end goal.[10]

Art gains symbolic value from its collective status. The public is the entity in the name of which an art object obtains the status of cultural patrimony or heritage, used here as terms for work that merits collecting for posterity. In this context it is never a single piece of art that is at stake, but rather the piece as it relates to the collection as a whole unit.[11] For art to become a promissory note, bearing potential to be realized as money, it needs the larger system of meaning.[12] As noted in the previous chapter, art can realize value, but it does not make it. This chapter will show in depth that art siphons value from surplus created in enterprises that abstract concrete acts of human labor in order to make profit, all of which take place on a social scale. Since the value of art is socially created it only makes sense that it be shared accordingly. If we understand that art's value potential is collectively endowed we need to ask: why is Stockman, or Christie's for that matter, pocketing the profit they made on the Prince sale after the artist's Guggenheim show? The public is the reason the work has gained in price, so why does the profit

not belong to the public? Paying back to society through tax is not enough. Donating in lieu of tax, even less.

This chapter has three sections, each addressing one level of how private individuals stand to gain, in obvious and hidden ways, from value made collectively. The first, "institutional advantage," demonstrates the flaws in the current system. The second, "symbolic value and ideology," shows how the status quo works to mask the real "substance of symbolic value," which is explained in the third section that also shows where value is actually made and why it therefore must be collectively shared.

Institutional value: price advantages for collector/trustees

The private metabolism of a public good

Institutional advantage is the benefit that trustees accrue because a public system works to sustain the worth of their private collections. Stockman's private gain from the sale is a consequence of the public status of the institution she serves. Museum exhibitions not only bring extra public and media attention to the artwork, they gain it scholarly interpretation and potentially a bibliography. Even when the work is not part of the exhibition, the general boost to the artist's reputation will result in a rise in what the work can fetch on the market, as Vogel further reports:

> Ms. Stockman's guarantee from Christie's includes other works she is selling as well, including one of Richard Prince's nurse paintings, "Last Resort Nurse," from 2003, which is expected to fetch $5 million to $7 million.
>
> Although it was not included in a recent retrospective of the artist's work at the Guggenheim Museum, prices for Mr. Prince's nurse paintings have skyrocketed recently.[13]

Nothing reported by Vogel was illegal. It can nevertheless be understood to constitute an appearance of conflict of interest, leading the art writer Lee Rosenbaum to exclaim about Stockman: "[D]id she really say that?"[14] Indeed, the Guggenheim trustee was openly revealing things that in the past were left unsaid, breaking the gentlemen's agreement upholding the appearance that board members serve for altruistic reasons.

Since the Gilded Age, it was an open secret between the ruling bureaucracies of the United States and the capitalist class that the latter would be supported in stockpiling unimaginable wealth as long as they "gave back" to society. The rapid amassing of great wealth at public expense and violence by the so-called Captains of Industry earned them the title "robber barons." They tended, for many reasons, to donate widely to the construction of libraries, universities, research centers, hospitals, and, of course, museums. This shaped a social structure dependent on philanthropy for welfare and the funding of civil society. But the system of welfare by philanthropic giving has never been benign. It was mostly designed to suit the needs of the wealthy and their heirs. Throughout the twentieth century, and still, tax law allowed philanthropists to disproportionately gain private advantage as they generated public resources designed to sustain their power.[15] Here again, it is the law that is faulty. Why are wealthy individuals allowed to gain at public expense? They are already getting honor, authority, and control that assures their continued dominance.

Increasingly, strong critiques of the structure of philanthropy are voiced in mainstream and academic circles. But the case of art is distinctly faultier, as the monetary advantage for the philanthropist is amplified because of art's complex status as both private and collective asset. The difference between a trustee in an art museum and other nonprofits is that in the latter the trustee does not share a financial interest in the assets owned by the charitable organization they serve. In art museums, board members are highly likely to be collectors of works similar to those owned by the institution. With contemporary art there is even more of a discernible overlap and much more vulnerability to market manipulation. A distinct pattern emerges from what museums are exhibiting and collecting. Enough to support the claim that contemporary collections are largely orchestrated by the interest of the upper class.

Contemporary art institutions are more vulnerable to conflict because the long-term significance of work by living artists remains in question, while prices can nevertheless be outlandish. Pressure by laymen collectors or financially interested dealers can lead to exceptionally biased outcomes. An anecdote shared with me by an internationally known painter of weighty market success who was also a board member at a major Los Angeles institution, can serve as an example. In front of the board was a choice between an abstract work by a white-male artist in his thirties or a key 1970s feminist, whose historical consequence has long

been established by an independent bibliography and generations of younger artists influenced by her work. My board-member colleague was barely able to dissuade his fellow collector/board members from making the blatant mistake of buying an unverified artist over one whose place in history is already assured. Board members were forcefully arguing that the abstract artist's prices are about to rise, as if that was proof of quality. But not all museums are lucky enough to have a powerful voice balancing their decision-making process, and many are accessioning unimportant works into their collections. This is a disturbing trend given that there are more contemporary art museums today than ever before, and that many encyclopedic and survey institutions are also now collecting contemporary art.[16]

Personnel, whose salaries are publicly subsidized, spend a tremendous amount of energy cultivating relationships with potential donors.[17] Curators, for example, help private collectors by accompanying them to galleries and art fairs, giving advice, or leading museum collector groups. The logic is that collectors may end up donating to the institution that helped them. Although it may not be considered unethical if the curator is not paid by the collector,[18] and the mutually beneficial relationship serves the museum, such arrangements nevertheless ensure that museum personnel and administrators remain loyal to the monied class.[19] One collector describes the relationship as that where "curators help the collector to develop worthy collections ... and it's good to remember to give a little back."[20] A little is precisely the point. As this book shows, the patron (capitalist) class receives disproportionally more than it gives.

One measure to try and balance boards of trustees has been to include artists or other advisors who are not of the collector class. In the Los Angeles case described above, this proved beneficial. The role of artist trustees, however, has no impact on deeper administrative or funding structures. It is also apparent that museum directors are not spending any time or expertise on changing the system.[21] This is ensured by the fact that they are constantly preoccupied with fundraising, and also that they are essentially competing one against the other for the same funds. Museums are agents of the status quo, shaped to orbit in the circuits of crisis-bound financial capitalism.

Art's role in the financial growth regime

Françoise Chesnais describes how the U.S.-led growth regime is driven by debt, and how it has spread to several European countries.[22] His

definition of financialization, "different from what is today generally called financial capital, namely concentrated money capital operating in financial markets," refers to the work of banks and investment firms of all types.[23] But since the former is a prerequisite for the common use of the term "financialization," Chesnais's criticism applies to both as he described today's dangerously imbalanced economic order:

> [Richardo] Bellofiore gives a good description of this regime: 'wage deflation, capital assets inflation and the increasingly leveraged positions of households and financial corporations were complementary elements where real growth was doped by toxic finance'. It permitted the expansion of the automobile, housing and construction sectors and experienced its climax in 2003–6 in the US housing bubble. The over-building of houses and over-capacity in the construction industry were fuelled by debt-supported securitisation and unsustainable levels of leverage. Despite the financial crisis, it remains the growth regime to which finance capital aspires to return.[24]

Unfathomable wealth is being made in financial speculation:

> In 1975, about 80% of foreign exchange transactions were related to the real economy and 20% to financial speculation. By the beginning of the 1990s, the first category had fallen to about 3% and the second had risen to 97%. Even the inclusion of hedging by TNCs as an obligatory trade and investment-related practice, only added 20% to the economy-related total.[25]

If we correctly understand the actual sources of value, these numbers become extremely alarming, as they represent the increasing circulation of promissory notes for which there is no backing. We know that the United States recorded a government debt equivalent to 106.90 percent of the country's GDP in 2019 and this is only predicted to increase.[26] Even leading capitalists have been warning about the reluctance to invest in production. Larry Fink, Chairman and Chief Executive Officer of the world's largest asset manager, BlackRock, sent a letter in 2015 to the S&P 500 CEOs in the U.S. and to the largest companies that BlackRock invests in, warning them about the failure to reinvest in production.

> As I am sure you recognize, the effects of the short-termist phenomenon are troubling both to those seeking to save for long-term goals such as retirement and for our broader economy. In the

face of these pressures [shareholders seeking immediate returns, velocity of capital, 24/7 news cycle, and public policy failing to encourage truly long-term investment], more and more corporate leaders have responded with actions that can deliver immediate returns to shareholders, such as buybacks or dividend increases, while underinvesting in innovation, skilled workforces or essential capital expenditures necessary to sustain long-term growth.[27]

First, notice the role of the state in failing to curb these crisis-bound cycles. Second, recall that the hordes of wealth made in destructive speculative finance need places to be parked. Enter the art market.

The financialization of art

Historically, art was an illiquid asset, bought for personal use or conspicuous consumption. Its ability to greatly appreciate has long captured the eye of business-minded investors. Earlier attempts to corral art's asset potential were followed, since the 1970s, by various attempts to establish art investment groups, collection by mutual funds or pension plans, and finally the development of loan collateral tools, until, by the twenty-first century, art collecting services became a standard part of wealth management. The formalization of art-secured lending, and the use of these loans in insurance hedging, has come to be generally referred to as "art financialization." This gave art some liquidity potential. Significantly, the more collectible an artwork, the more lenders were willing to loan against it. Managing Director for J.P. Morgan Private Bank explains:

> We lend against a variety of periods and have no particular affinity for any single era or style. The key variables when providing a loan include the number of pieces, their value, and diversification. One of our largest loans was against an Old Masters collection. Some contemporary artists have good characteristics (Gerhard Richter, for example) and we will happily lend against them.[28]

Since most lenders will only accept highly verified art, the museum inevitably plays a key role in establishing the credibility of an artwork as loan collateral.[29] Market actors see this trajectory as positive. Since, again and again, we hear that one of the biggest obstacles facing art investing is information opacity, museums are called upon to resolve this. An art and finance report casually expounds:

One of these stakeholder groups is the non-commercial art sector (museums and non-for-profit institutions). This sector's deep knowledge and access to expertise, combined with its market neutrality, could ensure that it plays a very important role in bringing more trust and transparency to the art market through education, and the sharing of expertise, knowledge, and information with the wealth management sector.[30]

But this is actually *not* the museum's role. These wrong presumptions point to the very problems at the heart of museum bias. Significantly, as Chapter 1 demonstrates, museums are frequently governed by the agenda and taste of collectors and their special interest. Moreover, these museum patrons are frequently the same people that benefit directly from systemic inequality.[31] Even museums who are not directly governed by their board of trustees are enlisted through a complex system of dependency to serve the upper echelon. For example, art museums in states that don't have use tax (such as New Hampshire, Delaware, or Oregon) often exhibit art that gives the lenders a sales-tax break.[32] What seems like a win-win situation, sending expensive art to smaller museums for display, is in fact the subordination of educational institutions to a limited inventory of taste in contemporary art, narrowing, rather than opening, the horizons of art judgment and reinforcing an international monoculture based on name recognition.

The dramatic growth of the art market is directly related to the formalization of art lending.[33] A wealth management executive speaks about a new generation of collectors driving demand for financial innovation:

> The art trade itself has also provided a significant impetus for the development of art financing in an effort to bring stability and lower levels of risk to the market ... Those wealth managers and family offices which now offer art advisory services and provide expertise in matters of artistic quality are forming strategic partnerships with experts and art professionals.[34]

Sébastien Montabonel and Diana Vives explain the incorporation of arts collecting into wealth management, its rapid growth echoed by that of the art-collateral lending market. Implicated are the ways in which all these wealth-generating and circulation instruments are not properly taxed. I quote it at length for its data and evidence:

Wealth managers are in a unique position to offer sound and impartial advice on other matters such as art succession planning, fiduciary services, governance and art philanthropy, and the ranks of wealth managers offering art advisory services grew steadily according to Art & Finance Report 2017 survey, from 67% in 2014 to 70% in 2016, to 83% in 2017, with an estimated US$1.62 trillion of UHNWI wealth allocated to this sector in 2016. In the same period, the art-secured lending market in the US grew by an estimated 13.3%, reaching around US$17-20 billion in 2016 … [W]ealth managers are now able to structure loans on artworks, offer a host of related financial services and occasionally even broker works between their clients.

Ultra-high-net-worth clients can today structure a bank loan on blue-chip artwork at attractively low interest rates of between 2.5–3.5%. As specified in 2017 Art & Finance Report, the work that previously had to be held in a Free- port as collateral, can now remain on the wall or be loaned to international museum shows, which further enhances its market value.[35]

The ostensible public benefit museums offer remains the reason that ultrawealthy art collectors receive preferential tax treatment by the state. Why would we allow judgment of art guided by these tendencies to sway museum content? This system works only for a very small sliver of blue-chip artists, subordinating the rest to market-competition logic that runs contrary to experimentation and diversity.

Because of art's financialization, the public institution is positioned to enhance the wealth of private individuals on a much larger scale than ever before. A bigger market and higher-priced art means higher stakes, exacerbating conflict of interest between collector/trustees and museums holding similar assets. Given the limited availability of quality historical art, we also have to ask what role public museums have played in the fact that the contemporary art market has doubled in a decade.[36] The problem here is not with proliferation of contemporary art, but with leveraging, financialization, exorbitant prices, and the lack of equal distribution of resources in the field. Under these circumstances, work done by the museum has the potential to add symbolic value to art that can disproportionally benefit private parties at the expense of what is better for the public.

"Conflict of interest": and its inadequate applications

Vogel's *NY Times* market report had more information about museum trustees selling works, which, according to Rosenbaum, should have been first offered to the museum. Rosenbaum based her argument on the 1981 handbook "Museum Trusteeship" by the American Association of Museums, a landmark publication that came at a time of heated debate about museum ethics:

> The trustee's own acquisitions must not compete with his museum's; he is obligated to put the collecting ambitions of his institution before his own.
>
> …
>
> The trustee who collects could be liable to the museum for profits he makes as a provable consequence of actions taken by the museum if his participation was a major influence in the institution's decision to take those actions … Whether his objects were exhibited or not, there is a conflict of interest and potential liability to the museum in this situation.[37]

A variety of conflicts abound, but unfortunately we do not have the legal tools or the regulating mechanisms to enforce them. One problem is lack of transparency. We have little access to transactions and agreements made behind the scenes. Yet, despite information opacity and with anonymity being a standard condition for speaking, evidence nevertheless leaks.

In his investigation of museum trustees, Milton Esterow lists several types of "strings" that come attached to their donations or service. The following quotes represents the words of museum directors recalling what trustees said or did:

> "I'll give this if you do this."
> "Looking over the director's shoulder."
> "They interfere with everything from how work is installed to marketing."
> "They try to get curatorial control."
> "Making decisions over exhibitions."
> "Wanting to come to staff meetings."
> "Allowing an artist's dealer to pay for part of a museum exhibition, which can—but not always—be a conflict of interest."
> "Insisting that the donated works have to be all together."
> "Pressure to exhibit artists whose works they collect."[38]

We learn more from a conversation between the artist Andrea Fraser and the curator Helen Molesworth, quoted at length for the testimony it provides:

> **AF** I've never talked to a museum professional (until now!) who would publicly admit that trustees had *any* influence on programming.
>
> **HM** Part of this is due to the nuance of group dynamics and internal psychic mechanisms. This influence isn't as draconian as a trustee sauntering into a board meeting and saying, "I demand you show this artist, and here's the money for it." (Although I've seen that happen!) More often it's soft power that goes something like: "I think we could get the money from so-and-so because they like this."
>
> **AF** This is coming from a director?
>
> **HM** Yes, and from the curatorial ranks as well.
>
> **AF** Ingratiation and access again!
>
> **HM** There's an enormous amount of internal bargaining.
>
> **AF** Do you mean internal within oneself or inside an institution?
>
> **HM** Both. The internal logic has become as transactional as the board logic. If I do this, then I'll get this; both share a kind of phantasmatic professional quid pro quo that is never explicitly stated.
>
> **AF** I've heard museum people say things like that publicly, though framed in a way that has more to do with popularity than patron support—that they'll do popular shows to pay for esoteric shows.
>
> **HM** But patron support and the box office are frequently intertwined. There's such an identification of expertise with elitism that I fear boards may feel as if curators only like work that the public hates, whereas they know what the public likes, the "real stuff"— Koons, Hirst, and Murakami.[39]

Molesworth recalls the pressures to conform:

> I don't think there is a curator in this country who has the kind of exhibition history I have ... who hasn't struggled with the pushback around our stated interests ... That pushback comes in many forms. Sometimes it comes in the form of the very clear-cut, demonstrable insistence that the exhibition schedule be more 'balanced'—code

word ... I've been told that I have lot of 'swagger'—code: gay, code: black. I have been told: Do I have to look at *everything* through the lens of identity politics?[40]

Molesworth was fired from the Los Angeles MoCA for allegedly having "undermined the museum."[41] "Undermining" seems to have been a euphemism for refusing to compromise her intellectual integrity.[42] The following report is quoted at length as it demonstrates donor attitude:

> Multiple sources say that Molesworth was not interested in the diplomacy and statecraft practiced by many chief curators, who approvingly tour private collections and lead donors around art fairs. If she was not excited by a particular collector's holdings or an artist's work, she did not hide that fact. And she told some that she was not particularly interested in art made by white men. Instead, she pursued projects by lesser-known women and artists of color—an agenda that some powerful donors and members of the board did not share.
>
> ...
>
> But in the clubby Los Angeles art-collecting community, Molesworth's particular focus also sometimes rubbed donors—and perhaps more importantly, potential donors—the wrong way. One collector said he ultimately decided to donate a significant work to another museum instead of MOCA after Molesworth came to see his collection and made her lack of interest apparent.
>
> "It made me feel naked—it made me feel uncomfortable because she came to see my collection and made me feel like she really didn't like it," the collector told artnet News. "She didn't even pretend to like it." The exchange was particularly stark compared to friendlier encounters he had had with chief curators from other museums, he said.[43]

Only under the assumption that the role of the museum is to serve the donors can professional honesty register as some type of offense. That a collector believes he is entitled to blanket praise, so much so that he complains about it to the press, reveals his motive for engagement. Most disconcerting is also the question of why the publicly subsidized time of the curator is supposed to be spent catering to private collectors.

Obviously, not all board members have self-serving intentions. In her reply to Rosenbaum, Jennifer Stockman clarified:

> The director and the curators, not the trustees, of the Guggenheim make all decisions as to the exhibitions that are shown at the museum.

I in no way influenced the Guggenheim's decision to hold the 2007 retrospective of Richard Prince's work. In fact, at the time I purchased "Lake Resort Nurse" in 2003, I was not aware that the Guggenheim would hold the retrospective and had been collecting works by Richard Prince since 2000. "Lake Resort Nurse" was not loaned to or included in the Guggenheim's Prince exhibition. The Guggenheim's conflict-of-interest policy for trustees provides that no confidential information may be used by a trustee for personal gain. I did not act upon confidential information.[44]

But even if Jennifer Stockman did nothing wrong, she still made a profit because of a shared construct. This is not only a personal conflict of interest, but an administrative one that cannot be resolved or regulated by declarations about the personal ethics of the stakeholders. The problem with Stockman in this case is not when or why she bought the work, but when it was that she was selling it, and the law is not equipped to say anything about this matter.

Earlier in the twentieth century, some museums used to charge a fee if work exhibited was sold. It makes the appearance of conflict apparent because of the potential to sway curatorial decisions for gain.[45] This practice is now discouraged. While, obviously, the incentive of sales puts curatorial integrity at risk and was never a good idea, museums nevertheless seem to have come out the losers of the move to eliminate fees, while the market and collectors did not. The next logical step would be to conclude that if the duress of museum gaining from sales is so obvious, then the influence of trustee collecting on curatorial work should definitely be discouraged. Why is it still okay for trustees to own and sell work by the same artist collected by the institution they serve?

A more blatant quid pro quo is seen in shows like the Giorgio Armani (October 19, 2000–January 17, 2001), where it was reported that the designer donated $15 million to the Guggenheim, or its The Art of the Motorcycle (June 26–September 20, 1998), which was sponsored by BMW and Lufthansa and featured several BMW motorcycles. The problem with both shows is not with the mixing of the commercial with so-called high art, it is that a nonprofit should not become high-end advertisement for profit-making companies. Of course, there is broad interest in fashion and motorbike design and they merit museum shows, but we could, for example, curate shows based on archival research and scholarly comparisons without elevating one brand.

Conflict-of-interest policies for curators, directors, and trustees cover only partial topics such as payment or gifts in exchange for expertise,

personnel collecting guidelines, or self-dealing. But even then the conventions defining conflict of interest seem to favor the commercial market over the museum. Codes of conduct do not cover all the ways in which trustees stand to gain from the institution they serve, regardless of intentions.[46] They have little supervisory capacity or enforcement power. Member organizations such as the Association of Art Museum Curators or Association of Art Museum Directors can only provide general guidelines for professional practice ethics, asking that museums write their own guidelines in more detail (which some do). In extreme cases (mostly concerning deaccessioning) the American Alliance of Museums can de-accredit museums, but of course only those that have sought accreditation in the first place.[47] Accreditation is not a condition for tax exemption. Moreover, accreditation can be reinstated, and amnesia of institutional misconduct soon kicks in. Only the district attorney can sue an institution, and this only happens in rare cases of gross violation. Even when potential donors have clearly manipulated the museum or the community, sometimes in blatant and shocking acts of bad faith, there is rarely a suit, as institutions fear of appearing litigious and alienating future patrons.[48] Since objective third parties are habitually left outside of the negotiating rooms, conflicts, large and small, go unenforced.

In 1995, the Nolan committee in the U.K. outlined the Standards in Public Life as: selflessness, integrity, objectivity, accountability, openness, honesty, and leadership. Referring to the Nolan committee the author of an article sporting the questionable headline, "Contemporary Art Museums Can't Avoid Conflicts of Interest – but We Need to Trust Their Directors," concludes:

> The trouble is, such principles do not cover the fine grain of the dealings between the public and private parts of the art world. And the Nolan rules certainly don't apply in the United States, where the competition is even fiercer and the relationships closer, especially with the presence of so many significant collectors on boards. In Britain, the unspoken rules that applied 10 years ago have loosened. It is no longer *infra dig* for a commercial gallery to run a selling show at the same time that an artist is having a public exhibition. Galleries may be prepared to contribute, say, to the transport costs involved in a public show. They can help to sponsor a show, which seems to be acceptable as long as it is not an exclusive deal.[49]

The title asks us to trust museum directors, but how can we be asked to place trust in professionals whose high salaries are partially subsidized,

and sometimes even directly endowed, by trustees with whom they closely work? Trustees who spend much time and energy devoted to the museums they serve, and of course those who contribute art, money, or both, see themselves as generous. Museum leaders and professionals naturally gravitate to this frame of mind, when they perceive the trustee to be the hand that feeds. It is humanly impossible to not be swayed by such close relations, where one party is in a state of perpetual gratitude. As former curator and director of the National Gallery of Art in Washington, D.C., John Walker wrote in his memoir: "A museum director is a little like one of those donors in primitive paintings. He is always on his knees with his hands together in prayer."[50] Donors are thanked everywhere in the museum: from labels, to public speeches, to naming opportunities the size of buildings. Yet these are not "opportunities," but rather the *selling* of naming rights. They create the perception that the public somehow owes the wealthy gratitude. But we don't. The money they give is already public, and there is a long historical arc to prove it.

History and legal theory of the public/private distinction

The original wealth that enabled capitalism to rise was made by appropriating the commons, enclosing land and water as private property. The law historian Morton Horwitz chronicled the separation of the private and public realms in English law since the sixteenth and seventeenth centuries, demonstrating how the concept of the private was gradually formed through the transformation of law and its enforcement over a 200-year process. Initially, monarchs owned lands as feudal lords:

> Increasingly, English law defined a second category of crown lands—in essence, public lands—which he could not alienate. Here we see an example of the gradual emergence of a distinctively public realm, which in the field of crown ownership of land finally crystallized in seventeenth-century struggles over the King's power to alienate land between high and low watermark.[51]

Easements, such as the land between the high and the low watermarks, are still considered public in the U.S. today. In contrast, the status of foregone tax money (money diverted to donations) as either private or public remains in debate. Significantly, the history of tax monies shows

that they have been alternately considered to be private and public at different stages. Horwitz shows how sixteenth-century England did not initially see tax as an extraction by the state, but a gift of the taxpayer as donor—a consensual private transaction that was merely arranged by parliament. Public office was also seen as private property and potentially hereditary. In the seventeenth century, with the development of theories of sovereignty and nascent idea of the nation-state, taxes were established as public. While the idea of a distinctively private realm is grounded in the seventeenth-century natural-rights liberalism of John Locke and his successors, the actual distinction between the private and the public occurred in English and American law after the eighteenth century, when "the emergence of the market as a central legitimating institution brought the public/private distinction into the core of legal discourse during the nineteenth century."[52]

Horwitz's profound insights own much to Karl Polanyi's classic 1944 work, *The Great Transformation: The Political and Economic Origins of Our Time*, which chronicles the transition between the feudal society that has exchange markets, to a market society where the entire governance of human life is built around, and geared toward, commodity production and exchange for profit:

> Ultimately, that is why the control of the economic system by the market is of overwhelming consequence to the whole organization of society: it means no less than the running of society as an adjunct to the market. Instead of economy being embedded in social relations, social relations are embedded in the economic system.[53]

Often, when conditions emerge, the view of how problems had been formed at their core is already lost. Only a longue durée perspective can reveal how concepts, considered to be fundamentally unchangeable, did eventually transition and evolve. Polanyi gives an example:

> The rise in rural pauperism was the first symptom of the impending upheaval. Yet nobody seemed to have thought so at the time. The connection between rural poverty and the impact of world trade was anything but obvious. Contemporaries had no reason to link the number of the village poor with the development of commerce in the Seven Seas. The inexplicable increase in the number of the poor was almost generally put down to the method of Poor Law administration, and not without some good cause. Actually, beneath the surface, the ominous growth of rural pauperism was directly linked with the

trend of general economic history. But this connection was still hardly perceptible. Scores of writers probed into the channels by which the poor trickled into the village, and the number as well as the variety of reasons adduced for their appearance was amazing. And yet only a few contemporary writers pointed to those symptoms of the dislocation which we are used to connect with the Industrial Revolution. Up to 1785 the English public was unaware of any major change in economic life, except for a fitful increase of trade and the growth of pauperism.[54]

Like Polanyi, Horwitz shows how the law responded to, and has been changed by, ideological tendencies driven by economic considerations. The distinction between the private and the public realm was not so much driven by independent ideals as by goal-oriented approaches that either functioned to curb the market, or, conversely, allowed it to reign, corresponding to the politics of those in power. Driven by conservative judges who wanted to extricate the law from politics, "one of the central goals of nineteenth-century legal thought was to create a clear separation between constitutional, criminal, and regulatory law—public law—and the law of private transactions-torts, contracts, property, and commercial law."[55] As Horwitz shows, their agenda was to facilitate what they saw as "neutral ground" to form the base for business transactions. Business transactions could then be seen as nonpolitical. This corresponded with the political-economy theories of the nineteenth century, which aimed to render the market as a neutral system that merely distributes reward. Essentially, the conservative exercise of the law was counteracting the redistributive tendencies of budding democracy.[56] One example is the shift in the status of contracts from serving a regulatory function to being seen as private agreements between consenting parties. Common law itself was also gradually transformed from its more technical assignment of enforcing existing law to actively setting precedent and actually shaping legal doctrine—a function previously relegated to the legislative body and statutory law.[57] Again, the separation of public from private law was a way to detach the law from politics, by agents holding a worldview that aimed to remove the state from intervening into the realm of the market as an expression of private rights.[58]

While the conservative liberalism of the nineteenth century aimed to establish an appearance of neutrality for the market, the progressive liberalism of the early twentieth century regarded the law and the state as means to curb private greed. The 1920s and 1930s saw the influence of legal realism, an approach that considered the public good in

jurisprudence, and which exposed the conservatism of the public/private distinction:

> By 1940, it was a sign of legal sophistication to understand the arbitrariness of the division of law into public and private realms. No advanced legal thinker of that period, I am certain, would have predicted that forty years later the public/private dichotomy would still be alive and, if anything, growing in influence.[59]

While early in the twentieth century it was clearly understood that private hands could not successfully deliver public interest, a backlash came on the heels of World War II, when fear of totalitarianism allowed interest-group pluralism and a market theory of public interest—wielded by whomever won the battle on the market—to become the new face of progressivism. Important means to curb greed and domination were lost in the process.

Horwitz wrote in the early 1980s, undoubtedly responding to the backlash represented by the election of Margaret Thatcher and Ronald Reagan, both committed to undoing the welfare state and deregulating the economy, initiating an escalating trajectory of privatization, deregulation, globalization, and militarization (generally termed "neoliberalism") that resulted in the Great Recession of 2008 and its aftermath[60] A further development since is the dramatic privatization of the law that has been termed "neofeudal," as I will discuss in Chapter 4.

The nonprofit sector as shadow state

The American legal system, as Horwitz tells us, evolved from a libertarian view that wanted to cast the state as a neutral playground for business into a tendency to see the state as a means to curb endless accumulation. The latter ended after World War II, as the welfare state continued to develop in that brief "golden age" of capitalism that survived till the 1970s, by the end of which the neoliberal shift commenced. John Bellamy Foster takes the long view of the doctrine that shaped our present:

> The term *neoliberalism* had its origin in the early 1920s, in the Marxian [Max Adler] critique of Ludwig von Mises's *Nation, State, and Economy* (1919) and *Socialism: An Economic and Sociological Analysis* (1922), both of which were written as virulent anti-socialist tracts, constituting the foundational works of neoliberal-capitalist

ideology. In these works, Mises, then employed by the Vienna Chamber of Commerce, insisted that the "old liberalism" had to be "relaid" in such a way as to defeat socialism. In the process, he equated socialism with "destructionism," insisted that monopoly was consistent with capitalist free competition, defended unlimited inequality, and argued that consumers exercised "democracy" through their purchases, which were equivalent to ballots. He strongly condemned labor legislation, compulsory social insurance, trade unions, unemployment insurance, socialization (or nationalization), taxation, and inflation as the enemies of his refurbished liberalism.[61]

Neoliberalism, promoted again as a viable model under the ideological leadership of Milton Friedman at the University of Chicago, was heavily brought to bear on the national and international economic policies of Thatcher and Reagan, expanded globally by imperialist maneuvers and markets. The U.S. Democratic and U.K. Labour governments of the 1990s have not reversed the neoliberal trajectory, and neither did Barack Obama.[62] The neoliberal period saw a massive transfer of wealth into a limited range of corporate entities and private hands. The freeing up of more resources for the wealthy allowed and compelled them to pour into their pet social projects, creating a growth of the charitable sector and with it the expansion of arts philanthropy.[63] This was followed by repeated attempts to reduce taxes on corporations and the rich, while efforts to argue that tax monies should be considered private were reinvigorated.

In "How Public Is Private Philanthropy?" the Philanthropy Round Table has attempted to argue that philanthropic assets, charitable tax exemption, and tax deduction are private monies. The Philanthropy Round Table does not hide its conservative agenda to seek charitable independence and a return to "traditional principles of self-governance and private decision-making."[64] The document claims that tax money is the property of an individual who therefore has the right to determine its use and distribution. This philosophy is rooted in the liberal conception of personal liberties, but contradicts a liberal democratic agenda, as it places tremendous powers in the hands of the few over the many. To justify private supervision is to justify wrestling more resources and control away from the population, facilitating the dictatorship of the rich.

Here we witness how a nonprofit organization is used to influence tax reduction and deregulation policies, which then place even more

wealth in the hands of fewer people who can then have more influence not only on the policies that govern them directly but also on everybody's civil society. The American tax code is such that the liberty to write off charitable donations is not afforded to the majority of Americans.[65] All this runs counter to the claim that the nonprofit system promotes pluralism.

Neoliberalism has perfected the task of subordinating the state to the need of wealth accumulation, as political scientist Nancy Fraser summarizes:

> Consider the epochal transformation of capitalism that began in the 1970s and is now unraveling. The structural aspect of that transformation is well understood: whereas the previous regime empowered states to subordinate the short-term interests of private firms to the long-term objective of sustained accumulation, the current one authorizes global finance to discipline states and publics in the immediate interests of private investors, including by divesting from social reproduction and imposing austerity.[66]

Divestment from social reproduction and the holes created by the retreat of the welfare state have been replaced in the U.S. by nonprofit institutions. Like NGOs, they are a vehicle for substituting defunded infrastructural state functions with these semi-privatized social services.[67]

The expansion of a gray area that is semiprivate and semipublic was neither one-sided nor decisive, but the combined and uneven development of "the shadow state," as Wolch showed. Her detailed 1990 multipronged investigation of municipal, state, and federal government services provision describes the process:

> The transfer of social responsibilities from state to voluntary sector has occurred in the context of growing international economic competition, restructuring of domestic relations of production, public economic management strategies, and welfare state reorganization and change.[68]

Up to the point of Wolch's study, research only focused on supply-side questions such as: "degree of optimizing behavior, productive efficiency, speed of supply response, income-generation behavior, and patron control."[69] In contrast, her questions addressed the social change that took place as the relation between the voluntary sector and the state shifted in ways that, although complex to quantify, nevertheless showed

the machinations of increasing privatization as it took place through and by the delegation of services from the state to the nonprofit apparatus. Wolch's work was central to another key critical text that characterized the nonprofit system as a type of "industrial complex." INCITE!, the moniker for Women of Color Against Violence, who edited the influential, now classic, volume, *The Revolution Will Not Be Funded: Beyond the Non-Profit Industrial Complex*, exposes how the tax exemptions of the charitable sector work to ameliorate, if not eliminate, radical socially-oriented organizing. As such they run contrary to their pluralistic promise. As Dylan Rodríguez writes,

> This popularized and institutionalized "law and order" state has built this popular consensus in part through a symbiosis with the non-profit liberal foundation structure, which, in turn, has helped *collapse* various sites of potential political radicalism into non-antagonistic social service and pro-state reformist initiatives.[70]

The pluralism facilitated by existing charities thus runs the gamut between an extreme or libertarian right wing and a liberal consensus, diminishing as we go left of center. How does this unfold? Justin Laing provides an example:

> Attorney General Robert F. Kennedy convened a group of foundation leaders in 1961 and asked them to put money into an initiative called the Voter Education Project. His idea was to encourage civil rights organizations like the SCLC, the Student Nonviolent Coordinating Committee (SNCC), the Congress of Racial Equality (CORE), and the NAACP to turn their attention to voter registration rather than the direct-action strategies such as sit-ins and freedom rides. His argument to those groups was that voter registration would have a bigger impact on discriminatory policies than smaller local efforts such as sit-ins. However, writers in both the book and the report contend that much of the Kennedy administration's motivation was to take pressure off the federal government to provide protection for the activists, because providing that protection would alienate Southern white voters.
>
> These anecdotes bring interactions among government, institutional philanthropy, program officers, and the civil rights movement into focus in a way that is troubling. They appear to illustrate an attempt to coerce civil rights leaders to alter either their behavior or their theory of change.[71]

Scholars, practitioners, and audiences share the sense that nonprofit dependency has coercive consequences and is thus contrary to economic justice. This is also evident in the type of diversity promoted, which generally tends to be the kind whose criticism of the system can be contained.[72] Another problem of privately driven pluralism is that it remains unsupervised, and unaccountable, especially when it purports to measure its success with its own tools.

We conclude that the system cannot solve its problem with its own means. The nonprofit system fails the social-good parameters on two levels, even by its own ethical standards. The first are the direct uses of private philanthropies to promote policies favorable for the business agenda of the donors, or to coerce any radical demand for change. The second is unintended misuse, as in the case of Stockman, who seems to have benefited by circumstances. While we should fight the first head-on, our job with the second is to see how, in the larger picture, they are not actually accidental because state structure has been shaped to facilitate economic and political domination of a narrow class.

Tax monies: private or public

The voluntary sector is accompanied by a network of secondary-level nonprofits whose mission is to support the system through analysis and advocacy. But this advocacy tends to be heavily biased toward supporting the interests of the wealthy—a bias rooted in lack of historical perspective. This leads to an inability to see that the present state is an outcome of the process of the law having favored the powerful. We need to consider that the scale here is massive. For perspective on the scale: "[I]n the United States, for example, subsidies for charitable contribution cost citizens at least $50 billion in foregone federal tax revenue in 2016."[73] This means that $50 billion of money changing hands through unregulated arrangements, many of which are opaque to public scrutiny and therefore accountability. The claim that donor-directed foregone tax monies are private makes sense only if we disregard major developments in the concept of society in the twentieth century that have changed the composition of what we mean when we say "public."

Ironically enough, when "How Public Is Private Philanthropy?" authors Evelyn Brody and John Tyler summarize the arguments of their opposition, they seem to make the idea that tax money is public even more sound:

> Historically, proponents have relied on three groups of arguments for their conclusion: (1) foundations and other charities must serve

public rather than private purposes, for which the state Attorney General has traditionally provided oversight; (2) foundations and other charities are chartered by the state or otherwise qualify as state actors or quasi-public bodies; or (3) foundations and other charities receive tax-favored treatment.[74]

Indeed, a charter does not exactly grant a charity governmental status, as I discuss, but it does, as I show in Chapter 3, facilitate individual organizations that do perform state-replacing activities.

The first problem with Brody and Tyler's argument is that they use "public" to mean the government. In contrast, arts administration specialist Margaret Jane Wyszomirski makes a necessary distinction:

> One can argue that an artist who is commissioned by a government agency to produce an art-work for a public plaza and who is paid with taxpayers' money is not engaged in a private activity ... [T]here was a time when even major arts institutions—museums, orchestras, opera and ballet companies—essentially were the creation of individual patrons. This is seldom the case today. Rather, the greatest of these institutions have acquired the informal status of national treasures. In other words, much artistic and philanthropic activity, particularly that of a large institutional character, has become more public and less private than was previously the case ... Thus, "public" has meanings other than governmental and has come to encompass that which is of societal or community importance.[75]

Legal scholar Christopher Stone demonstrates the need to define the meaning of respective terms within specific contexts:

> [A]ny grand effort to collect and unify all the diverse functions public/private plays, context to context, would produce a large compendium, but little insight. In this area, scholars would better aim to identify the context-specific criteria for public and private, and even to encourage the development of more precise surrogates (open, governmental, secret) when other needs of the law, such as reckonability, require ... A good society needs a commitment that public/private matters, even allowing that the terms are destined, over time, to matter in different ways in different areas.[76]

For this reason, I have deliberately refrained so far from defining "public." What is clear is that I do not associate it only with the hand of

the government, but something like an abstract will (or need) of the people, which is necessarily negotiable and subject to change. While the next chapter will outline one trajectory of several historical developments of the term and its uses, a more robust definition will be amassed by this book's conclusion. The point for now is that the definition of the public does not mean government. This is clear in the case of museums because a major stakeholder is the concrete entity of the visiting public. There is overlap between the sociologically described public and the abstract beneficiary for whom nonprofit and tax law employ the term "public." Public money is money designated to benefit the actual or potential visiting public of the museum. Brody and Tyler make long semantic arguments about the definition of "nonprofit" and what type of organization its nondistributive definition covers. But these are not consequential to the question of whether a charity's assets are public or private. Even if foregone tax money was private, it does not mean that the use of tax-defraying deductions should be decided by individuals. If the purpose of the foregone tax money was intended for public charity, this purpose should be carried through to the end goal. In defense of their argument, Brody and Tyler cite foundation presidents as authorities. Unsurprisingly the latter would be biased, for as Upton Sinclair famously quipped, "[I]t is difficult to get a man to understand something when his salary depends on his not understanding it."

Another line argued by Brody and Tyler is that if assets are considered public they will be in danger of liquidation in case of a financial emergency. Yet, as we have seen with the fate of Detroit's art collection following the city's bankruptcy in 2013, even though the artworks were bought by the city or given to it, that is, they belonged to a public entity, they nevertheless were only momentarily at risk of being auctioned to pay the city's deficit. It is precisely because of anticipated legal difficulties that the "Grand Bargain" was negotiated, such that foundations and businesses paid to have the work transferred to another foundation and the art remained in the public trust. We also cannot simply look at the law without any context. We will only get a partial picture if we fail to ask, in the case of Detroit, how and why does a city come to be bankrupted in the first place? The collective city coffers were emptied by the type of privatizing ideology Brody and Tyler support, which included offshoring jobs for the sake of profit that resulted in reduced tax revenues for the city.[77] Thus, to argue that privatizing tax money shields charitable assets from emergency is deceptive, because it is a measure necessary only in a world where private accumulation goes untaxed and drains public resources.

Another fundamental problem with the Brody and Tyler argument is that the authors leave out the fact that private and public are discursively and historically specific formulations that have meant different things in respective historical periods.

A brief history of the legal distinction between the private and public realms

As Horwitz shows, the conception of private banks, transportation, or insurance companies inherited from eighteenth-century English legal theory was that they *were* arms of the state, so much so that they were granted monopolistic privileges based on priority (for whomever it was that set up an enterprise first):

> As it became bound up with a state policy of promoting development, private investment was also regarded as an extension of state efforts to further economic growth. The legal system thus rarely distinguished between public and private forms of investment. But as development proceeded, the early monopolistic strategy for encouraging economic growth soon became a legal barrier to further growth.[78]

In order to encourage economic development, judges began adjudicating in favor of competition, even considering incidental injury permissible. By the early nineteenth century, as part of a larger agenda, corporations were separated from public law and from being considered as an arm of the state:

> Certainty and predictability of legal arrangements became incompatible with sustained economic development. Previous state concessions to private interests thus had come to represent obstacles to continued growth, and for the first time state efforts to encourage economic growth began to diverge from private efforts to preserve existing legal expectations. Under the continuing pressure to encourage further investment, the legal system gradually began to distinguish between public and private interests.[79]

Importantly, Horwitz proves that the transition to privatization was done under the assumption that private economic growth takes precedent because it is for public benefit. He takes care to underscore that what may have been done with the intention of serving the public good, felicitous or not, may have nevertheless failed to deliver on the

promise for all sorts of reasons, be them ideology or shortsightedness. His long view reveals how the concept of public benefit is, again and again, transformed to serve commercial interests that frequently fell short of delivering. This was extended to the U.S.:

> During the eighty years after the American Revolution, a major transformation of the legal system took place, which reflected a variety of aspects of social struggle. That the conflict was turned into legal channels (and thus rendered somewhat mysterious) does not obscure the fact that it took place and that it enabled emergent entrepreneurial and commercial groups to win a disproportionate share of wealth and power in American society.[80]

Horwitz shows in detail how sweeping transformations in legal thought retooled concepts such as "public benefit" over time. Significantly, the growth of the American economy between the eighteenth and the nineteenth century went hand in hand with a process of dramatic change that, unique to the American case, took place not by legislation, but by the exercise of common law:[81]

> By the end of the eighteenth century, the new American states had become involved in the process of promoting economic development by granting corporate charters and franchises to private investors. Though this pattern has often been portrayed as economically inevitable, it actually seems to have arisen out of conscious considerations of policy. In every state after 1790 a political decision to avoid promoting economic growth primarily through the taxing system seems to have crystallized. While economic disarray and postrevolutionary suspicion of government partially explains this turn of events, historians have never really attempted to understand the effects on the distribution of wealth that an alternative taxing policy might have entailed as compared with the system of private financing that actually came into being.[82]

The point here is that what was passed as public benefit was in fact serving an uneven distribution of wealth.

Brody and Tyler base their claim—that a charter does not make an organization an arm of government and is therefore not public—on their interpretation of the foundational 1819 Supreme Court case *Trustees of Dartmouth College v. Woodward,* where the private institution fought the attempt of the state of New Hampshire to convert it into a

public university. The college was established in 1769 under a corporate charter from King George III of England, and the Supreme Court adjudicated that a charter is a contract, giving primacy to its original intent over its potential public benefit. They rely on the oft-cited concurring opinion of Justice Story, a landmark for clarifying differences between private and public corporations. They conclude:

> Justice Story's understanding is essential to a political and economic system founded on respect for the distinction between public and private and on the principle that governmental authority, absent the most exigent circumstances, is subordinate to liberty and individual rights.[83]

Although *Dartmouth* is considered a victory for private corporations over state interest, Brody and Tyler address an idealized political system as if it is monolithic and unchanging. They ignore the monumental shifts in demographics, economy, ecology, and politics that have profoundly transformed the United States and its identity since the logic shaping Judge Story's opinion was common sense. Story's ideas were formulated during a period of underdevelopment, not the current state of rampant and imbalanced overproduction. The liberal philosophy at the core of the argument operates under the assumption that growth and competition are positive. It relies on the nineteenth-century axiom that economic growth promotes public purpose. These ideas should never have crossed the threshold into the twenty-first century.

Responding specifically to *Dartmouth*, Horwitz cites another case that adjudicated on the public good:

> In 1809 the Virginia Supreme Court upheld a legislative act amending the charter of an insurance corporation. "With respect to acts of incorporation," Judge Spencer Roane observed, "they ought never to be passed, but in consideration of services to be rendered to the public... It may be often convenient for a set of associated individuals, to have the privileges of a corporation bestowed upon them; but if their object is merely *private* or selfish; if it is detrimental to, or not promotive of, the public good, they have no adequate claim upon the legislature for the privileges."[84]

Nevertheless, the law governing corporations morphed into a system that established structural means for sustaining the processes of wealth accumulation:

No longer primarily representing an association between state and private interests for public purposes, the corporate form had developed into a convenient legal device for limiting risks and promoting continuity in the pursuit of private advantage. The general incorporation laws which had begun to crop up in the thirties [1930s] expressed this tendency to regard the corporation as just another form of business association. Yet, even after the private nature of corporations was recognized for the purpose of limiting the state's power over vested property rights, the anomaly persisted of regarding them as essentially public bodies entitled to share in the historic privileges conferred on arms of the state.[85]

Brody and Tyler argue that there is no distinction between nonprofit and for-profit corporations, as both are chartered by the state, and both should protect the interests of shareholders, and therefore, charities "should enjoy the same freedom of self-determination as business corporations—if not more so, because of the important associational and non-market interests they serve."[86] But the public *is* a shareholder in the work of any nonprofit. The idea that only holders of money shares deserve to have influence on decisions that concern everybody else, especially holders of other forms of interests like a museum's public, is resolutely undemocratic. Are we back at a world where only property owners can vote? There is a difference between what the public needs and what might benefit an individual. To collapse and confuse the two results in false logic.

Brody and Tyler treat nonprofit corporations as if they were individuals. Perhaps we can consider this question through the subsequent 2010 ruling of the Supreme on the case of *Citizens United v. Federal Election Commission*, which granted corporations individual rights. The ruling does not affect 501(c)(3) organizations, as their type of tax exemption prohibits them from endorsing or opposing candidates in federal elections. It thus may be possible to argue that the 501(c)(3), which is by far the largest category of charity organization type, is public, because clearly it is considered public enough to be barred from possessing the same rights as individuals.

When Brody and Tyler claim that "after all, it is a private decision that determines which charitable purposes to serve and how to serve them,"[87] this is not an argument, but a description of the outcome of a man-made political system. As law philosophers Liam Murphy and Thomas Nagel argue convincingly,

Private property is a legal convention, defined in part by the tax system; therefore, the tax system cannot be evaluated by looking at its impact on private property, conceived as something that has independent existence and validity. Taxes must be evaluated as part of the overall system of property rights that they help to create.

This is a good lesson in rhetoric. Murphy and Nagel remind us that property is a convention, even though it might seem natural because we are born into this preexisting system. It takes critical distance to understand that the modern economy is only possible because of the framework provided by government support, funded by taxes:

> This doesn't mean that taxes are beyond evaluation—only that the target of evaluation must be the system of property rights that they make possible. We cannot start by taking as given, and neither in need of justification nor subject to critical evaluation, some initial allocation of possessions—what people originally own, what is theirs, prior to government interference.
>
> Though a consistent application of sophisticated libertarian political theory leads to deeply implausible results that hardly anyone actually accepts, in its naive, everyday version libertarianism is taken for granted in much tax policy analysis.[88]

As they themselves testify, Murphy and Nagel are not radicals, declaring that capitalism is the best system for democracy. Nevertheless, they show that the charitable donation deductions system allows private individuals to direct funds away from the treasury, on top of which they are given the added bonus to decide how such resources are allocated. Political economist Rob Reich argues convincingly that today "donors are not exercising a liberty to give their money away; they are subsidized to exercise a liberty they already possess."[89] Instead, Murphy and Nagel suggest:

> We have to think of property as what is created by the tax system, rather than what is disturbed or encroached on by the tax system. Property rights are the rights people have in the resources they are entitled to control after taxes, not before.[90]

For this reason, to argue that foregone tax monies are private is in fact a logical fallacy, as it confuses, or perhaps deliberately obfuscates, what is given and what is constructed. In other words, it mystifies truth.

Brody and Tyler admit that museums, and also public hospitals, have a more obvious governmental status. Clearly, that in Europe museums are governmental institutions is proof that the autonomy of museums from government is not natural, but a decision that reflects the specific administrative structure of the nation. This is not necessarily to advocate for government control of museums, but to point out that the dichotomy of charitable sector autonomy versus government control is misleading. Most certainly the logic of philanthropy is not conducive to change because it is reactive, tending to narrow cause-and-effect analyses when identifying a problem only as it appears and only offering topical solutions. To reconceptualize public redistribution, we need a deeper view of the public/private distinction.

Symbolic value and ideology

From a radical perspective, Ann E. Davis in her article, "The New 'Voodoo Economics': Fetishism and the Public/Private Divide," uses the concept of commodity fetishism to identify the false distinction of the state as "public" versus the market as "private." Marx used the term "commodity fetishism" to describe the process by which the social nature of value is masked by exchange relations and the function of price, making it appear as if value is created in exchange and is identical with price. Davis describes the role of the state as a "financial intermediary," where the market is in fact:

> [t]he composite effect of social production ... The social nature of commodity production, or the wealth of the entire nation, backs the credit of the state and its power to issue currency ... Once the role of a particular commodity or paper currency is well established, the money token can represent the entire power of total social labor.[91]

Davis quotes Marx: "[M]oney itself is a commodity, an external object, capable of becoming the private property of any individual. Thus social power becomes the private power of private persons."[92] The wealth of the entire nation is used to facilitate private exchange:

> Currency is used, in turn, as a vehicle for the circulation of "private" commodities and the expansion of value through the exploitation of individual workers in private factories. The expansion of value then helps to finance the role of the state through tax collections. Without

the social production of private commodities, the currency would be worthless and the state coffers empty. On the other hand, the individual capitalist's ability to borrow currency on credit, to purchase the commodities of labor power and raw materials *before* production and sale, depends on the ability of the state to issue currency based on the production of commodities as a whole.[93]

The same goes for art. The market establishes the precedent for prices, while the common institutions provide stability and a symbolic guarantee through ongoing storage, research, and display of the art that is held in common for posterity. This way, private individuals then reap personal gain when they deal in what is socially established.

This second section shows how art's value is constituted by a combination of the economic and symbolic/ideological dimension. It is only as a socially established symbolic vessel that art can siphon and hold value, that is, come to be filled with money when it is sold, or used as loan collateral. To be an economic object, art needs symbolic value. The symbolic becomes economic when it endows the object with the potential to realize value by fetching a price. This relies on art's social status that is established interdependently by the museum and the market. The museum's role is corralled by the market to symbolically guarantee the worth of art. The symbolic worth of art is established in the name of the public, for a privately realized economic advantage.

Ideological frameworks allow us to see museums and their collections as benign institutions that serve the public, while in effect, by enhancing the value of work that is privately collected, the museum perpetuates inequality on both symbolic and economic levels. In the third section I will apply what Beverley Best calls the "value theory of ideology" to show how the symbolic and the economic work in concert.[94] Briefly here, value in capitalism is only created by organized and abstracted labor power that transforms raw materials into commodities; it nevertheless appears to have been made by the capitalists and belong to them in the process of production. The fetishism of commodities, the misunderstanding of how this system functions and who it is that creates surplus value, conceals the hidden abode of labor. Art does not create the value it carries. Art can siphon value because of the symbolic power given to it by collective agency, and which is facilitated by the institution. Here, a social system of art provides the public alibi for art's symbolic value because the symbolic can only be established by collective agreement. The entire cycle looks like this: when art realizes its symbolic potential through sale it fetches a price, paid in money,

which has been transformed from the surplus value created in commodity production by rationalized and abstracted labor. But first, we need to address what is symbolic value, and what is wrong with the common use of the concept "symbolic capital."

Bourdieu's symbolic capital

In her cultural history, *High Price: Art Between the Market and Celebrity Culture Today*, Isabelle Graw argues that the artwork is both a commodity and an asset, and is "split into a symbolic value and market value."[95] But this is not exactly how it works; art is not split, its value is established by two dynamic interdependent systems. Graw's study is pioneering and important, and she is right to assert that market value needs symbolic value for its legitimacy. However, the sociological terms, based in Pierre Bourdieu's theory of cultural and symbolic capital, leave something to be desired. Graw refers to the rise in an object's price as *surplus value,* as if the increase is of art's own accord. Indeed, it is a consequence of the authority of the institution, be it the market, the museum, or the authority of art critics or historians.[96] But what is happening is a rise in art's price, which is an utterly different category than value. The price of art realizes value transformed from revenue. Art itself cannot produce surplus value, as it is not an activity that is productive for capitalism. When Marxist art historians don't underscore that this surplus value is made elsewhere in production, they are passing on a mistake that sustains the fetishizing capacities of bourgeois culture.

Extending Bourdieu, Graw develops concepts such as "intellectual surplus" and "symbolic surplus," in what amounts to metaphorical usage of a material category. There is no such thing as intellectual or symbolic surplus value. The work of historians, critics, or institutions, which is unproductive labor, does not add value to the work; it enhances its absorbency, its ability to draw, adding to its *price* not its value. Ignoring this allows us to indulge in the illusion that we can change the world by changing things on the symbolic level, as the sociologist Dylan Riley has shown in his criticism of Bourdieu's class theory:

> Bourdieu's account of symbolic power promises a transformation of the social world through a transformation of the categories through which the social world is understood. Social change can thus be achieved without identifying an external nonacademic agent that might carry that change forward.[97]

Although Bourdieu shows how prestige or authority generates power that ultimately translates into monetary reward, his use of "capital" to describe it obfuscates the actual meaning of capital and therefore the concomitant political implications. Collapsing sociological and economic categories, Bourdieu suppresses the question of where the substance infusing the symbolic with monetary value actually comes from. The explanatory power of the term "capital" is then lost.

In his article "The Forms of Capital," Bourdieu indeed begins with defining value for what it actually is, "accumulated labor," and he applies the concept of monopoly, but he claims that social organization is as equally determining as economic organization in ways that do not clarify their imbrication.[98] His is an attempt to explain the reproduction of society and its class stratification as an outcome not only of economic forces, but a set of social properties he also refers to as "capitals." Bourdieu developed Louis Althusser's canonical formulation of how ideological and state apparatuses sustain the reproduction of a stratified social order.[99] He nuanced them as dispositions and institutions. Acquired early or later in life, they arrange individual actors into groups, which, for the most part, are consequently kept in their designated social role. His various typologies of "capital" explain how people embody and perpetuate ideology. Bourdieu produced a complex account of class stratification, developing the term "fields" to describe arenas of struggle between different constituencies, and "habitus, as a socially constituted cognitive capacity."[100] But this is predominantly a theory of individual actors, with no collective potential. Conceivably, it is a theory of the middle class. But the middle class is not a revolutionary class, rather one that has historically collaborated with the ruling class against the interests of the working class. Riley contends:

> Thus, as a way of empirically demonstrating the connection between class and habitus, Bourdieu attempts to demonstrate a connection between class position and differences in aesthetic tastes. His work in this area, however, suffers from two problems. Bourdieu fails to specify either an empirically tractable meaning of the term "class," or to show any compelling evidence for the existence of "habitus" in the sense of a "generative mechanism" that can be applied to numerous domains. This is most evident in the book that many consider to be his masterpiece, *La distinction* (*Distinction*, in English).[101]

Published in 1979, *La distinction* was based on rigorous sociological research, after which Bourdieu concluded that museums, as national

social institutions, serve to retain class immobility rather than opening the possibility to transcend class determination. Undoubtedly he was right, and his work has been widely used in museum analysis, but this approach led to class as a question of representation, while both capital and class are economic categories. The problem Riley describes is crystalized in Bourdieu's 1986 theory of capital's forms, where none of the additional social dynamics Bourdieu calls "capital" are actually capital. This changes the outcome of cultural and institutional analysis. What Bourdieu calls capital is actually a form of power, which can result in monetary reward, but money is not capital. Capital is money invested in production in order to make more money from surplus created by abstract labor. Money is not capital unless it is invested in purchasing means of production and labor power in order to make more money (which is why, for example, Marx refers to financialized gains as "fictitious capital").[102] Bourdieu identifies economic, cultural and social typologies of capital.[103] He breaks cultural capital itself into three types: embodied, objectified, and institutionalized:

> [Cultural capital] thus manages to combine the prestige of innate property with the merits of acquisition. Because the social conditions of its transmission and acquisition are more disguised than those of economic capital, it is predisposed to function as symbolic capital, i.e., to be unrecognized as capital and recognized as legitimate competence, as authority exerting an effect of (mis)recognition, e.g., in the matrimonial market and in all the markets in which economic capital is not fully recognized, whether in matters of culture, with the great art collections or great cultural foundations, or in social welfare, with the economy of generosity and the gift.[104]

In short, "symbolic capital" refers to all of the forms of capital that are represented, rather than material, but significantly, they authoritatively represent something that is constructed, not innate.[105] "Symbolic capital" is a potential, an empty vessel. That it can be rewarded in monetary gain because of the advantages it gives the subject who possesses it and therefore has a relationship to wealth that is directly or indirectly a result of capital is correct. But naming it "capital" does not render the process by which this happens, leaving the systemic nature of it undescribed.

To describe the complete process, we must stick to the materialist definition of capital as an outcome of social relations where surplus value is extracted from the unpaid wages of productive labor (the wages

appropriated by the capitalist as surplus). "Symbolic capital" exists, but to understand its power correctly we need to accurately name it. We know very well that in the so-called democratic societies equal opportunity is a myth, and that the wealthy have exponential advantages anywhere they turn, very much along the lines that Bourdieu describes.[106] We also know that racism is a means of social stratification. But, again, these are outcomes, neither cause nor the basic operating principle of social relations. Symbolic capital is the gravity, by social agreement (conscious or not), to pull value from elsewhere, which is where we locate the characteristic social relations of art. For this reason, I forego the term "symbolic capital" and use "symbolic value" when referring to art endowed with institutional or market authority (with the historical understanding that without museums there would be no global market for art).

Art functions not as capital, but on the contrary, as a means to withdraw money from production and circulation. As an asset art is hoarded revenue, it has a potential to be realized as money, it is a promissory note. If you sell your Van Gogh you can invest it in an enterprise, but until then art is money withdrawn from circulation and money withdrawn from circulation is not capital.[107] In fact, money withdrawn from circulation, money accumulated and hoarded, is a threat to the economy. Here, it is not art that is a threat. The danger is in the construct that allows some art to be so massively expensive. The financialization of art and its entry into the hedging and lending circuit has only exacerbated this condition. To understand the role of symbolic value in this scheme we need an economic theory of art's ideology.

An economic theory of art's ideology

Value is a set of relations, or outcome thereof. Value is not a property of any actual commodity. It is an ideological construct that allows art to siphon more value from the general aggregate, thus serving the wealthy. Museums have a role in this scheme. And a "value theory of ideology" helps us understand how it all happens.

In "Distilling a Value Theory of Ideology from Volume Three of *Capital*," Beverley Best argues that ideology-critique has been abandoned by Marxists all too soon, leaving open the question of how, despite the extremely obvious conditions of inequality, consent is manufactured and sustained. Best challenges Althusser's psychoanalytic reading of ideology as a mechanism for subjective formation that works when subjects are interpolated into misidentification. This offers a limited

modality of subjectivity with no political potential for social organizing.[108] Instead, showing that Marx replaced the concepts of fetishism and mystification with his earlier use of "ideology," Best proposes "a value theory of ideology," derived from his analysis of the perceptual economy: "the particular essence-appearance dynamic that is immanent to capital."[109] Specific to this theory is the ability to distinguish between neutral ideological critique that can identify and narrate the lens by which we come to know the world, and a critical ideological critique that offers tools for identifying where and how our perception of reality is inverted such that what appears as objective runs counter to capitalism's actual movement. But even this is not enough.[110] The deeper cause of such inversion is inherent to the structure of capitalism, hence "perceptual *economy*." In other words, in concealing the true origin of value under capitalism, the perceptual economy is the ideological operation that makes it seem like entrepreneurship (or art) "makes" rather than takes value. It is echoed in the mainstream belief that art-making adds value to the general aggregate.[111]

The substance of art's value

It is not a qualitative judgment but rather an economic description to identify that under capitalism the social relations governing art's making render it an object of circulation rather than the creations of value. Only abstracted labor that makes more value than it costs can add value to commodities and therefore to the general aggregate. The abstraction of labor is its organization on a massive social scale, and the equalization of all human labor into a common substance, as Michael Heinrich explains:

> Abstract labor is thus not a special type of labor expenditure, such as monotonous assembly-line labor as opposed to artisanal, content-rich carpentry. As labor *constituting use value,* monotonous assembly-line labor is just as much concrete labor as carpentry. Assembly-line labor (just like carpentry) *only constitutes value as equal human labor,* abstracted from its concrete character, or, in short: assembly-line labor and carpentry only constitute value as *abstract labor.*
>
> As "crystals" of abstract labor, commodities are "values." Marx therefore describes abstract labor as the "value forming substance" or as the "substance of value."[112]

Socially combined living labor, abstracted labor, is distinct from individual acts of labor. It is labor in the aggregate, pooled and equalized as labor itself, rather than specific and concrete acts of labor. In the contradiction between labor and capital, where the interest of one group runs contrary to the other, the goal of the capitalist is to push to a minimum the cost of labor (the "cost of labor" being one example of the abstraction of human beings into numbers), so they can garner more surplus. Abstract labor, the source of surplus value, is historically determined, rationalized, and organized (through Taylorism, or Fordism) for the sole purpose of producing commodities for profit. Capitalists produce goods not for the welfare of consumers, but for profit. Commodities usually need to be either useful or desirable so as to encourage exchange. All else follows. This is the logic undergirding the economic organization of the world today and what we wish to change.

The source of value, crystals of abstract labor that are the content of capital, then take many forms through complex processes that mediate value:

> As Marx demonstrates throughout *Capital*, but which becomes the particular focus of Volume III, capital's content takes a form that then becomes the determination of subsequent forms, or the 'base' of a series of transformations of form that index different moments in the processes of production, valorisation and accumulation: for example, abstract labour takes the form of value, which takes the form of exchange value, which takes the form of price; the price-form is instrumental in the transformation of form that is the cognitive apprehension of surplus-value as profit, wages, rent, and so on.[113]

Mystification shapes the perception that it is the capitalist making value and not the worker. The wealth of nations is produced not by capitalists, but by productive workers, also as taxpayers, but predominantly as the source of the socially combined value that is transformed into profit and distributed to the unproductive sectors (for example, some of the wealth of Western nations is today produced in the global south, its fruits expropriated to the branding country, as discussed in Chapter 1).

But this fact is masked by the ideological view that fragments the appearance of the economy into units, presenting the process of labor as divided by firms. It makes us imagine value to be an outcome of advancement in technology, innovation, mechanization, successful

design or branding by firms, all of which are in effect forms of monopoly (or brand monopoly today). But since the economy functions by the total aggregate, what actually takes place is that one firm is making more because it is taking it away from others in the capitalist production across the relevant social formation (competition in the sector, for example). Marx showed how the introduction of machinery that can initially give a capitalist enterprise advantage will ultimately result in lowering prices across the sector, an underlying cause of the law of the tendency of the rates of profit to fall, which we know to be an empirical fact.[114] That similar products may fetch different prices during exchange make it seem like value is produced at that stage. This type of worldview is actually confusing value-added with surplus value, while the former is only a transformed form of the latter.[115]

It is not for naught though that mainstream thinking is blind to how deeply concealed the domain of value creation is:

> That which needs to be clear, and which also contains a moment of real difficulty, is that the labor objectified in the exchange-value of a commodity does not correspond to the quantity of labor immediately spent in its production. Instead, it is the fruit of a mediation with socially allocated labor ... as Marx [emphasizes] 'exchange-value in the singular does not exist', but because it presupposes a value determined quantitatively by labour individually employed in the production of this commodity, and not by social labour. This, on the other hand, is not a definite size once and for all. Rather, it is variable and its variability *retroacts* on the determination of the quantity of social labour contained in a commodity.[116]

The retroaction—the fact that price and value affect one another through a feedback loop connected to the consumption needs of workers making the commodity, its subsequent sale, and a host of other factors—is because they operate through a very large and complex system. This is why we cannot simply translate labor time into prices. Money mediates labor abstracted into value, but it is human labor that makes money commensurable, allowing money to function as a general equivalent for exchange. Diane Elson distinguishes Marx's approach from Adam Smith and David Ricardo's labor theory of value:

> [I]t is *money*, and not labour-time, which functions as the social standard of measurement, in Marx's *Capital*, as in capitalist society

itself. The reason that labour-time is stressed as the measure of value, is to argue that money in itself does not make the products of labour commensurable. They are only commensurable insofar as they are objectifications of the abstract aspect of labour.[117]

Human labor is what creates wealth and establishes the equivalence underlying the capitalist economy. If we understand correctly how the economy functions, we will be able to calculate a fair and sustainable system of distribution. This is not pie in the sky. As Best shows, it entails measuring profit and surplus separately:

> The value of constant capital – raw materials and the used-up portion of tools and machinery – returns to the capitalist in the same quantity; the value of variable capital – labour-power – increases, i.e., produces surplus-value. Fortunately for the capitalist, when purchasing labour-power s/he does not receive what s/he pays for (as we saw earlier). The capitalist pays an equivalent to the value of labour-power, that is, the cost of reproducing labour-power. What s/he receives is 'living, value-creating labour-power that actually functions as productive capital'. What the capitalist pays for and what s/he receives are two different things and two different quantities of value. However, in the imagination of the capitalist (i.e., according to the surface story), there is no distinction between constant and variable capital, there is only the cost price of the production of the commodity, a value that enters circulation and returns valorised.
>
> ...
>
> This appearance mystifies the source of capitalist profit, that the latter is actually surplus-value created in production through the agency of cooperative (that is, socially combined) living labour, realised in circulation, and appropriated as the private property of the capitalist: 'Profit is the [ideological-mystified] form of surplus-value'.[118]

In other words, if we wanted to calculate the aliquot share that actually belongs to the worker, we could. We have the theoretical tools to plan a just economy and enough knowledge to measure it.

The distinction between productive and unproductive labor is an important distinction for measuring the total economy. It would entirely alter the concept of GDP, for example. It is especially important for art precisely because art-making is unproductive. "Unproductive" is a technical term, not a judgment or qualification; it merely designates a

type of social relation. Thinking about the economy of art can be extended to other forms of care and social reproduction. Simply put, we would measure and distribute them in similar ways, providing for all.

Productive and unproductive labor

Sungur Savran and Ahmet Tonak clarify the various steps for the classification of activities and products. The first is between productive labor in general versus labor that is productive for capital. The production of surplus value is the first condition to determine if the labor is productive. Surplus value is produced only when labor power is "sold as a commodity and the buyer of this specific commodity consumes its unique use-value, i.e., the capacity to produce more value than it embodies." [119] Savran and Tonak continue with another distinction:

> Hence, only labour which is predicated upon the sale of labour-power as a commodity can serve as productive labour under capitalism ... Even the sale of labour-power, however, is not a sufficient condition for the existence of productive labour. And here we come to the distinction PUPL [productive unproductive labour] properly speaking. For this, one should also make a distinction between *labour exchanged against capital*, on the one hand, and that *exchanged against revenue*, on the other.[120]

If a domestic worker works for a cleaning firm and they clean the house of the capitalist, this labor is still not productive because it is exchanged against revenue and not capital, it is exchanged against the money garnered by the capitalist for personal use and not for reinvestment in productive economy. However, a cleaner that transforms dirty rooms into clean ones in a hotel is indeed producing a commodity because they are producing use values for exchange:[121]

> At the stage we have reached, the criteria for productive labour can be summarized as (1) that of commodity production, (2) that of the sale of labour-power, and (3) that of the exchange of labour-power against capital as opposed to its exchange against revenue. Yet these three conditions are still not sufficient to guarantee the production of surplus-value.
>
> ...
>
> The secret of the paradox lies, of course, in the distinction between production and circulation.[122]

For us these distinctions matter greatly. Art can generate jobs, and, since it launched in 2013, the Bureau of Economic Analysis Arts and Cultural Production Satellite Account has been measuring the "value added" of the creative economy. But this does not mean that art generates surplus value for the common wealth. We need new methods to measure the economy so we can facilitate a new distributive system. Tomás Rotta explains:

> Despite directly consuming the surplus from productive endeavors, unproductive accumulation can well enhance labor productivity or even boost aggregate demand in productive activities, and therefore indirectly improve the creation of surplus value. Hence, there is a double effect under consideration: unproductive activity might *indirectly* increase labor productivity and it might also increase demand for productive activity, while it draws on the value that it does not *directly* produce. Even though un- productive activities *indirectly* impact productive accumulation, they do not *directly* add any new surplus value to the economy.[123]

Reworking orthodox data, Rotta develops an accounting system that distinguishes between productive and unproductive activities. The point is that we have the knowledge to conceptualize an economy that acknowledges the indispensability of creative and social reproduction work but calculate how to distribute if fairly. This goes hand in hand with a reorganization of the economy so the means of production are collectively owned and remuneration exists for all aspects of life, including social reproduction, care, and culture.

But under capitalism, art and all its auxiliary practices no matter their content are unproductive, since the entire sector is unproductive. Thus, even art that is not commodity art sells for lower prices, produced in less quantity, is conceptual, performance, or social practice—if it circulates anywhere in the broader field of art, if it is what Gregory Sholett referred to as "dark matter," it still either serves to sustain the symbolic sphere of art, or is part of the nonprofit system that is itself nonproductive.[124] As artists or art workers cannot reconfigure the social relations of their activity through individual practice, their only means of being political is working toward systemic change, and collectively thinking what alternatives would entail.

The appearance of value in art

Art is not a regular commodity because the work of making it is always private and particular, rather than rationalized, generalized, and

abstracted. Once it circulates publicly, art enters into a relation with total social wealth and therefore with the value-form, which is the various ways in which (trans)formed value appears in exchange relative to all other commodities and equivalent to money, a relationship made possible because of the underlying equivalence of labor power. It is social wealth, the wealth created by a society as a whole, that allows a private aspect rooted in art's authorship to fetch a price, price being a representation of value that originates from productive abstract labor, which has now been transformed into other forms of value's appearance. Although this is not a structure we can dismantle at will or on a small scale, if we understand art's place in the process it can play a part of a larger restructuring.

As Dave Beech shows, art is exceptional to the capitalistic mode of production as it is not part of a system where capital outlays are invested to be valorized in the production process.[125] Art doesn't transform raw materials into commodities on a systematic scale, it doesn't contribute surplus value to a capitalist entrepreneur, or the national aggregate, rather art is bought with revenue, and is part of the mercantile circuit. Art is also subject to a different logic of competition, it resembles a Veblen good, a "conspicuous consumption" good aimed at reflecting affluence, distinguished by the fact that higher price is incentive, rather than a deterrent for demand.[126] For these reasons, a rise in art's value is not valorization, that is, the creation of value, but rather an appreciation of its price, or its potential to fetch a price (an enhancement of its symbolic value). It is through its relation to money that art enters into the circuit of the market alongside commodities. As Heinrich shows, all commodities carry a relation to the total labor of society:

> The magnitude of value of a commodity is not simply a relationship between the *individual* labor of the producer and the product (which is what the "substantialist" conception of value amounts to), but rather a relationship between the *individual* labor of producers and the *total labor of society*. Exchange does not produce value, but rather mediates this relation to the total labor of society.[127]

Asking how art fits into a typological classification of objects—merit goods (funded because they are necessary, like health and education), public goods (nonexcludable, like air and water), and nonrival (whose quantity does not diminish with marginal use like broadcast television)— Beech tells us:

It is possible for an artwork to be a Veblen good, a luxury good and a public good and a merit good all at the same time. Sports cars and jewellery are not public goods or merit goods in addition to being luxury goods. Artworks, on the other hand, even if and when they are luxury goods, are more than luxury goods.
...
Art's relationship to merchant capital, which I have examined in terms of art's encounter with the gallerist and the collector, neither follows the pattern of the standard commodity nor conforms to any of the three main theories of luxury goods.[128]

So how is art "more than a luxury good"? How is art different, say, from wine or yachts? First, as Beech explains, the public can consume the art good along with the capitalist. But here we have to add another condition, and that is art's public aspect, the museum. It is only because the public also collectively own cultural patrimony that art is more than a luxury good, because it has common significance. To appreciate wine one must drink it, but appreciating a work of art does not diminish it. When it comes to art, to look is to use. This should, as an aside, also settle the question of whether art has use value or not. Art has use value because looking or thinking about art is use. But the difference is that the general audience can have access to the full use value of the art. We can look at luxury cars at a fair or at yachts at the boat show , but we can't drive them or go sailing. No shared aspect of any other luxury good comes even close to the status or magnitude of museum collections as collective institutions. This leads us to the second, and historically continuous, distinction of art as symbolic patrimony.

As Beech explains, the key to understanding what art is, categorically, is to ask from a Marxian economic perspective about the social relations of its production. We think here of the art object not through the description of its making, but through the typology of its production. In her analysis of the classification of services, Fiona Tregenna underscores the fundamental Marxist distinction between appearances and essences, showing that we cannot classify activities by inspection:

In bourgeois economics, the typological method is primarily phenomenological: observing an activity generally allows for a determination as to which sector it falls within. The classification of an activity within a Marxian schema, by contrast, is contingent on the underlying social form of the activity. The fundamental issues in analysing an activity relate less to what a person is 'doing' in an

observable way, and more to generally unobservable characteristics such as the relationship of the activity to the production and realization of surplus-value. Moreover, from a Marxian perspective a commodity is classified as such not according to its physical characteristics, but rather according to the way in which it was produced. Marxian economic categories thus have a fundamentally different epistemological basis from bourgeois economic classifications as used in national accounting, in mainstream economics, and also in non Marxian heterodox economics.[129]

The question for Marxist classification of activities, and their outcomes, that is, commodities, is then whether they are productive or unproductive, not what sector they fall under. The same activity can be productive or unproductive, depending on the social relations through which the activities produce use values.[130] As discussed in Chapter 1, this is not a judgment but rather an observation. In fact, there is nothing positive about being a productive worker:

> In explicating the differentiation between productive and unproductive labour adopted by Smith, Marx separates the concept of the productive from its relation to the 'external thing [*Ding*]' and connects it to the social relation in which a labour is performed. The concept thereby reveals its relativity or its particularity [*Standpunktbezogenheit*]. That which, from the standpoint of capital, is productive because it forms surplus-value is not necessarily so from the standpoint of the preservation of life, and vice-versa. In capitalism, therefore, he states emphatically, it is not good fortune, but rather, 'a misfortune' to be a productive worker.[131]

Art, like social reproduction, is a necessary social need. Saying that it is unproductive is merely in order to know how to account for it when the discipline of economics and the national accounting system sober up and recognize that to conceptualize the measurement of the economy we need to account for its totality.

Conclusion: some immediate solutions

It is because art is collected on a social scale and for the broader public that art is *more* than a luxury good. Collections have been the content of representational institutions since rulers began using art as justification

for their claims on sovereignty, through the development of museums as instruments of the nation-state, and into our present of a globally networked and international art scene. There is no city that respects itself today that does not boast at least one art museum, if not several. Art's value and its relation to the political and economic system in which it circulates is one orbit in a constellation that includes the nation-state, which prints and regulates money; the nonprofit or third sector, which operates as a shadow state; and museums as art collections—publicly constituted, but where private individuals reap the benefits. Stabilized by the role museums play in the associational and cultural spheres of civil society, the appreciation of art's prices takes place at a triple expense of the public. Collectors who exhibit works in public institutions or own works collected by museums profit by:

1. receiving the benefits of institutionally endowed symbolic power, that enhances the value of their own work by the public alibi of the museum;
2. gaining ideological influence on society at large;
3. privately benefiting from the socially constituted economy, itself necessary to establish a general equivalent (money) toward a system of exchange, where art is traded as a promissory note that siphons value from the general aggregate.

With the first, while it may not be illegal for collectors to exert direct or indirect influence on the professional process, it is nevertheless unethical even by the logic of liberal democracy. The second demonstrates how unjust social order is made to appear natural. And the third addresses the hidden abode where value is actually created. The second masks the third, allowing the first to take place, so much so that a newspaper like the *New York Times*, with which this chapter commenced, can report, without raising an eyebrow, about a collector benefiting enormously from the circuit related to an institution she is supposed to altruistically serve.

Established in the modern period, the above conditions, which have been exacerbated by the financialization of the art object, have been standardized by the twenty-first century. Collectors can borrow money against their art, because of the symbolic powers of the institution, made possible by its social scale. The art is worth more because it has either been loaned to the institution or it is made by the same artist the institution owns. If it is the museum that endows the art with an ability to siphon more money from the general aggregate, then we have private

individuals making money off a common social structure, but not sharing it.

Art is an example of how ideology facilitates the perceptual economy, sustaining an economic order that subordinates the vast majority of the population to serve the interests of the upper echelons. Symbolic value facilitates an ideology that serves a double role in masking social relations. On the one hand, it supports the idea of museums as scholarly and impartial authorities, endowing it with power. On the other, it facilitates the siphoning of actual substance that is not "symbolic capital," but rather the ability of the symbolic to embody the fruit of abstract labor at the expense of actual living labor.

Although expanded by symbolically enhanced institutional means, when sold, the value of art is realized as money, which not only mediates the substance of value, it contains material crystals of abstract human labor. As financialized capital and art write more and more promissory notes, they suck away more and more value from the laborers who made it. The winner-takes-all market is vampiric. Money is one formal iteration of value. In the social order systematized and rationalized by the capitalistic economy, symbolic value and commodities made by nonproductive means are also assessed in terms of money. Since there is a finite amount of substantive value, but potentially infinite promissory notes in circulation, this means that by supplying the wealthy tools of asset-hoarding, investment, and financialization, art is playing an active role in sustaining, if not exacerbating, a crisis economy. The higher the prices of art the more the sector is sucking up abstract crystals of labor from the general aggregate without redistributing or replenishing the pot.

But it doesn't have to be this way. There are other ways to support living artists without contributing to the crisis-bound status quo. Here are a few suggestions for solutions that take the logic of liberal democracy and then aim them at redistribution.

Valuable art should not be in private hands. If a museum is deaccessioning works from their collections it should go to another public institution. Cultural patrimony laws could prohibit the sale of art that is socially significant to private hands. Mandating that public institutions get refusal rights that can sequester a public market for art, or place limitations on price, can make contemporary art affordable for institutions. Massively raising taxes on income, assets, inherited wealth, and all forms of financialization and capital gains. This should include the secondary art market, more specifically, the resale of art, where it is most likely to see gains on investment, taxed at rates so high as to

discourage the use of art as a vehicle for financialized investment. This will retroactively balance the speculative drive of the primary market and its winner-takes-all character. Naturally, collectors will be barred from making any choices on what institutions accession or exhibit. Curatorial decisions, collecting and display in public institutions, could be reviewed or augmented by peer-based panels composed with demographic, disciplinary, and methodological diversity reflecting the museum's public. This can be a double-review system working in concert with volunteer specialist committees (art historians and/or curators from other institutions). We can allot percentages to public votes, we can pay artists who do not have object-based practices, we can collect locally and find more ways to thwart the brand-making machines, or to redistribute rather than accumulate. Museum funding and programmatic decision-making could, for example, be open to public scrutiny by way of open debate. There are ways to administer such activities without deskilling the field. The practices of the public institutions would thus become part of its programming, facilitating transparency. Transparency of other museum operations is also fundamental for scholarship and administrative analysis. If all museums had working archives, where scholars and specialists could gain access to documents, meeting minutes, and financial decision-making processes, we could share knowledge. While these examples raise as many questions as they do answers, their purpose is to demonstrate that there are simple ways to limit the reach that private individuals have into exploiting public resources for self-gain. Given the interdisciplinary nature of these questions, they need to be processed theoretically, empirically, and through debate with professionals and specialists from all the intersecting fields.

At this point in human history, we have the knowledge and ability to direct creativity and innovation (and even competition for those who insist that it is intrinsic to human nature) toward cooperative organization of life and production. As Best shows, it is simple to calculate the difference between the rate of surplus and the rate of profit, such that the elimination of profit as an inevitable form is not such an outlandish idea, as is the one that we can produce for consumption, not for exchange, and share in the outcome—abolish wages, and the capitalist war to reduce labor's share as a political driving force. Under such conditions we will be able to use common resources to support human creativity in myriad new ways.

Chapter 3

FROM MEDICI TO MOMA: COLLECTIONS, SOVEREIGNTY, AND THE PRIVATE/PUBLIC DISTINCTION

The Renaissance roots of MoMA's two audiences[1]

"The irony is not lost on me," a sympathetic floor manager responded to my visible distress at having been shut out of Adrian Piper's installation *What It's Like, What It Is #3* (1991), a section of her monumental retrospective *A Synthesis of Intuitions* (1965–2016) at the Museum of Modern Art (MoMA), New York. The irony mentioned by the floor manager was that the celebration of one of the museum's major philanthropists was impeding the public use of its galleries. The floor was closed to the general public in anticipation of that evening's annual garden party honoring Agnes Gund. In fact, the entire museum entrance was rerouted in preparation for the event. On display that day at the MoMA was the museum's different attitude to its two audiences: its wealthy patrons, and the rest of us. The staff was also diverted into upholding the hierarchy, the very same hierarchy that works against the social and economic interests of all workers. Other than high-ranking positions and executives, MoMA employees famously have low salaries, and its several unions have consistently battled the institution since their inception.[2] This is an endemic problem for most major museums. But what the ideology that foregrounds the philanthropist as a generous donor and pillar of society is set to conceal from artworkers like the floor manager and myself (workers here distinct from laborers) is that our work is not primarily meant for the public, it is historically designed to serve the wealthy.[3] Although I am a scholar of Piper's work and wrote a catalog essay for the very exhibition on display, my need to see the work for professional purposes that advance the discourse was clearly secondary to the museum's other objective.[4] This is because one of the functions of the museum is to also be an instrument of soft power, where the gifting of money and art appeases

and distracts from potential social upheaval, allowing the wealthy to maintain control over culture, in a cycle that keeps their power in place. In this the MoMA, and other American museums that are similarly structured, resemble their Renaissance ancestors in ways adverse to democratic ideals. Furthermore, a resemblance emerges in both economic structure and position in the economic cycle, where investment in luxuries and other nonproductive activities overcomes that of reinvestment in production, indicating a stage of decline, characterized by several scholars as neofeudalism. For this reason, this chapter emphasizes the founding of the Uffizi Gallery in late-sixteenth-century Florence, and only takes a contextual look at the history of museums in the eighteenth and nineteenth centuries, as the latter has been well documented and analyzed. While the tendency to locate the origin of the modern museum in the eighteenth century is correct, a longer view is necessary in order to understand the ultimate failure of these institutions to fulfill their promise to serve the public and to advance democratic ideals. Indeed, the sweeping influence of Michel Foucault on the field has led to nuanced critiques, cited throughout this book, of the museum as an apparatus of the power structure, aiming to corral and reform the ever-growing urban populations.[5] Leading to ideological critique, what is missing from this picture is an economic analysis of art collections as treasuries, and the ways in which the notion of the public and its material existence were what gave art its ability to hold value in the first place. Because this book is oriented to questioning the legal and administrative uses of a categorical public, I am specifically referring to an abstract notion of what the term represents, and not to any specific historical, anthropological, sociological, or otherwise empirical corpus.[6] This chapter paints a historical picture in broad strokes, offering a theory of the public-facing collection that can explain the role museums play as political and economic entities. That the relation of art collections to money and political power in the founding of the Uffizi Gallery resembles our current affairs in several key ways is both cautionary tale and a window into what can be done to make museums more democratic.

The Medici rose as merchant bankers, ruled indirectly during the fifteenth century, resurrecting a secondary family line that turned the dynasty into a duchy during the sixteenth. While collecting was standard throughout Europe and especially Italy, the Medici perfected art and collecting as statecraft more deliberately and self-consciously than traditional nobility, perhaps compensating for,

or attempting to conceal, their merchant roots. In miming the rulers of ancient Rome who displayed their art to the public, the Medici counteracted the Christian disdain for wealth, managing it in acceptable ways instead. One Medici after the other legitimized their power by various cultural contributions, one of which was collecting.

Initially, the inward-gazing private collection represented power, beyond an inner circle, by glorifying its owner through hearsay. The way the Medici then externalized their collection at the seat of their government became the cornerstone of modern public collections at museums as we know them today. It went hand in hand with the development of secular collecting among a professional class that also established their position in society by serving the ruling class. This is one of the cornerstones of bourgeois society. The process I identify as the "externalization" of private collections is a window into an early shape of arts policy, where collections were turned outward as propaganda for the ruler and their agenda. In the early development of the nation-state form, this public was expanded to include more strata of the population. The salient point about the transformation of the public's composition is the need of power to both exhibit and justify its wealth to this public. When looking at the history of the collection with the question "Who is the public?" in mind, we get a sense of who has access to the benefits of the state and to what degree. We then can hold museum conduct accountable to its promise.

In Florence, as elsewhere, the production of luxury was incorporated into the heart of the reign. The Medicis' need to justify their right to reign was more pronounced though than in more traditional despotic cities, because these rulers basically suffocated the Republic:

> Duke, later Grand Duke, Cosimo I (1519–74), clarified the matter by cleaning out the political stables—in the manner of Hercules, his personification in art—and laying the foundations of a truly absolutist state. Most of the republican institutions were thrown out, and those that survived, including two of the most important economic institutions, were redefined in altogether new terms: the Mercanzia [merchant court of law], now pushed out of the political sphere and confined to a strictly judicial function; and the guilds, most of which were merged into even larger agglomerates, with their headquarters relocated under one roof, the Uffizi, where they were absorbed into the new ducal bureaucracy.[7]

In formally constituting the Accademia in 1563, Cosimo I institutionalized artistic production. While he was still regent for his father, Francesco de' Medici continued this tradition, constructing the Casino di San Marco (1574) which included a foundry, a distillery, facilities for alchemical research, and various workspaces for craftsmen, many of which were transferred later to the Gallery of Works at the Uffizi. As Richard Goldthwaite notes, although it was not the first program of its kind in the history of Europe, "it marked a qualitative difference from anything that went before with respect to range, centralization, and overall success. It anticipated the royal manufactories set up a century later, on a much larger scale, and with explicit commercial objectives, at Versailles."[8] The primary goal of these institutions was to bolster the power of the reign:

> Ducal policy was directed largely to political ends: to furnish the court of these newly arrived princes with an appropriate aura of luxury, to supply gifts in accordance with the contemporary culture of diplomacy, to boost the international prestige of the new state in the courts of Europe. Some of this production ended up in the market, but hardly to the extent of enjoying what could be called commercial success.[9]

Somewhat akin to a government-sponsored arts research and production center, collections became more than a display of luxury as magnificence because they also represented mastery over classification and other forms of knowledge, or tool of diplomacy, proving the Medicis' just reign over their domain. During this process, art gradually became its own object class, with painting transitioning from a cheap form of art to taking its primary role as *the* example of the fine-arts object. Of course, Giorgio Vasari and his *The Lives of the Most Excellent Painters, Sculptors and Architects*, published in 1550, were key to this transition, but my emphasis throughout the many transformations we are following remains on the significance of the collection as an economic and political phenomenon and the influence of its development on the development of art's exceptional status.

The Uffizi Gallery and the MoMA bracket an arc where this externalization was developed as a mechanism of what today we would call soft power. My ambition is to raise a set of big-picture questions by introducing world-systems level of analysis to describe how museums are shaped by the relation of wealth to governance. This chapter follows the journey of collecting from an introverted private activity to an

outward-facing public display, where it was further developed as an activity of amassing national patrimony and representing national identity, ending with its American reprivatization (emulated in neoliberal Europe). Simply put, art went from private to public, and back again.

Art's economic character

In his comprehensive economic study of Renaissance Florence, Goldthwaite identifies the roots of the conventions that have made art into a unique collectible, and that still guide institutional attitudes today:

> By the end of the sixteenth century some men were consciously collecting these products. A few deceased producers whose products were still sought in the market acquired the new status of "old master"; and in reaction to the growing traffic in these products, the ducal government of Florence issued legislation in 1602—the first of its kind—to limit the exportation of the products of no fewer than sixteen producers, some of whom were not Florentine, and to lay down the procedures for adding new names to the list in the future. Nothing like this happened in any other manufacturing sector in the economy.[10]

Although dissonant to the contemporary ear, classifying art as a "manufactured product" is the correct baseline for our inquiry here, not only because the concept of art as such was only nascent at the time, but because of our focus on how its economic functions are imbricated with its symbolic status. It is in the course of acquiring the status of a collectible that art gains its special place in culture, a status it will retain throughout the development of fully-fledged capitalist production, where it will become economically distinct from the mass-produced commodity form, as seen in Chapter 2. The ability of art's symbolic value to transform into monetary value, the ability of what was initially a relatively cheap commodity to transform into an expensive asset, is the consequence of administrative and economic policy that, although necessarily part of an expanded network of patricians, was consolidated and amplified in the actions of the Medici.[11]

Initially, art's economic character was similar to other manufactured luxuries. Painting was a relatively cheap artisanal object, and like all artisans in Florence, artists tried to make their production efficient:

"Among the most visible of these in the scholarly literature are the sculptors who introduced new and cheaper materials and the painters who devised ways to facilitate production in series and developed stylistic innovations to keep ahead of the market."[12] Lindsay Alberts notes how even Lorenzo de' Medici, famed for his patronage of Renaissance masters, in effect held little of what would now be classified as contemporary art:

> An inventory of the Palazzo Medici taken upon Lorenzo's death in 1492 records 20% of its items as household goods; the entire balance of the inventory is devoted to collectibles. While modern taste may prefer fine art over the items that dominated his collection, mostly gems, cameos, coins, medals, rings, gold chains, maps, and his famous hardstone vases, the value of these small-scale collectibles far and away outstripped the price of paintings. For example, one of Lorenzo's celebrated cameos, the Noah Cameo, was worth 2,000 florins, twenty times the price for the most expensive painting listed in the 1492 inventory, a Fra Angelico work valued at 100 florins. Ruth Rubinstein observes that his carnelian intaglio depicting Apollo and Marsyas was worth over 1,000 florins, more than Domenico Ghirlandaio was paid for the entire Tournabuoni Chapel. Other individual items were valued at equally astonishing prices, such as a "unicorn horn" estimated at 6,000 florins and the famous Tazza Farnese, valued at 10,000 florins—in short, even one of these tiny collectibles was worth a true fortune.[13]

Becoming more costly only in the late sixteenth century, the unique status of painting developed from the part it played for the larger whole of collections that initially had a different focus. The escalation of art prices to what art may fetch today has occurred in fits and starts, as well as seeing periods and circumstances of regression. Yet, without the larger circuit, where collecting generates a market and collections as public entities ensure the status of art as an asset, we would not have seen the historical development of a robust market.

Francesco I de' Medici's Uffizi is a model for the sweeping changes that followed. As Alberts summarizes, it was a two-pronged process:

> This moment of transition in Medici collecting crystallizes within one collector's career two trends emerging among European elites—a move towards increasingly accessible collections, and, more broadly, an increasing expectation that rulers would fundamentally engage with culture as part of their expression of political authority.[14]

While the latter was already a feature of fifteenth-century collecting practices, the significant turn (or perhaps re-turn, but in greater force) to accessibility is a development that is key to what art and museum will become. That the fine arts, with painting in particular, eventually came to be worthy of treatment as national patrimony and finally distinguished as *the* foremost collectible, is anchored in this transition.

A few methodological and typological notes

There exists a body of literature on typologies and practices of classifications, as there is on the psychology and meaning of collecting.[15] There are also many ways in which collections themselves have been classified, with paradigmatic distinctions made between the poles of wonder versus knowledge, the religious and the scientific, the organization of morphologies or materials, or comparison of institutional typologies.[16] Different scholarly perspectives also examine the evolution of personal studies, cabinets of curiosity, and galleries into libraries, natural history museums, or fine arts institutions, tracing the development of classification into scientific and humanities disciplines, over the course of two hundred years. In contrast, my goal is to understand the processes by which art collections not only came to represent wealth or knowledge, but became a necessary component of authorial identity and the right to sovereignty, first for individuals, then for governments.

The history of museums largely periodizes the inception of their modern form in the eighteenth and nineteenth centuries when they became public in the sense we understand now.[17] In focusing instead on the proto-public function of collections between governance and economy, I highlight the long transition into modernism and the capitalist economy as a starting point, because it helps us understand the process of reprivatization of art by the ruling class. If the story of museums since the eighteenth century is that of progress, zooming out on a bigger picture can help us turn the tide on its current undemocratic trajectory. Florence and the Medici duchy are a model for us because of the relation of art to money, for as Giovanni Arrighi states, "[H]igh finance in its modern, capitalist form is a Florentine invention":[18]

> In part, the conspicuous consumption of cultural products was a direct result of the adverse commercial conjuncture which made

investments in the patronage of the arts a more useful or even a more profitable form of utilization of surplus capital than its reinvestment in trade (Lopez 1962; 1963). In part, it was a supply-driven phenomenon associated with the invention of mythical collective identities as means of popular mobilization in inter-city-state warfare (cf. Baron 1955). And in part, it was a direct result of the struggle for status among competing factions of merchants whereby "building magnificently became a strategy for distinguishing some families from others". (Burke 1986: 228)[19]

In many ways the leveraging of art in relation to high finance today echoes its uses at the end of the Florentine cycle of accumulation. It relies on the similar function of governmental arts policy as a mechanism of stabilization which in turn serves other markets that gyrate in overlapping commercial and diplomatic orbits. Collecting is therefore not merely associated with the inventions of mythical collectives, it is part of the very mechanism that generates them. By giving an identity to functions in the economic system, outward-facing secular collections, then and now, formed a public out of a society of producers and consumers.

Externalizing the collection: a prehistory of the public

Open today on its original site, the Uffizi Gallery is a model case study for the externalization of collections, but it is by no means the first or the only one.[20] In Florence, Cosimo I placed Cellini's Perseus in the Loggia dei Lanzi, an unrestricted public space originally constructed in the fourteenth century for public ceremonies. A few precursors included the Capitoline collection, founded in 1471 with a donation by Pope Sixtus IV, Pope Julius II's Belvedere in Rome, and the Statuario Pubblico in Venice, created at the end of the sixteenth century. There were also smaller civic collections.[21] This chapter focuses on Francesco I de' Medici's transformation of his *studiolo* (a private chamber designated for contemplation) to the Uffizi in 1583, because, as Guiseppe Olmi's oft-cited summary explained,

> The need to legitimize the Grand Duke and his dynasty meant that the glorification of the prince, the celebration of his deeds and the power of his family had constantly to be exposed to the eyes of all and to be strongly impressed on the mind of every subject.

This transition from private to public also entailed a new arrangement of the collection. Works of art and antiquities gradually came to be seen as status symbols and instruments of propaganda, while grand-ducal policy increasingly brought scientific research under state patronage.[22]

Unlike many princely or royal collections that were dismantled, Anna Maria Luisa de' Medici, Electress Palatine and sister of the last Medici Grand Duke who inherited the Medici collection from her brother at his death in 1737, negotiated the Patto della Famiglia with the Holy Roman Emperor and new Lorraine rulers, willing the family's possessions to the Tuscan state and leaving one of the most important historical collections intact. Today, the Uffizi has an international public. But the concept of who or what the public is has changed dramatically since this institution's inception.

To ask, as David Carrier has, "[W]hy were there no public art museums in the Renaissance Italy?" is to describe how the modern character of the public was not yet possible. For this reason, in order to identify the embryonic forms of public institutions, we need to ask: what were the underlying political shifts that determined public art as an ideological necessity for the rulers of the city state? Indeed, as Carrier concludes, "[O]nly when a distinction is made between possessions of the prince and the property of the state can there be public art museums."[23] But what about that long period of history when the ruler's domain and property were one and the same? Renaissance politics hinged on leading figures representing power, wealth, and identity to one another. Bit by bit, the representation of identity through the collection expanded its audience to broader social strata. Urban elites developed collections, and an emergent professional class formed them for scholarly or personal purposes.[24] Middle- and even lower-class subjects also collected modestly, forming a tiered hierarchy of luxury consumption as a basis of society:[25]

> The greater wealth available to the middling levels of society was crucial for the development of new art forms and for an increased demand for modestly priced luxury products, a demand which brought the artisan classes for the first time into a consumer society.[26]

This development of a consumer society was key to the transition from city-state to nation-states.

Increasingly as the industrial revolution concentrated masses in urban areas throughout Europe, populations came to be administered

as collectives of free citizens. In this context state-makers and reformers retooled cultural institutions as technologies of social control. Only then did institutions become public in the sense we know today. Yet, the transition was not only as Carrier concludes, an outcome of cultural and intellectual development represented by the scholarly distinction between the natural and the artificial. Advancement in classification methods and knowledge technologies, as significant as they were, are effects, not the cause. Instead, I would argue that there *were* public museums in Renaissance Italy, only that the contemporaneous notion of the public was different.

The demographic composition of the "public" has changed several times in history. In the shift from the religious Middle Ages to a secular social order, the accountability of the patrician was first to a narrow elite entity. The contemporaneous definition of the public did not include the popular class of the countryside or the peasantry. Rulers did not need the type of broader justification as the modern republican order would later seek. But nevertheless, in the long Renaissance we find the precursor to the relation of collecting and sovereignty that eventually led to the voluntary or forced nationalization of princely collections for the benefit of the public. What changed therefore was the referent of the term "public," which expanded to include the working class (former peasantry).

From the private studiolo *to the proto-public Uffizi*

Francesco I de' Medici commissioned his *studiolo*, a form that has been prevalent for about one hundred years, from Giorgio Vasari, who, with the humanist Don Vincenzo Borghini, planned and executed it between 1570 and 1575. A guarded and hidden private chamber, it was only ever seen by very few individuals during its brief first life. By 1583 Francesco was relocating the room's movables and some of his family's collections from the Palazzo Vecchio to the galleria at the Uffizi. Although this collection has mostly been dispersed, the room was reconstructed in the twentieth century and is available for viewing today. Measuring only about 24 feet by 9 feet, the vaulted room has thirty-four paintings by late Mannerists, four bronze statuettes, and frescoed barrel-vaulted ceiling and lunettes. In the lower register, oval paintings of biblical, mythological, or legendary themes substituted as doors for the built-in cabinets lining the walls. With each side devoted to one of the four elements, their themes reflected their content, which included materials, objects, and documents.

In 2014 Lindsay Alberts discovered a 1574 inventory from which the content of the cabinets could be gleaned.[27] It held rare, precious, and exotic stones, corals, objects, and other materials of mysterious, miraculous, or medicinal powers; works of art, metalwork, arms, musical instruments, official or ceremonial objects; as well as an abundance of unidentified bundles of writing and musical compositions, the latter considered to be just as significant as material culture. The major theme unifying the room was celebrating the creativity of nature and man.[28] As Alberts tells us, "[T]he selection and organization of objects, reflecting the Renaissance ideal of discrimination, was oftentimes as important to collectors as the objects themselves."[29] Paula Findlen shows that although these early collections provided a space of introspection for their owners, they nevertheless were made widely known through correspondences among elites and scholarly circuits. This was a significant part of their purpose, and ultimately, a stage in the process of collections becoming public:

> The transformation of studiolo from a domestic concept to a more public one perfectly illustrates the way in which the museums of the late Renaissance continued to incorporate both private and public notions of space in their conception and utilization. While the studiolo of Federico da Montefeltro at Urbino served largely personal functions and the Grotta of Isabella d'Este, entered only through her studio, was secreted within the palace at Mantua, the studiolo of Francesco I operated in both contexts. Situated in the Palazzo Vecchio in Florence, the seat of government, off the Sala Grande and leading into the private family chambers, it was a striking transition point: a room in which the Grand Duke could seclude himself without entirely leaving the realm of public affairs.[30]

While knowledge *of* the collection was already a form of speaking through it to the world, opening it for a broader set of viewers was the historical turn significant to us. The display of the collection, as Lindsay Alberts shows, deliberately utilized cultural objects toward political objectives:

> The Galleria degli Uffizi, displaying the famous Medici collection of art and antiquities in an impressive new gallery space, is perhaps the clearest indication of Francesco's engagement with cultural politics as a site at which the Grand Duke could communicate messages of authority directly to visiting dignitaries and one that could to some extent speak for the Grand Duke.[31]

The Uffizi's galleries were installed into the building's preexisting spaces, creating the form of the gallery as a corridor, which later influenced the design of Vincenzo Gonzaga's Galleria della Mostra in the Palazzo Ducale of Mantua, opened shortly after the Duke's marriage to Francesco's daughter Eleonora; or the Galleria degli Antichi in Sabbioneta.[32] About two hundred years later, the collections of the Medici and the work of Vasari would inspire the approach to classification by geography that was developed by Luigi Lanzi and influenced nineteenth-century categorization and classification.[33]

Newly added to the Uffizi buildings was the octagonal Tribuna, whose shape and organizational program associated the orderly rule of the Medici with the glory of Athens and Rome—a metaphor for Francesco's command over his domain. Adriana Turpin underscores that "the classical meaning of the term tribune should also be considered: as the platform from which the representatives of the people could speak in the Senate."[34] In many ways then, the process of externalization can be seen in this turn to considering the oratorical power of the collection. This focus on the collector's ability to speak, its externalization, coincides with the turn to centering not only the owner but also paying significant attention to its visitor.

Collection as oratory

The association of collecting with oratory and statecraft was already on the mind of Samuel Quiccheberg, whose 1565 treatise *Inscriptiones vel tituli Theatri amplissimi* ("Inscriptions or headings of the most complete Theater") was an organizational plan for the collections of Albrecht V, and the first known thesis about collections display. Quiccheberg instructs on the use of classification as means to study order:

> For I sense that it cannot be expressed by any person's eloquence how much wisdom and how much use for administering the state—in the civil and military spheres and the ecclesiastical and literary— can be gained from examination and study of the images and objects that I have described.[35]

Mark Meadow confirms:

> This passage is found in the section of Quiccheberg's treatise in which he amplifies on the purposes and structure of the collection. In this passage and the one immediately preceding, he compares and

contrasts the accumulation of objects with the training suggested by Cicero (the epitome of eloquence for the Renaissance) for the ideal orator. That person should be able to enumerate and learn about all things because all in the world that pertains to mankind is the natural domain of the orator. The collecting of objects, as enumerated by Quiccheberg, is an equivalent to the Ciceronian collecting of knowledge and ideas. But the equivalence is not exact, because however eloquent an orator may be, be it Cicero himself, the pragmatic value of the collection could not be conveyed as well by him as it could by the objects themselves.[36]

Collections were seen as repositories of knowledge that could be applied to administering the state. Meadow describes the contemporaneous frame of mind through the dual concerns of a banker merchant like Hans Jacob Fugger, who trafficked in luxury objects in support of both his business interests and class mobility. The Fugger family of German merchant bankers is often compared with the Medici. They formed their own collections while brokering and curating for well-known princely collections. Collections, and gifting, facilitated merchant networks.

Another manifestation in the late sixteenth century of the tendency to externalize collection is seen in the shift of catalog language from the perspective of the prince to that of the visitor. As Dora Thornton shows,

> Sixteenth-century descriptions, in contrast to their fifteenth-century predecessors, are usually written from the viewpoint of a visitor rather than an owner. This literary development was intimately connected with the perceived status of collecting as an activity.[37]

While these examples refer to a different notion of the public than its modern definitions, we find in them the motivators that would later make public collections essential to the consolidation of civic or national identity.

As we work our way through descriptions that render these historical figures as cultural heroes, we must remember that the Medici was a dynasty of oligarchical despots, and that the Fuggers were also slave traders. The history of collections, like that of museums, is a history of humanity's barbarism.[38]

Secular collections: expanding the audience circuit

Specialization did not necessarily develop in the princely cabinet or galleria, it was already emerging in nascent form in the work of botanists

who formed iterations of what would later become the natural history museum. The protagonists of both spheres were aware of one another, sometimes forming deeper relationships. Francesco de' Medici was a patron of the naturalist and professor Ulisse Aldrovandi, who used the taxonomy he developed for classifying the natural world to organize his collection into a teaching display for his students. Open to the public during his lifetime, he also donated it to the city of Bologna in 1603. The collection became a pedagogical space, a laboratory, in the turn of humanism to secular scholarship which substituted the older metaphysical values for a new mercantilism. Anthony Shelton summarizes:

> The perfection of the secularized model of the encyclopaedic ideal was achieved by the Medici when Francesco I became Grand Duke of Tuscany in 1574.
>
> …
>
> The ideals that had motivated his endeavours, however, no longer envisaged a model of the universe with God at its centre, but instead a representation of creation that allowed each princely ruler symbolically to claim his dominion over the world as a means of glorifying and celebrating a family's influence, and legitimating its titles and position. In sixteenth-century Milan, all but two of the sixteen leading galleries of pictures belonged to members of the Milanese government. This transfer to the public gallery of sumptuous private property, paralleling a change in its perception from souvenirs to the 'great world' metaphor, consecrated collecting as an expression of the worthiness of an individual life.[39]

That the collection went from an assortment of objects and trinkets to a whole was critical to its ability to both represent the power of its owner and to establish its status as an entity that can sustain the value of its individual units. This was a function of the shift, by the sovereign, from conveying his command of knowledge word to mouth, to displaying it at the seat of government, visible to invited dignitaries, and to those who knew how to request access—the contemporaneous public.

In his 1591 guidebook, *The Beauties of the City of Florence,* Francesco Bocchi contextualizes the public aspect of the Uffizi Gallery in precedents:

> Already the emperors and the Roman nobles had this same praiseworthy and honorable idea. In order to escape the accusation

of greed and jealousy for keeping the wonderful art works of painting and sculpture within their private houses, they placed them in public places for the benefit of others. Among them, Marcus Agrippa was so passionate in this respect that he delivered a very committed speech, demanding that all paintings and sculptures be exhibited in public.

These works in the Gallery are most carefully protected from dust, wind, and water. Thus well preserved and clean, they can be viewed, and they are made public [*publiche*] at almost all times, if someone courteously [*cortesemente*] asks to see these precious works of art. [italics added by Alberts][40]

Of course, knowledge of how to ask courteously was already a screening mechanism, though one might say it echoes the various ways that museums throughout the twentieth century kept out entire demographics by access, customs, and other exclusions, as they continue to be intimidating to individuals and social groups today. In any case it merits mention that the Uffizi had a full-time guard on payroll. This underscores that the Uffizi was in some sense public, at least in terms of its own time. This accords with Alberts's analysis of Francesco's cultural politics as an application of soft power. Although the latter term is much more modern, it nevertheless describes how the Grand Duke let his collections stand as testimony to his knowledge and authority, as was previously done by narrative iconography in commissioned artworks. Collecting, classifying, and exhibiting collections as bodies of knowledge joined other forms that represented mastery over the political and economic order. Arrighi underscores the relation of luxury consumption to sovereignty:

> In so far as the system of city-states is concerned, the conspicuous consumption of cultural products was integral to a state-making process, that is, to the reorganization of the northern Italian capitalist enclave into a system consisting of fewer, larger, and more powerful political organizations. The anomalous character of the ruling groups of the city-states meant that they could not rely on the automatic, customary allegiance that was available to more traditional kinds of authority. Hence, these groups "had to win and hold that allegiance by intensifying the community's self-consciousness."[41]

A community whose economy was driven by luxury production was fit to rely on the collection of other types of luxury object for unifying its cultural identity, which in return sustained confidence in the economic system.

Florentine economy, governance, and art

The incredible trove Florentine culture left for posterity is associated with the development of a market for luxury objects between the fourteenth and the sixteenth centuries. What I am suggesting here is not a process of cause and effect, for as Roberto Lopez showed, prosperity and lasting artistic production are not necessarily linked.[42] The question is not what caused the incredible artistic achievement of Renaissance Florence, but how the institutionalization of art as a tool of sovereignty, most specifically through the form of the collection, created the blueprint for the modern constellation where art orbits on the circuits of its markets, which is held by the gravity of museums as governmental institutions that are shaped and administered by the ideology and interests of the ruling class. It shows the early blueprints of how a ruling class set up the cultural conditions that legitimized their exclusive access to a combination of political and economic power, a combination despotic by character.

Based in their wool and later silk industries, with iron production remaining important throughout, the Florentines established an extensive international network of merchant banking. Operating expanded currency exchange and credit markets, they leveraged favorable balances and engaged in government finance all over Europe. This propelled the initial visibility of these merchant bankers who grew their operations to ultimately fund international politics. In the long run, they established systems of government borrowing, rather than taxes, to finance their wars and affairs. They mobilized massive public debt in ways that served the wealthy in their private accumulation.[43]

The externalization of the collection is part of the state institutionalization of art as a means of soft power, that helped to conceal an absolutist turn. As Anthony Molho has shown,

> This "financial oligarchy," which, by the time of Lorenzo's regime when it became highly visible, had accumulated decades-long experience in this practice, represented an elite within an elite, whose access to public resources was assured both in their capacity as public officials and as creditors of the government.[44]

The specific forms of Medicean political power transformed the republic into a patrimonial regime that relied heavily on personal connections. Significantly, the financial oligarchy in ducal Florence

contributed to setting the foundations for the creation in Florence of the sort of patrimonial state that would clearly emerge at the time of Cosimo I. The interpenetration of private and public interests ... had been a staple of Florentine political tradition for generations. But while before an entire social class had been implicated in this practice, now, increasingly, the perquisites of office were being reserved for a restricted group, who could not help but end up by thinking that their own interests were identical with those of the collectivity.[45]

Arrighi underscores how state accumulation meant personal accumulation: "[T]he formation and expansion of the Medicis' financial empire was closely associated with the formation and expansion of the state-making capabilities of the House of Medici."[46] As Molho shows, by investing in government public funds the city's rulers, courtiers, and government officials not only had become accustomed to drawing profit from the state, they theorized this practice as indispensable.[47] Long after the Medici banking activities faded, the ducal bureaucracy was rooted in a drive for accumulation. A "vigorous protomercantilist program formulated by the first Medici dukes to stimulate the economy, including the development of Livorno as a free port," incorporated the structure of the state to support trade and continuous luxury production:[48]

> These initiatives of Cosimo and his sons defined an activist role for government in the economy that went well beyond, in degree if not in kind, the protomercantilist legislation that characterized the economic policy of the medieval commune, including republican Florence. They clearly anticipate what became a major theme in the history of the early modern state.[49]

By the sixteenth century the family tradition of combining merchant banking with state-making reversed its trajectory. With the aristocratic title maintained by wealth, now state-making became the instrument for wealth accumulation. The Medici profited greatly from their economic initiatives, reinvesting massively into the urban-scape of architectural projects, monuments, and sculptures, as they did into numerous types of artistic, intellectual, or humanitarian patronage, and, of course, collecting. The symbolic use of collecting was twofold. It represents wealth, intellectual mastery, and spiritual engagement, and it was also simply a treasury, a means to store wealth, the two functions supporting and justifying one another.

Luxury and abstraction

For the broader populations to participate in an economy of artisanal luxury production and circulation, abstract thinking and accounting were necessary tools, put to regular use beyond the aristocracy:

> Accountancy was more than just a technical instrument in the hands of the artisan that allowed him to clarify the organization of his affairs: it transported him to the world of credit and provided him with all the rules that were needed to play the game of shifting debits and credits through various other players simply by a stroke of the pen.[50]

The centrality of accounting was characteristic not only of Florence, but was widely spread through the territory of Italy:

> The knowledge, practice, and discipline of keeping accounts were deeply instilled in the habits of entrepreneurs of all kinds, including also artisans, and shopkeepers in provincial towns (to judge from their surviving account books in places such as fourteenth-century Prato and fifteenth-century Arezzo): they kept an array of standardized records, knew double entry, thought abstractly in terms of moneys of account, dealt in credit, and were familiar with sophisticated instruments of transfer.[51]

The double-booking system was a core tool. Found in accounting books as early as the thirteenth century, by the fifteenth century perfected double-entry bookkeeping that includes cross-referencing was used widely. It helped merchant bankers track complex networked transactions and supported their international expansion to financing a world system. Within this larger context, significant for us is that artisanal labor was taking the form of value:

> Monetary exchange thus became a matter of book entry. And in this process it conditioned men such as the brickmaker Papi di Compagno to think about money, the most basic of economic tools for dealing in the marketplace, as a pure abstraction. The actual coins that passed from hand to hand in the marketplace ... are rarely mentioned in the written record of their transactions, whether their own or that of capitalist clients. Instead, workingmen fixed the prices of their products and of their labor, in effect placing a value on their own

human capital, in terms of a ghost money, as Carlo Cipolla called moneys of account.[52]

Although nothing like the wage relations developed in the systemization of agricultural or industrial revolutions, nevertheless the changes resulted in artisans facing the market much more than they did the guild (whose role was mostly relegated to apprenticeship, its political power exercised indirectly, as membership was a condition for office election).

By the fifteenth century and increasing in the sixteenth century, the local Florentine market saw wide demand for elaborate and innovative luxury production, that was distinct from Bruges and Antwerp, where a market—publicly supported by state policy—resulted in a tendency to standardized and specialized popular religious artwork for serial production and a dealer-based export market:

> As production in volume became normal – in 16th-century Antwerp and Mechelen, 17th-century Holland and 17th-century Rome – institutions and mechanisms for the bulk marketing of images also developed, or were adapted for the purpose. These display an interesting variety of form as well as in the rules used to structure sales. In the case of Antwerp the city authorities played a central role, adapting to paintings and prints an older marketing institution – the display hall, used for textiles at fair times in Bruges.[53]

In Florence, a boosted luxury sector fed tiers of local consumption that relied little on importation. They regulated for quality, not efficiency. This kept the economy of Florence running for generations after its ostensible decline.

Although historians tend to see luxury consumption as cause and sign of economic decline in late-sixteenth-century Italy, Goldthwaite argues that the contraction was only relative.[54] He attributes this retreat to the gradual withering of the Spanish empire and the rise of Dutch and English world trade. He also emphasizes that Italian city-states were nevertheless carried forward by momentum, where manufacture and trade trajectories were even reversed, with Italy becoming an exporter of luxuries to regions, east and west—from which it was previously importing. The existence of public banking, characterized by smaller deposits and pawning transactions and spreading throughout Italy in the seventeenth century, signals that wealth was broadly distributed. Luxury consumption, architecture, furnishing, and very specifically

collecting, expanded significantly in the sixteenth century and into the seventeenth.

The characteristics of art as a collectible luxury object can be said to have been born in Renaissance Florence. Despite changes in its form, the social relations of its creation remain little changed.[55] The world of commodity production, however, grew and transformed until the logistics of its organization became the fabric of our modern life. For this reason, our next section will synthesize a key debate on whether capitalism commences in sixteenth-century Florence or eighteenth-century Britain.

The origins of capitalism in the sixteenth century: a debate

Goldthwaite characterizes the economy of Renaissance Florence as preindustrial capitalism, recognizing that the latter's full form emerged in England in the eighteenth century.[56] Production was not industrial, but a variation on the putting-out system, where workspace belonged to the workers, requiring no investment in plant facilities and less fixed capital. Nevertheless, he shows that Florentines relied on some features that would later structure capitalism. For example, partnership firms separated investors and managers by guild regulations, where the latter enjoyed exclusive access to raw material. The Florentine commercial and banking network elites, whose circles overlapped with producers or were one and the same individuals, provided raw materials and distributed the finished products internationally. But this integration of finance, manufacture, and distribution was more by way of diversifying investment than a form of capitalist accumulation driven by the logic of optimization:[57]

> These men were a far cry from those clothiers in England who forged backward linkages to supply by investing in sheep pastures and who abandoned the putting-out system to take direct control of production by buying fulling mills, spinning houses, and dyeing establishments and by assembling a labor force under their own roof.[58]

The Florentines played a part in what Raymond De Roover called the commercial revolution, which marked the beginning of mercantile, or commercial, capitalism and ended with the industrial revolution.[59] Foundational characteristics of capitalism were nevertheless extant, as Goldthwaite argues:

Already during the fifteenth century there were signs that the profit motive was uppermost in the minds of at least some of these urban capitalist entrepreneurs who invested in the agricultural sector—and the evidence might be more substantial if someone were to look for it.[60]

Firms were organized in partnership institutions, as evidenced by contracts, articles of incorporation, and accounting records; those though are distinct from our contemporary structure in that there was no common policy or trust law, and the intercontinental networks were not multinational in the contemporary sense. With no overseas industrial operations as the Dutch and the English would later establish, this structure nevertheless afforded the advantage of cooperation, planning, and flexibility of limited liability investment opportunities. But the reliance on opportunity for profit arbitrage is precisely the characteristic of the Renaissance economic mode that distinguishes it from mature capitalism.

Ellen Meiksins Wood draws a clear line between economies that are constituted on market *opportunity*, and capitalism, which is driven by market *imperative*. The historical specificity of capitalism is characterized by a drive to improve the productivity of labor, "the development of certain social property relations that generated market imperatives and capitalist 'laws of motion', which imposed themselves on production."[61]

If market imperative is defined by competition, accumulation, and maximization of profit in production, Florentine capitalism was characterized by a contrary logic of government regulating high standards for luxury production, negating any potential impulse to make production efficient for the goal of profit maximization (at the expense of quality). Wealth accumulation was sustained by monopoly, mercantilist price arbitrage, and other privileges supported by force, or war, but that nevertheless amounted to market opportunity, not market imperative, as Meiksins Wood explains:

> [T]he success of Florentine trade in its own manufactured commodities continued to depend on extra-economic factors, on monopoly privileges, or on especially sophisticated commercial and financial practices (double-entry book-keeping is supposed to have originated there), which facilitated a commerce in goods whose success in a luxury market in any case had less to do with cost-effective production than with the skills of craftsmanship. Not the least significant trait of the Florentine economy was that its greatest

commercial families, notably the Medici, moved into more lucrative non-productive enterprises, such as financial services for monarchs and popes, not to mention public office up to and including dynastic rule of the city-state itself.[62]

These enterprises drove technological innovations, but those were not part of a systematic push to lower the costs of production in order to prevail in price competition. Meiksins Wood sees the historical specificity of capitalism when

> both capital and labour are utterly dependent on the market for the most basic conditions of their own reproduction ... This market dependence gives the market an unprecedented role in capitalist societies, as not only a simple mechanism of exchange or distribution but the principal determinant and regulator of social reproduction.[63]

When the means of reproduction—for example, food—become market-dependent, that is when we have a fully formed capitalism.

The combination of typologies of relations of production makes it so that the economies of the capitalist centers are indeed driven by an imperative to lower cost of production and maximization of profit, but this cannot be fully understood in the confines of a nation-state that itself has risen from and always been part of a world system.

We find ourselves here with an opportunity to offer a synthesis of what has been a long debate among Marxist art historians regarding the origins of capitalism.[64] The question of the time, place, and cause of the rise of capitalism raises several methodological questions, a key being whether the appropriate level of analysis is the nation-state or world system.[65] Immanuel Wallerstein periodizes the origins of capitalism in the long sixteenth century, 1450–1640, because according to him, the relations of production that define a system are that of the whole system, and the whole system was that of the European world economy. Despite the fact that not all the nations and territories that participated, or were coerced into participating, in this economy were themselves capitalist systems, Wallerstein evinces how several economic modes concentrated in different zones of the world economy—slavery and "feudalism" in the periphery, sharecropping in the semiperiphery, and wage labor and self-employment in the core—were necessary components for a capitalist world system to rise. Different modes of production were organized according to the mode of labor control best suited for the particular

types of production. Without this it "would not have been possible to assure the kind of flow of the surplus which enabled the capitalist system to come into existence":[66]

> The emergence of an industrial sector was important, but what made this possible was the transformation of agricultural activity from feudal to capitalist forms. Not all these capitalist "forms" were based on "free" labor—only those in the core of the economy. But the motivations of landlord and laborer in the non-"free" sector were as capitalist as those in the core.[67]

Capitalism could expand by siphoning the surplus value not only of local production, but also because international value transfers from a less mechanized region—the importation of cheap wheat from eastern Europe, for example—subsidized the food consumption of English labor. In other words, English capitalism owns its success to a world system. Significantly, for these dynamics to have played out, the economy functioned on a world scale while the politics where cloistered within state borders. Free labor in one territory depended upon coerced labor elsewhere:

> Free labor is indeed a defining feature of capitalism, but not free labor throughout the productive enterprises. Free labor is the form of labor control used for skilled work in core countries whereas coerced labor is used for less skilled work in peripheral areas. The combination thereof is the essence of capitalism. When labor is everywhere free, we shall have socialism.[68]

Significantly, a capitalist world system "is based on the constant absorption of economic loss by political entities, while economic gain is distributed to 'private' hands … It has made possible the constant economic expansion of the world-system, albeit a very skewed distribution of its rewards."[69] This skewed distribution of reward is sustained by force and ideology.

The revolutions sparked by the Enlightenment promised to change this unity that advantaged the ruling class at the expense of the people, but key administrative, cultural, and economic characteristics carried forward, retaining inequality with which we are still plagued today. Throughout, the outward-facing collection is one orbit in which this uneven social contract is performed.

From city- to nation-state: collections and national identity

The bourgeois revolutions and regime transformations aimed to unlink the sovereign from unity with his domain, demanding a government that serves the people. The budgets of the royal and aristocratic courts were separated from that of the state:

> The first visible mark of the analogous [to the church] polarization of princely authority was the separation of the public budget from the territorial ruler's private holdings. The bureaucracy, the military (and to some extent also the administration of justice) became independent institutions of public authority separate from the progressively privatized sphere of the court.[70]

With the bourgeois revolutions, when collections became properties of nations, the people became the benefactors. Displays were organized to tell the triumph of egalitarianism. As governmental instruments, museums have been flagships of upholding this appearance while in reality they were aiding an essence of an economic order that continued to serve the few and exploit the many. In this way collections dragged their absolutist character into their republican future. Throughout the processes of industrialization and urbanization, museums served as mechanisms of popular indoctrination and mass coercion, becoming a site of the bourgeois public sphere.

Tracing the term "public" to its Greek origins, Jürgen Habermas locates the secular characteristic of the bourgeois public sphere in the transition from the city- to the nation-state:

> New form of representative publicness, whose source was the culture of the nobility of early capitalist northern Italy, emerged first in Florence and then in Paris and London. It demonstrated its vigor, however, in its assimilation of Bourgeois culture, whose early manifestation as humanism became a component of courtly life.[71]

Private became that which was excluded from the public domain of the state. By the eighteenth century the public sphere took on a political function when it became a vehicle of interest-group pressure that could affect policy change. It was a space where private citizens could come together and form a public in the sense of a citizenry acting in common. But the positive meaning of the term "private," to follow Habermas, arrived only when social relations were replaced by exchange relations:

With the expansion and liberation of this sphere of the market, commodity owners gained private autonomy; the positive meaning of "private" emerged precisely in reference to the concept of free power of control over property that functioned in capitalist fashion.[72]

Liberty, as a concept based on private property, is inherently only available for some, since the existence of private property was (and still is) based on relations of exploitation. Habermas shows how the role of the public sphere was to mask relations of domination:

> Finally, in the course of the accumulation of capital, the market became deformed into oligopolies, so that one could no longer count on an independent formation of prices—the emancipation of civil society from authoritarian state regulation did not lead to the insulation of the transactions between private people from the intrusion of power. Instead, new relationships of power, especially between owners and wage earners, were created within the forms of civil freedom of contract.[73]

This history of modernity is that of the difference between the promise of democracy and what it actually delivered. In it, the story of museums charts the explicit promise of these institutions to enact inclusion and uplift, yet reveals in the outcome an institution that has always served to keep the masses in their place, using the architecture, the display and other mechanisms of control as has been extensively demonstrated in the work of scholars such as Pierre Bourdieu, Carol Duncan, Tony Bennett, and others cited throughout this book.

Continuing the long Renaissance's use of collecting as a sovereign apparatus, modern elites and their representatives took charge of expanding this operation on a much larger scale, disseminating culture to the lower classes. If we observe the period before the Age of Enlightenment and the bourgeois revolution and what came after, not in terms of a break but rather continuity, we see a common thread in the interests of the bourgeoisie, the landed gentry, and the aristocracy. As Wallerstein clarifies,

> The process of the crystallization of class-consciousness of a bourgeoisie, thinking of itself as a universal class, drawing its members from all social ranks, has been illustrated in our discussions of the emergence of the gentry as a social category in Tudor England or the rise of the burghers in the northern Netherlands. One of the ways they

supported their claim to be a universal class was by the development of national sentiment, which gave a cultural veneer to their claim.[74]

Benedict Anderson referred to the solidification of national loyalties as that of "imagined communities."[75] It allowed for the identification of disparate social groups with a unified concept of nation, orchestrated by shared vernacular language, disseminated by print media to ensure the loyalty of middle and working classes. Art collecting, in both its private and public forms, played a role in this process. The museum institution is an example of how cultural hegemony was mobilized to convince lower classes that they shared in the class interests of the bourgeoisie, allowing the latter to lead and manage all aspects of civil society's connective tissue, in many ways to shape society's consciousness.[76]

Under the structure of the nation-state, museums were retooled to address the visitor as subject/citizen.[77] Andrew McClellan details the eighteenth-century expansion of collections to accommodate a broader public. I quote his concise and comprehensive summary at length, because it covers the period this chapter glosses:

> In the middle decades of the century, private and princely collections in Paris, Rome, Florence, London, Stockholm, Vienna, Dresden, Dusseldorf, Kassel, and elsewhere, opened to the public with varying degrees of liberality. Accessible and well-ordered collections, indicative in themselves of a ruler's taste and enlightenment, seemed all the more so when offered to his people as a means of public instruction. Patronage of museums and related institutions for the public good replaced ceremonial pomp and grandiose monuments as the Age of Absolutism gave way to the Age of Enlightenment. Responsibility for the collections was entrusted to the same class of advisors and dealers that had helped form them, giving rise to the prototype of the modern museum curator. Once opened to the public, royal collections came to be seen as national patrimony, stewardship of which became a measure of good government. These fundamental transitions, part and parcel of the evolution towards modern nationalism, occurred at different rates in different countries, but the crucial moment was undoubtedly the French Revolution and the creation of the Louvre as the paradigmatic public art museum.[78]

Collections were reoriented by a secular curatorial program to tell a narrative of progress, replacing religion with a contractual citizenship ritual, as Carol Duncan identified:

As a new kind of public ceremonial space, the Louvre not only redefined the political identity of its visitors, it also assigned new meanings to the objects it displayed, and qualified, obscured, or distorted old ones. Now presented as public property, they became the means through which a new relationship between the individual as citizen and the state as benefactor could be symbolically enacted.[79]

For example, didactic or genius ceilings assert genealogies that were also enacted through curatorial choices of chronology and display, positioning France as the natural heir to great cultural contributions. Commencing with ancient Egypt and continuing in the legacies of Greece, Rome, and the Renaissance, a compelling story, to which the nation and the visitor now belonged, was presented as an undisputable truth. I refer to this ritual as contractual because it will be instrumentalized toward the notion that museums hold collections in the public trust, and also to ask what type of contract with the public it is.

Nevertheless, as dramatic as it remains, marking the French Revolution as a fault line between the absolutist state and the republic can obscure significant continuities between the two forms of sovereignty. The Revolution caught the collection that was to become the Louvre in the process of being readied for public viewing.[80] Carol Duncan and Alan Wallach show how the paradigmatic revolutionary museum adopted the iconographic program of the public royal collections, which were, before the big change, already in the process of being externalized.[81] They show how the representation of the monarchical nation was transformed into that of the republican state by shifting the king's subjects into the new national citizenry and his patrimony into public ownership. Whether a subject was the subject of a royal regime or a secular republic, its role remained the same: to facilitate the wealth of the ruling class and to legitimize the ceremony of governance as an observer.

The museum: an instrument of social control

Museums were in many ways transformed into educational institutions of refinement, with a goal of teaching working class citizenry how to behave like the middle class. While, for example, the British parliament debated the museum's role in preserving art for posterity or displaying it for the enjoyment of the working class, the consequent boost to national identification was explicitly geared to maintain a stratified economic order. In the nineteenth century, Prime Minister and champion of the National Gallery, London, Sir Robert Peel, argued

that its purpose was "to cement the bonds of union between the richer and poorer orders of the state."[82] Culture could serve to mask economic injustice, by providing luxury for temporary enjoyment and indoctrination to the urbanizing masses.

Historically, and in the present, whether privately or state-funded, the reality of museums is that they continue to sustain class stratification. As Tony Bennett evidences in a detailed history, the major shift from exclusion to inclusion accompanied the development of social management theories. The liberal governance system instrumentalized the museum as a machine of "rational recreation," posed as the moral alternative to salacious outlets such as drinking or fornication. As "passionless reformers," they were designed to induce self-regulation by directed propaganda and indirect means, such as architectural manipulation.[83] One stark example Bennett gives is the use of upper-floor mezzanines, from which visitors could overlook the main hall. Sensing the gaze from above, entering audiences would internalize the sense of surveillance and, presumably, self-police their own behavior. But the goal of reform was never complete, because museums continued to maintain class distinction:

> Or perhaps it would be better to say that the museum is neither simply a homogenizing nor simply a differentiating institution: its social functioning, rather, is defined by the contradictory pulls between these two tendencies. Yet, however imperfectly it may have been realized in practice, the conception of the museum as an institution in which the working classes – provided they dressed nicely and curbed any tendency towards unseemly conduct – might be exposed to the improving influence of the middle classes was crucial to its construction as a new kind of social space.[84]

Presented as a gift, polite recreation was designated to satisfy the soul and calm potential social unrest. Andrew McClellan summarizes that "socially conscious museums, supported by the state and the rich, would do their share to avoid anarchy and promote the gradual assimilation of the working classes into the bourgeoisie."[85] This demonstrates the agenda shared between the monarchical and the republican state forms to ensure the domination over the working class.

McClellan maps the nineteenth-century distribution of approaches to museum philosophy and administration between the elitist and the populist, between the contemplative fine-arts exhibition and the functionalist arts-and-crafts model that was geared toward educational

emphasis. The latter, epitomized in the South Kensington (later Victoria and Albert) Museum, was a primary influence on the initial development of museums in New York and Boston, suiting, as McClellan shows, the frame of mind advanced by the captains of industry. The shift to the fine arts in some institutions would come early in the twentieth century, as did a growing commitment to public education. Ultimately, "most art museums from the 1920s pursued a middle course between the two philosophies, blending appreciation and history in their educational programs."[86] The combination of the two roles resulted in a perfect outcome: an institution that could serve the ideological purpose of coercing the masses, while supporting the aesthetic proclivities of the wealthy and the ruling classes, which often where one and the same. Here, again, we focus our attention on continuity rather than a break between, as McClellan says, the state and the rich, and also between American institutions and their European forebears.

While, generally speaking, the European nation-state made more concessions to the citizenry, the U.S. was founded on the idea of the small government where a business-driven agenda was a key factor in shaping the nation's administrative orientation. Despite these differences, both forms of state shared the goal of controlling the populace for the purpose of facilitating capitalist economies, which, although different types of capitalist economies, nevertheless display similar dynamics between the state, the population, and the development of civil society. While European institutions are, or were, mostly (but not exclusively) government-funded, American institutions are privately funded through vehicles established by government charters. In both, the museum is one instrument for the formation of a civil society, an example from a broader set of cultural institutions ranging from the free press to public parks, and everything in between. The American difference was that the state delegated its administration to a third sector, funded by charitable giving and administered by a tax-relief system. Consequently, civil society in the U.S. was, and still is, administered with less oversight despite the fact that it does assume responsibilities and provides service for state-like functions.

The United States: private philanthropy and public collections

In 1890 Bernard Berenson, influential scholar and consultant to collectors such as Isabella Stewart Gardner and later to the dealer Joseph Duveen, wrote in a private letter to Mary Costello: "[I]n the last thousand

years whenever art has had its day, it has owed it to a merchant aristocracy—the very utmost opposite therefore of a democracy."[87] Duveen himself was a shrewd businessman that recognized this power of museums to secure and raise the value of art, advising his American clients to donate their collections to public institutions: "Duveen was the first to see that by persuading his clients to leave their possessions to public galleries, he ensured the safety of his own market against future shocks."[88] The role of art as an investment asset was stabilized by the power of the public institution, akin to the way that the confidence in the state stabilizes currency. Donations were facilitated by tax law, which established the undergirding logic of art's public status, through its connection to the very heart of the state funding structure. As former Louvre Director Germaine Bazin observed already in the mid-1960s:

> For a number of years a donor could make an official gift of works of art, keeping the treasures in his possession until death while still taking advantage of tax exemptions but this is no longer true. The system is held responsible by many for the inflation in prices of works of art. Dealers, collectors and curators are to a certain extent responsible for the constant rise in prices because the assessment of the value of a gift has such bearing on a donor's decision to present it. When a Rembrandt jumps from $100,000.00—a fairly normal price for paintings by this master—to $2,300,000.00 (in 1961 for Aristotle Contemplating the Bust of Homer), all American collectors owning his works suddenly found themselves in a position to realize considerable tax relief by either selling or giving their art away.[89]

The impact of the American system of philanthropy on an international market for art renders for us the extent to which a system of governance establishes and stabilizes an economy of value, which, in the name of giving to the public, serves to enhance the concentration of resources in a few hands, all the while obtaining ideological control, and also ensuring mass identification with the status quo. The assumption that success in business can be translated to political economy has resulted in allowing the wealthy to consult, or even govern, in the name of the citizenry. In this way the philanthropic system was a conduit for unelected officials to oversee what were in other countries governmental functions, allowing them to bend the public system to serve their private needs.[90] In museums, gratitude for receiving the artwork for public viewing obfuscated the disproportionate gain for the benefactor. John Pierpont Morgan, for example, brought his business acumen to museum

leadership and gained from it significantly. He clearly used public institutions, primarily the Victoria and Albert Museum and the Metropolitan Museum in New York (where from 1871 to 1913 he served as a founding trustee, vice president of the board, and, from 1904, president), to enhance the monetary value of his collections. Flaminia Gennari-Santori tells us:

> Starting in 1901, he placed thousands of objects on loan to the V&A, an arrangement that greatly enhanced the value of his collection.
> ...
> Dozens of "experts," including art dealers, museum curators, and art historians scattered around Europe, were personally invested in this adventure and benefited in different ways from Morgan's patronage.[91]

It is precisely because the Victoria and Albert Museum had a Loan Committee which rigorously examined potential loans and validated the collectability of these objects that Morgan manipulated it into being a clearing house for his own needs:

> By 1902 Morgan's objects were pouring in by the hundreds, usually sent directly to the museum by dealers. Some members of the Loan Committee voiced their discomfort with the quantity – and often the quality – of Morgan's objects. One in particular, a Mr Crames, repeatedly argued for a more selective approach since the display of objects in the museum greatly increased their value. In 1905, the suspicions held by the Committee from the beginning were confirmed. Morgan was sending to the museum objects he had not yet purchased and would only acquire them if they were approved.[92]

Not only did the proclivities of an individual (or his dealers) enter into the mix that determined how a public collection was shaped, the feedback loop, where museum inclusion enhances market value, benefited him directly. Moreover, it is not just that tax code influenced his decision-making, he was one of the forces that actively shaped it. Morgan kept his collections in London, moving them to the U.S. only when the art importation tariffs were repealed in 1909, a legal process to which he actively contributed.[93]

Between the end of the Civil War and the turn of the twentieth century the U.S. developed from a colonial economy to an industrial empire in dazzling speed. The expansion was widely supported by a legal system

that favored business. The few that came to be known by the moniker "robber barons" enjoyed land grants, low-interest loans, and exploitative labor law that allowed them to grow their businesses to colossal scale and make excessive amounts of money. American wealth bought European art voraciously, and changed the market in the process.[94] Assisted, or at times manipulated, by intermediaries such as Berenson or Duveen, collecting helped these men cast themselves as Renaissance princes:

> Bernard Berenson and his colleagues in turn-of-the-century Florence saw how Italian Renaissance culture—its secularism, its self-consciousness, its business sense and innovations in scholarship, its ideas of collecting, display, and magnificence—anticipated, suggested, and influenced our own. By the end of Berenson's career, it had become common for people concerned with the making and preserving and consuming of culture to think of their ideas as, in some special way, related to the view of life expressed by the men and women of the Italian Renaissance.[95]

Although he opposed Berenson's opportunist mixing of scholarship and art dealing, legendary museum studies professor and Berenson mentee Paul Sachs continued to teach his students at Harvard the donor etiquette he himself practiced. Nevertheless, historical amnesia set in when it served him to glorify his philanthropists by comparing them with an imaginary version of the Medici. Writing to accept an offer by Rockefeller to serve on the art and architecture board of the eponymous Center, Sachs complements his patron:

> I look upon this undertaking as one of public importance, and also because it gives me the opportunity that I welcome, to in some small way indicate to you my deepest appreciation and my gratitude for all that you have done in such a princely fashion for the development of [the Fogg Art Museum].[96]

Like sixteenth-century Florence, the civic space whose primary purpose is to benefit the prince was presented as a gift to the people. And like Ducal Florence, it was not democratic.

American philanthropy and the state

Initially, most American civic life and social welfare was conducted through small-scale associations. Then, as small government made way

for big business, the American so-called captains of industry applied the organization logic to their state-replacing activities. A culture of gratitude served the assumption that the weak state was a natural order, or at least the best type of order available, and that it would function well with a third sector that would pick up those services not provided by the narrow system of governance.

Andrew Carnegie brought the scientific analysis of business efficiency to facilitate wholesale rationalized giving for the purpose of reforming society:

> It drew on the intellectual and business experience of the great capitalists, who had after all made their fortunes by innovating organizational strategies (especially the vertical integration of related extractive and manufacturing industries) and by employing the intellectual resources of the second scientific revolution (which was being so successfully managed by the emerging system of research universities). The insight was that these new techniques could be deployed to solve social, economic and medical problems just as effectively as they had served Standard Oil or United States Steel.[97]

The framework advanced by Carnegie in his infamous 1889 essay "Wealth" (known later as "The Gospel of Wealth") argued that surplus is better handled by the capitalist philanthropist rather than redistributed to benefit the worker.[98] The irony was that, while underpaying his workers, Carnegie invested huge sums of money to study the causes and solutions to the poverty for which he was in part responsible.

While the goal of the robber barons was to appear nongovernmental, their actions were much more so than they would have liked to believe:

> The early philanthropists feared the state, and worried especially that the state in America would move in the direction of European welfare states of the late nineteenth and early twentieth centuries. The answer was for individuals to take up the responsibility that Europeans assigned to the states, and to retain the wellsprings of reform in the private sector [Karl and Katz (1981)]. Times have changed and government in America has grown, but the significant emphasis of the conservative movement of the last generation in American politics shows just how tied the rhetoric of American philanthropy is to state-replacing activities. I doubt most American philanthropists are self-consciously state-replacers in any explicit sense, but their instinct to imagine and support the non-profit engines of

human betterment derive from the original Carnegie–Rockefeller tradition.[99]

Foundations were developed as a key administrative tool by which the American orientation toward small government orchestrates civil society. Their status as public or private was reactively defined by the outcome of the legal process.

Early corporations were considered public, becoming private through both legislation and common law in the eighteenth century. As Peter Dobkins Hall clarifies, "[N]o private corporation as we understand the term today existed in America before the 1780s."[100] Charitable institutions were ruled to have private status by the 1819 Dartmouth versus Woodward case, discussed in the previous chapter:

> The court, in ruling that a corporation was a private contract and hence protected by the contracts clause of the United States Constitution, gave assurance to donors that the institutions they founded and supported would be safe from government interference. Later, in the Girard Will Case, the Court would affirm the legal basis for private philanthropy, even in states such as Pennsylvania, which had annulled British charities' statutes.[101]

As opposed to the early European forms of charity, where social problems were relieved by temporary amelioration through giving rather than structural change, the goal of American philanthropy was to address the causes at their root. Obviously though, no matter how much money was poured into scholarship and reform, the social ills that philanthropy intended to address did not get fixed. This is because of the simple fact that poverty was, and still is, rooted in the capitalist imperative to extract surplus from labor. Handling welfare allows philanthropists greater control over the treatment of the working classes and cost of labor. Nevertheless, the U.S. government and state welfare expanded, commencing in the aftermath of World War I with Franklin Roosevelt's legislation through the Great Depression, the funding requirements of World War II, and Lyndon Johnson's Great Society policies. The nonprofit sector was also expanding.[102] Its entanglement with government was far more substantial than either sector readily admitted. When the government set up public health, science, humanities, and art agencies, although they were not legally similar to foundations, they appropriated planning strategies and granting procedures from foundations:

Two points are worth noting. First, much of the thinking behind Roosevelt's New Deal was heavily influenced by philanthropically funded research; the foundations, in other words, helped ease the federal government into their realm [Critchlow (1985)]. Second, New Deal activism, at least, actually encouraged philanthropy both because its very progressive tax rates encouraged charitable contributions, and because government policy depended for its implementation on the private infrastructure that philanthropy succored and in part constituted.[103]

This deep imbrication is reason enough to consider the third sector to be a public entity, in the sense that it should not be subject to private control or benefit private individuals.

In his critique of the big three, namely Ford, Carnegie, and Rockefeller, Inderjeet Parmar refutes the four fictions characterizing their self-perpetuating myth. Although these foundations narrate themselves as nonstate, nonpolitical, nonbusiness, and nonideological (scientific), they in fact mirror the governmental mindset of their founders, their personal connections to government officials and political parties, reflecting their corporate interests and the ideology of liberal American internationalism. They enact their own agenda, not the will or the interest of the public. It was the power of the purse that gave, and gives, credibility to their claim to serve the public. Parmar demonstrates in depth the "numerous and significant overlaps in outlook and interests between the state and elite sectors of society."[104] He synthesizes the work of several political scientists who come from a variety of methodological approaches but nevertheless all agree that the distinction between the state and civil society is conceptually and legally blurry.

When the interests of a few wealthy individuals are cast with that of the state we have a compounding problem. It allows unelected and unaccountable persons to act only according to their class interests, as the lack of any checks and balances prevents them from ever considering a dissenting point of view. Worse, it gives private individuals the ability and license to have power on governmental scale.

Parmar gives us a glimpse into the machinations of secretive boardrooms, where networks of private persons are put in charge of decisions affecting the policies and concrete directions on matters ranging from civil society to global politics:

> The network concept encompasses, combines, and synthesizes "public" and "private" domains, "society" and "state". The network is an

alloy—neither entirely private nor public but a complex mixture, a hybrid form that may be peculiar to societies featuring a "weak" state.[105]

The system, as Antonio Gramsci has theorized, is built on the assumption that elite class interests serve the entire population. This special-interest network overlapped with museum trustees:

> The original leadership of the Carnegie Endowment for International Peace [CEIP] was drawn from a narrow East Coast elite, with twenty-seven of its twenty-eight trustees having been born before the Civil War. According to its third president, Alger Hiss, the endowment had changed little fundamentally almost forty years later, when he took office. The CEIP's trustees were "interlocked," he claimed, with the charitable bodies, the New York public library, the Metropolitan Museum, the Metropolitan Opera, and the Rockefeller Foundation. It was through such interlocking that the attitudes of a small section of the United States predominated culturally and otherwise.[106]

Step by step Parmar unpacks the ways in which funding by foundations guided the scholarship, aesthetics, and social programs of the civic institutions they had funded, showing how reformist outcomes have been directed to serving the status quo and tempering demands of social movements.[107]

This is evident enough in the museum institution throughout, where a middle class of administrators and artworkers believe that the institution serves everyone's best interest. In contrast, the museum is the very site where the middle classes work for the rich, concealing the ways in which wealth has been made at the expense of the working poor. What museums and the big foundations sell as a decoy is the belief that the poor will also ultimately be raised. We need to nevertheless remember that for the wealthy to get wealthier they need a reserve army of cheap labor, so equality runs against their class interest. What they are really working towards is maintaining social stability despite class difference.

Philanthropy claims to support pluralism, arguing that it facilitates the existence of competing entities.[108] But the result is not actual pluralism. The logic of competition that derives from a capitalist conception of business is detrimental to diversity and the well-being of civil society. As Mark Dowie has shown,

The foundations, bound by their charters and the law of trusts to honor and preserve the values and interests of, usually, one man or woman, are of necessity not democratic institutions. The early founders knew, too, though they rarely acknowledged it, that their philanthropy was a privilege that could exist only in an environment market by economic inequity and social hierarchy. That is still true. The power to accumulate such wealth and distribute it as they choose would not long survive in a truly democratic society.[109]

If the big foundations are indeed as close to government as they are, but do not themselves facilitate democratic use of their funds, then we must work to replace them.

There are of course nuanced differences between local, small-scale, and grassroots organizations that are part of the American nonprofit system, and the big powerful foundations. However, two caveats instruct us to why the faults of the system are significantly more substantial than its benefits. First, the same system that supports social- and justice-oriented grassroots organization also sustains right-wing organizations with sinister motives.[110] Secondly, the museums examined in this book, and many other smaller museums, are ultimately governed by the same interest group as that of the big foundations. The MoMA's connection to the Rockefeller family is a case in point.

The New York Museum of Modern Art

Founded by three women, including Abby Rockefeller, the Rockefeller influence on the museum extended through the deep involvement of her sons, Nelson and David Rockefeller, who chaired the MoMA board at various stages and referred to the MoMA as "mother's museum."[111] Other Rockefeller family members served the MoMA in various capacities over the years as well, but the Rockefeller brothers, especially known for an autocratic control of their foundations, turned the institution into a tool of power that made its description as "soft" seem mild.[112]

Much of the museum world was plugged into this network in several ways. Paul Sachs, as Sally Anne Duncan tells us, being a major conduit of power:

> The Rockefeller Foundation and the Carnegie Corporation started as private fiefdoms and became mighty corporate givers. National

foundation administrators (especially the Carnegie's Frederick Keppel) were given broad unincumbered powers to expend vast sums. Foundations funded national art-related associations and university programs with a particular concern for supporting leadership. They subsidized organizations such as the Association of American Museums, the College Art Association, and the American Federation of the Arts. Another avenue to leadership was the underwriting of graduate training in museum work and academic art history through which a new generation of intellectual leaders emerged.

...

Through his activity on the Carnegie Foundation's Executive Committee of the Arts Group, Sachs ensured that his students were able to receive scholarships for study and travel in record numbers.[113]

The coercion of the museum world into identification with the financial elite was guaranteed from the college classroom. But museum leadership was also part of a networked cadre of influence that spread far beyond the purview of business or philanthropy. As Parmar underscores, "[W]e can see reasonably strong specific shared experiences and interconnections between private foundations, an elite think tank [Council on Foreign Relations], and the federal government's foreign policy apparatus."[114] This foreign policy apparatus included overt and covert modes of influence, the MoMA being one node in this matrix of links. As Eva Cockcroft shows, personnel groomed at Rockefeller-controlled foundations and agencies—like René d'Harnoncourt, MoMA director 1949–67, or Porter A. McCray who held various positions until he became the head of MoMA's international program—previously worked at Nelson's Office of Inter-American Affairs:

> Primarily, the MOMA became a minor contractor, fulfilling 38 contracts for cultural materials totaling $1,590,234 for the Library of Congress, the Office of War Information, and especially Nelson Rockefeller's Office of the Coordinator of Inter-American Affairs Office, 'mother's museum' put together 19 exhibitions of contemporary American painting which were shipped around Latin America, an area in which Nelson Rockefeller has developed his most lucrative investments—e.g. Creole Petroleum, a subsidiary of Standard Oil of New Jersey, and the single most important economic interest in oil-rich Venezuela.[115]

Art, monies, and personnel acted as conduits between governmental foreign policy and diplomacy. The MoMA's international program sent

exhibitions abroad, acting, as Cockcroft identifies, in "quasi-official" capacity, sometimes in venues where it was the only privately funded representative among government-sponsored exhibitors. At home in the U.S. this was a way to circumvent McCarthy-era censorship, reiterating the belief in free-market liberalism as the means to facilitate artistic and social freedom. In effect, governmental and third-sector nongovernmental agencies were used as propaganda for American economic imperialism, opening countries for extractive practices and exchange markets, where the gains were privately reaped. The ostensibly apolitical work representing high-modernist individualism was instrumentalized to promote an image of American freedom for the purpose of opening markets, from petroleum to business, for private accumulation. Art played a major role in sustaining the belief that this apparatus was benign.

MoMA and the private/public ambiguity

The MoMA is a quintessential example of the hybrid private/public municipal museum. Boosted by the city's wealthy to draw local visitors and tourists, it is at once an educational institution and a cultural economic engine. Chartered by the Regents of the University of New York, which represents its contract with the government to perform service for the public and to which it is legally obligated, its educational goal is inherent to its reason of being and included in its mission statement. Naming the original incorporated trustees, and including unnamed associates and successors, the charter obliges the institution to fulfill "the purpose of encouraging and developing the study of modern arts and the application of such arts to manufacture and practical life, and furnishing popular instruction, under the corporate name of The Museum of Modern Art ..."[116] As evidenced in meeting minutes held at the MoMA archives, in forums of personnel and trustees, when issues such as expansion, collecting policy, museum structure, and exhibition content were debated, the core mission stated in the charter was the guiding principle against which decisions were measured. Over the course of its early years, the museum's goals and purpose as an education institution were consistently reaffirmed. Yet, so did its tendency to maintain the political status quo, despite its explicit commitment to a culture of avant-garde.

This is the constituting paradox of the MoMA. On the one hand, as Carol Duncan writes, "their most successful efforts to increase attendance were aimed at the middle classes, the natural social and

political allies of the WASP elite."[117] Yet, on the other, as Claire Bishop states, "it is well known that the Museum of Modern Art in New York regularly rehangs its permanent collection on the basis of its trustees' latest acquisitions."[118] Much like with the Medici, the general assumption is that what is good for the trustees is good for the public. The problem is that despite its pre-Enlightenment philosophy, this assumption is nevertheless still embedded in the law:

> A charitable trust serves two masters – the property owner who created it and society which is its beneficiary. On the initial assumption that the interests of each coincide, the law guarantees the trust enforcement, perpetual existence and tax immunity.[119]

Our difficulty is that this is passed as an axiomatic truth that habitually goes unchallenged in museum operations and programming. Yet it is pure ideology. It naturalizes the museum's ability to pull its public and private dimensions in and out of focus, such that the institution is presented as public when it suits the agenda of its governing body (trustees) and administration (personnel), but private when arrangements result in private benefits that need to be obscured. Carol Duncan underscores how the ambivalent status of these institutions allows them to use public funds:

> The men who built and backed them took care to make their art museums demonstrably public. They almost always built them on public land and usually with at least some public money, a circumstance that gave substance to their claim that museums belong unequivocally to the public realm. At the same time, however, the management of museums together with the ownership of their collections usually remained firmly in the hands of autonomous, self-perpetuating boards of trustees.[120]

Duncan is right to describe the ambiguous status of museums, but is wrong to claim that the boards actually own the work. The question of ownership may be philosophical but it definitely becomes pragmatic when it comes to questions of deaccessioning. Under the American museum model, ownership status is as ambiguous as the distinction between what is private and what is public in its administrative structure, but still, this doesn't mean that the trustees own the art. Yet, even James N. Wood, former director of the Art Institute of Chicago and the Getty Trust, has understood that the collection is trustee-owned:

The American art museum must define and exercise its authority with particular care. In one sense it holds and conserves its collections in trust for future generations, but in many of our museums the trustees have ultimate ownership of these collections, while building and the land on which they rest are owned by municipal authorities. While this situation, in clear distinction to the state ownership of almost all European museum collections, has given the American museum flexibility and independence, particularly in such areas as hiring, acquisition, and deaccessioning, it ultimately puts an added pressure and responsibility on the institution to assure that in exercising this independence it does not undermine the public trust.[121]

MoMA bylaws state that the trustees are bound to hold, control, and manage the property of the corporation: "The property of the Corporation shall be held and controlled and its affairs shall be managed by a Board of Trustees consisting of thirty members."[122] Holding is distinct from owning. If we are to ask on behalf of whom the trustees are holding the art, the question would be, "Who is the beneficiary of the corporation?" Such a question was asked indirectly to another institution when the Detroit Institute of Art (DIA) collection was in danger of being used to pay the city's bankruptcy bill.[123] Since the threat to the DIA collection was resolved by the Grand Bargain, the opportunity to settle such a key question in court did not arise. Nevertheless, as Maureen Collins clarifies, "As the trustee, the City is obligated to administer the trust according to its purposes and for the benefit of its intended beneficiaries. While the trustee may hold the legal interest or title in the assets, the equitable title rests with the beneficiary."[124] Holding, it seems, implies a different set of responsibilities and obligations than ownership. If we ask what holding implies, we are asking what it means to hold a collection in public trust.

What is the "Public Trust"?

The 2001 publication *Whose Muse? The Art Museum and the Public Trust* anthologizes approaches by top American directors, most of whom see it as the trust of the public in museum authority, judgment, scholarship, stewardship, and development of the common collections.[125] Although emphases vary, the general agreement is that, at its base, the role of the museum is to collect, preserve, and display the world's treasures. Yet, most directors acknowledge the term "public trust" has no

teeth, so to speak. As MoMA director Glenn D. Lowry explains, "In many ways it is up to individual art museums to establish a relationship with the public—or at least those segments of the public interested in their activities—and then to act in a way that is consistent with their understanding of the museum."[126] In a single article Lowry is making the contradictory claim that museums are public or civic spaces, and at the same time he affirms that they are devoted to presenting the ideas of their private founders.[127] He is easily able to sustain this contradiction because this is how the museum has been administratively structured. To see this function within one system we look at how law professor Jennifer Anglim Kreder explains that "despite use of the term 'public trust' in recent litigation, in the museum context it amounts to an ethical ideal, not a legal standard."[128] In other words, the tool by which the public could be a stakeholder at the museum decisions table has not much more than honorary capacity.

Let us then separate the two audiences with which we began this chapter—the two masters also served by the modern charitable trust—to ask of the museum, "Who is your beneficiary?" Kreder looks at deaccessioning and provenance cases, establishing that "'public trust' likely meant, as understood by the Founding Fathers, an entrustment of confidence and reliance for a public or community interest."[129] It appears at the end of Article VI of the U.S. Constitution—Debts, Supremacy, Oaths, Religious Tests—in the phrase, "no religious Test shall ever be required as a Qualification to any Office or public Trust under the United States." Dormant for centuries in many respects, the term has only been developed in three areas of law: "(1) environmental regulations; (2) tax law (specifically charitable trusts, non-profit theory and tax exemptions); and (3) museum law."[130]

The fiduciary obligation of public officials was articulated by John Locke, whose theory of the state characterized the government as the holder of a trust and the people as its beneficiaries. For Locke, private property was key to social organization: "The reason why men enter into society, is the preservation of their property; and the end why they chuse [sic] and authorize a legislative is, that there may be laws made ... as guards and fences to the properties of all the members of the society."[131] Indeed, the grounding of freedom in private property remains a bedrock of the liberal organization of society. But when tax money on a governmental scale crosses the divide between private and public, much is at stake such that its status and autonomy need to be questioned. The status of foregone tax money or philanthropic donations such as artwork reveals much about who this structure is set to serve.

Congress enacted the first federal income tax statute and with it a tax-exemptions for nonprofit organizations in 1894, which was then deemed unconstitutional, but ratified with the Sixteenth Amendment in 1913:

> The floor debate over the Act "leaves no doubt that Congress deemed the specified organizations entitled to tax benefits because they served desirable public purposes."
>
> ...
>
> In doing so, it has continually reaffirmed the view that charitable deductions are "based upon the theory that the Government is compensated for the loss of revenue by its relief from financial burdens which would otherwise have to be met by appropriations from other public funds..."[132]

For Kreder, the above is supported by the precedent set when "American courts established that a charity fundamentally was an entity that helped the general public by serving a public interest to lessen the burden of government."[133] Theoretically, this suggests that we can hold any tax-exempt charitable organization to public accountability, but in effect it does not. It nevertheless opens for us a horizon to a definition of the term "public" whose administrative or financial structure is societal in its orientation, but not necessarily governmental in its administration, although such structures are yet to be imagined. How to actually put this to work is a very broad question; it calls for a separate interdisciplinary discussion between professionals and scholars. For the time being, we observe the limits of the term "public trust" in protecting the interests of the museum public.

In museums and museum law, "'public trust for the public benefit' is a nebulous concept, and is not to be confused with the duty of a trustee bound by a trust instrument":[134]

> It appears to be a theoretical mix of the undefined understanding that museums ought to use museum resources for public benefit; the duties placed upon museum directors by their non-profit status, corporate charter, or charitable trust document; fiduciary duties; and donor expectations.[135]

Most arts organizations have ethical and/or standards guidelines, with many citing an obligation to the public trust. For example,

> The regulations of the New York Board of Regents, the authority in charge of supervising New York museums, give the concept a limited

definition. The regulations state that the "public trust" refers to the responsibility of museums to "carry out activities and hold their assets in trust for the public benefit. 8 NYCRR § 3.27(a)(18) (2013)"[136]

But such guidelines lack precision and therefore a definition that can guide museum administration at the moment. The American alliance for Museums also agrees that "it is hard to say exactly what a museum should do" to meet the standards that relate to 'public trust and accountability.'"[137] Nevertheless,

> While the exact scope and meaning of the "public trust for the public benefit" are hard to pin down, the museum's general obligation to act in the public's interest is not. A museum's responsibility toward the public derives from their status as charitable institutions, which can take the form of either a not-for-profit corporation or a charitable trust.[138]

Although the question of what is meant by acting in the public trust still remains open, if we are clear about the interest of the public, we would definitely distinguish it from the trustee and patron body. Built on precedent, the peculiar logic of the law confines its process of change to reaction. As the artist and lawyer Shevaun Wright explains,

> The law progresses in "streams"—so it builds and builds upon itself—sometimes it borrows from other streams, for example, when looking at definitions, but generally it confines itself to precedents from within its own stream. So, for museums, that would be precedents pertaining to museum law. When Keder concludes that the term "public trust" currently has no teeth, she does so because of the nebulous nature of the beneficiaries of the trust. So while the property and goods are held on trust for the public, it would be difficult for a member of the public to sue the board holding that property because they are part of a quite diffuse membership.[139]

It is precisely on this diffuse membership that museums play when they operate as both public and private. Given that the museum has several publics, and that there exist contradictions in their varying interests, it is highly likely that what would be good for one public will in fact come at the expense of the other. For this reason, we must now ask, "Who is the public?"

My approach follows Jodi Dean's notion of "the rest of us," which proposes a definition of the people as the entity opposed to the proverbial "1%."[140] In this sense my definition of the public tends to be abstract and philosophical rather than empirical. While it seems organic to say that the museum public is its repeat and occasional visitors, I follow Paul Dimaggio and Francie Ostrower and ask, "How are individuals and groups that do not visit museums not also the museum's public?" In the U.S. context there is a long history of people shunned, excluded, misrepresented, or exploited by institutions—a public that might visit museums now if they changed their collecting and programming practices.[141] To speak of the public only in terms of who has already visited the museum perpetuates exclusion. In other words, we might speak not only of who is the public, but who the public *should* be.

Kreder asserts that "the 'public' is generally the community in which the museum is located."[142] But this is not true for museums that are tourist destinations drawing national and international publics, or for museums in gentrifying communities that are imposing an audience upon the communities they invade. Museum board members do not necessarily live in proximity to the museum's locations, especially in cases of downtown urban museums whose trustee and officer population inhabit wealthy residential neighborhoods. Museums today have come very far from their domestic origins treated in the beginning of this chapter.

Kreder proposes a definition for future litigation, legal analysis, and scholarship:

> "Public Trust" can be defined as "any entity given special privilege by the government, beyond the simple grant of a state corporate charter often coupled with state or federal tax waivers, so long as that entity is legally obligated to engage in conduct that could traditionally have been performed by the government itself for the public's benefit."[143]

It could therefore be concluded that any attempts by trustees to influence the museum's programming, collections, or content in effect violates the public trust. For this contradiction to be resolved we must ask again what it means that the MoMA is private.

What does it mean that the MoMA is private?

In a letter dated June 19, 1935, and addressed to Mr. Mabry, the museum's executive secretary, the lawyer John Lane responds to the

latter's question, "What must be done to transform the Museum of Modern Art into a 'public institution?'"[144] Lane proposes a goal-oriented approach. His response sheds light on the lack of definition:

> Federal funds under recent appropriations may be given to 'public institutions', but the law is not definite as to what this means. Officials themselves give no definite answer to such a question and I gather that when a project is presented to them they decide whether it represents a public purpose.[145]

Going on to discuss the finances of New York City, or the likelihood to obtain funds toward a building, Lane's definition of the public continues under the presumption that the purpose of becoming public is to obtain of access to tax-based funds, embodying the desire to make the museum public for the benefit of the elite who runs it. Addressing the trustees at the opening of the building in 1939, Paul Sachs echoed this sentiment and made no attempt to hide it: "The Museum of Modern Art has a duty to the great public. But in serving an elite it will reach, better than in any other way, the great general public by means of work done to meet the most exacting standards of an elite."[146] We know that this ethos broadly underlies not only the American approach: it represents the assumptions of liberalism in general.

Sachs is largely responsible for the education of museum leadership in the United States spanning the early years of MoMA's founding.[147] His work formed one of the major conduits of philanthropic distribution through cultural interpretation and preservation. Naturally, the ideological dispositions he relayed to his students could only remain within a permissible boundary, as they were never set up to be radical or undermine the status quo. As Sally Anne Duncan tells us,

> In the conservative atmosphere of the Fogg's fine arts department, little was said about Europe's revolutionary social movements or Roosevelt's domestic reforms. The faculty remained aloof in their studies of the safely distant past and the museum staff occupied itself with the connoisseurship and the conservation of objects.[148]

Alfred Barr, founding director of the MoMA and premier architect of its collection, was a student and close associate of Sachs. When Milton Brown, a rare Marxist amongst Sachs's students, asked to meet with Barr, the latter ignored his request.[149]

Barr's famous theory of collecting was centered on the scheme of a forward-moving torpedo: "[I]ts nose the ever advancing present, its tail the ever receding past of fifty to a hundred years ago,"[150] where the new is supported by a canon of modernist masterworks, and the propellers are the "background" collection of historical and non-Western work relevant to the contemporaneous practice for educational purposes.[151] This was reflected in the mechanics of collecting and its ideological consequences at the MoMA.

Originally, the idea was to amass a "permanent" collection whose actual holdings were nevertheless fluid:[152]

> In speaking of the collection's permanence the word "comparative" must be used. A really permanent collection in the Museum of Modern Art would be impossible. Therefore, recognizing that time passes and the modern must cease to be modern, the Trustees have considered the Museum's collection to be continuous but gradually changing in content—with "somewhat the same permanence a river has." This metabolic process is also of special value because it makes sure that the collection will not be simply a cumulative repository, but will serve as a testing ground for works of art which over a period of several decades will be given a chance to prove their claim to lasting value. Eventually, those that survive this test may pass on to the Metropolitan Museum or some other permanent collection of historic art.[153]

The concept initially led to a relationship between the MoMA and the Metropolitan Museum, similar to that of the Musée du Luxembourg and the Louvre, where contemporaneous works of art would be passed on (or sold in the U.S. case) by the avant-garde institution to its encyclopedic sibling. Yet, the concept has ultimately short-lived because of art's asset status and institutional constraints. As Bruce Altshuler shows, although Barr thought that the museum should not hold works for more than fifty or sixty years after they were created, nevertheless,

> Not surprisingly, the Modern's trustees began to look for a way out of this agreement in 1951. Worries about future gifts and holding onto their patrons, and concerns about losing their most valuable assets—their Cezannes, van Goghs, and Picassos—led in 1953 to an official repudiation of the notion of transferring MoMA's collection piece by piece to other institutions and to a commitment "to have permanently

on public view masterpieces of the modern movement, beginning with the latter half of the nineteenth century."[154]

In the struggle for primacy between an art-centered dynamic collection and one oriented toward the logic of the masterpiece, it is the latter that won. An art-centered approach would have resulted in the ability to include many more artists in the work of the museum, but clearly the approach of holding on to art because of its value won the match. Debates about the nature of the collection and a system for collecting eventually led to a decision to establish a permanent collection of masterpieces that would not be subject to deaccessioning. We must ask ourselves whether attempts at a radical conception of the collection are abandoned largely because the work becomes so significant, or because it has become expensive.

The distinction of the collection as public is found repeatedly in numerous meetings and correspondences. While much more work could be done on such questions, and the various identifications of the key players theorized, we can detect cardinal examples. In a Report of the Committee on the Museum Collection from 1943, curator James Johnson Sweeney argues for a systematic rather than erratic approach to create a well-rounded collection "to which artists, students, and the public can go for the best in each field," contrasting it to the limited and personal choice of private collections precisely because the museum has a "duty toward a large public and the education of that public."[155] Noting that holes in the collection result from lack of funds, but also, significantly, the "unwillingness of the Acquisitions Committee to make certain purchases because of the dislike for certain forms of contemporary art," he again emphasized: "and once again it is recommended that the museum Collection should be built up as a rounded educational instrument, not as a private collection formed mainly along the lines of individual taste."[156] That Sweeney paraphrases this theme one last time on the next page indicates the urgency to put emphasis on the public aspect of the collection. While one can only speculate why this called for repetition, it may very well have been an attempt to ward off pressure by trustee taste.

Grumblings by museum personnel about demanding trustees, and discussions on how to delicately handle them, pop up in personal correspondences. Relaying to Barr that a trustee has been offended because he, "chief bottle washer of the Dep. of Ptg. & Sculp., had never gone to see him and his pictures," curator James Soby jokingly signs off: "undiplomatically yours."[157] As Sybil Kantor evidences, although Barr

indeed considered himself advisor to the patrons of the Museum, the relationship consisted of much disagreement,

> Barr was said to have "a fine Italian hand" in dealing with trustees. That is, without seeming willful, he could maneuver the trustees to support his proposals for the museum; unfortunately, it was an ability that, at times, would work against him.[158]
> Although Barr constantly praised those he worked with, including the board of trustees, the impression remains that his accomplishments at the Museum were made through outmaneuvering rather than cooperating with them.[159]

Clearly, professional personnel were serving at the pleasure of the board, and its aesthetic proclivities. This structure shaped a self-interested collecting policy. The power of the board stemmed from the fact that the museum depends upon them for donations of money and art. With all the museum's modernity, the relations of board to the staff retained an air of patronage, and a lingering adoration of a Renaissance ideal.

The momentous role played by the MoMA in consolidating and stabilizing the discourse of the European and American avant-garde was firmly entrenched in idealist principles that concealed the liberal pact between the private sector and the state.[160] Shaped by the weak state structure, the distributive function was complicit, while the art itself was perhaps radical, but nevertheless corralled by the discourse of individuality. Radicality was an aesthetic program whose politics were status quo. Its concrete outcomes were reflected not only in the euphemisms used to hail the patronage at gala openings and printed publicity—those metaphors forming the ideology of philanthropy and gratitude—but also in the very concrete ways the funding structures resembled their absolutist ancestors directly serving the double purpose of soft power and hoarding functions, if the museum held in public trust the same type of assets that most of its trustees also owned privately.

Like most museums, at MoMA the promise of democratic inclusion met the economic reality of exclusion. But, even if it is considered to be a private institution, the MoMA is in fact concretely entangled with the state such that it ought to be upheld to standards of maintaining the public trust. Since this public consists of membership that exceeds the museum's patrons and audience, the museum should be upheld to the standards that reflect, at the very least, the needs and interests of the entire population of greater New York, not only its wealthy patrons and paying liberal audience.

Conclusion

Commencing as a private activity, collections have undergone a long process of being turned outwards, first to mostly face an audience of peers and subordinates, then, throughout the European turn from monarchies to republics and since, offered for a broader and broader public. In many ways, the American museum marks a retraction of the historical trajectory to make collections more public. This reversal has increasingly been influencing a wave of private museums in Europe and internationally in the twenty-first century. The exacerbated connection between the museum and a financialized and growing art market echoes forms of accumulation at the decline of the Florentine cycle of accumulation. Museums today resemble their absolutist forebears when they wield art collections as soft power, in close association with the agenda of the state. The nonprofit system gives them tremendous leverage to shape civil society according to their needs.

The U.S. administrative system is structured as a (relatively) weak government, which is networked with leaders of a strong civil society through the delegation of government work to a third sector that funds and directs a whole range of knowledge, culture, social services, and welfare. Yet, despite huge amounts of money and resources invested in the scientific study of social problems and the bureaucracies of giving solutions, which have transformed and reformed several times over, we see inequality today at the rate it was in the 1920s. This is because a system that is neither private nor public allows flexibility and autonomy for the ruling class, while keeping some of its most consequential processes shrouded in secrecy, thus avoiding direct scrutiny and accountability. The soft influence of giving directs research and development to status quo methodologies, avoiding transformative, let alone revolutionary outcomes. Within these systems, the public is invoked for collecting common funds on its behalf, but is barred from access to decision-making and its economic impact. It results in a conception of the public good that ignores the actual entity to be considered when we say "the public." When the role of the public is passive we have absolutism, even if tamed and disguised. When the role of the public is active we can have a basis of social democracy, which can then be taken further.

Chapter 4

BLUEPRINTS FOR THE FUTURE: DEMOGRAPHIC AND ECONOMIC CHANGE

In 2020 Gary Garrels resigned from his post at the San Francisco Museum of Modern Art (SFMOMA), because a series of slips of the tongue led to pressure by staff who wrote in their petition:

> As Senior Curator, he represents the museum in tone and content. Through actions and words, Gary has been obtuse (at best) to the point of offense or deliberately racist (at worst) in his retorts to criticism. When pressed on the museum's collecting policies he has repeatedly said some variation of "don't worry, we will continue to collect white male artists." Amongst SFMOMA staff as well as in public view, Gary has used and continued to use white supremacist and racist language such as "reverse discrimination." This has been documented.[1]

That an experienced cultural leader would carelessly voice oppression evinces just how engrained white supremacy is in the fabric of our society. The question is not whether Garrels is personally at fault or not. The argument here is never personal in its nature. As a MASS (Museums as Sites of Social Change) Action blog post states, "No one in this field intends to be racist, but there can still be racist impact."[2] The working assumption here is that individuals transmit the dictates of society, consciously or unconsciously, and therefore that white supremacy should be tackled on personal and social levels simultaneously. The first part of this book has shown how privatized culture relies on wealth, which, as we know from the work of scholars cited in this chapter and throughout the book, relies on racism for its existence, because racism is a tool to keep society primed for the discrimination necessary to sustain wealth.

There is overwhelming evidence that American museums have so far served the hegemony of white mainstream culture.[3] If we ask how to

fundamentally change the museum in the short and long runs, the answer is by changing its culture and its economic dependency on the ruling class. To create equitable institutions and collections, demographic representation is merely the beginning, and efforts so far have amounted to appearances lacking statistical significance, as a show in Chapter 1.[4] We also need to see methodological diversity, that is, a better representation of the manifold typologies of historical and contemporary art-making, which are much more heterogeneous than are currently represented in our institutions. Importantly, aligning demographical and museum statistics is not enough, we need to theorize ethical guidelines and continuously revise them. For example, the meager representation of Native American artists doesn't even echo their aliquot share in the population. But representing Native Americans according to such a metric will not constitute justice, because their demographics are an outcome of genocide and repression on their unceded land. We might find that we want to turn over much more control to Native voices and choices than an ostensible "fair" share. Perhaps when we say "demographics," in the case of Native Americans we should count their ancestry?[5] In any case this is an idea, and it is not my call but theirs. What follows does not aim to replace diversification on all levels as we move forward, it rather proposes how to introduce diversity at the ground level on a much broader scale than adding a few artists to a collection. It assumes that humans can change the system that they themselves developed, and that it takes big-picture vision and collaboration rather than competition and winner-takes-all systems.[6]

Today, a mounting wave of museum protests by workers and artists reveals the social and racial dimensions of what amounts to crisis of public trust. Workers have been protesting their treatment, as seen in open letters to the New Orleans Museum of Art, Brooklyn Museum, Guggenheim (where the chief curator Nancy Spector departed after pressure), and the MoMA, Met, and Whitney Museums, to name several written just in 2020.[7] On social media, several anonymous accounts compile testimonies by workers that name problematic institutions and individuals. Union drives are taking place in museums across the U.S. We have also been seeing an upsurge of protests against museum board members or named donors profiteering from prison, war, and big pharma, including: an open letter to the Los Angeles County Museum of Art Count (LACMA) demanding the removal of Tom Gores, owner of Securus Technologies, the nation's largest prison telecommunications corporation that was implicated in exploiting prisons, jails, and

detention center phone calls;[8] the nine weeks of protest against teargas manufacturing mogul Warren Kanders led by Decolonize This Place at the Whitney; and actions against the OxyContin manufacturing Sackler family at the Victoria and Albert Museum, the Louvre, the Met, and the Guggenheim, and more.[9] What all these protests share is participant awareness that the interdependence of racial and economic dynamics that stratify the museum field also echo society's income and civil rights disparities. To wit, the most exciting developments in the field are taking place outside the museum's walls.

Since the discussion of diversity, identity politics, and multiculturalism has been prevalent in art institutions at least since the 1970s, becoming major between the 1980s and the 1990s, we have reason enough to argue that the ways in which our institutions handled the demands for social justice have been unsuccessful in affecting enough of a widespread change in programming, collections, and the demographic composition of personnel.[10] But this is not for lack of knowhow, as La Tanya S. Autry has underscored: "[W]e've been writing about these things for decades."[11] Another recent example is Porchia Moore's "Cartography: A Black Woman's Response to Museums in the Time of Racial Uprising," where she outlines a framework for "mapping" museum transformation. Moore highlights a substantial range of resources written by museum workers of color and allies who have compiled such maps to guide institutions in doing antiracist work. She asks museums to show us their maps, demanding accountability for their listening, hiring, decision-making, or museum membership practices and policies. Grabbing the problem by the head, Moore underscores the significance of the social composition of leadership:

Show us pictures of your museum boards.

Tell us the dates and times when you will ask current board members to step down. (In fact, do we even need boards?)

Tell us when you replace those board members with community members who reflect your community and/or the representation needed to increase equity, access, and inclusion.

Show us your process for selecting these members. Not members who are deemed "respectable", "magical", or "vetted" through your personal social networks. Select members who will challenge and stretch you; not those with social capital that aligns with your views.[12]

I agree with every one of Moore's demands and conclusions. One question though is left open. If current museum leadership steps down and is replaced by representatives that reflect its stakeholders—artists, its audience, and all its potential publics, including all those who do not yet visit museums for various reasons—who will foot the extremely expensive bill? Moore's demand strikes me as intentionally provocative exactly along these lines. After all, we know that the demographics of wealth are overwhelmingly white.[13] To suggest that wealthy white boards be replaced with community members is to suggest a sweeping socioeconomic restructuring. This is profoundly different than isolated advocacy for demographically diversifying boards. Diversifying the racial compositions of boards without diversifying their class or type of commitment presents an appearance of diversity without its essence. Socializing funding streams and freeing them from dependency on wealth is necessary for greater autonomy and objectivity in representing and collecting a more reflective record of our contemporary culture, and for moving discussion to ask what does humanity need to collect moving forward, if at all. Moreover, diversifying collections, exhibitions, and staff on all levels is fundamentally different than diversifying a board, as the social relations structuring these roles are unalike one another. As long as the board is a funding and donations source, its collective interests remain opposed to those of the public. Only a board that includes people of all abilities and walks of life in a composition that reflects their aliquot share in the population (or what it should have been) can govern the public equitably, and only when they address in practice the intersection of ascriptive identities and class. This isn't to propose a rigid prescription, but to begin a debate on how to pry civic leadership out of control by a narrow interest-group, including the question: who are museum stakeholders and who decides on behalf of a community, or even bigger constituencies such as humanity as such? This chapter contributes to the larger project of socializing museums by asking how we can combine the work of economic and racial justice. Those pushing for socializing the economy are wise to get behind antiracist movements because antiracist work is the most direct means to organize for economic justice today.

I take as axiomatic that the social fabric is woven from cultural and economic threads. The structure itself is economic. It cannot be fixed by diversifying collections or demographics from the top down. But the standard Leftist argument that to solve racial, gender, and other forms of ascriptive discrimination we need to start from the social relations

that cause economic inequality, in other words, class, does not suffice. We cannot solve economic inequality if we don't address it as an outcome of white supremacy, because at this historical stage their imbrication is so complete that the internal dynamics between race and class are no longer on a trajectory of cause and effect, but are mutually coexistent. In terms of political strategy and struggle, there is clear potential for a mass movement forming under the call Black Lives Matter (BLM). To be clear, I am using the BLM call abstractly, not as a proper noun designating the related nonprofits and NGOs represented by this moniker. The latter are but one aspect of a much larger picture that includes movements that preceded this specific turn, additional movements that have been energized in its wake, and the growing emphasis on an explicitly anticapitalist framework in identity-based movements that are led by the principle that Black lives matter. As Keeanga-Yamahtta Taylor shows, BLM is an extension of a long tradition of Black resistance.[14] Its chapter-based organizations and many unaffiliated offshoots address intersecting agendas such as the crisis of housing, trans rights, labor rights, climate and ecology emergencies, etc., most sharing the fundamental recognition that capitalism drives inequality. Again, the idea and ideal of Black Lives Matter is not the same as its institutionalized manifestations, and its multiple aspects continue to offer radical potential. In many ways BLM functions as alloy, connecting equivalent and mutually beneficial causes into a solidarity network with influence power. The fundamental difference between this network and the elite and middle class one discussed in the previous chapter is their agenda. One seeks to share in the prosperity and equalize, the other to keep wealth and power in the hands of a few. They are not two sides of the same coin. It is evident that BLM activism is directly responsible for a recent change in public opinion, where ideas once considered radical, like police and prison abolition, are now openly debated in mainstream media and politics. This has opened the door for further discussions on issues ranging from rent and debt cancelation to universal healthcare and basic income, in ways unimaginable even a few years ago. It should settle down the criticism leveled from the Left against ascriptive politics.[15] Recent changes in public opinion and the spread of activism among a previously dormant liberal population can also nip in the bud attempts to claim that socialism is unpopular or unrealistic. We want to take this opportunity to join the conversation of how to imagine new economic structures of support for culture and the arts.

Racial capitalism and world system

What type of historical understanding will help us think about equitable collecting and collections for the public? Or how do we reconceptualize our museums concretely and immediately, and also in a theoretical future? We know that museum collection and classification methods reflect the social hierarchies of a historical world system dependent upon enslavement and exploitation. The literature is abundant with records and analysis of how museum discourse justifies domination and oppression.[16] As Cedric Robinson underscored,

> For far longer than a millennium, the history of Europe has amounted to an almost uninterrupted chronology of fratricidal warfare and its celebration. The museums of civilization are the current testament to that preoccupation, its histories chilling accounts.[17]

Robinson advances Marx's critique of political economy and Wallerstein's world-systems level of analysis, yet, appropriately, he also issues criticism of their oversight of the primary role slavery played in the rise of capitalism.[18] He points to the failure of European-based radicalism to understand the full extent to which racialization, as it permeated into every social formation, translated into a universal force of material oppression:

> Racism, I maintain, was not simply a convention for ordering the relations of European to non-European peoples but has its genesis in the "internal" relations of European peoples. As part of the inventory of Western civilization it would reverberate within and without, transferring its toll from past to the present. In contradistinction to Marx's and Engels's expectations that bourgeois society would rationalize social relations and demystify social consciousness, the obverse occurred. The development, organization, and expansion of capitalist society pursued essentially racial directions, so too did social ideology. As a material force, then, it could be expected that racialism would inevitably permeate the social structures emergent from capitalism. I have used the term "racial capitalism" to refer to this development and to the subsequent structure as a historical agency.[19]

The profits made by capitalism are not the fruit of progress, they are fruit of stolen people, stolen land, and stolen wages. Marxist analysis can

lead to answers, but those require development, because of how race continues to function as means of social stratification, a tool for oppressing populations so they can function both as a reserve army of cheap labor for capitalism and as an ideological counterpoint by which to police the working class with additional racial hierarchies.[20] We witness the actual and material consequences of the ideological construct of race and racism.

Robinson follows W. E. B. Du Bois in showing the ways racism was used to fragment the working class into subclasses. Racism helped form the liberal hegemony where the white working class became ready allies of the ruling class, as long as this white working class could itself exploit a lower class of Black and other workers of color. For the promise that they themselves could accumulate wealth and join the capitalist class, the white working class formed a labor aristocracy that betrayed other working classes. Robinson cites Du Bois's classical work *Black Reconstruction in America*:

> Indeed, the plight of the white working class throughout the world today is directly traceable to Negro slavery in America, on which modern commerce and industry was founded, and which persisted to threaten free labor until it was partially overthrown in 1863. The resulting color caste founded and retained by capitalism was adopted, forwarded and approved by white labor, and resulted in subordination of colored labor to white profits the world over. Thus the majority of the world's laborers, by the insistence of white labor, became the basis of a system of industry which ruined democracy and showed its perfect fruit in World War and Depression.[21]

This describes the socio-ascriptive character of hierarchies. It is very evident that museum-personnel pecking order echoes this composition and has a clear racialized character.[22] Capitalism still needs extreme class stratification to push wages down, but to understand its relationship to other forms of social control, of which the museum is an instrument, we must take into account something fundamental about the changing character of capitalism.

Is it still capitalism? A neofeudal present

There is compelling evidence that the current stage of our historical period cycle can be described as neofeudal. As Wallerstein, Robinson, and Giovanni Arrighi all show, the history of capitalism advanced in

cycles of accumulation followed by declining profit rates. Arrighi defines systemic cycles of accumulation in this way:

> The notion of successive systemic cycles of accumulation has been derived from Braudel's [Fernand Braudel's trilogy, *Capitalism and Civilization*] observation that all major trade expansions of the capitalist world-economy have announced their "maturity" by reaching the stage of financial expansion. Following Braudel, we identify the beginning of financial expansions with the moment when the leading business agencies of the preceding trade expansion switch their energies and resources from the commodity to the money trades.[23]

At any given cycle of accumulation, the downturn can be characterized by decline in productive investment and increased speculation in land, financialized products, savings, and luxuries. By 1990, Arrighi showed, globalization and the offshoring of production to low-wage countries aimed to offset diminishing profit rates of the American accumulation cycle. Since then, a process of decline entailed excessive financialization, crises, growing inequality, and a horizon of more. It is hard to imagine the current moment as anything but the total culmination of the American cycle of accumulation.

Art in this context sits, as I show in Chapter 2, not on the side of productive labor, but on that of money trades and financialization. That art can be used for portfolio diversification, loan collateral, or hedging of art loans, only exacerbates its status as a form of "money trade," money withdrawn from circulation and not reinvested in production. This means it is not productive for capitalism, it is a means of circulation, and mostly, it plays the role of squirreling value away from reproduction. Art collateralized to raise capital is not productive either, it simply means that it has been instrumentalized as a financial tool. In historic stages of economic decline, as Chapter 3 tells of the late Renaissance, as well as in the present, elites and later capitalists turned from investment in production to investment in accumulation.

Historically, art collections developed as treasuries, while markets networked and expanded.[24] Collections performed a variety of hegemonic and ideological functions. A distinct recent development though is the influx of collectors interested solely in art's investment potential, and its use to diversify investment portfolios.[25] This is tied to the belief that art is an asset that does not directly correlate with other commodity prices.[26] But art can also be a dangerous investment given

such risks as damage or theft, and the high cost of art's storage, physical maintenance, and insurance.[27] Despite this we see a proliferation of art as investment, directly related to the amounts of available cash at the top that investors are reluctant to put back into the economy. As asset, art has several unique characteristics. In opposition to financial assets, "your Canaletto, for example, will never go down to zero like a stock or bond or in an Enron situation."[28] The exceptionalism of art is rooted in the fact that it is not a commodity, that is, not part of a wage system, but rather of a set of social relations that remained as they were before the advent of capitalism.[29] Whether the market for art rises in a historical cycle of decline is a question for large-scale empirical research. In any case we know that under such circumstance art is a tool for hoarding.

Significantly, since the investable feature of art's status lies in the fact of it being part of national collections that ensure the stability of its symbolic and therefore economic value, the role museums now play in stabilizing art prices is leveraged to support an exacerbated financialized economy. Willing or not, living artists, artworkers, and intellectuals are caught in this web of complicity. Together with an increasing leveraging of art's asset potential, this not only raises the stakes for the market, it raises costs and introduces serious ethical dilemmas for museums. All this is happening just as contemporary art is now at the prime of the field.

Contemporary art began to dominate the high-stakes luxury market in 2009 and reached "52 per cent of the market in 2016":[30]

> The non-profit sector also reflected this increasing bias towards the new: according to The Art Newspaper's annual survey of museum attendance, '44 per cent of the more than 2,300 shows organized by 29 major US museums between 2007 and 2015 were dedicated to the work of artists active after 1970'.[31]

It is therefore hard to see as accidental the fact that a tendency toward the new on the market coincided with one at museums. There is further evidence to at least hypothesize that museums are following the trends of the high-stakes market.[32] Beyond being disproportionately of a white and male demographic, the practices of asset-class artists mostly tend to be limited to painting or traditional art forms. There is probably enough evidence to assert that the boom in the market and institutions dedicated to contemporary art (that takes marketable forms) in the twenty-first century are directly associated with a world that is polarizing economically, concentrating great wealth in the hands of the few, which

in and of itself is destructive as it further accelerates economic and environmental decline.

When art is an asset that can act as debt collateral, or for portfolio diversification, it works on the side of the forces of accelerated privatization and monopoly concentration. Today, when accumulation by nonproductive means such as rent, debt, and force is now at an equal rate to commodity production, this means a heightened condition of exploitation, and a growing likelihood of crisis. As Jodi Dean explains,

> Globally, in the knowledge and technology industries, rental income accruing from intellectual property rights exceeds income from the production of goods. In the United States, financial services contribute more to GDP than manufactured goods contribute. Capital isn't reinvested in production; it's eaten up and redistributed as rents. Valorization processes have spread far beyond the factory, into complex, speculative, and unstable circuits increasingly dependent on surveillance, coercion, and violence.
> Capitalism is turning itself into neofeudalism.[33]

In other words, capitalism has lost its central characteristics. If the argument ever was that capitalism is the only economic structure that can facilitate democracy, it has now lost its last leg of merit. But there is an additional, even more fundamental way in which capitalism has lost its central characteristic.

If we return to Ellen Meiksins Wood's description of capitalist imperative cited in Chapter 3, the imperative to reinvest in production toward capitalist growth, then the capitalism Meiksins Wood is describing has a different economic logic from that which we see today, where the investment is diverted into enterprises that yield profit for the investor, but not productive growth. Increasing investment in unproductive rather than productive enterprises exacerbate capitalism's already underlying tendency for the rates of profit to fall.[34] The decrease of investment in production and the increase of investment in financial markets, land, and assets resemble key features of the late-Renaissance mercantile city-state in the stage of its decline.[35]

By the sixteenth century, the contraction of the Renaissance city-state economy meant that surplus was increasingly reinvested in luxuries.[36] Although the cause and effect here are not clearly known to us, as the economic historian Richard Goldthwaite explains, he nevertheless places the Italian economic contraction in the broader context of Habsburg decline, the shift of trade to northern ports, and

the expansion of the Dutch and English economies. Still, as Goldthwaite had underscored, although contracted, city-state economies survived very well by inertia for centuries after their apparent decline.[37] In what ways do contemporary features—investment in arbitrage opportunities over market imperatives and the heightened investments in land and luxuries—echo the dusk of the city-states as the center of the world system? Circumventing public influence on matters that ultimately affect the population, the nation-state in its current form bears alarming resemblance to the absolutist model of the Italian city-state. This includes the defeat of labor and privatization since the 1980s, as well as the diversion of public welfare for serving big business at the expense of workers and the public, which is a major indicator. This has been facilitated by new administrative forms that are no longer liberal:

> Political power is exercised with and as economic power, not only taxes but fines, liens, asset seizures, licenses, patents, jurisdictions, and borders. At the same time, economic power shields those who wield it from the reach of state law.[38]

That these mechanisms disproportionately affect Black and other historically excluded communities of color is by now well documented.[39] New Deal America, and even more so following World War II, started seeing democratic advancement in labor law, followed by a civil rights movement rooted in struggle for the poor that brought racial justice into mainstream awareness. But the decline of profitability in the 1970s, which led to the return of free-market doctrine and the election of Reagan and Thatcher, was followed by a wave of privatization of the law that dramatically exacerbated inequality and gave more power to the elites. We are today in the trajectory described by Robert Kuttner and Katherine Stone where "elites are pursuing something aptly described as a new form of feudalism, in which entire realms of public law, public property, due process, and citizen rights revert to unaccountable control by private business."[40] This results in private law governing such massive sectors as the giant tech monopolies, the drug industry, financial derivatives servicing, and mortgaging, forcing private arbitration and banning class action in labor contracts and trade law. The turn to arbitration over public jurisprudence is a return to a feudal form of social control that blends political and economic power, rather than separating them as a means of democratic checks and balances. This is all geared toward extraction of surplus value by coercion or force:

Laws to protect workers and consumers, reflecting 70 years of struggle to expand rights, are now erased by compulsory arbitration regimes. Trade law permits similar private tribunals to overturn or sidestep public regulation. Tech platform monopolies have created a proprietary regime where they can crush competitors and invade consumer privacy by means of onerous terms, often buried in online "terms of service" provisions. The unity of common scientific inquiry has been balkanized by confidentiality agreements and abuses of patents, as scientific knowledge comes to be "owned" by private entities. Companies like Monsanto, manipulating intellectual property and trade law, prevent farmers from following the ancient practice of keeping seeds for the next planting season. This is not deregulation or neoliberalism. It is legally sanctioned private jurisprudence—neo-feudalism.[41]

Private law—for example, the law of contracts and torts—has historically existed alongside public law and regulation, but that entire areas of public law have now been outsourced to self-regulating agencies governed by private commercial interests with abusive outcomes marks a different development altogether:

> Entire domains were handed back to private entities that were empowered to exercise quasi-state functions and create their own proprietary systems of law ... After Wall Street invented financial derivatives in the 1980s, the whole field of derivatives creation and trading came to be governed by rules established by the industry trade association ... By definition, the self-interest of securities dealers is not identical to that of the investing public.[42]

Jodi Dean underscores that the privatization of sectors like tech, broadband, energy, or rail gives their owners access to monopoly rents that are thus more extractive than they are productive. Moreover, other advantages, like tax breaks, ultimately come at the expense of community welfare, while the presence of these companies in urban clusters is a gentrifying force eliminating affordable housing and driving out small business.

Beyond settling in low-income neighborhoods as avant-garde for real-estate speculation, museums exhibit the persistence of neofeudal power when, for example, collectors on trustee boards own shares in commercial galleries or auction houses, a phenomenon more frequent than is acknowledged and that clearly prevents the separation between

access to information and influence on the public aspects of art. This leads to self-interested decision-making. The interests of the few come to govern what is given to the public. By definition the economic interests of private collectors or galleries are contradictory to that of the public. This is not a matter of taste or preference; it cannot be resolved with popularity tests or participatory ratings polls that give museums the appearance of democracy. As museums and art collections offer the perfect infrastructure for exacerbated neofeudal forms of accumulation, we ask again whose interests are represented and drive decision-making processes.

Economic dependency and racial inequality

A correlation exists between economic dependency on private interests and racial inequality. While correlation is not causation, we look at the larger picture to see that they are intimately related, so we can ask the questions that will lead us to design scholarship that can bring us answers. Privatization is undoubtedly a factor in a complex dynamic of causes that have left white supremacy entrenched in our society. That the economic status of historically excluded groups has been declining again since the 1970s is an alarm that should lead to more study.[43] Wealth accumulation relies on white supremacy to breed inequality because inequality is necessary for the extraction of wealth from (ancestral or common) land, (property-less) abstract labor, and (common) natural resources. When we address inequality from the top, white supremacy is allowed to carry on uninterrupted, and when interrupted it tends, like water, to carve new paths. In museums we see this when diversification means that so many museums are accessioning the same type of signature works by a limited number of artists of color, rather than allowing for curatorial work to be led by the changing dynamics in stakeholder communities and support new types of artistic practices. Former MoMA curator Robert Storr demonstrates the dynamic of decision-making:

> The criteria for judging a work's value to a collection transcends taste and—in the case of much modern and contemporary art that has deliberately upset the apple cart—it may willfully violate prevailing tastes. Everybody knows this is true when retrospectively considering paradigm-breaking works of previous avant-gardes, but experience shows that frowns around the table at acquisitions meetings often reflect unexamined preferences and comfort zones or a spontaneous

resistance to the "new new" that is often grounded in a defense of the "old new."[44]

When this "old new" of which Storr speaks is dependent on the market for evaluation, it sidelines questions of significance, contribution, and lasting importance.[45] But today we have market success determining which contribution the museum decides to support:

> The curator is charged with encouraging fledgling or established collectors in the hopes they may also become donors. Curiously, at the very moment when this potential seems gloomiest, museums have awakened to the necessity of intimate familiarity with the marketplace. We see many more curators escorting collector groups to sales than ever before.[46]

The logic of the market cannot guarantee excellence in the long run, if it ever did.[47] Collectively, these institutions raise the price of private assets for their patron class, all the while lowering the latter's taxes, which should be redistributed by democratic means and not by the private taste of collectors. The concomitant bubble effect is hurting museums and artists.

The SFMOMA case, seen in Chapter 1, reveals how curatorial ideas seem to flow toward money. Garrels, for example, expressed comfort with the limitations imposed by the Fisher collection: "There are so many possibilities about how to approach this collection ... Some much more unorthodox ideas are already bubbling for future rotations."[48] Yet, if we remove the donor's interest from the equation and observe the curatorial constraint imposed on the museum's overall program from the standpoint of demographical statistics and the question of diversification, the introduction of the Fisher collection is negative. For a very substantial percentage of its exhibition space, the museum, it now seems, is contractually obligated to rely on a collection that is dominated by white and male artists. Again, what we see here is not a direct relation of cause or effect, no one is saying the SFMOMA or anyone associated with it is racist, but rather, observing the decision-making process reveals the dynamic by which an institution unintentionally becomes a symptom of a larger social condition. To ensure that the role they play is social, museums cannot take their dictates from the very system whose profit is based on the hierarchies it wants to undo.

Museum collections: who will be the judge?

The prevalent assumption that what is good for collectors is necessarily good for the public frames the remarks of the gallerist Esther Kim Varet, who in an interview openly reveals the benefit and influence given to private donors, which have been long known to the ruling class: "A huge part of what I feel like my role is, to match institutions with collectors and broker partnerships, all while I'm stabilizing the markets of our artists by placing their work in institutions."[49] Yet, it is not the role of public museums to stabilize the market for artists selected by a market-driven process. No matter how sophisticated or astute the gallerist is, by definition, the gallery and art market function on exclusion, while their aesthetic purview is either limited to what they can sell or subordinated to that logic. This is not how our collective collections should be determined. Yet, practices of leveraging the public museum to stabilize the prices of individual artists are more widespread than recognized, also because most transactions are opaque to scrutiny. An article about the market success of Jennifer Guidi explains another strategy that I have been hearing about for years:

> Work currently up at a solo show at David Kordansky Gallery in Los Angeles is so highly desired that in order to acquire one, a collector had to first purchase a work that would be a gift to an institution. The artist herself is intimately involved with placing the pictures.[50]

The museum has become an arbiter of taste for a brand-name luxury market. It helps consolidate desirability around a small group of artists, many of whom output signature styles, often limited to the production of objects. Not surprisingly, the aesthetics of a philanthropic culture that thrives on atomization is focused on the mythology of the singular genius artist, and is invested in the ideology of the entrepreneurial individual.

In principle, there is nothing wrong with conventional art practices, they certainly have their place. Ideally though, we would see them command attention and fetch prices that are proportionate to other forms of contribution within an equitable economy. While this might seem like a distant horizon, we can nevertheless approximate it by administering our institutions to facilitate a more just distribution of the arts economy by regulating markets and ensuring that museums represent the public and not a small sliver of the population. Fairness

alone dictates that, since collectors of contemporary art have a vested financial interest in the product, they should be barred from influence on decision-making processes that affects the entire public, and from having advanced knowledge about the museum's future plans, which is a baseline regulated in every other sector. But somehow in the arts the lack of separation between public and private benefit is evident and open:

> So if there's anything I could say to the listeners in the Hollywood industry out there who are hearing this podcast, get on museum boards, because that is going to help in a big way.
> ...
> There are a lot of people joining acquisition committees and boards so that they can get access. And $15,000 to join the acquisition committee at LACMA is a very cheap buy-in for a credential for them to get access to work. Institutions know their collections are starting to become transformed by market interests precisely because of these collectors that are infiltrating [themselves].[51]

Access means a doorway to information in a notoriously opaque market, and advance knowledge of what the museum will be collecting and exhibiting. Access is what would be considered to be insider trading in other sectors. But Kim is not the problem. Everything she is doing is legal. She is smart to understand the system and wield its gravity to her advantage. The problem is with the law. The law governing philanthropy is set up to benefit the wealthy (as we keep in mind that this is even more exacerbated when it comes to the fine arts than it is for every other sector):

> Generally, the presence of a substantial private benefit will disqualify an organization's tax-exempt status. However, even substantial private benefits may be tolerated if they are considered qualitatively and quantitatively incidental in comparison with the organization's charitable goals. Qualitatively incidental private benefits are "a mere byproduct of a public benefit," whereas, quantitatively private benefits should be insubstantial in amount. A qualitatively incidental "private benefit must not be substantial after considering the overall public benefit conferred by the activity." According to the IRS, some private benefit is qualitatively permissible if "the benefits from the organization's activities flow principally to the general public ... [and] [a]ny private benefits derived do not lessen the public benefits

flowing from the organization's operations." Furthermore, the IRS ruled that "it would be impossible for the organization to accomplish its purposes without providing" some private benefit.[52]

While quite visibly these private benefits have long been upgraded from "incidental," some being massive, the rub is also that it remains up to the donor to determine what "public benefit" constitutes of. This type of neofeudal self-regulation allows casting all sorts of self-interested decisions as public: "A private benefit is *quantitatively* incidental if it is 'a necessary concomitant of the activity which benefits the public at large, i.e., the activity can be accomplished only by benefiting certain private individuals.'"[53] The problem extends to the private foundation and jewel-box museums where megawealthy individuals benefit exponentially from the tax exemptions, deductions, or other benefits that were conceptualized to encourage public, not private, benefit.[54] With the market for contemporary art skyrocketing, and changes in tax code incentivizing megacollectors to open private operating foundations rather than donating works to established publicly supported museums, we have a proliferation of nonprofit institutions largely sporting the same brand-name artists.[55] There are better systems to support contemporary art.

As a condition for having a 501 (c) (3) nonprofit status the core mission of museums such as LACMA, MoMA, SFMOMA, or even private foundations such as The Broad, must engage in education as a major component of benefit for the public. Based on this mandate, we can determine that these institutions be held to public standards as part of their tax-exemption and therefore disallowed to be shielded as private.

In the case of jewel-box museums we clearly need much greater scrutiny, if they are allowed at all to be tax-exempt. After all, if their foregone taxes were in control of a demographic that actually represents the population and the museum's community stakeholders, the art we collect as a social body would undoubtedly look radically different. Because the original intent of the philanthropic system is public benefit, in effect these museums are not private, but privatized. It is the power of private interest to govern them that privatizes them. The actual process of their privatization is an outcome of public funding decrease, the increase of private profit and philanthropy under neoliberal economics since the 1980s, and the conservative turn in philanthropy that advanced donor control. What has also changed is its scale.

Philanthrocapitalism

The contemporary privatization of government-sized industries, services, and welfare is supported by an industrial-scale philanthropy that has come to be characterized as the philanthropic-industrial complex, or philanthrocapitalism:[56]

> Over the past decade a series of new foundation management rationales have developed, and along with them a consultant industry (mainly drawing on business school models and experience). The new calls are for "effective", "strategic", or "venture" philanthropy, and each of these is essentially a business management point of view.[57]

While American philanthropy has always been structured like businesses, what is new is the scale and the level of aggressivity in which they carry out their agenda internationally. Concentrated in a few hands, most notably Broad Foundations, the Walton Family Foundation (from the founders of Walmart), and the Bill and Melinda Gates Foundation, the first two also support the arts extensively.[58] That concentrated power can legitimize itself through internal mechanisms for diagnosis and prognosis is especially alarming.[59] Born into these forms, the professional and managerial class that works within them, and who reap the rewards of a middle class or higher lifestyle, work tirelessly to sustain them and normalize their benign appearance. Again, this history is that of middle class collaboration with the elites:

> The third wave of American philanthropists emerged in the early 1960s. Having watched second-wave foundations struggle with politicians and bureaucrats, the new class of philanthrocrats (the professional foundation officers who by then ran the major foundations) believed that the next stage of national progress could not be reached by relying solely on government policy and initiatives. Social movements, they concluded, were necessary catalysts to such changes. The foundations thus emerged as noticeable, though cautious, advocates and financial champions of civil rights; a little later they lent their support to environmentalism and, eventually, to moderate feminism.[60]

"Moderate" is the key word in this narrative. Funding seems to have always been contingent upon conformity and the survival of the status quo. Significantly in this respect:

By the end of the twentieth century the only American social movement overlooked by organized philanthropy was, quite understandably, organized labor. (Why would captains of industry and their heirs support a movement that increased their cost of doing business and, by its very existence, challenged the primacy and authority of capital?)[61]

It created a tiered system of welfare, leaving out large swaths of the population. As Keeanga-Yamahtta Taylor shows, these quasi-state actors have always supported the stratification of the working class by race. Their agenda carefully avoided affecting structural change to actually alleviate poverty:

> The volatile politics surrounding who should be eligible for public welfare also aided in creating the political categories of "deserving" and "undeserving." These concerns overlapped with the growing popularity of "culture" as a critical framework for understanding the failure to find the American dream. This political context, as well as the deepening influence of the social sciences and an "objective" arbiter in describing social patterns (sponsored by the Ford Foundation, among others), helped to map a simplistic view of Black poverty that was largely divorced from structural obstacles, including residential segregations, police brutality, housing and job discrimination, and the systematic underfunding of public schools in Black communities.[62]

Funded by board-governed philanthropic institutions, privatized knowledge and welfare are inherently unable to see merit in solutions that would undo their class dominance. In effect they pursue the exact opposite, as they work to shape policy that enhances their control.[63] It becomes worse when scale contributes to their power. It is also fair to say that the neofeudal condition is spreading through the dominance of this massive system of privatized social infrastructure.

Freedom of opportunity and speech are thwarted in direct and indirect ways. The problem is always twofold, first because this system comes from and sustains racial hierarchies, and second because it inevitably contains or stifles art that is radical or can otherwise lead to actual change. The system tends to support art whose implications it can contain. In museums, we see this when they finally collect the work of artists of color, and the tendency is toward consensus and mainstream, or representation over analysis:

Exhibiting "political" work is still rare, with many art institutions steering clear of "anything that would be considered controversial," says curator Larry Ossei-Mensah.

But even when they try, many art institutions have a history of not "dealing with Black and brown artists with the same level of care [as white artists]," he says.[64]

This example is one among so many; it is hard to choose which ones to describe, but here are some searchable names and institutions that will yield published stories of brave individuals who have spoken up about their experience trying to bring important work to museums: Kelli Morgan and the Indianapolis Museum of Art, La Tanya S. Autry and the MoCA Cleveland, Taylor Brandon and the SFMOMA, with numerous incidents of varying intensities regularly reported in the art news. In a field known for its retaliatory climate, speaking up can amount to self-sacrifice. But there is power in numbers, and they are growing. There are several social media discussion threads with thousands of followers, exposing faulty human relations practices. Museum workers have increasingly been lining up behind an intersection of racial and economic justice, as protest by art and cultural workers from outside the museum have created networks of solidarity. As we wait to see what will come of this moment's visible potential, the field is being pushed into a starker division along the lines of class identification. We should welcome this polarization: it will discourage collaboration with elites and empower those working for change. How then in such conditions can we work toward an art institution that is equitable and continues to promote equality? Our problem with the philanthrocapitalist system is that it masks its operations by its sheer scale, and in its neofeudal character it can claim to be private, concealing where it is that systemic white supremacism results in statistical exclusion on every level of its operation. Philanthrocapitalist upscaling is a major trap to avoid, as we expand the concept and practice of who is the public.

The public: abstract and concrete

Political disparities among the different museum constituencies are not new. The sociologist Paul DiMaggio classifies the museum's public by three categories or coalitions that are present in most large art museums. In what he calls the patron's submuseum, art historians, critics, curators, and fundraising staff are the heart of the institution and its mission to acquire, conserve, and research art. Here we can ask why, for example, it

is common to see curators accompanying collectors to art fairs. If we were to follow Porcia Moore's directives and take seriously the commitment of museums to the public, curators might place their extracurricular efforts with publics other than the wealthy. Years in the field allow me to assume that a structural change that will free curators of this obligation might be very welcome.

The second is the marketing submuseum. Here, the regular and occasional museum customers define its public. Whether targeted for education (or as income), the goal here is robust attendance, which generates incomes and can help with grants that are contingent upon such figures. The third is the social submuseum that is centered on education and outreach, aiming to serve disenfranchised groups.[65] This description of the concrete public shows how our administrative edifice ensures that the outcome of this coalition is oriented to serving the patron class by casting the middle class as consumers, and the working class as charity. Significantly though, DiMaggio expands the parameters of the term "public" in his fourth category:

> The people who do not visit are not necessarily uninterested in art; many of them report watching shows about art on television, for example. Yet they do not appear to harbor a great sense of deprivation. People who already visit museums are far more likely to tell researchers that they want to visit more frequently than are people who do not visit museums at all. Nonetheless, if all the nonvisitors who reported wanting to visit did so, the proportion of Americans attending exhibitions would double. In other words, art museums may have a large untapped audience, but tapping it will require much effort.[66]

This untapped public, an ever-expanding potential public, is a major part of the abstract entity of which I have spoken throughout this book. In many respects it is a juridical entity, in the name of which the state governs. But ironically, it is this abstractness that also allows the state and the law to ignore (or even obliterate) those it needs to exclude in order for capitalism to thrive. The abstractness of the public allows museums to skirt the question of which constituencies it must serve.

From the perspective of outcome, we have statistics. But how did we get to these statistics, and how can we home in on the kernel of these problems? As Kimberlé Crenshaw has shown, intersectionality—the overlapping of class, race, and gender—renders subjects invisible to the law, masking the fact that intersectional groups are not extended the same

legal protections as privileged groups, allowing discrimination to persist.[67] When an abstract public becomes concretely intersectional it loses its universal rights. What can we learn from these modes of universalization about locating and fix discrimination in the institutional setting? How does the museum, in its capacity as a collecting and educational institution, as an employer, work to locate the causes behind the symptoms? The model for understanding intersectional identities that Crenshaw gives allows us to seek solutions in specific administrative circumstances. But it is much harder to pinpoint how it functions when one is inside the scene.

One of the biggest obstacles is that museum personnel and staff tend to be convinced that they are already doing antiracist work.[68] Time and again phenomena line up, while bureaucratic mechanisms work to conceal how their cause-and-effect processes have unfolded. We then say that racism is systemic, but where is it that it actually functions? The statement "institutions are composed of people" is only half an answer. Institutions are shaped by law, policy, and custom that are there before and after individuals come and go. The transformation of the system is reactive and slow. With lack of a bigger picture on the processes, reforms can have unintended outcomes, because they can only respond to what came before, such that an embedded error can be carried forward.

The limits of nonprofit scholarship and reform

Aware of disparities in the field, major foundations have invested in study and early solutions. In 2015, the Andrew W. Mellon Foundation, Association of Art Museum Directors (AAMD), American Alliance of Museums (AAM), and Ithaka S+R conducted a staff demographics survey of major art museums and found that their composition is not remotely representative of the U.S. population, evidencing that leadership, curatorial, and conservation are predominantly white.[69] The Mellon Foundation and Ithaka S+R followed up in 2018 with eight selected case studies deemed to be successful to examine what worked, and offer suggestions: "The research team at Ithaka S+R probed broadly how the museums think about diversity, equity, accessibility, and inclusion in relation to collections, programs, community engagement, partnerships, and board development."[70] While these studies are useful and illuminating, they are also quite limited. We are not so much interested in how museums "think" about diversity, but why, after so many years of awareness to the problem, they are not already concretely

diverse. Based on site visits and a narrow range of interviews mostly with top personnel, the results tend to be self-congratulatory. Inherently neofeudal in character, the study's design lacks a bigger picture and most importantly their case studies are not models, as most likely their success is particular and thus difficult to apply across the board. My aim in offering a history and theory is precisely to help design better methodologies so we can divert such resources to a deeper restructuring rather than superficial analysis and meek reformist suggestions. One of the biggest problems with trying to fix a problem like lack of diversity—which we have failed to solve despite efforts since at least the 1970s if not the 1950s—is that we keep fixing diversity when it appears as an outcome, that is, when it shows up as a symptom.

An obvious difficulty is that the research we see is done by privatized organizations whose accountability is unclear. They lack depth, breadth, and a vision that considers the total economy and social structure. Diversity will increase when access will be granted from the bottom and the pathway up supported, not by choosing a few tokens at the top to present an appearance of diversity.

The report is nevertheless right, in my opinion, to recommend that in order to achieve relatively high levels of representational racial/ethnic diversity among staff, audience, collections, exhibitions, and programs, museum need not only to expand job qualifications and descriptions with an intension of inclusion, but to make sure to foster a climate that will ensure retention of diverse hires by mentoring and material support programs, together with consistent antibias training for all museum personnel. They give an example:

> At the Studio Museum in Harlem, director Thelma Golden has led a curatorial development program that introduces new professionals of color to significant donors and leaders in the field. This involves taking emergent curators to international exhibitions, traveling with donors, and visiting the private collections of philanthropists. As a result of this and other mentoring programs, Studio Museum has an impressive track record as an incubator of talent, with many former staff now serving as curators and administrators in museums across the country. For a museum with a relatively small curatorial department (fewer than five staff), this institution has had a remarkable impact.[71]

This is significant because it shows that material resources and networking connections can make a difference. Golden leads the way,

but this is very much due to her personal capabilities and unique achievements. It is nevertheless an example that is not structural, and unfortunately can only alter the composition of the existing system. That said, this type of work can be supported as we move forward with ground-up solutions. Past advancements have been made because key individuals at opportune moments drove local change, but we cannot rely on the generosity and wisdom of individuals to alter a system that needs foundational overhaul. This is also true since we repeatedly see that confronting white supremacy tends to fade from the agenda quickly. To replicate examples of opportunity to a systematic scale we need public funding. The problem is, as Jane Burrell, senior vice president of education and public programs at the LACMA, confirms, "It isn't easy to come up with funding for your own program, because funders like their own ideas. With funders, you have to take the kernel of interest they have and make it make sense, so they still feel they own it."[72] We can't change the world tiptoeing on eggshells.

The positive examples given in the 2018 report are by and large anecdotal. Public funding could help implement them broadly. Many of the conclusions are already known and understood: pay all interns, cultivate alignment across departments in your organization, lead programming with values, redesign exterior areas as free civic gathering spaces while designing a welcoming facade to encourage visitors to enter, do not shy from controversies but use them as opportunities for education and engagement, form partnerships with other local organizations, involve the education department in curatorial decision-making, and when diversifying collections commit to rigorous research and transparency. But the problem is that as long as fundamental rights, like access to art and culture, are related to profit-maximizing enterprise, exclusion is necessarily part of the equation.

Take, for example, one typological strategy from the larger basket of unresolvable dilemmas of art and gentrification. Recent attempts to decentralize museums that aim to bring them into historically excluded communities run the risk of creatives moving into a neighborhood, followed by the rise of property values pricing out local population and businesses. But this problem is only extant in so far as housing is treated by society as a commodity and not a right. The same goes for art. Changing the economic structure into one based on common wealth and equitable distribution can help resolve the underlying problems we've been discussing. We need to imagine what we could do with the resources of the Mellon foundation if we put them to radical ends.

If we understand, as this book argues, that art is not productive for the capitalist economy, then in order to foster an equitable culture and society we need to change the economic infrastructure to create an economy whose social relations are not shaped by the value-form. This leads though to a key impasse that to have real socialism it needs to be global, a revolution that seems out of reach. National or local reform, it is argued—and I agree—cannot address global inequality. Nevertheless, initiatives such as the Green New Deal can push us toward immediate goals. In this vein we can pragmatically ask, for example, what is the place of art in a green new deal, as currently its outline does not talk about art or its institutions.

We can't wait for a change in the local, let alone global economic infrastructure to tackle the problems of white supremacy that result in a racist climate and deficient representation. Key strands on the Left have been working to correct dogma that has historically neglected the question of race, and focused its solutions on labor relations alone.[73] Ideally, resolving such issues would intersect both aspects and cover all the disciplinary perspectives affecting the field, including the law, economists, political and social science, and so on to devise feasible plans to propose policy and restructuring on a national level, with an eye to international cooperation. Thinking from the global constellation does not preclude thinking from the local issues, or the institutionally specific.

Solutions

As long as art's symbolic dimension is instrumentalized when it is publicly invested, that is, when our institutions collect, interpret, and display it, it will remain an undemocratic enterprise. To alter this, we need to change social relations such that it is never one entity that can reap the fruit of another's labor. While strategies for the latter are not art-field-specific, some remedial solutions do exist. For example, we can mitigate the winner-takes-all dynamic that makes some art worth so much money that it can be a means of further financialization. Financialized art—art that can function as loan collateral that can itself be insured and hedged—tilts the market, and its exhibition draws resources away from other practices in the field. The problem with the high-stakes market is that it relies on the rest of the arts economy, a substantial portion of which is underpaid and precarious. We keep in mind that, echoing other sectors, extreme inequality in the art world is

racially stratified: lower-paid jobs are more diverse, and as you climb up the ladder demographics increasingly become white. A different system can distribute the resources more evenly and can result in actual diversification of the field. At the very least we need a regulatory system that would facilitate better equilibrium, such that workers in the field can earn a stable living. The good news is that more and more people now clearly see that the high-stakes art market needs a thriving nonprofit sector, but that the side of the field that is interested in its content, not in profit, can function very well without the high-stakes art market.

Immediate solutions

Porcia Moore lists a series of "maps" that have been created by people of color to guide museums in antiracist work:

> There is MASS Action and the MASS Action toolkit, The Incluseum, Museums and Race, The Visitors of Color Project, Museum Workers Speak, Look at Art. Get Paid, Of By For All, Museum Hue, #MuseumsRespondToFerguson, #MuseumsAreNotNeutral, Museum Detox, Dr. Sina Bahram's work on Disability and Accessibility, Empathetic Museum, Marg[a]ret Middleton's Queer Inclusive Museum work, and a myriad of other initiatives and scholarship led by museum professionals here and abroad.[74]

MASS Action, for example, developed a Toolkit guided by the principle that "GLAM [Galleries, libraries, archives, and museums] institutions be active in the pursuit of social justice."[75] I cannot agree more. The work, they tell us, includes steps to actively assess individual and organizational biases in the museum's work culture, which should not expect assimilation, but rather foster multistreamed inclusion of ideas; review policy and practice for inclusion; pursue racial-bias training and workshops; concretely assess outcomes rather than intent; and recognize where and how policies and practices that are seemingly "race-neutral" are in fact discriminatory:

> Probing the concept of access as it relates to different collections and their histories can also be a productive exercise for staff as they reckon with past and present collections care practice. This collective work of self-reflection can lead to setting transformative goals for collections care moving forward and foster equitable exchange

between the Museum and the communities from which it has collected (or collects).⁷⁶

Kelli Morgan offers a model of equally emphasizing all stakeholders in the museum, including docents, guards, and BIPOC communities systematically ignored by marketing departments. In her museum work Morgan set a concrete example. After observing that potential communities have not been reached, she stepped in with her own resources (and personal funds) to organize an outreach campaign. Concrete positive consequences were immediately visible:

> I had gotten to know some of the museum's majority-BIPOC support staff pretty intimately. I had visited and spoken at their churches, given tours of the museum's permanent galleries to teachers and counselors from schools in their neighborhoods, partnered with local Black artists on projects that were already happening in their communities, worked in after-school art programs, and provided one-on-one mentoring to BIPOC teens and young adults. As a result of these relationships, many of which I maintain today, I knew that there was great interest in the exhibition. This allowed me and my colleagues to pepper homes, local businesses, churches, cars, windows, and schools with our DIY exhibition flyer. More BIPOC attended that exhibition opening than had visited the museum's galleries in over five years.⁷⁷

Morgan's work proves what can be done. Imagine what we could do on a social level when we allocate resources and salaries equitably.

Collecting solutions

Historical examples provide models for collecting contemporary art. According to a study by Zoë Samels at the Museum of Fine Arts Boston, in the two decades following the arrival of paintings curator William George Constable in 1941, the museum developed a "Provisional Collection," acquired alongside European masterworks with the support of Director George Edgell and the Board of Trustees. Samels cites Constable in the museum's Annual Report:

> The Trustees have opened the way to experimental acquisitions of modern work, especially of young and comparatively unknown painters. From these, in due course, those paintings which survive the

test of time will pass into the permanent collection. In this way the Museum will be able to present a cross section of contemporary activity, while guarding against the danger of being permanently saddled with acquisitions whose interest is only temporary.[78]

Unlike the model of the Musée de Luxembourg or the MoMA, discussed in Chapter 3, acquisitions did not require trustee approval, such that they could be more easily accessioned and deaccessioned:

> Over the next seventeen years, Constable's Provisional Collection grew to include one hundred and sixty-three works by 146 artists – 83 paintings and 80 works on paper. Prices paid for works in the collection ranged from 35 dollars to 3500 dollars – amounts that reflect the MFA's commitment to "young and comparatively unknown" artists. Constable and his team sourced these works from annual exhibitions, juried biennials, dealers in both New York and Boston, and the artists themselves.[79]

Purchases ranged in style, subject matter, geography, reflecting a certain diversity, of course only according to the general discriminatory logic of the time: "Women artists account for only 13% of the collection. Only two artists of color are represented despite the fact that Constable purchased works from galleries and exhibitions that featured non-white artists who fit the collection's parameters."[80] Nevertheless, such a collection, outmoded as it stands, still allows us to rediscover artists that were part of the living art world of their time, but have been overlooked for various reasons:

> The joy of my research has been in uncovering the stories of artists like Edward Melcarth – a queer communist from Kentucky who painted blue-collar workers and heroin junkies with an Old Master attention to the human form. Or Fannie Hillsmith, who explored emotion and her interior life through the fractured spaces of cubism decades after the style had fallen out of fashion.[81]

So how can we apply such a model today and also expand it to include many more? The colossal growth of the speculative market for contemporary art, which has gone hand in hand with the increase of museum exhibition and collection of the contemporary, form an impasse. The tight feedback loop between the museum and the market is artificially raising the market for artists accessioned into collections,

potentially hurting those who are deaccessioned, and overlooking entire typologies and individual practices. We need new models for collecting. We need to collect more and more laterally. While large institutions in key cities remain important, a network of well-funded small-scale institutions in cities of all sizes, towns, and rural centers can offer infrastructure for a local arts scene and exchange programs on a national scale. It should be publicly funded.

Driven by long-term research-based goals, study collections can be formed by what Kirsten Lloyd at the University of Edinburgh has termed "slow collecting," where the emphasis is on the "use" of the collection.[82] At Edinburgh, students are involved in the process of commission, lead public forums and workshops, and participate in ongoing dialogue surrounding the acquisition of complex artistic projects. Also forging bridges to other disciplines, an in-depth engagement with the subject is complemented by learning how to work with the practical and critical issues in collection development. Beyond offering production support to a living artist, this approach ensures that the relationships and the activities around an artist commission are just as significant as the work. As students are involved in producing the work and the exhibition, it adds opportunities for student learning and practice, and also helps research-based artwork receive financial or other forms of support.

If we are to follow Porcia Moore's suggestion to get rid of boards, not just by changing their demographics, but by altering who shapes decisions regarding acquisition or other forms of support in the case of living art, we can use shared governance models where decisions regarding administration, finance, and content would be reviewed by committee and augmented by peer-based panels, composed with demographic, disciplinary, and methodological diversity consideration of both the panel and the recipients. For example, artist boards and committees would draw not from star artists, but local artists who practice in circles other than the mainstream. Museum funding and programmatic decision-making would be transparent to stakeholders and include mechanisms for engagement and feedback. We can set up structures to allow for the museum's public to be a part of its governance. We can find ways to leave room for experimentation and failure, and end the culture of self-praise.

Taxing the secondary market

Work on this book has led me to the idea of levying a marginal tax (beyond capital gains and sales tax) on the resale market for art, where

the disproportionate price hikes are most extreme. The goal of supplementing meager government funding with an alternative public resource is twofold.

The first is to ensure those who profit from the field pay for its sustainability. Taxes from an overpriced art sphere can be directed toward an equitable system of public funding of the arts. The second outcome is a separation of powers, removing the influence of self-interested collector-donors. A residual outcome may be to disincentivize the use of art for pure investment purposes and especially the practice of flipping, creating a mechanism that will potentially mitigate a winner-takes-all market that feeds off sustained and deliberate information asymmetry but leverages the reputations of museums. Proposed as a congressional bill, it will include closing major tax-avoidance and deference loopholes. Equalizing prices will relax the spectacle. It will lower costs like shipping and insurance and may free up money to exhibit other types of art. The reporting necessary for the collection of such an *art and museums tax* can also provide a measure of information transparency and a potential means to regulate the market. The idea is to regulate the market in a way that is not a governmental top-down mechanism (to curb fear of government control over the arts).

In the long run

A colleague once asked me, "[B]ut under full socialism why would it matter if art-making is productive or unproductive for capitalism?" The simple answer is that we are not there yet. We cannot simply leap from high capitalism, or even neofeudalism, to socialism. To have a thriving art system, where we can administer the economy to equally support everybody, we need to know how to measure the economy correctly, as discussed in Chapter 2. Every society has an economy, there is no such thing as a society without an economy; the question is what administrative forms will a future economy take and what kind of society it will facilitate. We need a system to foster global solidarity and coordination, rather than competition. Housing, health, education, the commons, etc. should not be commodified, and we need to socialize transportation, telecommunication, and industry that would be better administered if they are not driven by the destructive logic of profit maximization. The historical fear has been that a government with a central administration of society might become authoritative or totalitarian. But, as has been painfully evident in the recent past,

capitalist systems are just as vulnerable to authoritarian takeover as communism was. But knowing history, there are ways to ensure that an equitable society would not be imposed by authoritarian means.

Museums can be a proving ground to test the potential and possibilities of disseminating public funds democratically. If we, as a society, find ways to allocate our shared resources equitably, we can calculate a different kind of relation of productive to unproductive. If art won't be expensive, then museums won't be so expensive to run, and we can divide the resources, apportion them differently, and fund ideas and the art that are already out there and the surprising new ones that can only follow from a changed infrastructure.

CONCLUSION

The visibility of a solidarity network of artists and artworkers invested in new forms of creativity, politics, and critical economic analysis that have been protesting museums and forming unions has polarized the art world in positive ways. Power in numbers is challenging the dominance and influence wielded by the ruling classes, on whom the field funded by a system of philanthropy is dependent. It forces the liberal strata, the professional/managerial class, to choose sides, in ways that can shape the direction museums will be taking in the future. Intersecting demands for racial equality, this network brings into relief the inevitable fact that in the U.S. (and elsewhere) class also has a racial character. Underscoring that the fight for racial justice is a fight for economic justice, their actions delineate how alliances are formed, and they push individuals to clarify their personal stake in the struggle. The recognition that a monied ruling class is unfit to govern our cultural institutions, because of how they sustain an unequitable social order, makes this moment ripe for the discussion and action of change. If we separate our collective cultural patrimony and the administration of contemporary art from serving wealth accumulation in the hands of the few, then the wealthy will not have access to dictate the cultural proclivities the state sanctions for all. To make institutions truly common, the connection between the public significance of art and art's price must be undone.

Art is produced outside the first orbit of capitalist social relations. It becomes a commodity by exchange, not by production. Art's social relation did not change through the industrial revolutions, the development of the capitalist nation-states, and until today, because art is not produced through a system that entails the extraction of surplus from wage labor and its reinvestment in production. Exceptional to the commodity form, art's status is a continuum that existed before capitalism and, in terms of its social relations, has survived mostly unchanged. What has changed dramatically are the world's politics, economy, and culture and with them art's ability to potentially fetch exponential growth in prices and to store value.

As a form of consumption, collections have always straddled what are here proposed as two distinct typologies of activity or motive, saving and consumption, and we know that church, princely, and smaller collections doubled as treasuries. Objects in the collection became a means to store wealth and preserve it, but their value was generated by their public status, and their ability to "speak" on behalf of their owners, not as individual objects but rather as orchestrated choirs. The externalization of the collection played a role in the ability of objects to hold value. Patronage and even more so display would produce the notoriety that then allowed objects to double as promissory notes for value. This externalization of the collection, the mandate to share it with a public, went hand in hand with the transition to absolutist rule that governed the state as a means for self-enrichment, using collections as a form of soft power to coerce by persuasion. As this custom spread through Europe, so did the definition of the public develop and expand. What the prince first shared with his peers and immediate subordinates developed into gifting of these collections by kings or governments, to their seizure by the people (or their theft by war on behalf of a people).

We observe an early version of this process in the proto-capitalist state of late-Renaissance Florence, where artists and artisans participated in an abstract economy of monetary exchange. The practice of what today we know to be art-making was just another artisanal vocation, and painting was the less valuable asset among other objects that compose the collections. The economy was not yet capitalist. Art was not produced as a commodity, but as an artisanal object. The art object then began to be collectively understood as a work of exceptional craftsmanship, a collectible. Art retained this status while the structure of the state transformed from patrimonialism or absolutism to republicanism (in its modern form). Since the late sixteenth century, art has been rendered a representative item by the ways in which royals and governments have used it systematically to signify personal, sovereign, or state identity on a world-systems scale.

The rise in demand for luxury objects in Renaissance Italy was part of the process where wealth was invested less and less in saving and more and more in consumption. At the stage of Florence's economic decline, the treasure status of art became a source for the diversion of capital from production of luxury to being a means to hoard and trade. Nevertheless, it is this investment that helped sustain Florence for generations after its alleged decline (perhaps even concealing the fact of decline to centuries of subsequent observers). We have focused on ducal Florence, because of its resemblance to our current system. Today, as

then, a financialized economy invested more in profit extraction than the reproduction of society, elevated art, collecting, and display, that today play a significant role in a financialized system of exacerbated trade in money itself.

During the Industrial Revolution and the process of urbanization, the museum was developed as a means of social control. The goal was to indoctrinate working class people into middle class manners and worldview by covert instruction. The public began to be seen as a collection of individuals characterized by their personal freedom. The upper and middle class were free as property owners. Labor was "free" because they owned their own labor power and theoretically could sell it the highest bidder. Of course, this ideal was never actually available, mostly because state and economic structures were administered and reformed by the elite according to their worldview and to serve their interests (a major one being class stratification exacerbated and sustained by racism). The development and growth of museums, as we know them today, came about at the same period when wage relations became the primary mode of organization and domination of labor in modern life. The ruling class perpetually found ways to suppress wages. One of the ways to quell concomitant social unrest, by eliciting the identification of the middle and working classes with the ruling classes and the state that administers their interests, was for the museum to foreground the appearance that the collection belongs to the public. Museums offered art to the laboring classes as a form of inclusion in the public life of the citizen. But while the appearance was and is that of freedom, the essence was and is that of exclusion and domination.

This is an extension of a capitalist system that has always had a racialized character, and has been policed accordingly. Racialization has continued to reverse the (uneven) trajectory toward more democracy and more participation, of which art has been a part during the Enlightenment and the development of the liberal, and then welfare nation-state.

Herein lies the deep-seated hypocrisy of a system that purports freedom, but is in fact built to maintain the status quo and a reserve army of labor. The ideal of personal freedom is the ideological veneer of an economy whose goal is extraction. National culture serves to convince the laborer that their well-being is the same as that of the state. Schools, religious institutions, and museums are part of the ideological state apparatus, and they are also a tool of the hegemony—the formulation where the middle and laboring classes are convinced that they are free citizens, equal in principle with the monied classes. The

assimilation is both ideological in that the working classes are being convinced to accept that the interest of the state are organically their own, and economic when they accept that the surplus they have made serves interests that are not their own. Within this, racism plays a key role in oppressing populations and thus sustaining cheap labor for capitalism and a social order based on hierarchical stratification. Our ambition to understand art's economic characteristics is that this way we can think materially about restorative justice, equity, and racial equality in art institutions.

While value is the accumulation of crystals of objectified labor, its fetishized appearances gives it a form by which it becomes visible when it is realized, or during exchange transaction. The value-form is an outcome of capitalist social relations, or rather, capitalist social relations are governed by the value-form. In this scheme art is a store of value, a value it took from labor power applied elsewhere. But as a singular object art does not hold value. It can only hold value in its status as part of a collection, because of the social role that such collections take.

Art's price potential is made possible by the political and economic power of the public. That art is at once a plaything for the elite and a storage of value, and corrals art institutions to play a role in boosting and sustaining the art market. Our problem is that museums collect the same art objects that are also collected privately, the latter sometimes at the scale of a small government. Indeed, collectors that are arts philanthropists can benefit from advantages given to them by their role in a quasi-governmental function, which render the system undemocratic. This connection of the philanthropic system and the state-backed economy provides the infrastructure on the basis of which a narrow set of particular art prices can skyrocket, increasingly raising the stakes that affect the entire circuit.

The American model reprivatized the European museums that were on their way to be public—a goal never actually reached. In the U.S., the sharing of collections with the public is administered through the nonprofit system, which itself was developed extensively as a shadow-state, essentially a privatized mode of administering welfare. While its stated legal goal is decisively to serve the public, the American nonprofit often acts as if it is a completely private entity. Born from charity, the voluntary or third sector nonprofits are neither governmental nor private, but rather operated by charter, an instrument that affords certain privileges and obligations that stem from the status of nonprofits as extensions of the state. But there is mounting evidence that

philanthropy not only serves the status quo, but is in fact one of the endemic causes of inequality. Even those who believe in the system have admitted its shortcomings. This book is a cautionary tale for all the other countries that are increasingly emulating the American model.

If the goal is to eliminate the fundamental social hierarchy of class, we need to change the relation of the economic system and society, of which the museum is an example. By looking at the museum we can get a sense of the problem and ultimately its solution.

Art collections should be considered public because art's value is social on three accounts:

1. Historically, the growth of the art market developed hand in hand with collections coming to be held in common. It is the public status of art that lends stability to the art market.
2. Today, art's ability to be tradable on a systematized market is sustained by an international network of public museums, just as the confidence in money and the stability of central banks is stabilized by the existence of total social labor. It is by virtue of its dual statuses that art's consumption is simultaneously both private and public. The market is therefore common, its profits ideally shared.
3. Art is not productive of value. Art can only hold the value it siphons from total social labor. This is not qualitative judgment but rather explains that art is an essential part of society and is necessary for the ethical dimensions of its reproduction.

Since the public is the *raison d'être* of nonprofits, we push museums for transparency on finances, acquisitions, hiring, and curatorial decision-making to ensure they represent the public; for mandating the separation of collector-patrons from any form of influence; and for paying artists. We then return to the administrative dichotomies of the museum and continue to experiment with how to administer an egalitarian society. Rather than compete for private or privatized resources, we create common pools that are then shared.

NOTES

Introduction

1. Robert Frank, "Billionaire Collector Shares Secrets to Investing in Great Art," *CNBC*, October 22, 2018, https://www.cnbc.com/2018/10/22/billionaire-collector-shares-secrets-to-investing-in-great-art.html. Tomilson Hill was Chairman of Blackstone Group's multibillion dollar hedge fund solutions group.
2. Patrick Butler and Dominic Rushe, "UN Accuses Blackstone Group of Contributing to Global Housing Crisis," *The Guardian*, March 26, 2019, sec. US news, https://www.theguardian.com/us-news/2019/mar/26/blackstone-group-accused-global-housing-crisis-un.
3. Alex Marshall, "Museums Cut Ties With Sacklers as Outrage Over Opioid Crisis Grows," *The New York Times*, March 25, 2019, sec. Arts, https://www.nytimes.com/2019/03/25/arts/design/sackler-museums-donations-oxycontin.html. Hakim Bishara and Ilana Novick, "Decolonize This Place Launches 'Nine Weeks of Art and Action' with Protest at Whitney Museum," *Hyperallergic*, March 23, 2019, https://hyperallergic.com/491418/decolonize-this-place-nine-weeks-launch/. Jasmine Weber, "Almost 50 Whitney Biennal Artists Sign Letter Demanding Removal of Warren Kanders from Museum Board," *Hyperallergic*, April 29, 2019, https://hyperallergic.com/497515/almost-50-whitney-biennal-artists-sign-letter-demanding-removal-of-warren-kanders-from-museum-board/.
4. Chin-Tao Wu, *Privatising Culture: Corporate Art Intervention since the 1980s* (London & New York: Verso, 2003), 93. Wu quotes Alan D. Ullberg and Patricia Ullberg, *Museum Trusteeship* (Washington, D.C.: American Association of Museums, 1991), 78–86; and Albert Elsen and John Henry Merryman, *Law, Ethics, and the Visual Arts* (Philadelphia: University of Pennsylvania Press, 1987), 677–96.
5. Graham Bowley and Patricia Cohen, "Buyers Find Tax Break on Art: Let It Hang Awhile in Oregon," *The New York Times*, April 12, 2014, sec. Arts, https://www.nytimes.com/2014/04/13/business/buyers-find-tax-break-on-art-let-it-hang-awhile-in-portland.html.
6. Geraldine Fabrikant, "European Museums Adapt to the American Way of Giving," *The New York Times*, March 15, 2016, sec. Arts, https://www.nytimes.com/2016/03/17/arts/design/european-museums-are-shifting-to-american-way-of-giving.html.
7. Roger Schonfeld, Mariët Westermann, and Liam Sweeney, "The Andrew W. Mellon Foundation: Art Museum Staff Demographic Survey" (*The Andrew W. Mellon Foundation*, July 28, 2015), https://mellon.org/media/filer_public/ba/99/ba99e53a-48d5-4038-80e1-66f9ba1c020e/awmf_museum_

diversity_report_aamd_7-28-15.pdf; Roger C. Schonfeld and Liam Sweeney, "Diversity in the New York City Department of Cultural Affairs Community" (*Ithaka S+R*, April 21, 2016), https://doi.org/10.18665/sr.276381; BoardSource, "Museum Board Leadership 2017: A National Report" (Washington, D.C.: BoardSource, 2017), https://www.aam-us.org/2018/01/19/museum-board-leadership-2017-a-national-report/; Mariët Westermann, Roger Schonfeld, and Liam Sweeney, "Art Museum Staff Demographic Survey 2018" (*The Andrew W. Mellon Foundation and Ithaka S+R*, January 28, 2019), https://mellon.org/news-blog/articles/art-museum-staff-demographic-survey-2018/; Chad M. Topaz et al., "Diversity of Artists in Major U.S. Museums," *PLoS ONE* 14, no. 3 (March 20, 2019), https://doi.org/10.1371/journal.pone.0212852.

8 The work of Beverley Best is notable here. Beverley Best, "Distilling a Value Theory of Ideology from Volume Three of Capital," *Historical Materialism.* 23, no. 3 (September 11, 2015): 101–41, https://doi.org/10.1163/1569206X-12341424.

9 Dave Beech, *Art and Value: Art's Economic Exceptionalism in Classical, Neoclassical and Marxist Economics*, Historical Materialism Book Series (Leiden: Brill, 2015).

10 This argument is refuted by the rigorous overviews offered in Gail Day, *Dialectical Passions: Negation in Postwar Art Theory* (New York: Columbia University Press, 2010).

11 On the way every question, in this case that of feminism, must be taken up in its totalizing condition, see: Angela Dimitrakaki and Kirsten Lloyd, "Social Reproduction Struggles and Art History," *Third Text* 31, no. 1 (January 2, 2017): 1–14, https://doi.org/10.1080/09528822.2017.1358963.

I do not address social reproduction further in this book because I rely on the definition of value that is productive for capitalism from a technical standpoint. This merits a lengthier exposition, but suffice to explain here that I see value-form theory as a tool to analyze current relations of production and, more importantly, as a means to theorize how to calculate an equally distributive economy. Social reproduction theory addresses the concrete and qualitative aspect of reproduction, such that it is aimed at a political program. A synthesis that can move us forward takes the economic aspect of value-form analysis with the political goals of social reproduction theory.

12 Evald V. Ilyenkov, *The Dialectics of the Abstract and the Concrete in Marx's Capital*, trans. Sergei Kuzyakov (Moscow: Progress Publishers [1960], 1982), 160. "Thus materialist dialectics interprets concreteness of theory as a reflection of *all the necessary aspects* of the object in their mutual conditionality and *internal interaction*" (ibid., 81). "And still why did Marx, taking all this into account, define the ascent from the abstract to the concrete as the only possible and scientifically correct mode of theoretical assimilation (reflection) of the world? The reason is that dialectics, as distinct from eclecticism, does not reason on the 'on-the-one-hand,

on-the-other-hand' principle but always points out the determining aspect, that element in the unity of opposites which is in the given instance the leading or determining one. That is an axiom of dialectics" (ibid., 99).
13 My use of the term "constellations" echoes that of Walter Benjamin, for whom constellations of ideas were to be discovered by the work of the interpreter. My work differs in the typologies of phenomena observed, looking at their social rather than cultural aspects, the goal being to articulate their historical specificity.
14 Martin Jay, *Marxism and Totality: The Adventures of a Concept Form Lukács to Habermas* (Berkeley: University of California Press, 1992), 105. Jay quotes Karl Marx, *A Contribution to the Critique of Political Economy*, trans. Nahum Isaac Stone (London: Charles H. Kerr, 1904), 293.
15 Jennifer R. Wolch, *The Shadow State: Government and Voluntary Sector in Transition* (New York: Foundation Center, 1990).
16 Thomas R. Bates, "Gramsci and the Theory of Hegemony," *Journal of the History of Ideas* 36, no. 2 (1975): 351–66, https://doi.org/10.2307/2708933.

Chapter 1

1 SFMOMA Press Office, "SFMOMA Announces Deaccession to Benefit the Acquisitions Fund and Strategically Diversify the Collection" (Press Release, February 15, 2019), https://www.sfmoma.org/press-release/rothko-deaccession-2019/.
2 Claire Selvin, "Aiming to Diversify Collection, SFMOMA Purchases 11 Works with Profits from $50 M. Rothko Sale," *ARTnews*, June 26, 2019, http://www.artnews.com/2019/06/26/sfmoma-acquisitions-rothko-deaccession/.
3 Sotheby's, "A Rare Rothko Represents the Artist at the Height of His Career," *Sothebys.com*, February 15, 2019, https://www.sothebys.com/en/articles/a-rare-rothko-represents-the-artist-at-the-height-of-his-career.
4 Lindsey Westbrook, "Field Report from Yours, Mine, and Ours: Museum Models of Public-Private Partnership," SFMOMA, February 2017, https://www.sfmoma.org/read/field-report-yours-mine-and-ours-museum-models-public-private-partnership/. Artworks mostly seem to have been given as "promised gifts." Staff, "Going Public," *The Economist*, April 30, 2016, sec. Books & arts, https://www.economist.com/books-and-arts/2016/04/30/going-public.
5 That the market for art is bigger than it has been historically is the conclusion of many professionals in the field evidenced in several citations throughout this book. William N. Goetzmann, Luc Renneboog, and Christophe Spaenjers, "Art and Money," Working Paper (National Bureau of Economic Research, April 28, 2010) show that art-market prices correlate with income inequality over two centuries. If we consider the

movements of fluctuating, yet ultimately exponentially growing inequality, as shown in Piketty's massive study, we can derive that the market for art is relatively large at the moment.
6 Alessia Zorloni and Antonella Ardizzone, "The Winner-Take-All Contemporary Art Market," *Creative Industries Journal* 9, no. 1 (April 25, 2016): 1–14, https://doi.org/10.1080/17510694.2016.1154651.
7 Georgina Adam, *Dark Side of the Boom: The Excesses of the Art Market in the 21st Century* (London: Lund Humphries, 2017).
8 Tony Norfield, *The City: London and the Global Power of Finance* (London: Verso, 2016), 30. Significantly, Tony Norfield is not just a Marxist theorist, he worked as an Executive Director in charge of analyzing global FX markets for a major European bank.
9 On how biased the system is toward supporting wealth accumulation, see Rob Reich, *Just Giving: Why Philanthropy Is Failing Democracy and How It Can Do Better* (Princeton: Princeton University Press, 2018). This particular discrimination is discussed in chapter 2, "Philanthropy and Its Uneasy Relationship to Equity," 65–105.
10 Richardson Virginia and Francis Reilly John, "Public Charity or Private Foundation Status Issues under IRC 509(a)(1)-(4), 4942(j)(3), and 507," Exempt Organizations-Technical Instruction Program for FY 2003 (IRS, 2003), https://www.irs.gov/pub/irs-tege/eotopicb03.pdf.
11 In 2007, for example, the museum received $51,682,253 in direct public funding, and $640,875 in government contribution. San Francisco Museum of Modern Art, "SFMOMA Form I-990," Schedule A; I.7, 2007.
12 In a grant application, for example, it claims to be public: SFMOMA, "Application MA-10-15-0494-15," Project Category: Learning Experiences Funding Level: $25,001-$150,000 (Museums for America, 2016), https://www.imls.gov/sites/default/files/ma-10-15-0494_-_san_francisco_museum_of_modern_art.pdf.
13 Charles Desmarais, "Unraveling SFMOMA's Deal for the Fisher Collection," *San Francisco Chronicle*, August 21, 2016, https://www.sfchronicle.com/art/article/Unraveling-SFMOMA-s-deal-for-the-Fisher-9175280.php.
14 SFMOMA Press Office, "SFMOMA Announces Pioneering Partnership to Share the Fisher Collection with the Public," Press Release, September 25, 2009, https://www.sfmoma.org/press-release/sfmoma-announces-pioneering-partnership-to-share/.
15 According to current tax law, if the foundation were to be dissolved, without being transferred to another charitable foundation, the beneficiaries of the assets will have to pay tax. Internal Revenue Service, "Life Cycle of a Private Foundation Termination of Foundation Under State Law," June 5, 2019, https://www.irs.gov/charities-non-profits/private-foundations/life-cycle-of-a-private-foundation-termination-of-foundation-under-state-law.

16 David Bonetti, "The Picasso Has Left the Building," *SFGate*, April 16, 2000, https://www.sfgate.com/entertainment/article/The-Picasso-has-left-the-building-3065216.php; Judith H. Dobrzynski, "Whitney Gives Up a Gift, and Competitors Blanch," *The New York Times*, May 28, 1999, sec. Arts, https://www.nytimes.com/1999/05/28/arts/whitney-gives-up-a-gift-and-competitors-blanch.html; Judith H. Dobrzynski, "Sold Calder May Head To Museum In Bay Area," *The New York Times*, June 2, 1999, sec. Arts, https://www.nytimes.com/1999/06/02/arts/sold-calder-may-head-to-museum-in-bay-area.html.

17 Tony Bonsignore, "A £50m Painting, the 7th Duke of Sutherland, and the Taxpayer," *Citywire*, August 30, 2008, http://citywire.co.uk/funds-insider/news/a-50m-painting-the-7th-duke-of-sutherland-and-the-taxpayer/a312605; National Gallery, London Press office, "'Diana and Actaeon' Is Secured for the Nation" (Press Release, February 2009), https://www.nationalgallery.org.uk/about-us/press-and-media/press-releases/diana-and-actaeon-is-secured-for-the-nation; Staff, "National Galleries Pay Duke of Sutherland 45m Pounds for Second Titian," *HeraldScotland*, March 1, 2012, https://www.heraldscotland.com/news/13048987.national-galleries-pay-duke-of-sutherland-45m-pounds-for-second-titian/.

18 Jori Finkel, "SFMOMA Chooses Architect for $250-Million Expansion: Norwegian Firm Snøhetta," *Culture Monster* (blog), July 21, 2010, https://latimesblogs.latimes.com/culturemonster/2010/07/sfm.html.

19 Press Office, "Nixon Peabody Congratulates the Fisher Family and SFMOMA as the Transformed and Expanded Museum Opens to the Public," Press Release, Nixon Peabody LLP, May 11, 2016, https://www.nixonpeabody.com/en/news/press-releases/2016/05/12/nixon-peabody-congratulates-the-fisher-family-and-sfmoma-as-the-transformed-and-expanded-museum-ope.

20 "Nixon Peabody LLP's Art & Cultural Institutions Practice, led by partner Thaddeus J. Stauber, served as deal counsel and advisor to the Fisher Family and SFMOMA to create this unprecedented agreement . . . Mr. Stauber and his team . . . supported SFMOMA's effort to meet its $610 million campaign goal which covers construction costs, nearly tripling its endowment and funded operating expenses for the three years the museum was closed." Ignacio Villarreal, "The Dealmaker behind the San Francisco Museum of Modern Art and Fisher Family Partnership," *Artdaily*, May 16, 2016, http://artdaily.com/news/87290/The-dealmaker-behind-the-San-Francisco-Museum-of-Modern-Art-and-Fisher-Family-partnership#.XRSxFnu-khs.

"In addition, Mr. Stauber and team supported SFMOMA's effort to raise landmark contributions of $250M, more than 50 percent of the $480M campaign to expand the museum and grow its endowment." Press Office, "Nixon Peabody's Art & Cultural Institutions Team Plays Key Role in SFMOMA Expansion: San Francisco Museum of Modern Art to

Expand; Museum Will Showcase Fisher Family's Renowned Art Collection," Press Release, Nixon Peabody LLP, March 15, 2010, https://www.nixonpeabody.com:443/en/news/press-releases/2010/03/15/nixon-peabodys-art-cultural-institutions-team-plays-key-role-in-sfmoma-expansion-san-f.

21 Ariel Hagan, "Public Duty and Private Pursuits: Reconciling 21st Century Relationships Between Collectors and Art Museums" (MA diss., Boulder, University of Colorado, 2011), 60.
22 Desmarais, "Unraveling SFMOMA's Deal for the Fisher Collection."
23 Hilarie M. Sheets, "How The Gap's Founders Helped Shape the New SFMOMA," *Artsy*, April 28, 2016, https://www.artsy.net/article/artsy-editorial-how-the-gap-s-founders-helped-shape-the-new-sfmoma.
24 Hagan, "Public Duty and Private Pursuits," 55. Hagan quotes her interviews with John Zarobell, August 6, 2010, and with Laura Satersmoen, August 4, 2010.
25 David Littlejohn writes that the Fisher Family Foundation will pay for the work's upkeep and conservation. Littlejohn, "SFMOMA Fills In Some Blanks."
26 The Fisher Foundation tax returns for 2014, for example, show the foundation has written off $875,116 in support of the SFMOMA. Fisher Art Foundation, "Form I990-PF," 2014, Part IX-A
27 Julian Guthrie, "Why Gap Founder Fisher Decided to Build His Own Art Museum," *SFGate*, August 12, 2007, https://www.sfgate.com/news/article/Why-Gap-founder-Fisher-decided-to-build-his-own-3758499.php.
28 This is supported by Eli Broad's statements in Guthrie, "Why Gap Founder Fisher Decided to Build His Own Art Museum."
29 Hagan, "Public Duty and Private Pursuits," 59.
30 Hagan, "Public Duty and Private Pursuits," 60.
31 Judith H. Dobrzynski, "The Fisher Folly: SFMoMA's Bad Deal," *Real Clear Arts* (blog), August 22, 2016, https://www.artsjournal.com/realcleararts/2016/08/the-fisher-folly-sfmomas-bad-deal.html.
32 Ibid., 62. The law mentioned is the 2006 Pension Protection Act, which changed the rules for fractional or partial gifts disallowing donors tax advantage for future appreciation of the work. Another example for tax considerations can be seen here: "Parents often use such partnerships to pass assets to heirs in a way that lowers estate taxes, said Laura Peebles, a director in the estate gift and trust group at Deloitte & Touche. The Internal Revenue Service has opposed the practice, she added." Staff, "Gap Founders Transfer Assets," *Los Angeles Times*, August 7, 2004, https://www.latimes.com/archives/la-xpm-2004-aug-07-fi-gap7-story.html.
33 Jonathon Keats, "How Billionaire Charles Schwab Brokered San Francisco's New $610 Million Masterpiece," *Forbes*, June 21, 2016, sec. Arts, https://www.forbes.com/sites/jonathonkeats/2016/06/01/billionaire-charles-schwab-on-san-franciscos-new-610-million-masterpiece-sfmoma/#648197434378.

34 Andrew S. Ross, "Schwab Office Opens in Style," *SFGate*, October 28, 2009, https://www.sfgate.com/business/article/Schwab-office-opens-in-style-3212015.php.
35 Lawrence Mishel, "Vast Majority of Wage Earners Are Working Harder, and for Not Much More: Trends in U.S. Work Hours and Wages over 1979–2007" (Economic Policy Institute, January 30, 2013), https://www.epi.org/publication/ib348-trends-us-work-hours-wages-1979-2007/; Meagan Day, "Working Hard, Hardly Working," *Jacobin*, March 5, 2018, https://jacobinmag.com/2018/03/labor-workforce-unemployment-overwork.
36 Thomas Piketty and Arthur Goldhammer, *Capital in the Twenty-First Century* (Cambridge, MA: The Belknap Press of Harvard University Press, 2017).
37 Liz Ann Sonders, "Trade Mistakes: Will a Trade Spat Turn Into a Trade War?" (Charles Schwab Corporation, March 26, 2018), https://www.schwab.com/resource-center/insights/content/trade-mistakes-will-trade-spat-turn-into-trade-war.
38 Fox Business, *Charles Schwab on Trump's Tariffs: There Is Really Is No Free Trade* (Fox Business), accessed June 3, 2018, https://www.youtube.com/watch?v=S27O7nO1V4M.
39 Romi S. Mukherjee, "Make America Great Again as White Political Theology," *Revue LISA/LISA e-Journal [En Ligne]*, vol. XVI, no. 2 (September 10, 2018), https://doi.org/10.4000/lisa.9887; Issac Bailey, "Why Trump's MAGA Hats Have Become a Potent Symbol of Racism," *CNN*, March 12, 2019, sec. Opinion, https://www.cnn.com/2019/01/21/opinions/maga-hat-has-become-a-potent-racist-symbol-bailey/index.html.
40 Reuters, "Who Donated to President Trump's Gigantic Inauguration Fund," *Fortune*, April 20, 2017, https://fortune.com/2017/04/20/donald-trump-inauguration-donors/; Graham Lanktree, "Billionaire Robert Mercer Is Helping Pay Donald Trump's Legal Bills," *Newsweek*, October 3, 2017, https://www.newsweek.com/trump-legal-fund-paid-billionaire-robert-mercer-day-comey-fired-676383.
41 "Since World War II, the tax rate has changed significantly six times. The effects on the economy were different each time: the tax rate on high income earners has no relationship to economic growth." Tyler Fisher, "How Past Income Tax Rate Cuts on the Wealthy Affected the Economy," *POLITICO*, September 27, 2017, https://www.politico.com/interactives/2017/gop-tax-rate-cut-wealthy/; Emily Stewart, "Republicans Said Their Tax Bill Would Go to Workers. Instead, It's Going to Wall Street," *Vox*, March 22, 2018, https://www.vox.com/policy-and-politics/2018/3/22/17144870/stock-buybacks-republican-tax-cuts.
42 La Tanya S. Autry and Mike Murawski, "Museums Are Not Neutral," MuseumsAreNotNeutral, accessed May 8, 2021, https://www.museumsarenotneutral.com/learn-more.
43 Sam Lefebvre, "Special Report: 'Toxic Donors' Are Coming under Fire at Art Museums — but Not in Liberal San Francisco. What Will SFMOMA

Do?,'" *Mission Local* (blog), May 15, 2019, https://missionlocal.org/2019/05/toxic-donors-are-coming-under-fire-at-art-museums-but-not-in-liberal-san-francisco-what-will-sfmoma-do/.

44 Rebecca Solnit, "Get Off the Bus," *London Review of Books*, Diary, 36, no. 04 (February 20, 2014), https://www.lrb.co.uk/the-paper/v36/n04/rebecca-solnit/diary.

45 Ultra Red, "Desarmando Desarrollismo: Listening to Anti-Gentrification in Boyle Heights," *FIELD*, no. 14 (Winter 2020), http://field-journal.com/issue-14/desarmando-desarrollismo.

46 Magally Miranda and Kyle Lane-McKinley, "Artwashing, or, Between Social Practice and Social Reproduction," *A Blade of Grass*, February 1, 2017, https://www.abladeofgrass.org/fertile-ground/artwashing-social-practice-social-reproduction/.

47 Lefebvre, "Special Report."

48 Adam Brinklow, "UN Expert Decries Homeless Conditions in Bay Area as 'Cruel,' 'Unacceptable,'" *Curbed SF*, January 22, 2018, https://sf.curbed.com/2018/1/22/16920118/homeless-oakland-san-francisco-united-nations; Alastair Gee, "San Francisco or Mumbai? UN Envoy Encounters Homeless Life in California," *The Guardian*, January 22, 2018, sec. US news, https://www.theguardian.com/us-news/2018/jan/22/un-rapporteur-homeless-san-francisco-california.

49 Rebecca Solnit, "Google Invades," *London Review of Books*, Diary, 35, no. 03 (February 7, 2013), https://www.lrb.co.uk/the-paper/v35/n03/rebecca-solnit/diary.

50 Peter E. Moskowitz, *How to Kill a City: Gentrification, Inequality, and the Fight for the Neighborhood* (New York: Bold Type Books, 2017); Sam Wetherell, "Richard Florida Is Sorry," *Jacobin*, August 19, 2017, https://jacobinmag.com/2017/08/new-urban-crisis-review-richard-florida.

51 Craig N. Smith, Sean Ansett, and Lior Erez, "How Gap Inc. Engaged With Its Stakeholders," *MIT Sloan Management Review*, June 22, 2011, https://sloanreview.mit.edu/article/how-gap-inc-engaged-with-its-stakeholders/.

52 Hector Figueroa, "In the Name of Fashion: Exploitation in the Garment Industry," *North American Congress on Latin America*, September 25, 2007, https://nacla.org/article/name-fashion-exploitation-garment-industry; Sarah Morrison, "Bangladesh Factory Collapse: Gap Refuses to Back Safety Deal," *The Independent*, May 14, 2013, http://www.independent.co.uk/news/world/asia/bangladesh-factory-collapse-gap-refuses-to-back-safety-deal-8615599.html; Christie Miedema, "Five Years after Rana Plaza, the Need for the Bangladesh Accord Persists," News, Clean Clothes Campaign, April 18, 2018, https://cleanclothes.org/news/2018/04/18/five-years-after-rana-plaza-the-need-for-the-bangladesh-accord-persists; Business & Human Rights Resource Centre, "NGO Statement Alleges That Alliance for Bangladesh Worker Safety Led by Gap, Wal-Mart Contains 'Empty Promises,'" Latest News, October 7, 2013, https://www.business-

humanrights.org/en/ngo-statement-alleges-that-alliance-for-bangladesh-worker-safety-led-by-gap-wal-mart-contains-empty-promises.
53 David Boyer, "Despite Obama's Praise for Higher Pay, The Gap Inc. Has Spotty Record on Sweatshops," *The Washington Times*, March 16, 2014, sec. Politics, https://www.washingtontimes.com/news/2014/mar/16/despite-obamas-praise-for-higher-pay-gaps-has-spot/.
54 Kieran Guilbert and Amber Milne, "Big Clothes Brands Found to Fall Short of Own Fair Wage Promises," *Reuters*, May 30, 2019, https://www.reuters.com/article/global-garment-workers-pay-idUSL8N23540T.
55 Martin Gilens and Benjamin I. Page, "Testing Theories of American Politics: Elites, Interest Groups, and Average Citizens," *Perspectives on Politics* 12, no. 3 (September 2014): 564–81, https://doi.org/10.1017/S1537592714001595.
56 Matt Smith, "Filling the Civic Gap," *SF Weekly*, June 21, 2006, http://www.sfweekly.com/news/filling-the-civic-gap/.
57 Although cast as support for education, numerous studies have shown the charter-school movement to be an attempt at privatizing education, harmful to the public education system, but also failing to deliver on their promises. Eric Blanc, "Billionaires vs. LA Schools," *Jacobin*, January 15, 2019, https://jacobinmag.com/2019/01/la-teachers-strike-charters-privatization; Cynthia Liu, "Weaponized Generosity: How L.A.'s 1% Disrupt Democracy and Dismantle the Public School System," *The Progressive*, September 25, 2015, https://progressive.org/public-school-shakedown/weaponized-generosity-l.a.-s-1-disrupt-democracy-dismantle-public-school-system/.
58 The term "global south" indicates developing nations that are financially exploited by leading nations. This includes Mexico–U.S. relations, Eastern–Western European relations, and China as a manufacturing center, acknowledging that what John Smith called "global labor arbitrage," where manufacturing follows cheap labor, is an ongoing dynamic. My analysis in this section relies heavily on Smith's meticulous and comprehensive study: John Smith, *Imperialism in the Twenty-First Century: Globalization, Super-Exploitation, and Capitalism's Final Crisis* (New York: Monthly Review Press, 2016).
59 Adam Smith, "Of the Accumulation of Capital, or of Productive and Unproductive Labour," in *The Wealth of Nations*, ed. Edwin Cannan (London: Modern Library, 1994). "Both productive and unproductive labourers, and those who do not labour at all, are all equally maintained by the annual produce of the land and labour of the country" (361).
60 John Smith, "The GDP Illusion," *Monthly Review*, July 1, 2012, https://monthlyreview.org/2012/07/01/the-gdp-illusion/. Beyond showing false growth of a crisis-bound system, higher GDP gives imperialist nations powerful advantages. See Tony Norfield, "Index of Power," *Economics of Imperialism* (blog), February 12, 2018, https://economicsofimperialism.blogspot.com/2018/02/index-of-power.html.

61 Smith, *Imperialism in the Twenty-First Century*.
62 Andy Higginbottom, "'Imperialist Rent' in Practice and Theory," *Globalizations* 11, no. 1 (January 2, 2014): 23–33, https://doi.org/10.1080/14747731.2014.860321.
63 Immanuel Wallerstein, *The Modern World-System I: Capitalist Agriculture and the Origins of the European World-Economy in the Sixteenth Century* (New York: Academic Press, 1974).
64 François Chesnais, *Finance Capital Today: Corporations and Banks in the Lasting Global Slump*, vol. 131, Historical Materialism Book Series (Leiden: Brill, 2016), 162, https://doi.org/10.1163/9789004255487.
65 The NEA's Office of Research & Analysis, "NEA Guide to the U.S. Arts and Cultural Production Satellite Account" (National Endowment for the Arts, December 2013), https://www.arts.gov/sites/default/files/nea_guide_white_paper.pdf.
66 Book Launch, *World in Crisis: A Global Analysis of Marx's Law of Profitability*, Historical Materialism Conference, November 9, 2018, London. For Brian Green's website, see https://theplanningmotive.com.
67 Smith, *Imperialism in the Twenty-First Century*, 265.
68 Joseph E. Stiglitz and Linda J. Bilmes, "The Book of Jobs," *Vanity Fair*, January 2012, https://www.vanityfair.com/news/2012/01/stiglitz-depression-201201. A Keynesian, Stiglitz does not go into the core crisis of capitalism in the tendency of rates of profit to fall, or question what government stimulus might mean without an orchestrated economy that can control overproduction, for example. For these reasons I am not in agreement with his solutions, but this does not mean we should not use his analysis, as I do with Paul Krugman, or Martin Wolf, for example.
69 See, for example, this blog written by an economist who has worked in the City of London for over forty years. Michael Roberts, "A World Rate of Profit: A New Approach," *Michael Roberts Blog* (blog), July 25, 2020, https://thenextrecession.wordpress.com/2020/07/25/a-world-rate-of-profit-a-new-approach/.
70 See, for example, David Roberts, "None of the World's Top Industries Would Be Profitable If They Paid for the Natural Capital They Use," *Grist*, April 17, 2013, sec. Business & Technology, https://grist.org/business-technology/none-of-the-worlds-top-industries-would-be-profitable-if-they-paid-for-the-natural-capital-they-use/; Clare O'Connor, "Report: Walmart Workers Cost Taxpayers $6.2 Billion In Public Assistance," *Forbes*, April 15, 2014. https://www.forbes.com/sites/clareoconnor/2014/04/15/report-walmart-workers-cost-taxpayers-6-2-billion-in-public-assistance/#293a2df3720b.
71 "Silicon Valley power players, from Marissa Mayer to Marc Andreessen, are beginning to buy art — and museum directors and dealers are eager to help; Creating a 'farm team' of young donors." Ellen Gamerman, "The New High-Tech Patrons," *The Wall Street Journal*, February 28, 2013, https://www.wsj.com/articles/SB10001424127887323384604578328121811415726.

See also Dodie Kazanjian, "Inside Yves Béhar and Sabrina Buell's High-Tech San Francisco Home," *Vogue*, May 30, 2016, https://www.vogue.com/article/sabrina-buell-yves-behar-san-francisco-home.

72 Annie Armstrong, "For Third Year in a Row, Trump Administration Threatens to Cut NEA Funding," *ARTnews*, March 18, 2019, http://www.artnews.com/2019/03/18/trump-administration-threatens-to-cut-nea-funding-2020/.

73 Mike Huckabee, "A Conservative Plea for the National Endowment for the Arts," *The Washington Post*, March 22, 2017, sec. Opinions, https://www.washingtonpost.com/opinions/mike-huckabee-a-conservative-plea-for-the-national-endowment-of-the-arts/2017/03/22/8d6d746a-0d94-11e7-9d5a-a83e627dc120_story.html; Graham Bowley, "How to Block Trump Arts Cuts? Groups Look for G.O.P. Help," *The New York Times*, December 22, 2017, sec. Arts, https://www.nytimes.com/2017/02/28/arts/how-to-block-trump-arts-cuts-groups-look-for-gop-help.html.

74 Earle Mack, Randall Bourscheidt, and Robert Lynch, "Funding the Arts Is More than Preserving Culture. It's Big Business.," *TheHill*, February 19, 2017, https://thehill.com/blogs/pundits-blog/uncategorized/320235-funding-the-arts-is-more-than-preserving-culture-its-big. The authors—Earle I. Mack, chairman emeritus of the New York State Council on the Arts; Randall Bourscheidt, president emeritus of the Alliance for the Arts; and Robert L. Lynch, president and CEO of Americans for the Arts—cite U.S. Bureau of Economic Analysis, "Arts and Cultural Production Satellite Account, U.S. and States 2014," April 19, 2017, https://www.bea.gov/news/2017/arts-and-cultural-production-satellite-account-us-and-states-2014.

See also College Art Association, "CAA Arts and Humanities Advocacy Toolkit," *CAA News Today*, March 2, 2017, http://www.collegeart.org/news/2017/03/02/caa-arts-and-humanities-advocacy-toolkit/; Americans for the Arts, "National Findings," Arts & Economic Prosperity IV, May 15, 2019, https://www.americansforthearts.org/by-program/reports-and-data/research-studies-publications/arts-economic-prosperity-iv/national-findings.

75 John Thomasian, "Arts & the Economy: Using Arts and Culture to Stimulate States Economic Development" (National Governor's Association, January 14, 2009), https://www.americansforthearts.org/sites/default/files/0901ARTSANDECONOMY.pdf; Nancy Geltman, "New Engines of Growth: Five Roles for Arts, Culture, and Design" (National Governors Association, May 2012), https://www.americansforthearts.org/sites/default/files/NGANewEnginesofGrowth.pdf.

76 National Endowment for the Arts, "NEA Quick Facts 2018," 2018, https://www.arts.gov/sites/default/files/NEA_Quick_Facts_2018_V.1.pdf.

77 John Wake, "Why Isn't The Black Homeownership Rate Higher Today Than When The 1968 Fair Housing Act Became Law?," *Forbes*, May 16, 2019, sec. Consumer, https://www.forbes.com/sites/johnwake/2019/05/16/heres-why-

the-black-homeownership-rate-is-the-same-50-years-after-1968-fair-housing-act/.
78 Carole Vance, "Reagan's Revenge: Restructuring the NEA," *Art in America* 78, no. 11 (1990): 49–55.
79 INCITE!, *The Revolution Will Not Be Funded Beyond the Non-Profit Industrial Complex* (Durham, NC: Duke University Press, 2017).
80 A sample includes David Callahan, *The Givers: Wealth, Power, and Philanthropy in a New Gilded Age* (New York: Vintage, 2018); Kathryn Brown, "Private Influence, Public Goods, and the Future of Art History," *Journal for Art Market Studies* 3, no. 1 (May 14, 2019), https://doi.org/10.23690/jams.v3i1.86; Robert F. Arnove, ed., "Introduction," in *Philanthropy and Cultural Imperialism: The Foundations at Home and Abroad* (Bloomington: Indiana University Press, 1982); Mark Dowie, *American Foundations: An Investigative History* (Cambridge, MA: MIT Press, 2001); Anand Giridharadas, *Winners Take All: The Elite Charade of Changing the World* (New York: Alfred A. Knopf, 2018).
81 Michael Lipsky and Steven Rathgeb Smith, "Nonprofit Organizations, Government, and the Welfare State," *Political Science Quarterly* 104, no. 4 (Winter, 1989–1990): 625–48, https://doi.org/10.2307/2151102; Lester M. Salamon, "The Marketization of Welfare: Changing Nonprofit and For-Profit Roles in the American Welfare State," *Social Service Review* 67, no. 1 (March 1993): 16–39, https://doi.org/10.2307/30012181.
82 Drew Desilver, "U.S. Income Inequality, on Rise for Decades, Is Now Highest since 1928," Factank, *Pew Research Center* (blog), December 5, 2013, https://www.pewresearch.org/fact-tank/2013/12/05/u-s-income-inequality-on-rise-for-decades-is-now-highest-since-1928/.
83 The "upsidedown effect." Reich, *Just Giving*; Benjamin Soskis, "Giving Numbers: Reflections on Why, What, and How We Are Counting," *Nonprofit Quarterly*, November 1, 2017, https://nonprofitquarterly.org/giving-numbers-reflections-counting/.
84 Jane Mayer, "The Koch Brothers' Covert Ops," *The New Yorker*, August 23, 2010, https://www.newyorker.com/magazine/2010/08/30/covert-operations.
85 Vance, "Reagan's Revenge." See also Richard Bolton, ed., *Culture Wars: Documents from the Recent Controversies in the Arts* (New York: The New Press, 1992); Richard Meyer, "The Jesse Helms Theory of Art," *October* 104 (April 1, 2003): 131–48, https://doi.org/10.1162/016228703322031749.
86 Cynthia M. Koch, "The Contest for American Culture: A Leadership Case Study on The NEA and NEH Funding Crisis," *Public Talk*, 1998, http://www.upenn.edu/pnc/ptkoch.html. Charles T. Clotfelter gives us an earlier version: "Since its establishment in 1965, the NEA has been a bellwether for judging the government's disposition toward funding the arts. Table 9.2 summarizes the agency's appropriations over its history. In real terms, its

budget grew rapidly over the first decade and a half of its existence, growing at an annual compounded rate of 18 percent from 1967 to 1979. But this growth was reversed in the wake of increased inflation and the Reagan retrenchments. Between 1979 and 1988, the real value of the budget declined by more than one-fourth. Even at its peak, however, direct federal funding for the arts in the United States has remained significantly smaller on a per capita basis than government support in Western Europe." Charles T. Clotfelter, "Government Policy Toward Art Museums in the United States," in *The Economics of Art Museums*, ed. Martin Feldstein, A National Bureau of Economic Research Conference Report (Chicago: The University of Chicago Press, 1991), 245, https://epdf.pub/the-economics-of-art-museums-national-bureau-of-economic-research-conference-rep.html.

87 "By the end of the 1990s, the inflation-adjusted value of federal appropriations to the NEA had declined by more than half (54 percent) from the start of the decade, and the agency had moved from over a dozen divisions focused on specific disciplines to 'a few generic themes.' Community-based arts represented a particular casualty of these changes." Steven Lawrence, "Arts Funding at Twenty-Five: What Data and Analysis Continue to Tell Funders about the Field," *Grantmakers in the Arts Reader* 29, no. 1 (Winter 2018): 16, https://www.giarts.org/article/arts-funding-twenty-five. Lawrence quotes Dudley Cocke, "The Unreported Arts Recession of 1997," *Grantmakers in the Arts* 20, no. 2 (Summer 2011), https://www.giarts.org/article/unreported-arts-recession-1997.

88 Indicated in Figures Koch, "The Contest for American Culture: A Leadership Case Study on The NEA and NEH Funding Crisis."

89 "It is well known that the actual dollar contribution of the federal agencies to the nation's cultural life is minute. The combined 1998 appropriations for the two national endowments is $.78 per person in the United States, while the total government (including state and local) spending on culture in this country is $6.25. In other Western countries the government share of spending on culture is much higher: $27.40 per person in the United Kingdom and $97.70 in Finland, the biggest spender in Europe. The combined budgets of the NEA and the NEH will amount to approximately 1/100 of 1% of the 1999 federal budget of $1,751 billion. In the United States private philanthropy's share is much more important than it is in other countries, but it only amounts to another $2.96 per person — bringing our total support for culture to less than $10 per person." Koch, "The Contest for American Culture," 3. This serves to refute the argument that foregoing tax money in lieu of philanthropy amounts to proper subsidy for the arts.

90 Ibid., 18. Koch cites Jamil Zainaldin, "Chronology of 1995 Legislative Activities," report delivered to the National Conference of State Humanities Councils, September 10, 1995.

91 As a report written in 2014 indicates, "Although the nominal increase over the past twenty-one years is positive, the landscape for public funding for

the arts in this time period is much bleaker when accounting for inflation. In fact, after adjusting for inflation, public funding for the arts has decreased by more than 30 percent in this same period." Ryan Stubbs, "Public Funding for the Arts: 2014 Update," Arts Funding Snapshot: GIA's Annual Research on Support for Arts and Culture, GIA Reader (Grantmakers in the Arts, Fall 2014), 8, https://www.giarts.org/sites/default/files/25-3_Vital-Signs.pdf.

See also Scott M. Stringer, "Culture Shock: The Importance of National Arts Funding to New York City's Cultural Landscape" (Office of the New York City Comptroller Scott M. Stringer, March 9, 2017), https://comptroller.nyc.gov/reports/culture-shock-the-importance-of-national-arts-funding-to-new-york-citys-cultural-landscape/.

92 Margaret J. Wyszomirski, "Philanthropy and Culture: Patterns, Context, and Change," in *Philanthropy and the Nonprofit Sector in a Changing America*, ed. Charles Thomas Clotfelter and Thomas Ehrlich (Bloomington: Indiana University Press, 2005), 461–80, 466.

93 Andy Horwitz explains that NEA funding from the 1990s to the 2010s went to larger more "mainstream" institutions and the smaller ones, that tend to be more oriented towards historically excluded communities, were left behind, implying a bias: "'There's a structure in place that has kept opportunity away from certain folks,' says Janet Brown, the president of Grantmakers in the Arts." Horwitz, "Who Should Pay for the Arts in America?," *The Atlantic*, January 31, 2016, https://www.theatlantic.com/entertainment/archive/2016/01/the-state-of-public-funding-for-the-arts-in-america/424056/. Horowitz also examines a DeVos Institute study that confirms that trend of bias against minority funding "the median budget sizeof the 20 largest arts organizations of color surveyed inthis paper is more than 90 percent smaller than that of the largest mainstream organizations in their industries." The DeVos Institute of Arts Management, "Diversity In The Arts: The Past, Present, and Future of African American and Latino Museums, Dance Companies, and Theater Companies" (the University of Maryland, September 2015), http://devosinstitute.umd.edu/~/media/D6750176AEF94F918E8D774693C03E53.ashx. The DeVos Institute study is nevertheless problematic, as he points out, because in spite of the proposed increase in support for a small number of well-established institutions, this would actually further increase disparities. Not only are more studies required, they need critical methodologies to reveal the oversights of mainstream economics and sociology. For example, a study that found that there is no bias in NEA grant allocation to wealthier communities perhaps reached these conclusions because it failed to ask basic questions that would arise from a critical geography perspective. Gan, Voss, and Giraud Voss conclude: "[F]unding is more often awarded to economically diverse communities with a higher percentage of households that are wealthy and a higher percentage of households that are below the poverty line." This key finding fails to account for the fact that many arts

institutions are located in gentrifying neighborhoods and that their public is not actually the same communities that the institutions inhabit. See Anne Marie Gan, Glenn Voss, and Zannie Giraud Voss, "Do Grants from the National Endowment for the Arts Represent a Wealth Transfer from Poorer to Wealthier Citizens?" (National Center for Arts Research, July 2014), https://www.smu.edu/~/media/Site/Meadows/NCAR/NCAR%20NEA%20Study.

94 On February 9, 1961, Representative Frank Thompson (D-NJ) introduces H.R. 4172 to establish an advisory council on the arts, within the Department of Health, Education and Welfare, that would coordinate private and government arts activities. Hearings were held, but the bill was defeated in the House. Then in March 1962, President Kennedy appointed August Heckscher as his Special Consultant on the Arts and asked him to prepare a report on the relationship between the arts and the federal government. He submitted his report, "The Arts and the National Government," which recommended the establishment of an Advisory Council on the Arts and a National Arts Foundation to administer grants-in-aid, in May 28, 1963. President Kennedy established the President's Advisory Council on the Arts by executive order on June 12, 1963. However, the president was assassinated before members could be appointed. The National Foundation on the Arts and the Humanities Act was signed by President Johnson on September 29, 1965. National Endowment for the Arts, "National Endowment for the Arts, 1965-2000: A Brief Chronology of Federal Support for the Arts" (National Endowment for the Arts, 2000), https://www.arts.gov/sites/default/files/NEAChronWeb.pdf.

95 Vance, "Reagan's Revenge."

96 Laurence Jarvik, "Ten Good Reasons to Eliminate Funding for the National Endowment for the Arts," Budget and Spending (The Heritage Foundation, April 29, 1997), https://www.heritage.org/report/ten-good-reasons-eliminate-funding-the-national-endowment-orthe-arts.

97 Vance, "Reagan's Revenge," 53.

98 The malevolent attack on the NEA by the Heritage Foundation cites some of the Reagan-year sentiments. Faulty at its core, it separates race and ethnicity from class, ignoring their historical and structural interlinks. See Jarvik, "Ten Good Reasons to Eliminate Funding for the National Endowment for the Arts."

99 We need many more data sets for diversity statistics than we currently have. Antonio Cuyler, "An Exploratory Study of Demographic Diversity in the Arts Management Workforce," *Grantmakers in the Arts* 26, no. 3 (Fall 2015), https://www.giarts.org/article/exploratory-study-demographic-diversity-arts-management-workforce.

For how starkly undiverse museum collections are, see Chad M. Topaz et al., "Diversity of Artists in Major U.S. Museums," *PLoS ONE* 14, no. 3 (March 20, 2019), https://doi.org/10.1371/journal.pone.0212852.

For how methodological diversity is compromised by market interest, see Robin Pogrebin, "Art Galleries Face Pressure to Fund Museum Shows," *The New York Times*, March 7, 2016, sec. Arts, https://www.nytimes.com/2016/03/07/arts/design/art-galleries-face-pressure-to-fund-museum-shows.html; "Nearly a third of the major solo exhibitions at museums in the United States between 2007 and 2013 featured artists represented by just five galleries, according to a recent survey by the The Art Newspaper: Gagosian, Pace, Marian Goodman, David Zwirner and Hauser & Wirth."

100 SFMOMA Press Office, "SFMOMA Announces Pioneering Partnership to Share the Fisher Collection with the Public" (Press Release, September 25, 2009), https://www.sfmoma.org/press-release/sfmoma-announces-pioneering-partnership-to-share/.

101 Keats, "How Billionaire Charles Schwab Brokered San Francisco's New $610 Million Masterpiece". See also David Bonetti, "SFMOMA's 'top Secret' Acquisition," *SFGate*, April 29, 1999, https://www.sfgate.com/entertainment/article/SFMOMA-s-top-secret-acquisition-3085512.php.

102 Carol Vogel, "Inside Art," *The New York Times*, April 16, 1999, sec. Arts, https://www.nytimes.com/1999/04/16/arts/inside-art.html.

103 Gerald Reitlinger, *The Economics of Taste: The Rise and Fall of the Picture Market 1760-1960* (New York: Holt, Rinehart and Winston, 1964). Dramatic changes in purchasing power, standards of living, the availability of cash prevents us from establishing an absolute exchange rate to measure the value of art across history. Nevertheless, Reitlinger's study, although admittedly accounting in rough strokes for denominational changes and later inflation, demonstrates what is ultimately a rise in the magnitude of arts prices in sporadic leaps that reflect changing taste.

104 Emilie Villette, "Art & Finance Report—Highlights in the Art Market," Art & wealth management: A win-win combination (Deloitte, 2017), 145. https://www2.deloitte.com/lu/en/pages/art-finance/articles/art-finance-report.html. For how rapidly services are expanding, see Scott Reyburn, "In a Tough Art Market, Auction Houses Are Seeking More From Less," *The New York Times*, November 4, 2016, sec. Art & Design, https://www.nytimes.com/2016/11/07/arts/design/in-a-tough-art-market-auction-houses-are-seeking-more-from-less.html.

105 Ben Steverman, "The Wealth Detective Who Finds the Hidden Money of the Super Rich," *Bloomberg Businessweek*, May 23, 2019, https://www.bloomberg.com/news/features/2019-05-23/the-wealth-detective-who-finds-the-hidden-money-of-the-super-rich.

106 Staff, "Artiquette," *The Economist*, June 18, 2015, sec. Books & arts, https://www.economist.com/books-and-arts/2015/06/18/artiquette.

107 Katya Kazakina, "Advisers to the Ultra-Rich Try to Treat Art as Just Another Asset," *Bloomberg Businessweek*, April 27, 2017, https://www.bloomberg.com/news/articles/2017-04-27/advisors-to-the-ultra-rich-try-to-treat-art-as-just-another-asset.

108 Sébastien Montabonel and Diana Vives, "When Financial Products Shape Cultural Content," Report, Alaska Editions (London: Institutions of the 21 Century, August 2018), 40, http://www.artinstitutions.org/reports/when-financial-products-shape-cultural-content/.
The authors cite Evan Beard, National Art Services Executive. U.S. Trust, Bank of America Private Wealth Management. Merrill Lynch, Pierce, Fenner & Smith, Inc., interview from June 2018.
109 Doris and Donald Fisher, *Calder to Warhol: introducing the Fisher collection*, interview by Neal David Benezra (San Francisco: San Francisco Museum of Modern Art, 2010).
110 Jonathan Curiel, "At SFMOMA, Donald Fisher's Art Collection Proves Surprisingly Diverse," *SF Weekly*, June 24, 2010, sec. All Shook Down, https://www.sfweekly.com/music/at-sfmoma-donald-fishers-art-collection-proves-surprisingly-diverse/. This article's title is highly misleading, the collection is quite undiverse. Also see *Donald Fisher on Collecting Art, Interview July 25, 2007*, Video (San Francisco: San Francisco Museum of Modern Art, 2010), https://www.youtube.com/watch?v=490srFST-Ks.
111 Sally Anne Duncan, "Paul J. Sachs and the Institutionalization of Museum Culture between the World Wars" (PhD diss., Tufts University, 2001), Appendix R.
112 Ibid., 393.
113 The quote is attributed to Tobias Meyer, former chief auctioneer at Sotheby's. Sarah Thornton, "Love and Money," *Artforum*, May 11, 2006, https://www.artforum.com/diary/sarah-thornton-on-sotheby-s-contemporary-evening-sale-10968.
114 James Thrall Soby, Report to the Trustees in Connection with a Review of the Museum Collection, January, 1945. "Alfred H. Barr, Jr. Papers," New York, n.d., II.6.58, The Museum of Modern Art Archives, New York.
115 Ibid.
116 Ibid.
117 Littlejohn, "SFMOMA Fills In Some Blanks."
118 Benezra's compensation package, bonuses, and housing loan are publicly available on the museum's IRS 990 forms. Tax filings from 2013 indicate the museum has loaned Benezra $801,900, and chief curator Gary Garrels $500,000, each for the purchase of a primary residency. San Francisco Museum of Modern Art, "SFMOMA Form I990," Schedule L, 2013.
119 Hagan, "Public Duty and Private Pursuits", 66. Elephant dung refers to Chris Offili's work.
120 Grace Glueck, "San Francisco's Modern Museum Aims for the Top; West Coast Showcase Brightens Up the Lobby Revue About 30's Hollywood," *The New York Times*, September 15, 1980, sec. Archives, https://www.nytimes.com/1980/09/15/archives/san-franciscos-modern-museum-aims-for-the-top-west-coast-showcase.html. For full disclosure, Hopkins was my MA advisor at UCLA from 2000 to 2002.

121 Bonetti, "The Picasso Has Left the Building."
122 Dorothy Spears, "An Unusual New Home for a San Francisco MoMA Collection," *The New York Times*, November 11, 2009, sec. Giving, https://www.nytimes.com/2009/11/12/giving/12FISHER.html; Laura Allsop, "Gap Founders' Modern Art Collection on Display in San Francisco," *CNN*, August 2, 2010, http://edition.cnn.com/2010/WORLD/americas/07/30/fisher.collection/index.html.
123 As Morgan Quaintance writes, "At the institutional level, consider how the anti-racist sentiment in curators Mark Godfrey and Zoe Whiteley's much trumpeted celebration of art in the age of Black Power 'Soul of a Nation' is profoundly undermined by the funds Tate received from Leonard Blavatnik towards the eponymous gallery extension opened in 2016. The Ukranian billionaire also gave $1 million to Donald Trump's inaugural committee, a president favoured by the Ku Klux Klan, Neo-Nazis, and White Nationalists, who many feel has done much to legitimize and embolden the far right, and is expected to do considerable harm to race relations in America during his term." Morgan Quaintance, "The New Conservatism: Complicity and the UK Art World's Performance of Progression," e-flux conversations, *Frontpage* (blog), October 2, 2017, https://conversations.e-flux.com/t/the-new-conservatism-complicity-and-the-uk-art-worlds-performance-of-progression/7200. See also Julian Stallabrass, "The Branding of the Museum," *Art History* 37, no. 1 (February 2014): 148–65, https://doi.org/10.1111/1467-8365.12060.
124 Henri Neuendorf, "Georg Baselitz Makes Disgraceful Sexist Remarks on Women Painters, Again," *Artnet News*, May 21, 2015, https://news.artnet.com/art-world/georg-baselitz-women-painters-300663.
125 Ibid.
126 Ibid.
127 Reitlinger's classical work is full of such examples. The lower prices of Gainsborough in contrast with Reynolds during their lifetimes is one of many sets of evidence that the "market test" is a shallow fallacy. Reitlinger, *The Economics of Taste*.
128 Benjamin Buchloh, "Figures of Authority, Ciphers of Regression: Notes on the Return of Representation in European Painting," *October* 16 (1981): 39–68, https://doi.org/10.2307/778374.
129 Douglas Crimp, "The Postmodern Museum," in *On the Museum's Ruins* (Cambridge, MA: MIT Press, 1993), 282–325.
130 Ibid., 287.
131 For the richness of 1980s and 1990s artistic production, see, for example, Helen Anne Molesworth, ed., *This Will Have Been: Art, Love & Politics in the 1980s* (Chicago: Museum of Contemporary Art Chicago, 2012); Anne Ellegood and Johanna Burton, eds., *Take It or Leave It: Institution, Image, Ideology* (Los Angeles: UCLA Hammer Museum, 2014).
132 Gerhard Richter, "Meet the world's most expensive painter," interview by Nick Glass, Video, CNN, October 16, 2014, https://www.cnn.

com/2014/10/16/world/gerhard-richter-most-expensive-painter/index.html; Henri Neuendorf, "Gerhard Richter Says He's Shocked by the State of the Art Market," *Artnet News*, December 23, 2015, https://news.artnet.com/market/gerhard-richter-criticizes-art-market-398694.

133 Hannah Furness, "Richter Breaks Record for Most Expensive Living Artist in Europe," *The Telegraph*, February 11, 2015, https://www.telegraph.co.uk/culture/art/artsales/11407110/Richter-breaks-record-for-most-expensive-living-artist-in-Europe.html.

134 Alessia Zorloni and Antonella Ardizzone, "The Winner-Take-All Contemporary Art Market."

135 Personal conversation, May 2019. In over a dozen discussions with artists and art historians over the years about the work of Richter, many have expressed frustration with his overexposure. That these opinions remain hidden from view is, to my mind, another proof of the coercive effects of the market.

136 On the phenomenon and risks of overproduction, see also Adam's *Dark Side of the Boom*.

137 Gerhard Richter, "Meet the world's most expensive painter."

138 "Around 40% of Richter's total output is in museums today." Georgina Adam, "Buyer's Guide to … Gerhard Richter," *The Art Newspaper*, June 10, 2019. See also *Gerhard Richter: Catalogue Raisonné*. (New York: Artbook D A P, 2015) and Gerhard Richter et al., *Gerhard Richter, Editions 1965-2004: Catalogue Raisonné* (New York & Berlin: Hatje Cantz, 2004). Is 40% of Richter's work museum-worthy?

139 "I Have Nothing to Say and I'm Saying it", Conversation between Gerhard Richter and Nicholas Serota, Spring 2011 in Mark Godfrey, Dorothée Brill, and Achim Borchardt-Hume, *Gerhard Richter: Panorama: A Retrospective* (London: Tate Publishing, 2011).
"The smudging makes the paintings a bit more complete. When they're not blurred, so many details seem wrong, and the whole thing is wrong too. Then smudging can help make the painting invincible, surreal, more enigmatic – that's how easy it is."
Interview with Astrid Kaspar, 2000. Richter, Elger, and Obrist, *Gerhard Richter. Text. Writings, Interviews and Letters, 1961-2007*, 368.
"In fact, I really prefer making figurative work, but the figure is difficult. So to work around the difficulty I take a break and paint abstractly. Which I really like, by the way, because it allows me to make beautiful paintings."
Conversation with Henri-François Debailleux, ibid., 306.

140 Artprice.com, "Gerhard Richter, the 'Picasso of the 21st Century,'" Artprice's Report, ArtMarket® Insight, January 23, 2018, https://www.artprice.com/artmarketinsight/gerhard-richter-the-picasso-of-the-21st-century.

141 Thierry de Duve, "Andy Warhol, or The Machine Perfected," *October* 48 (1989): 3–14, https://doi.org/10.2307/778945.

142 Jennifer Doyle, Jonathan Flatley, and Jose Esteban Munoz, eds., *Pop Out: Queer Warhol* (Durham, NC: Duke University Press, 1996).

143 As evident in *Gerhard Richter Painting* [Film] Dir. Corinna Belz (USA: Zero One Film, 2011).
144 Jaleh Mansoor, "Minima Moralia: Notes on Richter's Readymade Red in The Singer of 1965," in *Gerhard Richter: Colour Charts* (London: Dominique Lévy, 2016), 29–38, 31.
145 Cited in Kimberly Bradley, "Artnet.de Digest," *Artnet Magazine*, August 27, 2007, http://www.artnet.com/magazineus/news/bradley/bradley8-27-07.asp.
146 When asked by Isabelle Graw whether his contribution has helped enhance Richter's market, Benjamin Buchloh agreed that it was probably likely. "Zufall, Intention Und Serialität in Gerhard Richters Abstraktionen" (Seminar, [Mosse] lectures in the Humboldt University of Berlin, Berlin, May 31, 2012).
147 Benjamin Buchloh, "The Chance Ornament: Aphorisms on Gerhard Richter's Abstractions," *Artforum*, 2012, 172, https://www.artforum.com/print/201202/the-chance-ornament-aphorisms-on-gerhard-richter-s-abstractions-30074.
148 T. J. Clark, "Gerhard Richter," *London Review of Books* 33, no. 22 (November 17, 2011): 3–7, https://www.lrb.co.uk/v33/n22/tj-clark/grey-panic.
149 Kelly Crow, "The Top-Selling Living Artist," *The Wall Street Journal*, March 9, 2012, https://www.wsj.com/articles/SB10001424052970204781804577267770169368462.
150 Era Dabla-Norris et al., "Causes and Consequences of Income Inequality: A Global Perspective," Staff Discussion Notes No. 15/13 (International Monetary Fund, June 15, 2015), https://www.imf.org/en/Publications/Staff-Discussion-Notes/Issues/2016/12/31/Causes-and-Consequences-of-Income-Inequality-A-Global-Perspective-42986; Paul Krugman, "Debunking the Reagan Myth," *The New York Times*, January 21, 2008, sec. Opinion, https://www.nytimes.com/2008/01/21/opinion/21krugman.html; Joseph E. Stiglitz, "Inequality and Economic Growth," in *Rethinking Capitalism* (Wiley-Blackwell, 2016), 134–55, https://doi.org/10.7916/d8-gjpw-1v31.

Chapter 2

1 Carol Vogel, "Big New York Auction Houses Brace for a Slower Dance at the Fall Sales," *The New York Times*, October 29, 2008, sec. Art & Design, https://www.nytimes.com/2008/11/02/arts/design/02voge.html.
2 Ibid.
3 Brady Anna and Anny Shaw, "Guarantees: The next Big Art Market Scandal?," *The Art Newspaper*, November 12, 2018, sec. Art market, http://theartnewspaper.com/news/guarantees-the-next-big-art-market-scandal.

4 Mary Childs, "Auction Houses Hammer It out as Competition Heats Up," *Financial Times*, November 10, 2015, https://www.ft.com/content/8dba3e18-873e-11e5-9f8c-a8d619fa707c.
5 Christie's, "Peter Doig (b. 1959), Pine House (Rooms for Rent)," Post-War & Contemporary Art Evening Sale, November 12, 2014, https://www.christies.com/lotfinder/lot_details.aspx?intObjectID=5846091.
6 Paul Sullivan, "A Museum's Seal of Approval Can Add to Art's Value," *The New York Times*, October 14, 2016, sec. Your Money, https://www.nytimes.com/2016/10/15/your-money/a-museums-seal-of-approval-can-add-to-arts-value.html.
7 *Jeffrey Deitch's Los Angeles*, [Video], vol. 10, episode 5, Artbound (KCET, 2019), https://www.pbs.org/video/jeffrey-deitchs-los-angeles-pomi9f/, around minute 24:00.
8 John Walsh in Martin Feldstein, ed., *The Economics of Art Museums*, A National Bureau of Economic Research Conference Report (Chicago: The University of Chicago Press, 1991), 25.
9 Crispino Jacqueline, "Art-Wash: Regulations of Museums, Donors, and Board Members," *Center for Art Law*, July 8, 2019, https://itsartlaw.org/2019/07/08/art-wash-regulations-of-museums-donors-and-board-members/; Marie C. Malaro and Ildiko DeAngelis, *A Legal Primer on Managing Museum Collections*, 3rd ed. (Washington, D.C.: Smithsonian Institution, 2012).
10 "Foundations are made partly with dollars which, were it not for charitable deductions allowed by tax laws, would have become public funds to be allocated through the governmental process under the controlling power of the electorate as a whole." Christine E. Ahn, "Democratizing American Philanthropy," in *The Revolution Will Not Be Funded Beyond the Non-Profit Industrial Complex*, ed. INCITE! (Durham, NC: Duke University Press, 2017), 63–76, 65.
11 This theme has been addressed in Susan Stewart, *On Longing: Narratives of the Miniature, the Gigantic, the Souvenir, the Collection* (Durham, NC: Duke University Press, 1993); Walter Benjamin, "Unpacking My Library: A Talk about Book Collecting," in *Illuminations: Essays and Reflections*, ed. Hannah Arendt, trans. Harry Zohn (New York: Schocken Books, 1969), 59–67.
12 Jean Baudrillard "The System of Collecting," in *The System Of Objects* (Verso: 1968), 91-114.
13 Vogel, "Big New York Auction Houses Brace for a Slower Dance at the Fall Sales."
14 Lee Rosenbaum, "Conflicts of Interest: Museum Trustees Play the Market," *CultureGrrl* (blog), October 31, 2008, https://www.artsjournal.com/culturegrrl/2008/10/conflicts_of_interest_museum_t.html.
15 Alex E. Kirk, "The Billionaire's Treasure Trove: A Call to Reform Private Art Museums and the Private Benefit Doctrine," *Fordham Intell. Prop. Media &Ent. L.J.* 27, no. 4 (May 15, 2017): 869–933, 917, https://ir.lawnet.fordham.edu/iplj/vol27/iss4/4.

16 Larry's List Ltd and AMMA, "Private Art Museum Report" (Modern Arts Publishing, January 2016), https://www.larryslist.com/art-collector-report; Julia Halperin, "Contemporary Art Dominates US Museums, Our Visitor Surveys Confirm," *The Art Newspaper*, March 29, 2017, sec. News, http://www.theartnewspaper.com/news/contemporary-art-dominates-us-museums-our-visitor-surveys-confirm.
17 The extent can be gauged by how a new generation of trustees in grooming are either to be fortune heirs or new-money collectors. See David Gelles, "Wooing a New Generation of Museum Patrons," *The New York Times*, March 19, 2014, sec. Arts, https://www.nytimes.com/2014/03/20/arts/artsspecial/wooing-a-new-generation-of-museum-patrons.html.
18 See Association of Art Museum Curators, Professional Practices for Art Museum Curators, 2007.
19 Julie Nightingale, "Cultivating Private Donors," *Museums Journal*, Museum Practice, no. 42 (Summer 2008): 60–2, https://www.museumsassociation.org/museum-practice/fundraising/16534.
20 Julia Halperin and Javier Pes, "Can Museum Curators Ever Moonlight as Art Advisors Without Corrupting Themselves?," *Artnet News*, December 4, 2017, https://news.artnet.com/art-world/can-curators-give-advice-collectors-without-conflict-interest-1166267.
21 "Although the AAM, ICOM, and the Getty have some form of regulations, reforming museum administration to better conform with these regulations does not seem to be a priority for museums. The closest topics that the American Law Institute-Continuing Legal Education ('ALI-CLE') discussed at their March 2019 conference on Legal Issues in Museum Administration in D.C. were 'Morality and Museums,' 'Legal Ethics and Professional Responsibility,' and 'Museums and the First Amendment.' Even the ARFI Seminar in 2018, which occurred after many of the allegations against the Whitney and the American Museum of Natural History came to light, does not seek options for reforms." Crispino, "Art-Wash."
22 Chesnais, *Finance Capital Today*, 29.
23 Ibid., 5.
24 Ibid., 29. He quotes Riccardo Bellofiore, "Comment on de Brunhoff and Meacci," in *Marxian Economics, A Reappraisal: Essays on Volume III of Capital*, (London: Macmillan Press, 1998).
25 Ibid., 50.
26 International Monetary Fund, "General Government Debt," Global Debt Database, accessed October 21, 2020, https://www.imf.org/external/datamapper/GG_DEBT_GDP@GDD.
27 Larry Fink and The BlackRock Blog, "BlackRock CEO Larry Fink Tells the World's Biggest Business Leaders to Stop Worrying about Short-Term Results," *Business Insider*, April 14, 2015, https://www.businessinsider.com/larry-fink-letter-to-ceos-2015-4.
28 Ben Williams, "Art-secured lending," interview by Victoria Kisseleva, Deloitte Luxembourg and ArtTactic: Art & Finance report 2017, 161,

https://www2.deloitte.com/lu/en/pages/art-finance/articles/art-finance-report.html.
29 Emilie Villette, "Art & Wealth Management: A Win-Win Combination," Art & Finance Report 2017 (Deloitte Luxembourg and ArtTactic, 2017), https://www2.deloitte.com/lu/en/pages/art-finance/articles/art-finance-report.html; Clare McAndrew, *Fine Art and High Finance Expert Advice on the Economics of Ownership* (Hoboken: John Wiley & Sons, 2012); Montabonel and Vives, "When Financial Products Shape Cultural Content."
30 ArtTactic, "Art & Finance Report 2017" (Deloitte Luxembourg and ArtTactic, 2017), 29, https://www2.deloitte.com/lu/en/pages/art-finance/articles/art-finance-report.html.
31 Andrea Fraser, "L'1% C'est Moi," *Texte Zur Kunst* 83 (September 2011): 114–27; Andrea Fraser, "There's No Place Like Home" (Whitney Biennial 2012, New Haven: Yale University Press, 2012), 28–33.
32 Bowley and Cohen, "Buyers Find Tax Break on Art."
33 Montabonel and Vives, "When Financial Products Shape Cultural Content." See also William Goetzmann, Elena Mamonova, and Christophe Spaenjers, "The Economics of Aesthetics and Three Centuries of Art Price Records," Working Paper, Working Paper Series (National Bureau of Economic Research, August 2014), https://doi.org/10.3386/w20440. This study of record-breaking auction prices highlights the significance of what they call the "industrial organization of the art market" since the 1980s with changes to transaction fees, auction houses offering buyers credit, and the transformation of the auction market from a wholesale trading place to a retail market. In the literature review, they acknowledge the public dimension of the common value of art in studies that attempt to measure "emotional dividends," or the nonfinancial utility of art. Their research questions nevertheless remain within the parameters of individual consumption, such that the relation of the museum institution to the state, and therefore of art to total wealth, is never probed toward a totalizing perspective. Lost in the process is our ability to work our way out of the moral dilemma of art's association with unethical wealth accumulation and gentrification. What is important, nevertheless, is that their literature review and discussion acknowledge and attempt to measure the common-value component of an artwork, based on the artwork's ability to store and exhibit wealth, characteristics that require shared space and participants.
34 "There are valid reasons why sophisticated collectors borrow against their art: a) to generate liquidity and manage their short term-cash needs; b) to free up equity to redeploy capital and perhaps even purchase more art; c) to provide an orderly liquidation of their art to achieve long-term estate planning goals; d) to bridge loan to auction or private treaty sales; and e) to manage tax and capital gains." Montabonel and Vives, "When Financial Products Shape Cultural Content," 41.
35 Montabonel and Vives, "When Financial Products Shape Cultural Content," 41–2. The authors cite *How Easy Is It To Get An Art-Backed Loan?* Kathryn Tully,

October 2014, Forbes, https://www.forbes.com/sites/kathryntully/2014/10/27/how-easy-is-it-to-get-an-art- backed-loan/#5210397f94).

36 "Driven by growing demand, the total volume of auction turnover generated by the Contemporary Art auction segment worldwide has doubled over the past decade." ArtMarket.com, "The Contemporary Art Market Report 2019" *Artprice.com*, 2019, https://www.artprice.com/artprice-reports/the-contemporary-art-market-report-2019.

37 Lee Rosenbaum, "Conflicts of Interest." Rosenbaum cites Alan D. Ullberg and Patricia Ullberg, *Museum Trusteeship* (Washington, D.C.: American Association of Museums, 1991). The publication of this important document followed a few rejected attempts to standardize ethics in the field. See Tom Mullaney, "Museum Ethics: Still A Problem For The Profession And Contemporary Art," *New Art Examiner*, October 2016, http://www.newartexaminer.net/museum-ethics-still-a-problem-for-the-profession-and-contemporary-art/.

38 Milton Esterow, "Are Museum Trustees Out of Step?," *ARTnews*, October 1, 2008, http://www.artnews.com/2008/10/01/are-museum-trustees-out-of-step/.

39 Helen Molesworth, Andrea Fraser, and Helen Molesworth, interview by Andrea Fraser, *BOMB Magazine*, October 17, 2018, https://bombmagazine.org/articles/andrea-fraser-and-helen-molesworth/.

40 Sarah Douglas, "Prior to Her Firing, Curator Helen Molesworth Made Public Statements Critical of Museum Practices, MOCA," *ARTnews*, March 21, 2018, https://www.artnews.com/art-news/news/prior-firing-curator-helen-molesworth-made-public-statements-critical-museum-practices-moca-10009/.

41 Julia Halperin, "MOCA Fires Chief Curator Helen Molesworth for 'Undermining the Museum,' According to Report," *Artnet News*, March 13, 2018, https://news.artnet.com/art-world/moca-fires-chief-curator-helen-molesworth-according-to-report-1243853.

42 This is not to absolve Molesworth of responsibility to her colleagues. See the remarks of Alma Ruiz in "The Potential of Los Angeles Art Museums" (Forms of Reparations: The Museum and Restorative Justice, Museum & Curatorial Studies, California State University, Long Beach, 2020), https://youtu.be/aCZN0b_7K6U.

43 Julia Halperin, "Clashing Visions, Simmering Tensions: How a Confluence of Forces Led to MOCA's Firing of Helen Molesworth," *Artnet News*, March 16, 2018, https://news.artnet.com/art-world/moca-helen-molesworth-tension-1246358.

44 Lee Rosenbaum, "BlogBack: Guggenheim President Jennifer Stockman on Trustees' Conflict-of-Interest," *CultureGrrl* (blog), November 19, 2008, https://www.artsjournal.com/culturegrrl/2008/11/blogback_guggenheim_president.html.

45 Judith H. Dobrzynski, "A Possible Conflict By Museums In Art Sales," *The New York Times*, February 21, 2000, sec. Arts, https://www.nytimes.com/2000/02/21/arts/a-possible-conflict-by-museums-in-art-sales.html.

46 For a discussion of the development of museum ethics guidelines, see Tom Mullaney, "Museum Ethics."
47 *Professional Practices in Art Museums,* first published by the Association of Art Museum Directors in 1971 and revised every ten years thereafter. The International Council of Museums's code of ethics is naturally very general.
48 Tim Schneider, "What Happens When a Collector Promises to Donate an Artwork and Then Flips It at Auction Instead? It's Worse Than You Think," *Artnet News*, July 9, 2019, https://news.artnet.com/market/collectors-renege-promised-gifts-1593475.
49 Robert Hewison, "Contemporary Art Museums Can't Avoid Conflicts of Interest – but We Need to Trust Their Directors," *Apollo Magazine*, November 1, 2017, https://www.apollo-magazine.com/contemporary-art-museums-cant-avoid-conflicts-of-interest-but-we-need-to-trust-their-directors/.
50 John Walker, *Self-Portrait with Donors: Confessions of an Art Collector* (Boston, MA: Little, Brown and Company, 1974), 44.
51 Morton J. Horwitz, "History of the Public/Private Distinction," *University of Pennsylvania Law Review* 130, no. 6 (1982): 1423.
52 Ibid., 1423.
53 Karl Polanyi, *The Great Transformation: The Political and Economic Origins of Our Time* (Boston, MA: Beacon Press [1944], 2001), 60.
54 Ibid., 93.
55 Horwitz, "History of the Public/Private Distinction," 1424.
56 Ibid., 1426–7.
57 Morton J. Horwitz, *The Transformation of American Law, 1870–1960: The Crisis of Legal Orthodoxy* (New York: Oxford University Press, 1995).
58 "Just as nineteenth-century political economy elevated the market to the status of the paramount institution for distributing rewards on a supposedly neutral and apolitical basis, so too private law came to be understood as a neutral system for facilitating voluntary market transactions and vindicating injuries to private rights." Horwitz, "History of the Public/Private Distinction," 1425–6.
59 Ibid., 1426–7.
60 A classic introductory text is David Harvey, *A Brief History of Neoliberalism* (New York: Oxford University Press, 2007).
61 John Bellamy Foster, "Capitalism Has Failed—What Next?," *Monthly Review*, February 1, 2019, https://monthlyreview.org/2019/02/01/capitalism-has-failed-what-next/.
62 For the UK, see Ursula Huws, "Crisis as Capitalist Opportunity: New Accumulation through Public Service Commodification," *The Socialist Register*, 48 (September 24, 2011): 64–84.
 For the US, see Ryan Cooper, "The Rise and Fall of Clintonism," *The Nation*, February 14, 2018, https://www.thenation.com/article/the-rise-and-fall-of-clintonism/; Cornel West, "Pity the Sad Legacy of Barack Obama," *The Guardian*, January 9, 2017, sec. Opinion, https://www.theguardian.com/commentisfree/2017/jan/09/barack-obama-legacy-presidency.

63 Benjamin Soskis, "Giving Numbers: Reflections on Why, What, and How We Are Counting," *Nonprofit Quarterly*, November 1, 2017, https://nonprofitquarterly.org/giving-numbers-reflections-counting/.

64 Evelyn Brody and John E. Tyler, "How Public Is Private Philanthropy: Separating Reality from Myth," *Philanthropy Roundtable* (June 11, 2009), https://papers.ssrn.com/abstract=1522662.

65 Rob Reich explains the "upside-down effect," where, as one climbs up the tax bracket, the state subsidy becomes larger, because 70% of taxpayers take a standard deduction and are therefore arbitrarily excluded from the charitable contribution deduction for high-income earners who itemize their deductions. In 2017 a person in the 10% tax bracket paid $100 of their $100 donation, while it cost a person in the top income bracket only $60.4 to donate the same $100. Reich, *Just Giving*, 79.

66 Nancy Fraser, "Why Two Karls Are Better than One: Integrating Polanyi and Marx in a Critical Theory of the Current Crisis" (der DFG-Kollegforscher_innengruppe Postwachstumsgesellschaften, Jena, 2017). Nancy Fraser proposes to reconcile the intra-economic focus of Marx with the broader social view of Polanyi.

67 "The space left by the elimination of Keynesian state policy is thereby filled by a neoliberal development paradigm that brings to the forefront the nonprofit sector as a site for social engineering and the financialization of wider social spheres. Accordingly, a nonprofit-corporate complex (based in international non-governmental organizations, NGOs) dominating an array of social services, many of which were performed by the state in the past, emerged as the third pillar of the triangular structure of contemporary imperialism during the 1980s." Efe Can Gürcan, "The Nonprofit-Corporate Complex: An Integral Component and Driving Force of Imperialism in the Phase of Monopoly-Finance Capitalism," *Monthly Review* 66, no. 11 (April 1, 2015), https://monthlyreview.org/2015/04/01/the-nonprofit-corporate-complex/.

68 Wolch, *The Shadow State*, 210.

69 Ibid., 10.

70 Dylan Rodríguez, "The Political Logic of the Non-Profit Industrial Complex," in *The Revolution Will Not Be Funded Beyond the Non-Profit Industrial Complex*, ed. INCITE! (Durham, NC: Duke University Press, 2017), 21–40.

71 Justin Laing, "What Does Culture Look Like When #BlackLivesMatter?," *Grantmakers in the Arts* 26, no. 3 (2015), https://www.giarts.org/article/what-does-culture-look-when-blacklivesmatter.

72 Cedric Johnson, "The Panthers Can't Save Us Now," *Catalyst* 1, no. 1 (Spring 2017), https://catalyst-journal.com/vol1/no1/panthers-cant-save-us-cedric-johnson.

73 Ibid., 9.

74 Brody and Tyler, "How Public Is Private Philanthropy: Separating Reality from Myth," *The Philanthropy Roundtable* (2009).

75 Margaret Jane Wyszomirski, "Philanthropy, the Arts, and Public Policy," *Journal of Arts Management and Law* 16, no. 4 (January 1, 1987): 5–29, 13, https://doi.org/10.1080/07335113.1987.9943084.
76 Christopher D. Stone, "Corporate Vices and Corporate Virtues: Do Public/Private Distinctions Matter?," *University of Pennsylvania Law Review* 130, no. 6 (June 1982): 1444, https://doi.org/10.2307/3311978.
77 The most-cited cause was pension obligations liability. But these cannot be accurately described without a broader economic context, including history that takes a longer view into account when calculating cause and effect. Barry Grey, "The Rape of Detroit: Deindustrialization, Financialization and Parasitism," *World Socialist Web Site*, February 28, 2014, https://www.wsws.org/en/articles/2014/02/28/barr-f28.html.
78 Horwitz, *The Transformation of American Law, 1870–1960*, 111.
79 Ibid., 111.
80 Ibid., xvi.
81 Horwitz shows "that one of the crucial choices made during the antebellum period was to promote economic growth primarily through the legal, not the tax, system, a choice which had major consequences for the distribution of wealth and power in American society." Horwitz, *The Transformation of American Law, 1870–1960*, xv.
82 Ibid., 109.
83 Brody and Tyler, "How Public Is Private Philanthropy," 29.
84 Horwitz, *The Transformation of American Law, 1870–1960*, 112.
85 Ibid., 136–7.
86 Brody and Tyler, "How Public Is Private Philanthropy," 30.
87 Brody and Tyler, "How Public Is Private Philanthropy," 21.
88 Liam Murphy and Thomas Nagel, *The Myth of Ownership: Taxes and Justice* (New York: Oxford University Press, 2002), 8.
89 Reich, *Just Giving*, 8.
90 Ibid., 175.
91 Ann E. Davis, "The New 'Voodoo Economics': Fetishism and the Public/Private Divide," *Review of Radical Political Economics* 45, no. 1 (March 1, 2013): 42–58, 46, https://doi.org/10.1177/0486613412447057.
92 Ibid., 45, citing Karl Marx, *Capital* (New York: International Publishers, 1967), 132.
93 Ibid., 47.
94 Best, "Distilling a Value Theory of Ideology from Volume Three of Capital," 125.
95 Graw identifies that art is an exception. "This special character of art-as-commodity is considered to be at the root of the art market's inner contradictions. Compared to other commodities, the artwork-commodity is conceived of here as being split into a symbolic value and a market value. The specific quality of its symbolic value lies in the fact that it expresses an intellectual surplus value generally attributed to art, an epistemological gain that cannot be smoothly translated into economic categories." But this gain is neither surplus, nor is it impossible to explain in economic terms.

Isabelle Graw, *High Price: Art Between the Market and Celebrity Culture* (Berlin: Sternberg Press, 2009), 10.

96 "But this market value still needs the assumption of a 'symbolic value' for ultimate legitimacy. Without the assumption of such a symbolic value, there is no market value ..." (ibid., 21). "In the field of art history, it is usually art historians, critics, and curators who contribute to the generation of this symbolic value, although recently this role has also been increasingly performed by lifestyle and fashion magazines" (ibid., 23).

97 Dylan Riley, "Bourdieu's Class Theory," *Catalyst* 1, no. 2 (Summer 2017), https://catalyst-journal.com/vol1/no2/bourdieu-class-theory-riley.

98 Pierre Bourdieu, "The Forms of Capital," in *Handbook of Theory and Research for the Sociology of Education*, ed. John Richardson (New York: Greenwood Press, 1986), 241–58.

99 Louis Althusser, "Ideology and Ideological State Apparatuses," in *Lenin and Philosophy and Other Essays*, trans. Ben Brewster (London: Monthly Review Press, 1971), 127–86.

100 Pierre Bourdieu, "The Forms of Capital."

101 Dylan Riley, "Bourdieu's Class Theory."

102 Beverley Best, "Political Economy through the Looking Glass: Imagining Six Impossible Things about Finance before Breakfast," *Historical Materialism* 25, no. 3 (December 13, 2017): 76–100, https://doi.org/10.1163/1569206X-12341537.

103 "Economic capital, which is immediately and directly convertible into money and may be institutionalized in the forms of property rights; as cultural capital, which is convertible, on certain conditions, into economic capital and may be institutionalized in the forms of educational qualifications; and as social capital, made up of social obligations ('connections'), which is convertible, in certain conditions, into economic capital and may be institutionalized in the forms of a title of nobility." Pierre Bourdieu, "The Forms of Capital," 142–3.

104 Ibid., 145.

105 "*Symbolic capital*, that is to say, capital – in whatever form – insofar as it is represented, i.e., apprehended symbolically, in a relationship of knowledge or, more precisely, of misrecognition and recognition, presupposes the intervention of the habitus, as a socially constituted cognitive capacity" (ibid., 155).

106 Chuck Collins, "The Wealthy Kids Are All Right," *The American Prospect*, May 28, 2013, https://prospect.org/article/wealthy-kids-are-all-right. We also know that racial identity (and also gender and in some respects sexual identity, and so forth) influences how individuals are perceived and therefore how they are evaluated and remunerated. In this respect, wealth is an exponential form of advantage. Chris Bryant, "How the Aristocracy Preserved Their Power," *The Guardian*, September 7, 2017, sec. News, https://www.theguardian.com/news/2017/sep/07/how-the-aristocracy-preserved-their-power.

107 The collateralization of art, i.e., its turning it into cash and therefore potential capital does not make art productive, it merely reinforces its potential asset status.
108 "Althusser mistakenly dismisses the importance of the concept of the fetish to Marx's analysis of the movement of capital and, in doing so, obscures its genealogy in a critical concept of ideology." Best, "Distilling a Value Theory of Ideology from Volume Three of Capital," 110.
109 Ibid., 116.
110 "A critical concept of ideology cannot directly address the 'ideology' of white supremacy, nor can it directly address the 'ideology' of men's superiority over women (Eagleton's examples). A critical concept of ideology can only address those appearances that are generated as structural components of the mode of exploitation and domination *immanent* to capital" (ibid, 116).
111 John Thomasian, "Arts & the Economy: Using Arts and Culture to Stimulate States Economic Development" (National Governor's Association, January 14, 2009), https://www.americansforthearts.org/sites/default/files/0901ARTSANDECONOMY.pdf.
112 Michael Heinrich, *An Introduction to the Three Volumes of Karl Marx's Capital*, trans. Alexander Locascio (New York: Monthly Review Press, 2012), 49.
113 Best, "Distilling a Value Theory of Ideology from Volume Three of Capital," 39.
114 Andrew Kliman, *The Failure of Capitalist Production: Underlying Causes of the Great Recession* (London: Pluto Press, 2011); Guglielmo Carchedi and Michael Roberts, eds., *World in Crisis: A Global Analysis of Marx's Law of Profitability* (Chicago: Haymarket Books, 2018).
115 The expansion of capital merely appears to be autonomous. In effect, "however many layers of mediation intervene, autonomisation is never complete. No single form of value can acquire complete independence from the other forms in the system or from the exploitation of labour." "Mediations" are the various forms surplus value takes: value-added, profit, and all forms of revenue that distribute and redistribute the substance of capital. Strung, mediations actually form a network of dependency. Thus, all forms of fictitious or financialized gains are always connected to production, however remote the thread. In fact, the more remote the connection the bigger the damage to aggregate social wealth. Tomas Nielsen Rotta and Rodrigo Alves Teixeira, "The Autonomisation of Abstract Wealth: New Insights on the Labour Theory of Value," *Cambridge Journal of Economics* 40, no. 4 (July 1, 2016): 1185–201, https://doi.org/10.1093/cje/bev028.
116 Massimiliano Tomba, "Differentials of Surplus-Value in the Contemporary Forms of Exploitation," *The Commoner*, Summer 2007, https://thecommoner.org/back-issues/issue-12-spring-summer-2007/. Marx cited from Karl Marx, "Marginal Notes on Adolph Wagner's *Lehrbuch der Politischer Oekonomie* (1881-82)," *MECW* 24, 531–62.

117 Diane Elson, "The Value Theory of Labour," in *Value: The Representation of Labour in Capitalism*, ed. Diane Elson (London: CSE Books, 1979), 115–80, 138.
118 Best, "Distilling a Value Theory of Ideology from Volume Three of Capital," 125.
"The rate of surplus-value is, therefore, surplus-value over variable capital, while the rate of profit is surplus-value over total capital. This is a matter of simple ratios, a situation that produces an ideological appearance that is also quite simple to sort out: because surplus-value stands in relation to variable capital and profit stands in relation to total capital expended, the rate of surplus-value and rate of profit are, in almost all circumstances, different numerical values, and their fluctuations are not immediately reflected in the other value" (ibid., 126). Best cites Karl Marx, *Capital: A Critique of Political Economy. Volume 3*, translated by David Fernbach (London: Penguin, 1981 [1894]).
119 Sungur Savran and Ahmet E. Tonak, "Productive and Unproductive Labour: An Attempt at Clarification and Classification," *Capital & Class* 23, no. 2 (July 1, 1999): 113–52, 125, https://doi.org/10.1177/030981689906800107.
120 Ibid., 125.
121 Matt Cole, "Exploring the Labour Processes of Hospitality Work" (IIPPE 2017 at the Berlin School of Economics and Law, Berlin, 2017).
122 Savran and Tonak, "Productive and Unproductive Labour: An Attempt at Clarification and Classification," 128.
123 Tomás N. Rotta, "Unproductive Accumulation in the USA: A New Analytical Framework," *Cambridge Journal of Economics* 42, no. 5 (August 18, 2018): 1367–92, https://doi.org/10.1093/cje/bex080.
124 Gregory Sholette, *Dark Matter: Art and Politics in the Age of Enterprise Culture* (London: Pluto Press, 2011).
125 Dave Beech, *Art and Value*.
126 Ibid., 284–6. Beech shows that the one place that art differs from a Veblen good is that it can be consumed by the public, because to look is to consume. "Conspicuous consumption" is developed in Veblen Thorstein, *The Theory of the Leisure Class: An Economic Study of Institutions* (London: B. W. Huebsch [1899], 1912).
127 Heinrich, *An Introduction to the Three Volumes of Karl Marx's Capital*, 55.
128 Beech, *Art and Value*, 286.
129 Fiona Tregenna, "'Services' in Marxian Economic Thought," Cambridge Working Papers in Economics (Faculty of Economics, University of Cambridge, September 24, 2009), 6, https://ideas.repec.org/p/cam/camdae/0935.html.
130 "Marx clarifies that 'for labour to be designated productive, qualities are required which are utterly unconnected with the specific content of the labour, with its particular utility or the use-value in which it is objectified. Hence labour with the same content can be either productive or

unproductive.'" Tregenna, "'Services' in Marxian Economic Thought," 6–7. Tregenna cites Karl Marx, *Capital: A Critique of Political Economy, Volume 1*, (London: Penguin, 1976 [1867]), 278–80.
131 Wolfgang Fritz Haug and Joseph Fracchia, "Historical-Critical Dictionary of Marxism: Immaterial Labour," *Historical Materialism* 17, no. 4 (January 1, 2009): 177–85, 179, https://doi.org/10.1163/146544609X12562798328251.

Chapter 3

1 Special thanks to my generous colleague Heather Graham for her help and feedback on this chapter.
2 Grace Glueck, "MOMA Gets a Taste of Pasta," *The New York Times*, September 26, 1971, sec. Art Notes, https://www.nytimes.com/1971/09/26/archives/moma-gets-a-taste-of-pasta.html; Jillian Steinhauer, "Art World's Wage Inequality Sparks Waves of Protests," *The Art Newspaper*, March 8, 2019, The Armory Show special edition, http://www.theartnewspaper.com/feature/art-world-wage-inequality-protests; Julia Bryan-Wilson, *Art Workers: Radical Practice in the Vietnam War Era* (Berkeley: University of California Press, 2009); Emma Whitford, "MoMA Employees Protest 'Modern Art, Ancient Wages,'" *Gothamist*, June 3, 2015, https://gothamist.com/news/moma-employees-protest-modern-art-ancient-wages.
3 Significant here is the epic *Anti-Catalog*, written by Artists Meeting For Cultural Change. See https://primaryinformation.org/files/AntiCatalog.pdf.
4 Nizan Shaked, "Propositions to Politics: Adrian Piper's Conceptual Artwork," in *Adrian Piper: A Reader*, ed. Cornelia H. Butler and David Platzker (New York: The Museum of Modern Art, 2018), 68–101.
5 Foucault is also important for the analysis of Renaissance episteme and its significance to the development of museums as disciplinary institutions of knowledge. See Eilean Hooper-Greenhill, "The Museum in the Disciplinary Society," in *Museum Studies in Material Culture*, ed. Susan Pearce (Leicester: Leicester University Press, 1989), 61–72.
6 For some excellent work done examining the discourses, participation, and composition of such publics, see Thomas E. Crow, *Painters and Public Life in Eighteenth-Century Paris* (New Haven & London: Yale University Press, 1985); Brandon Taylor, *Art for the Nation: Exhibitions and the London Public, 1747-2001* (New Brunswick: Rutgers University Press, 1999).
7 Richard A. Goldthwaite, *The Economy of Renaissance Florence* (Baltimore: Johns Hopkins University Press, 2009), 579–80, 485.
8 Ibid., 392.
9 Ibid., 392.
10 Ibid., 580.
11 See also Michelle O'Malley, *The Business of Art: Contracts and the Commissioning Process in Renaissance Italy* (New Haven & London: Yale University Press, 2005).

12 Goldthwaite, *The Economy of Renaissance Florence*, 588.
13 Lindsay Alberts, "From Studiolo to Uffizi: Sites of Collecting and Display under Francesco I de' Medici" (PhD diss., Boston University, 2016), 173–4, https://open.bu.edu/handle/2144/17710. Alberts cites Nicholas Penny's catalogue entry for Noah Cameo, *Renaissance Florence: The Art of the 1470s*, 137; Ruth Rubinstein, "The Treasure of Lorenzo the Magnificent, in Florence," *The Burlington Magazine*, vol. 114, no. 836 (November 1972): 807.
14 Lindsay Alberts, "Francesco I's Museum: Cultural Politics at the Galleria Degli Uffizi," *Journal of the History of Collections* 30, no. 2 (September 27, 2017): 203–16.
15 Some examples include Jean Baudrillard, "The System of Collecting," in *Cultures of Collecting*, ed. John Elsner and Roger Cardinal (London: Reaktion Books, 1994), 7–24; Susan Stewart, "The Collection: Paradise of Consumption," in *On Longing: Narratives of the Miniature, the Gigantic, the Souvenir, the Collection* (Durham, NC: Duke University Press, 1993), 151–70; James Clifford, "Histories of the Tribal and the Modern," in *The Predicament of Culture: Twentieth-Century Ethnography, Literature, and Art* (Cambridge, MA: Harvard University Press, 1988), 189–214; Susan Vogel, ed., *Art/Artifact: African Art in Anthropology Collections* (New York: Center for African Art, 1989); select articles in Donald Preziosi and Claire Farago, eds., *Grasping the World: The Idea of the Museum*, (Farnham: Ashgate, 2003), 51–64; and Sharon Macdonald, *A Companion to Museum Studies* (Oxford: Blackwell, 2006).
16 Stephen Jay Greenblatt, "Marvelous Possessions," in *Marvelous Possessions: The Wonder of the New World* (Chicago: The University of Chicago Press, 1992), 52–85; Krzysztof Pomian, "The Collection: Between the Visible and the Invisible," in *Interpreting Objects and Collections*, ed. Susan M. Pearce (New York: Routledge, 1994), 160–74.
17 Jeffrey Abt, "The Origins of the Public Museum," in *A Companion to Museum Studies*, ed. Sharon Macdonald (Oxford: Blackwell, 2006), 115–34.
18 Giovanni Arrighi, *The Long Twentieth Century: Money, Power, and the Origins of Our Times* (London: Verso, 1994), 97.
19 Ibid., 96.
20 Thomas DaCosta Kaufmann, "Remarks on the Collections of Rudolf II: The Kunstkammer as a Form of Representatio," *Art Journal* 38, no. 1 (1978): 22–8, https://doi.org/10.2307/776251.
21 William Stenhouse, "Roman Antiquities and the Emergence of Renaissance Civic Collections," *Journal of the History of Collections* 26, no. 2 (July 1, 2014): 131–44, https://doi.org/10.1093/jhc/fht033.
22 Guiseppe Olmi, "Science-Honour-Metaphor. Italian Cabinets of the Sixteenth and Seventeenth Centuries," in *The Origins of Museums: The Cabinet of Curiosities in Sixteenth- and Seventeenth-Century Europe*, ed. O. R. Impey and Arthur MacGregor (Oxford: Clarendon Press, 1985), 10.
23 David Carrier, "Why Were There No Public Art Museums in Renaissance Italy?," *Source: Notes in the History of Art* 22, no. 1 (October 1, 2002): 44–50, https://doi.org/10.1086/sou.22.1.23206822.

24 Richard Goldthwaite and Patricia Simons, "The Empire of Things: Consumer Demand in Renaissance Italy," in *Patronage, Art, and Society in Renaissance Italy*, ed. Francis William Kent and John Christopher Eade (Oxford: Humanities Research Centre, 1987), 153–75.
25 This takes place from the fifteenth century and on. Richard A. Goldthwaite, *Wealth and the Demand for Art in Italy, 1300–1600* (Johns Hopkins University Press, 1995).
26 Judith C. Brown, "Prosperity or Hard Times in Renaissance Italy?," *Renaissance Quarterly* 42, no. 4 (1989): 761–80, 770, https://doi.org/10.2307/2862281.
27 Although 1584 is usually considered the year, "I propose a slightly earlier date, with work on the Tribuna beginning in the early months of 1583, based on archival records of the financing of the work." Alberts, "From Studiolo to Uffizi," 194.
28 Janet Cox-Rearick, "Epilogue: Francesco de' Medici and Aries," in *Dynasty and Destiny in Medici Art: Pontomo, Leo X, and the Two Cosimos* (Princeton: Princeton University Press, 1984), 283–91. See also Citta di Firenze, "The 'Studiolo' of Francesco I," September 18, 2020, http://museicivicifiorentini.comune.fi.it/en/palazzovecchio/visitamuseo/studiolo_francesco_i.htm.
29 Lindsay Alberts, "The Studiolo of Francesco I de Medici: A Recently-Found Inventory," *Art Histories Supplement 2.0*, no. 1 (Summer 2015): 3–24.
30 Paula Findlen, "The Museum: Its Classical Etymology and Renaissance Genealogy," *Journal of the History of Collections* 1, no. 1 (1989): 59–78, https://doi.org/10.1093/jhc/1.1.59.
31 Lindsay Alberts, "Francesco I's Museum: Cultural Politics at the Galleria Degli Uffizi," *Journal of the History of Collections* 30, no. 2 (September 27, 2017): 203–16, 203.
32 Adriana Turpin, "The Display of Exotica in the Uffizi Tribuna," in *Collecting East and West*, ed. Susan Bracken, Andrea M. Gáldy, and Adriana Turpin (Cambridge: Cambridge Scholars Publishing, 2013), 83–118.
33 Germain Bazin, *The Museum Age*, trans. Jane van Nuis Cahill (New York: Universe Books, 1967).
34 Turpin, "The Display of Exotica in the Uffizi Tribuna," 92.
35 Cited in Mark A. Meadow, "Merchants and Marvels: Hans Jacob Fugger and the Origins of the Wunderhammer," in *Merchants and Marvels Commerce, Science, and Art in Early Modern Europe*, ed. Pamela Smith and Paula Findlen (New York: Routledge, 2002), 194.
36 Ibid., 195.
37 Dora Thornton, *The Scholar in His Study: Ownership and Experience in Renaissance Italy* (New Haven: Yale University Press, 1998), 106.
38 This paraphrases the oft-cited Walter Benjamin, "Theses on the Philosophy of History," in *Illuminations: Essays and Reflections*, ed. Hannah Arendt, trans. Harry Zohn (New York: Schocken Books, 1969), 253–64. It also references Rosa Luxemburg's famous quip, "socialism or barbarism," in *The*

Junius Pamphlet: The Crisis in the German Social Democracy (Colombo: Young Socialist Publications, 1969), https://www.marxists.org/archive/luxemburg/1915/junius/index.htm.

39 Anthony Alan Shelton, "Cabinets of Transgression: Renaissance Collections and the Incorporation of the New World," in *Cultures of Collecting*, ed. John Elsner and Roger Cardinal (London: Reaktion Books, 1994), 177–203, 186–7.

40 Alberts, "From Studiolo to Uffizi," 231–2. The translations are hers.

41 Giovanni Arrighi, *The Long Twentieth Century: Money, Power, and the Origins of Our Times* (London: Verso, 1994), 96. Arrighi cites Garrett Mattingly, *Renaissance Diplomacy* (New York: Dover 1988), 49.

42 Robert Lopez, "Hard Times and Investment in Culture," in *Social and Economic Foundations of the Italian Renaissance*, ed. Anthony Molho (New York: John Wiley & Sons, 1969), 95–115.

43 "After the mid-fourteenth-century crisis, Florentines concentrated their interest in government finance on the papacy, first at Avignon and then at Rome, and on the French monarchy, at Lyons; in both governments they worked through new institutional structures devised for handling their floating debt. The history of that involvement reflects one of the major themes in the historiography of later medieval and Renaissance Europe, the rise of the modern fiscal state." Goldthwaite, *The Economy of Renaissance Florence*, 245.

44 Anthony Molho, "The State and Public Finance: A Hypothesis Based on the History of Late Medieval Florence," *The Journal of Modern History* 67 (1995): S97–135, https://doi.org/10.1086/245011.

45 Ibid.

46 Arrighi, *The Long Twentieth Century*, 106.

47 See also Molho's "Masaccio's Florence in perspective" that demonstrates how the economic system of Florence, while appearing to help the public with loans, ensured that wealth increasingly circulated among a smaller and smaller segment of society. Anthony Molho, "Masaccio's Florence in Perspective: Crisis and Discipline in a Medieval Society," in *The Cambridge Companion to Masaccio*, ed. Diane Cole (Cambridge: Cambridge University Press, 2002), 16–39.

48 Goldthwaite, *The Economy of Renaissance Florence*, 114.

49 Ibid., 493.

50 Ibid., 356.

51 Goldthwaite, *Wealth and the Demand for Art in Italy, 1300–1600*, 37.

52 Goldthwaite, *The Economy of Renaissance Florence*, 356.

53 Neil De Marchi and Hans J. Van Miegroet, "The History of Art Markets," in *Handbook of the Economics of Art and Culture*, ed. Victor A. Ginsburg and David Throsby, vol. 1 (London: Elsevier, 2006), 69–122, 86.

54 This is also Alberts's view. See also Carlo M. Cipolla, "The Changing Balance Of Economic Power," in *Before the Industrial Revolution: European Society and Economy, 1000–1700* (New York: Routledge, 1993), 182–214.

55 The argument that new forms of practice have altered the social relations of art is moot. At this stage, since so many conceptualist artists, or other artists

that do not make objects, are selling collectibles or commissions, from a broader historical perspective their original gestures can be read not as an upending of the art market, but rather as a strategy to introduce new forms of making to qualify as art.
56 Rather than use Marxist accounts of the Renaissance, which have tended to ideological analysis, I rely extensively on Goldthwaite's work even though it is rooted in terms of supply and demand, because it reveals the origins of state-run economies and their reliance on the symbolic power of luxury and art.
57 As Goldthwaite summarizes, it was "a commercial strategy for sales [rather] than an operational strategy to improve the efficiency of production and therefore industrial productivity" (ibid., 317).
58 Goldthwaite, *The Economy of Renaissance Florence*, 340.
59 Raymond de Roover, "The Commercial Revolution of the Thirteenth Century," in *Enterprise and Secular Change: Readings in Economic History,* ed. Frederic Lane and Jelle Riemersma (London: Allen & Unwin, 1953), 80, reprinted from *Bulletin of the Business Historical Society* 16 (1942).
60 Goldthwaite, *The Economy of Renaissance Florence*, 544.
61 Ellen Meiksins Wood, *The Origin of Capitalism: A Longer View* (London: Verso, 2002), 76.
62 Ibid., 86.
63 Ibid., 97.
64 The Sweezy/Dobb debate is key to Meiksins Wood and many other Marxist historians. Wood summarizes Sweezy's skepticism that industrial capitalists rose gradually from the ranks of petty producers, considering instead that capitalism had emerged much more fully-fledged. "Sweezy's second point was that the generalization of commodity production could not account for the rise of capitalism, and that highly developed commodity production—as, for instance, in medieval Italy or Flanders did not necessarily produce capitalism ... In opposition to Maurice Dobb's theory that the decline of feudalism resulted from the over-exploitation of peasants and the class conflicts engendered by it, Sweezy proposed that it might be 'more accurate to say that the decline of western European feudalism was due to the inability of the ruling class to maintain control over, and hence to exploit, society's labour power'" (ibid., 40).
65 Robert A. Denemark and Kenneth P. Thomas, "The Brenner-Wallerstein Debate," *International Studies Quarterly* 32, no. 1 (March 1988): 47–65.
66 Wallerstein, *The Modern World-System I*, 87.
67 Ibid., 126.
68 Ibid., 127.
69 Ibid., 348.
70 Jürgen Habermas, *The Structural Transformation of the Public Sphere: An Inquiry Into a Category of Bourgeois Society*, trans. Thomas Burger (Cambridge, MA: MIT Press, 1991), 12.

71 Ibid., 9.
72 Ibid., 74.
73 Ibid., 124.
74 Wallerstein, *The Modern World-System I*, 352.
75 Benedict Anderson, *Imagined Communities: Reflections on the Origin and Spread of Nationalism* (London: Verso, 2002).
76 Thomas R. Bates, "Gramsci and the Theory of Hegemony," *Journal of the History of Ideas* 36, no. 2 (1975): 351–66, https://doi.org/10.2307/2708933.
77 Annie Coombes, "Museums and the Formation of National and Cultural Identities," *Oxford Art Journal* 11, no. 2 (1988): 57–68.
78 Andrew McClellan, "A Brief History of the Art Museum Public," in *Art and Its Publics Museum Studies at the Millennium*, ed. Andrew McClellan (Malden: Blackwell, 2003), 1–50, 4–5.
79 Carol Duncan, *Civilizing Rituals: Inside Public Art Museums* (London: Routledge, 2006), 24.
80 Andrew McClellan, *Inventing the Louvre: Art, Politics, and the Origins of the Modern Museum in Eighteenth-Century Paris* (Berkeley: University of California Press, 2009).
81 Carol Duncan and Alan Wallach, "The Universal Survey Museum," *Art History*, no. 3 (December 1980): 448–69.
82 Neil MacGregor, "A Pentecost in Trafalgar Square," in *Whose Muse?: Art Museums and the Public Trust*, ed. James Cuno (Princeton: Princeton University Press, 2006), 27–8, 29. MacGregor is former director of the British Museum and the National Gallery before it.
83 Tony Bennett, *The Birth of the Museum: History, Theory, Politics* (London: Routledge, 2000).
84 Ibid., 28. For several case studies in the U.S., see Alan Wallach, *Exhibiting Contradiction: Essays on the Art Museum in the United States* (Amherst, MA: University of Massachusetts Press, 1998).
85 McClellan, "A Brief History of the Art Museum Public," 8.
86 Ibid., 21.
87 Cited in Rachel Cohen, *Bernard Berenson: A Life in the Picture Trade* (New Haven: Yale University Press, 2013), 244.
88 Reitlinger, *The Economics of Taste*, 229.
89 Bazin, *The Museum Age*, 258.
90 John Ott, "Metropolitan, Inc.: Public Subsidy and Private Gain at the Genesis of the American Art Museum," in *New York, Cultural Capital of the Gilded Age*, ed. Margaret R. Laster and Chelsea Bruner (London: Routledge, 2018), 122–38.
91 Flaminia Gennari-Santori, "An Art Collector and His Friends: John Pierpont Morgan and the Globalization of Medieval Art," *Journal of the History of Collections* 27, no. 3 (November 1, 2015): 401–11, 3, https://doi.org/10.1093/jhc/fhu039.
92 Ibid., 4–5.

93 Robert E. May, "Culture Wars: The U.S. Art Lobby and Congressional Tariff Legislation during the Gilded Age and Progressive Era," *The Journal of the Gilded Age and Progressive Era* 9, no. 1 (January 2010): 37–91, https://doi.org/10.1017/S1537781400003789.
94 As evinced by several excerpts in Titia Hulst, ed., *A History of the Western Art Market: A Sourcebook of Writings on Artists, Dealers, and Markets* (Oakland: University of California Pres, 2017).
95 Cohen, *Bernard Berenson*, 9.
96 Duncan, "Paul J. Sachs and the Institutionalization of Museum Culture between the World Wars," 113.
97 Stanley N. Katz, "Philanthropy," in *Handbook of the Economics of Art and Culture*, ed. Victor A. Ginsburg and David Throsby, vol. 1 (London: Elsevier, 2006), 1299–321, 1303, https://doi.org/10.1016/S1574-0676(06)01037-4.
98 Andrew Carnegie, "The Gospel of Wealth," Carnegie Corporation of New York, accessed October 27, 2019, https://www.carnegie.org/about/our-history/gospelofwealth/.
99 Katz, "Philanthropy," 1316.
100 Peter Dobkin Hall, "Historical Perspectives on Nonprofit Organizations in the United States," in *The Jossey-Bass Handbook of Nonprofit Leadership and Management*, ed. David O. Renz (Hoboken: John Wiley & Sons, 2005), 3–38, 5.
101 Ibid., 8. Dobkins Hall refers to the case where Stephen Girard left a large bequest for a school for orphans in Philadelphia to be administered by city-appointed trustees. In addition to deciding whether Philadelphia had the power to accept such a trust, the court had to decide whether Girard's will that clergymen be prohibited from teaching was legal.
102 "The growth of the federal state (measured in terms of the proportion of GNP expended upon it) and the enlargement of the jurisdiction of the national government have been accompanied, not unsurprisingly, by its involvement in what look very much like philanthropic activities." Katz, "Philanthropy," 1305.
103 Ibid., 1305.
104 Inderjeet Parmar, *Foundations of the American Century: The Ford, Carnegie, and Rockefeller Foundations in the Rise of American Power* (New York: Columbia University Press, 2014), 21.
105 Ibid., 259.
106 Ibid., 49.
107 See also L. Salamon, "Partners in Public Service: The Scope and Theory of Government-Nonprofit Relations," in *The Nonprofit Sector: A Research Handbook*, ed. Walter W. Powell (New Haven: Yale University Press, 1987), 99–117; Giridharadas, *Winners Take All*.
108 Arnove, "Philanthropy and Cultural Imperialism."
109 Dowie, *American Foundations*, 249.
110 For examples. see Nizan Shaked, "Looking the Other Way: Art Philanthropy, Lean Government, and Econo-Fascism in the USA," *Third*

Text 33, no. 3 (July 29, 2019): 375–95, https://doi.org/10.1080/09528822.2019.1628439.

111 Russell Lynes, *Good Old Modern: An Intimate Portrait of the Museum of Modern Art* (New York: Atheneum, 1973).

112 The Rockefeller brothers maintained control of their named foundations: a prominent example was the controversy on the Rockefeller Brothers Fund board because the "brothers" proposed giving away a large portion of the assets to cultural institutions in which they had a special interest." Richard J. Meislin, "Gardner Quits Rockefeller Fund, Citing 'Special Status,'" *The New York Times*, August 24, 1977, sec. Archives, https://www.nytimes.com/1977/08/24/archives/gardner-quits-rockefeller-fund-citing-special-status-of-brothers.html; Mary Anna Culleton Colwell, "The Foundation Connection," in *Philanthropy and Cultural Imperialism: The Foundations at Home and Abroad*, ed. Robert F. Arnove (Bloomington: Indiana University Press, 1982), 416–32.

113 Duncan, "Paul J. Sachs and the Institutionalization of Museum Culture between the World Wars," 103.

114 Parmar, *Foundations of the American Century*, 53.

115 Eva Cockcroft, "Abstract Expressionism, Weapon of the Cold War," *Artforum* 12, no. 10 (June 1974): 39–41. See also Frances Stonor Saunders, *The Cultural Cold War the CIA and the World of Arts and Letters* (New York: The New Press, 2013); Helen Laville and Hugh Wilford, *The US Government, Citizen Groups and the Cold War: The State-Private Network* (London: Routledge, 2012).

116 "MoMa Provisional Charter," September 19, 1929, R&P 11.1, The Museum of Modern Art Archives, New York.

117 Duncan, *Civilizing Rituals*, 57.

118 Claire Bishop, *Radical Museology or, "What's Contemporary" in Museums of Contemporary Art?* (London: Koenig Books, 2014), 9.

119 Elias Clark, "Charitable Trusts, the Fourteenth Amendment and the Will of Stephen Girard," *The Yale Law Journal* 66, no. 7 (1957): 979–1015, https://doi.org/10.2307/793871.

120 Duncan, *Civilizing Rituals*, 57.

121 James N. Wood, "The Authorities of the American Art Museum," in *Whose Muse? Art Museums and the Public Trust*, ed. James Cuno (Princeton: Princeton University Press, 2006), 103–28, 115–16.

122 "By-Laws of the Museum of Modern Art," May 12, 1960, R&P 11.1, The Museum of Modern Art Archives, New York.

123 Allison Tait, "Publicity Rules for Public Trusts," *Cardozo Arts & Entertainment Law Journal* 33, no. 2 (January 1, 2015): 421–71.

124 Maureen Collins, "Pensions or Paintings?: The Detroit Institute of Arts from Bankruptcy to Grand Bargain," *24 U. Miami Bus .L. Rev.* 1 (2015), https://repository.law.uic.edu/facpubs/613.

125 de Montebello et al., *Whose Muse?* See also Sally Anne Duncan, "From Period Rooms to Public Trust: The Authority Debate and Art Museum

Leadership in America," *Curator: The Museum Journal* 45, no. 2 (May 24, 2010): 93–108, https://doi.org/10.1111/j.2151-6952.2002.tb01184.x.
126 de Montebello et al., *Whose Muse?*, 135.
127 Glenn D. Lowry, "A Deontological Approach to Art Museums and the Public Trust," in *Whose Muse?: Art Museums and the Public Trust*, ed. James Cuno (Princeton: Princeton University Press, 2006), 129–50, 142, and 136, respectively.
128 Jennifer Kreder, "The 'Public Trust,'" *University of Pennsylvania Journal of Constitutional Law* 18, no. 5 (January 1, 2016): 1425–78, 1476, https://scholarship.law.upenn.edu/jcl/vol18/iss5/3.
129 Ibid., 1436.
130 Ibid., 1427.
131 Ibid., 1439–40. Cited John Locke, *Two Treatises of Government and a Letter Concerning Toleration*, ed. Ian Shapiro (New Haven: Yale University Press, 2003), 166.
132 Ibid., 1452.
133 Ibid., 1452.
134 Yael Weitz and Charles Goldstein, "Claim by Museums of Public Trusteeship and Their Response to Restitution Claims," *Art & Advocacy*, February 2013, http://www.herrick.com/art/publications/claim-by-museums-of-public-trusteeship-and-their-response-to-restitution-claims/.
135 Kreder, "The 'Public Trust,'" 1463.
136 Weitz and Goldstein, "Claim by Museums of Public Trusteeship and Their Response to Restitution Claims."
137 Ibid.
138 Ibid.
139 Shevaun Wright, email communication with the author, July 10, 2020.
140 Jodi Dean, *The Communist Horizon* (London: Verso, 2012).
141 Paul Dimaggio and Francie Ostrower, "Race, Ethnicity, and Participation in the Arts: Patterns of Participation by Hispanics, Whites, and African-Americans in Selected Activities," Report / National Endowment for the Arts (1992). See also Fred Wilson, *Mining the Museum: An Installation*, ed. Lisa Graziose Corrin, 1st ed. (Baltimore: New Press, 1994).
142 Kreder, "The 'Public Trust.'"
143 Kreder, "The 'Public Trust,'" 1478.
144 John Lane, "Letter to Mr. Mabry," June 12, 1935, EMH IV.38.C, The Museum of Modern Art Archives, New York.
145 Ibid.
146 Paul J. Sachs, address to the Trustees at the opening of the Museum's new building, May 8, 1939. "Statements and Notes" (MoMa, May 8, 1939), AHB. II. C. 76, The Museum of Modern Art Archives, New York.
147 His former student Milton Brown surmised that "the major positions went to people who took this course ... everyone who was a museum director at that point came out of the course. And it was Sachs that had gotten

them those positions." Cited in Duncan, "Paul J. Sachs and the Institutionalization of Museum Culture between the World Wars," 351.
148 Ibid., 348.
149 Ibid., 353.
150 MoMa, "The 'Permanent' Collection," circa 1938, AHB II.C.26, The Museum of Modern Art Archives, New York.
151 See also Kirk Varnedoe, "The Evolving Torpedo: Changing Ideas of the Collection of Painting and Sculpture of the Museum of Modern Art," in *Museum of Modern Art at Mid-Century: Continuity and Change*, ed. John Elderfield, Studies in Modern Art (New York: MoMA, 1995), 13–73.
152 "The 'Permanent' Collection. AHB II. C. 26.
153 Alfred H. Barr, *Painting And Sculpture In The Museum Of Modern Art 3* (New York: The Museum of Modern Art, New York, 1948).
154 Bruce Altshuler, "A Historical Introduction," in *Collecting the New*, Museums and Contemporary Art (Princeton: Princeton University Press, 2005), 1–14, 7. citing Varnedoe, "The Evolving Torpedo: Changing Ideas of the Collection of Painting and Sculpture of the Museum of Modern Art," 43.
155 James Johnson Sweeney, "Report of the Committee on the Museum Collection," 1943, JJS.10., The Museum of Modern Art Archives, New York, 2 and 8.
156 Ibid.
157 James T. Soby, "Letter to Alfred Barr," Microfilm, April 12, 1958, AHB:2181;1200, The Museum of Modern Art Archives, New York.
158 Sybil Gordon Kantor, *Alfred H. Barr, Jr. and the Intellectual Origins of the Museum of Modern Art* (Cambridge, MA: MIT Press, 2002), 71, citing A. Conger Goodyear, *The First Ten Years of the Museum of Modern Art* (New York: Museum of Modern Art, 1939), 20.
159 Ibid., 357.
160 Carol Duncan and Alan Wallach, "The Museum of Modern Art as Late Capitalist Ritual: An Iconographic Analysis," *Marxist Perspectives* 1, no. 4 (1978): 28–51.

Chapter 4

1 xSFM0MA Workers, "We Are Calling for the Resignation of SFMOMA Senior Curator Gary Garrels," Petition, *Change.org*, July 7, 2020, https://www.change.org/p/we-are-calling-for-the-resignation-of-sfmoma-senior-curator-gary-garrels.
 See also Carol Pogash, "Its Top Curator Gone, SFMOMA Reviews Its Record on Race," *The New York Times*, July 22, 2020, sec. Arts, https://www.nytimes.com/2020/07/22/arts/design/sfmoma-gary-garrels-resignation.html; Sam Lefebvre, "Senior SFMOMA Curator Resigns Amid Reckoning

With Institutional Racism," *Hyperallergic*, July 13, 2020, https://hyperallergic.com/576369/gary-garrels-resigns-sfmoma/.
2 "Toolkit" (MASS Action: Museum as Site for Social Action, 10/17), https://www.museumaction.org/s/TOOLKIT_10_2017.pdf.
3 A few recent resources include Joanne Jones-Rizzi and Stacey Mann, "Is That Hung White?" *American Alliance of Museums*, May 19, 2020, https://www.aam-us.org/2020/05/19/is-that-hung-white-a-conversation-on-the-state-of-museum-exhibitions-and-race/; Westermann, Schonfeld, and Sweeney, "Art Museum Staff Demographic Survey 2018"; BoardSource, "Museum Board Leadership 2017: A National Report" (Washington, D.C.: BoardSource, 2017), https://www.aam-us.org/2018/01/19/museum-board-leadership-2017-a-national-report/. We can also see how investing in resources helps, although nowhere near enough. Although slow progress is evident, the gender gap has been faster to close than the race gap: Press office, "Latest Art Museum Staff Demographic Survey Shows Number of African American Curators and Women in Leadership Roles Increased," Press Release (New York: Association of Art Museum Directors, January 28, 2019), https://aamd.org/for-the-media/press-release/latest-art-museum-staff-demographic-survey-shows-number-of-african.
4 In addition to note 465 below, see Cara Ober, "The BMA Spent $2.57 Million on Art by 49 Women in 2020. Guess How Many Are from Maryland?," *BmoreArt*, January 22, 2021, https://bmoreart.com/2021/01/the-bma-spent-2-57-million-on-art-by-49-women-in-2020-guess-how-many-are-from-maryland.html.
5 I am inspired here by Marianna Adams and Judy Koke, "'Stuck' is where you need to pay attention: Some barriers to creating truly inclusive art museums," in *Multiculturalism in Art Museums Today*, ed. Joni Boyd Acuff and Laura Evans (London: Rowman & Littlefield, 2014), 3–18; and Eve Tuck and K. Wayne Yang, "Decolonization Is Not a Metaphor," in *Decolonization: Indigeneity, Education & Society* 1, no. 1 (September 8, 2012).
6 On the winner-takes-all system: "This was borne out by the 2017 Art Basel/UBS report on the art market, which found that in 2016 almost half the value of sales at auction came from just 1 per cent of artists. 'Only 15 per cent of artists had works priced in excess of $50,000, and a tiny fraction (just over 1 per cent) had works that sold for more than $1 million,' said the report. From Picasso, Bacon and Richter to Zhang Daqian and Qi Baishi, these are the blue-chip, safe 'brand names' that investors want – and their focus on such a small group of artists is one of the elements that has been a strong factor in pushing up prices at the top. Research carried out by Artnet magazine in 2017 confirmed this concentration on a few artists. It found that just 25 artists were responsible for 44.9 per cent of all post-war and contemporary art auction sales in the first half of the year. 'As increasingly wealthy buyers compete for a shrinking supply of name-branded artists, the art market has become highly concentrated at the top,' it said" (Adam, *Dark Side of the Boom*, 236–7).

7 For example, Jennifer Williams et al., "Open Letter to the New Orleans Museum of Art," Dismantle NOMA, June 24, 2020, https://sites.google.com/view/dismantlenoma/collective-statement; #ForTheCulture, "An Open Letter to New York City's Cultural Institutions," 2020, https://fortheculture2020.com/; Valentina Di Liscia, "Brooklyn Museum Employees Accuse Administration of Staff Mistreatment," *Hyperallergic*, September 17, 2020, https://hyperallergic.com/588184/brooklyn-museum-staff-open-letter/; Robin Pogrebin, "Curators Urge Guggenheim to Fix Culture That 'Enables Racism,'" *The New York Times*, June 22, 2020, sec. Arts, https://www.nytimes.com/2020/06/22/arts/design/guggenheim-curators-racism-sexism.html; Weber, "Almost 50 Whitney Biennal Artists Sign Letter Demanding Removal of Warren Kanders from Museum Board."
8 Jennifer Valentino-DeVries, "Service Meant to Monitor Inmates' Calls Could Track You, Too," *The New York Times*, May 11, 2018, sec. Technology, https://www.nytimes.com/2018/05/10/technology/cellphone-tracking-law-enforcement.html.
9 Matt Stromberg, "Major Artists Demand LACMA Remove Board Member Who Owns Prison Telecom Company," *Hyperallergic*, September 16, 2020, https://hyperallergic.com/588856/open-letter-lacma-tom-gores/;
 Scott Roberts, Color of Change and Bianca Tylek, Worth Rises, "Call to Remove Tom Gores from the LACMA Board," September 9, 2020, https://static1.squarespace.com/static/58e127cb1b10e31ed45b20f4/t/5f626fc9dbc537 3a81461178/1600286667361/2020.09.09+-+LACMA+Letter+re+Tom+Gores.pdf; Bishara, "Warren Kanders, Former Whitney Museum Vice Chair, Vows to Exit Tear Gas Trade," *Hyperallergic*, June 9, 2020, https://hyperallergic.com/570073/warren-kanders-tear-gas-trade/;
 Alex Greenberger, "Nan Goldin's P.A.I.N. Group Protests 'Proud' Support from Sackler Family at Victoria & Albert Museum in London," *ARTnews*, November 16, 2019, https://www.artnews.com/artnews/news/sackler-pain-protest-victoria-and-albert-museum-13589/; Julia Jacobs and Zachary Small, "Whitney Cancels Show That Included Works Bought at Fund-Raisers," *The New York Times*, August 25, 2020, sec. Arts, https://www.nytimes.com/2020/08/25/arts/design/whitney-museum-exhibition-canceled.html.
10 For staff, see Westermann, Schonfeld, and Sweeney, "Art Museum Staff Demographic Survey 2018."
 For how awareness and action can make a difference, see Laura Washington, "Latest Art Museum Staff Demographic Survey Shows Increases in African American Curators and Women in Leadership Roles," *The Andrew W. Mellon Foundation News* (blog), January 28, 2019, https://mellon.org/news-blog/articles/latest-art-museum-staff-demographic-survey-shows-increases-african-american-curators-and-women-leadership-roles/; Topaz et al., "Diversity of Artists in Major U.S. Museums."

For board levels, see Ruth McCambridge, "Museums So White: Survey Reveals Deep Lack of Diversity," *Nonprofit Quarterly*, May 9, 2017, sec. Non Profit News, https://nonprofitquarterly.org/museum-boards-directors-whitest-getting-whiter/

For exhibitions, see Alex Greenberger, "Do Exhibitions at U.S. Museums Reflect Calls for Diversity?," *ARTnews.Com*, August 5, 2019, sec. White Cubes, https://www.artnews.com/art-news/news/u-s-museums-exhibitions-diversity-survey-13065/; Howardena Pindell, "Art World Surveys," pindell.mcachicago.org, accessed May 9, 2021, https://pindell.mcachicago.org/art-world-surveys/.

11 La Tanya S. Autry et al., *Beyond Statements: People Power*, Free Live Webinar (AAMC Foundation & Art Fund, 2020), https://www.youtube.com/watch?v=kEQcBpS-INc&list=PLMLsLpvY1C95m6e3thYFlY5qoYiY62gKY&index=2. See also La Tanya S. Autry, ed., "Social Justice & Museums Resource List," (July 11, 2015), https://bit.ly/2UG1aUD.

12 Porchia Moore, "Cartography: A Black Woman's Response to Museums in the Time of Racial Uprising," *The Incluseum: Best Practices* (blog), June 10, 2020, https://incluseum.com/2020/06/10/cartography-a-black-womans-response-to-museums-in-the-time-of-racial-uprising/.

13 Kriston McIntosh et al., "Examining the Black-White Wealth Gap," *Brookings Institute: Up Front* (blog), February 27, 2020, https://www.brookings.edu/blog/up-front/2020/02/27/examining-the-black-white-wealth-gap/.

14 Keeanga-Yamahtta Taylor, *From #BlackLivesMatter to Black Liberation* (Chicago: Haymarket Books, 2016).

15 See Nizan Shaked, "Getting to a Baseline on Identity Politics: The Marxist Debate," in *The Routledge Companion to African American Art History* (New York: Routledge, 2019), 209–18.

16 Beyond other citations in this book, additional examples can be seen in Ivan Karp, *Exhibiting Cultures: The Poetics and Politics of Museum Display* (Washington, D.C.: Smithsonian Institution, 1991); Bridget R Cooks, *Exhibiting Blackness: African Americans and the American Art Museum* (Amherst, MA: University of Massachusetts Press, 2011); Aruna D'Souza, *Whitewalling: Art, Race & Protest in 3 Acts* (New York: Badlands Unlimited, 2018); Amy Lonetree, *Decolonizing Museums: Representing Native America in National and Tribal Museums* (Chapel Hill: The University of North Carolina Press, 2012); Melanie A. Adams, "Deconstructing Systems of Bias in the Museum Field Using Critical Race Theory," *Journal of Museum Education* 42, no. 3 (July 3, 2017): 290–5, https://doi.org/10.1080/10598650.2017.1339172; Maurice Berger, "Are Art Museums Racist?," *Art in America* 78, no. 9 (September 1990): 68–77; Susan E. Cahan, *Mounting Frustration: The Art Museum in the Age of Black Power* (Durham, NC: Duke University Press, 2016).

17 Cedric J Robinson, *Black Marxism: The Making of the Black Radical Tradition* (London: Zed Press, 1983), 309.

18 Both address slavery and serfdom, but do not emphasize enough slavery's constitutive significance and the subsequent dependency of capitalism on racialized stratification of the working populations. Nevertheless, see, for example, Marx: "The discovery of gold and silver in America, the extirpation, enslavement and entombment in mines of the aboriginal population, the beginning of the conquest and looting of the East Indies, the turning of Africa into a warren for the commercial hunting of black-skins, signaled the rosy dawn of the era of capitalist production" (Marx and Engels, *Capital, Volume 1*, 739).
19 Robinson, *Black Marxism*, 2.
20 Cedric Johnson, "The Wages of Roediger: Why Three Decades of Whiteness Studies Has Not Produced the Left We Need," *Nonsite.Org*, no. 29 (September 9, 2019), https://nonsite.org/the-wages-of-roediger-why-three-decades-of-whiteness-studies-has-not-produced-the-left-we-need/; Ruth Wilson Gilmore, *Golden Gulag: Prisons, Surplus, Crisis, and Opposition in Globalizing California* (Berkeley: University of California Press, 2007); Angela Yvonne Davis, *Women, Race, and Class* (London: Vintage Books, 1983).
21 Robinson, *Black Marxism*, 203, citing W. E. B. Du Bois, *Black Reconstruction in America, 1860–1880* (Cleveland: World Publishing, 1935).
22 See notes 459 and 465 above.
23 Arrighi, *The Long Twentieth Century*, 87.
24 De Marchi and Van Miegroet, "The History of Art Markets."
25 This was already seen in Noah Horowitz, *Art of the Deal: Contemporary Art in a Global Financial Market* (Princeton: Princeton University Press, 2014).
26 The Michael Moses of the Mei Moses Art Index attempts to argue this point, but their methods and data are limited to repeat auction sales. Marion Maneker, "How Correlated Are Art Returns to Other Assets?" *Art Market Monitor*, April 28, 2016, https://www.artmarketmonitor.com/2016/04/28/how-correlated-are-art-returns-to-other-assets/.

Debates and discussion of methods can be found in this select list of resources: Clare McAndrew, *Fine Art and High Finance*; Olav Velthuis, *Talking Prices: Symbolic Meanings of Prices on the Market for Contemporary Art* (Princeton: Princeton University Press, 2007).

See also, for example, ArtTactic, "Art & Finance Report 2017" (Deloitte Luxembourg and ArtTactic, 2017); Clare McAndrew, "The Art Basel and UBS Global Art Market Report," March 11, 2019, https://d2u3kfwd92fzu7.cloudfront.net/The_Art_Market_2019-5.pdf.
27 Anna M. Dempster, ed., *Risk and Uncertainty in the Art World* (London: Bloomsbury, 2015).
28 Staff, "'Monet Talks' as Mideast Art Investment Proves a Pretty Picture," *Al Arabiyah English*, September 19, 2013.
29 Beech, *Art and Value*.
30 Adam, *Dark Side of the Boom*, 14.

31 Ibid., 14. Adam cites Julia Halperin, "Art of today dominates US museums," *The Art Newspaper*, April 1, 2017.
32 Julia Halperin, "Almost One Third of Solo Shows in US Museums Go to Artists Represented by Five Galleries," *The Art Newspaper*, April 2, 2015, sec. Exhibitions, http://www.theartnewspaper.com/news/almost-one-third-of-solo-shows-in-us-museums-go-to-artists-represented-by-five-galleries.
33 Jodi Dean, "Neofeudalism: The End of Capitalism?," *Los Angeles Review of Books*, May 12, 2020, https://lareviewofbooks.org/article/neofeudalism-the-end-of-capitalism/. Also see Kobena Mercer, "Where the Streets Have No Name: A Democracy of Multiple Public Spheres." In *This Will Have Been: Art, Love & Politics in the 1980s*, edited by Helen Molesworth (New Haven: Yale University Press, 2012) 134–147.
34 OECD, "Chapter 3: Lifting Investment for Higher Sustainable Growth," *OECD Economic Outlook*, vol. 2015, no. 1 (OECD Publishing, June 2015), 212; Lewis Alexander and Janice Eberly, "Investment Hollowing Out" (17th Annual Jacques Polak Research Conference: Macroeconomics after the Great Recession, IMF, 2016), https://www.imf.org/external/np/res/seminars/2016/arc/pdf/Alexander_Eberly_Session2.pdf; Kliman, *The Failure of Capitalist Production*.
35 About these tendencies, see also a resource compilation by John Smith here: John Smith, "The Global Economy - Crisis or Recovery?," DOI: 10.13140/RG.2.2.34812.54405.
36 Wallerstein shows this in regards to the rise of the Dutch and later the British empire.
37 Goldthwaite nuances the Lopez thesis: "[E]conomic 'hard times' discouraged men from business ventures and thereby released more wealth for consumption, which was in effect a kind of 'investment in culture' to achieve social status by men whose economic status was threatened." Richard A. Goldthwaite, "The Economy of Renaissance Italy: The Preconditions for Luxury Consumption," *I Tatti Studies in the Italian Renaissance* 2 (1987): 15–39, https://doi.org/10.2307/4603651.
38 Dean, "Neofeudalism."
39 Editorial, "Policing and Profit," *Harvard Law Review*, Developments in the Law, 128, no. 1723 (April 10, 2015), https://harvardlawreview.org/2015/04/policing-and-profit/.; Keeanga-Yamahtta Taylor, *Race for Profit: How Banks and the Real Estate Industry Undermined Black Homeownership* (Chapel Hill: The University of North Carolina Press, 2019).
40 Robert Kuttner and Katherine V. Stone, "The Rise of Neo-Feudalism," *The American Prospect*, April 8, 2020, https://prospect.org/api/content/95e27c24-7931-11ea-a366-1244d5f7c7c6/.
41 Ibid.
42 Ibid.
43 Wages declined in both sectors, but faster in the public sector. This is but one example of decline in the wealth share of historically excluded groups,

that included others such as home ownership: "What has emerged for public sector workers is a context of increasing precariousness. While all public sectors employees are vulnerable, this is especially true for minority workers; these workers saw significant middle class mobility and relative racial equality during the 1970s and 1980s compared to their private sector counterparts, only now to find these gains receding." Vincent J. Roscigno and George Wilson, "Privatization and Racial Inequality," *Contexts* 13, no. 1 (February 1, 2014): 72–4, https://doi.org/10.1177/1536504214522014.

44 Robert Storr, "To Have and to Hold," in *Collecting the New*, ed. Bruce Altshuler, Museums and Contemporary Art (Princeton: Princeton University Press, 2005), 31.

45 Shane Ferro and Rachel Corbett, "10 Former Stars The Art Market Left Behind," *HuffPost*, December 6, 2017, sec. BLOUIN ARTINFO, https://www.huffpost.com/entry/10-former-art-sensations-_b_2584507; Julia Halperin, "6 Forgotten Art Darlings From the Gilded-Age Market Boom," *Artnet News*, May 19, 2017, https://news.artnet.com/art-world/6-market-darlings-youve-never-heard-of-960833.

46 Jay E. Cantor, in Feldstein, *The Economics of Art Museum*, 19; also see Mark W. Rectanus, *Culture Incorporated: Museums, Artists, and Corporate Sponsorships* (Minneapolis: university of Minnesota Press, 2002)

47 Examples of radical fluctuation of market as a factor of shifting fashion, as opposed to lasting significance or quality determined in retrospect, is evident throughout Reitlinger, *The Economics of Taste*, which covers 200 years.

48 Sheets, "How The Gap's Founders Helped Shape the New SFMOMA."

49 Andrew Goldstein, "'We're Not Working in an ER': Dealer Esther Kim Varet on How to Run a Thriving Art Gallery Without Losing Your Mind," *Artnet News*, February 12, 2020, sec. People, https://news.artnet.com/art-world/various-small-fires-esther-kim-varet-interview-1773888.

50 Nate Freeman, "The Next Must-Have Market Darling Has Emerged," *ARTnews*, September 21, 2017, https://www.artnews.com/art-news/market/if-another-person-asks-me-to-get-them-a-jen-guidi-i-think-i-might-just-vomit-in-my-bed-the-next-must-have-market-darling-has-emerged-9028/.

51 Goldstein, "'We're Not Working in an ER.'"

52 Kirk, "The Billionaire's Treasure Trove," 899–900.

53 Ibid., 901. Kirk cites I.R.S. Gen. Couns. Mem. 39,598 (January 23, 1987).

54 Those can be substantial: "We could ask: who pays for shipping and insurance when works are moved between storage facilities and the various residencies of donors? Who pays for staff time when fire or flood danger threatens second and third homes or offices and mega-expensive works are shuttled around and insured? What kind of expenses are written off on publicly subsidized balance sheets? Such information, and much more, is hidden from public view with no regulation in sight." Nizan Shaked, "So Much for Philanthropy: The Marciano and 'All the Usual Suspects' — A Los Angeles Perspective," *East of Borneo*, May 12, 2020, https://eastofborneo.org/articles/so-much-for-philanthropy/.

55 "Collectors used to be able to donate works to a museum while keeping the art in their own homes while they were still alive. But a change in the tax law in 2006 outlawed the practice." Patricia Cohen, "Writing Off the Warhol Next Door," *The New York Times*, January 10, 2015, sec. Business, https://www.nytimes.com/2015/01/11/business/art-collectors-gain-tax-benefits-from-private-museums.html. See also Ralph E. Lerner and Judith Bresler, *Art Law: The Guide for Collectors, Investors, Dealers, & Artists*, vol. 2, 2 vols. (New York: Practising Law Institute, 2012).
56 David Rieff, "Philanthrocapitalism: A Self-Love Story: Why Do Super-Rich Activists Mock Their Critics Instead of Listening to Them?," *The Nation*, October 1, 2015, https://www.thenation.com/article/philanthrocapitalism-a-self-love-story/.
57 Katz, "Philanthropy," 1311.
58 Marta P Baltodano, "The Power Brokers of Neoliberalism: Philanthrocapitalists and Public Education," *Policy Futures in Education* 15, no. 2 (June 15, 2016): 141–56, https://doi.org/10.1177/1478210316652008.
59 Juanjo Mediavilla and Jorge Garcia-Arias, "Philanthrocapitalism as a Neoliberal (Development Agenda) Artefact: Philanthropic Discourse and Hegemony in (Financing for) International Development," *Globalizations* 16, no. 6 (September 19, 2019): 857–75, https://doi.org/10.1080/14747731.2018.1560187.
60 Dowie, *American Foundations*, 7.
61 Ibid., 7.
62 Keeanga-Yamahtta Taylor, *From #BlackLivesMatter to Black Liberation* (Chicago: Haymarket Books, 2016), 35.
63 Marta Baltodano cited above shows this in detail, citing an ample list of additional and related scholarship substantiating her analysis.
64 Melissa Smith, "Responding to Widespread Demands, Museums Are Acquiring More Works by Artists of Color. But How They Do So Matters More Than Ever," *Artnet News*, September 2, 2020, sec. Art World, https://news.artnet.com/art-world/museums-acquiring-works-artists-of-color-1905718.
65 Anne d'Harnoncourt et al., "The Museum and the Public," in *The Economics of Art Museums*, ed. Martin Feldstein, A National Bureau of Economic Research Conference Report (Chicago: The University of Chicago Press, 1991), 35–60, 45.
66 Ibid., 43. See also Paul Dimaggio and Francie Ostrower, *Race, Ethnicity, and Participation in the Arts: Patterns of Participation by Hispanics, Whites, and African-Americans in Selected Activities*, Report / National Endowment for the Arts (Santa Ana: Seven Locks Press, 1992).
67 Kimberlé Crenshaw, "Demarginalizing the Intersection of Race and Sex: A Black Feminist Critique of Antidiscrimination Doctrine, Feminist Theory and Antiracist Politics," *University of Chicago Legal Forum* 1989, no. 1 (1989), https://chicagounbound.uchicago.edu/uclf/vol1989/iss1/8.
68 Adams and Koke, "'Stuck' Is Where You Need to Pay Attention: Some Barriers to Creating Truly Inclusive Art Museums."

69 Westermann, Schonfeld, and Sweeney, "Art Museum Staff Demographic Survey 2018."
70 Liam Sweeney and Roger C. Schonfeld, "Interrogating Institutional Practices in Equity, Diversity, and Inclusion," *Ithaka S+R* (September 20, 2018), https://doi.org/10.18665/sr.309173.
71 Ibid., 7.
72 Ibid., 14.
73 Ashok Kumar et al., eds., "Identity Politics," *Historical Materialism* 26, no. 2 (July 2018), http://www.historicalmaterialism.org/special-issue/issue-262-identity-politics;

 Cinzia Arruzza, Tithi Bhattacharya, and Nancy Fraser, *Feminism for the 99%: A Manifesto* (London: Verso, 2019).
74 Porchia Moore, "Cartography: A Black Woman's Response to Museums in the Time of Racial Uprising," *The Incluseum: Best Practices* (blog), June 10, 2020, https://incluseum.com/2020/06/10/cartography-a-black-womans-response-to-museums-in-the-time-of-racial-uprising/.
75 "Toolkit" (MASS Action: Museum as Site for Social Action, 10/17), https://www.museumaction.org/s/TOOLKIT_10_2017.pdf.
76 Ibid.
77 Kelli Morgan, "To Bear Witness: Real Talk about White Supremacy in Art Museums Today," *Burnaway*, June 24, 2020, https://burnaway.org/to-bear-witness/.
78 Zoë Samels, "A Tale of Two Cities: Contemporary Art and the American Museum c. 1940" (*Le musée face à l'art de son temps Bicentenaire du Musée du Luxembourg, 1818-2018,* Archives nationales, Centre Pompidou, Musée d'Orsay Paris, 2018).
79 Ibid.
80 Ibid.
81 ibid.
82 Kirsten Lloyd, "Shaping Collections: Globalisation and Contemporary Art," The University of Edinburgh, Edinburgh College of Art, The Fabric: Social Reproduction and the Art Field in History and Praxis, May 11, 2017, http://www.fabric.eca.ed.ac.uk/university-edinburgh-contemporary-art-research-collection/.

BIBLIOGRAPHY

Adam, Georgina. "Buyer's Guide to . . . Gerhard Richter." *The Art Newspaper*, June 10, 2019. http://theartnewspaper.com/analysis/buyer-s-guide-to-gerhard-richter

Adam, Georgina. *Dark Side of the Boom: The Excesses of the Art Market in the 21st Century*. London: Lund Humphries, 2018.

Adams, Marianna, and Judy Koke. "'Stuck' is where you need to pay attention: Some barriers to creating truly inclusive art museums." In *Multiculturalism in Art Museums Today*, edited by Joni Boyd Acuff and Laura Evans, London: Rowman & Littlefield, 2014. 3–18.

Adams, Melanie A. "Deconstructing Systems of Bias in the Museum Field Using Critical Race Theory." *Journal of Museum Education* 42, no. 3 (July 3, 2017): 290–5. https://doi.org/10.1080/10598650.2017.1339172

Alberts, Lindsay. "Francesco I's Museum: Cultural Politics at the Galleria Degli Uffizi." *Journal of the History of Collections* 30, no. 2 (September 27, 2017): 203–16.

Alberts, Lindsay. "From Studiolo to Uffizi: Sites of Collecting and Display under Francesco I de' Medici." PhD diss., Boston University, 2016. https://open.bu.edu/handle/2144/17710

Alberts, Lindsay. "The Studiolo of Francesco I de' Medici: A Recently-Found Inventory." *Art Histories Supplement 2.0*, no. 1 (Summer 2015): 3–24.

Alexander, Lewis, and Janice Eberly. "Investment Hollowing Out." IMF, 2016. https://www.imf.org/external/np/res/seminars/2016/arc/pdf/Alexander_Eberly_Session2.pdf

Allsop, Laura. "Gap Founders' Modern Art Collection on Display in San Francisco." *CNN*, August 2, 2010. http://edition.cnn.com/2010/WORLD/americas/07/30/fisher.collection/index.html

Althusser, Louis. "Ideology and Ideological State Apparatuses." In *Lenin and Philosophy and Other Essays*, translated by Ben Brewster, 127–86. London: Monthly Review Press, 1971.

Altshuler, Bruce. "A Historical Introduction." In *Collecting the New: Museums and Contemporary Art*, 1–14. Princeton: Princeton University Press, 2005.

Americans for the Arts. "National Findings." Arts & Economic Prosperity IV, May 15, 2019. https://www.americansforthearts.org/by-program/reports-and-data/research-studies-publications/arts-economic-prosperity-iv/national-findings

Anderson, Benedict. *Imagined Communities: Reflections on the Origin and Spread of Nationalism*. London: Verso, 2002.

Anna, Brady, and Anny Shaw. "Guarantees: the next big art market scandal?" *The Art Newspaper*, November 12, 2018, sec. Art market. http://theartnewspaper.com/news/guarantees-the-next-big-art-market-scandal

Armstrong, Annie. "For Third Year in a Row, Trump Administration Threatens to Cut NEA Funding." *ARTnews*, March 18, 2019. http://www.artnews.com/2019/03/18/trump-administration-threatens-to-cut-nea-funding-2020/

Arnove, Robert F. "Introduction." In *Philanthropy and Cultural Imperialism: The Foundations at Home and Abroad*, edited by Robert F. Arnove, 1–24, Bloomington: Indiana University Press, 1982.

Arrighi, Giovanni. *The Long Twentieth Century: Money, Power, and the Origins of Our Times*. London: Verso, 1994.

Arruzza, Cinzia, Tithi Bhattacharya, and Nancy Fraser. *Feminism for the 99%: A Manifesto*. London: Verso, 2019.

Artprice. "Gerhard Richter, the 'Picasso of the 21st Century.'" Artprice's Report. ArtMarket® Insight, January 23, 2018. https://www.artprice.com/artmarketinsight/gerhard-richter-the-picasso-of-the-21st-century

ArtTactic. "Art & Finance Report 2017." Deloitte Luxembourg and ArtTactic, 2017. https://www2.deloitte.com/lu/en/pages/art-finance/articles/art-finance-report.html

Autry, La Tanya S., Errol Francis, Monica O. Montgomery, and Kelli Morgan. *Beyond Statements: People Power*. AAMC Foundation & Art Fund, 2020. Free Live Webinar, running time: 1:19:00. https://www.youtube.com/watch?v=kEQcBpS-INc&list=PLMLsLpvY1C95m6e3thYFlY5qoYiY62gKY&index=2

Autry, La Tanya S., and Mike Murawski. "Museums Are Not Neutral." MuseumsAreNotNeutral. Accessed May 8, 2021. https://www.museumsarenotneutral.com/learn-more

Bailey, Issac. "Why Trump's MAGA Hats Have Become a Potent Symbol of Racism." *CNN*, March 12, 2019, sec. Opinion. https://www.cnn.com/2019/01/21/opinions/maga-hat-has-become-a-potent-racist-symbol-bailey/index.html

Baltodano, Marta P. "The Power Brokers of Neoliberalism: Philanthrocapitalists and Public Education." *Policy Futures in Education* 15, no. 2 (June 15, 2016): 141–56. https://doi.org/10.1177/1478210316652008

Baranik, Rudolf, Sarina Bromberg, Sarah Charlesworth, Susanne Cohn, Carol Duncan, Shawn Gargagliano, Eunice Golden, et al. *An Anti-Catalog*. New York: The Catalog Committee, Inc., 1977. https://primaryinformation.org/files/AntiCatalog.pdf

Barr, Alfred H. *Painting And Sculpture In The Museum Of Modern Art 3*. New York: The Museum of Modern Art, New York, 1948.

Bates, Thomas R. "Gramsci and the Theory of Hegemony." *Journal of the History of Ideas* 36, no. 2 (1975): 351–66. https://doi.org/10.2307/2708933

Baudrillard, Jean. "The System of Collecting." In *Cultures of Collecting*, edited by John Elsner and Roger Cardinal, 7–24. London: Reaktion Books, 1994.

Baudrillard, Jean. *The System of Objects*. London & New York: Verso, 2005.

Bazin, Germain. *The Museum Age*. Translated by Jane van Nuis Cahill. New York: Universe Books, 1967.

Beech, Dave. *Art and Value: Art's Economic Exceptionalism in Classical, Neoclassical and Marxist Economics*. Historical Materialism Book Series. Leiden: Brill, 2015.

Bellamy Foster, John. "Capitalism Has Failed—What Next?" *Monthly Review*, February 1, 2019. https://monthlyreview.org/2019/02/01/capitalism-has-failed-what-next/

Belz, Corinna, dir. *Gerhard Richter Painting*. 2011; Berlin: Zero One Film, 2012. DVD.

Benjamin, Walter. "Theses on the Philosophy of History." In *Illuminations: Essays and Reflections*, edited by Hannah Arendt, translated by Harry Zohn, 253–64. New York: Schocken Books, 1969.

Benjamin, Walter. "Unpacking My Library: A Talk about Book Collecting." In *Illuminations: Essays and Reflections*, edited by Hannah Arendt, translated by Harry Zohn, 59–67. New York: Schocken Books, 1969.

Bennett, Tony. *The Birth of the Museum: History, Theory, Politics*. London: Routledge, 2000.

Berger, Maurice. "Are Art Museums Racist?" *Art in America* 78, no. 9 (September 1990): 68–77.

Best, Beverley. "Distilling a Value Theory of Ideology from Volume Three of Capital." *Historical Materialism* 23, no. 3 (September 11, 2015): 101–41. https://doi.org/10.1163/1569206X-12341424

Best, Beverley. "Political Economy through the Looking Glass: Imagining Six Impossible Things about Finance before Breakfast." *Historical Materialism* 25, no. 3 (December 13, 2017): 76–100. https://doi.org/10.1163/1569206X-12341537

Bishara, Hakim. "Warren Kanders, Former Whitney Museum Vice Chair, Vows to Exit Tear Gas Trade." *Hyperallergic*, June 9, 2020. https://hyperallergic.com/570073/warren-kanders-tear-gas-trade/

Bishara, Hakim, and Ilana Novick. "Decolonize This Place Launches 'Nine Weeks of Art and Action' with Protest at Whitney Museum." *Hyperallergic*, March 23, 2019. https://hyperallergic.com/491418/decolonize-this-place-nine-weeks-launch/

Bishop, Claire. *Radical Museology or, "What's Contemporary" in Museums of Contemporary Art?* London: Koenig Books, 2014.

Blanc, Eric. "Billionaires vs. LA Schools." *Jacobin*, January 15, 2019. https://jacobinmag.com/2019/01/la-teachers-strike-charters-privatization

BoardSource. "Museum Board Leadership 2017: A National Report." Washington, D.C.: BoardSource, 2017. https://www.aam-us.org/2018/01/19/museum-board-leadership-2017-a-national-report/

Bolton, Richard, ed. *Culture Wars: Documents from the Recent Controversies in the Arts*. New York: The New Press, 1992.

Bonetti, David. "SFMOMA's 'top Secret' Acquisition." *SFGate*, April 29, 1999. https://www.sfgate.com/entertainment/article/SFMOMA-s-top-secret-acquisition-3085512.php

Bonetti, David. "The Picasso Has Left the Building." *SFGate*, April 16, 2000. https://www.sfgate.com/entertainment/article/The-Picasso-has-left-the-building-3065216.php

Bonsignore, Tony. "A £50m Painting, the 7th Duke of Sutherland, and the Taxpayer." *Citywire*, August 30, 2008. http://citywire.co.uk/funds-insider/news/a-50m-painting-the-7th-duke-of-sutherland-and-the-taxpayer/a312605

Bourdieu, Pierre. "The Forms of Capital." In *Handbook of Theory and Research for the Sociology of Education*, edited by John Richardson, 241–58. New York: Greenwood Press, 1986.

Bowley, Graham. "How to Block Trump Arts Cuts? Groups Look for G.O.P. Help." *The New York Times*, December 22, 2017, sec. Arts. https://www.nytimes.com/2017/02/28/arts/how-to-block-trump-arts-cuts-groups-look-for-gop-help.html

Bowley, Graham, and Patricia Cohen. "Buyers Find Tax Break on Art: Let It Hang Awhile in Oregon." *The New York Times*, April 12, 2014, sec. Arts. https://www.nytimes.com/2014/04/13/business/buyers-find-tax-break-on-art-let-it-hang-awhile-in-portland.html

Boyer, David. "Despite Obama's Praise for Higher Pay, The Gap Inc. Has Spotty Record on Sweatshops." *The Washington Times*, March 16, 2014, sec. Politics. https://www.washingtontimes.com/news/2014/mar/16/despite-obamas-praise-for-higher-pay-gaps-has-spot/

Bradley, Kimberly. "Artnet.de Digest." *Artnet Magazine*, August 27, 2007. http://www.artnet.com/magazineus/news/bradley/bradley8-27-07.asp

Brinklow, Adam. "UN Expert Decries Homeless Conditions in Bay Area as 'Cruel,' 'Unacceptable.'" *Curbed SF*, January 22, 2018. https://sf.curbed.com/2018/1/22/16920118/homeless-oakland-san-francisco-united-nations

Brody, Evelyn, and John E. Tyler. "How Public Is Private Philanthropy: Separating Reality from Myth." *Philanthropy Roundtable*, June 11, 2009. https://papers.ssrn.com/abstract=1522662

Brown, Judith C. "Prosperity or Hard Times in Renaissance Italy?" *Renaissance Quarterly* 42, no. 4 (1989): 761–80. https://doi.org/10.2307/2862281

Brown, Kathryn. "Introduction." *Journal for Art Market Studies* 3, no. 1 (May 14, 2019). https://doi.org/10.23690/jams.v3i1.89

Brown, Kathryn. "Private Influence, Public Goods, and the Future of Art History." *Journal for Art Market Studies* 3, no. 1 (May 14, 2019). https://doi.org/10.23690/jams.v3i1.86

Bryant, Chris. "How the Aristocracy Preserved Their Power." *The Guardian*, September 7, 2017, sec. News. https://www.theguardian.com/news/2017/sep/07/how-the-aristocracy-preserved-their-power

Bryan-Wilson, Julia. *Art Workers: Radical Practice in the Vietnam War Era*. Berkeley: University of California Press, 2009.

Buchloh, Benjamin. "Figures of Authority, Ciphers of Regression: Notes on the Return of Representation in European Painting." *October* 16 (1981): 39–68. https://doi.org/10.2307/778374

Buchloh, Benjamin. "Zufall, Intention Und Serialität in Gerhard Richters Abstraktionen." Seminar presented at the [Mosse] lactures in the Humboldt University of Berlin, Berlin, May 31, 2012.

Buchloh, Benjamin. "The Chance Ornament: Aphorisms on Gerhard Richter's Abstractions." *Artforum*, 2012.

Business & Human Rights Resource Centre. "NGO Statement Alleges That Alliance for Bangladesh Worker Safety Led by Gap, Wal-Mart Contains 'Empty Promises.'" *Latest News*, October 7, 2013. https://www.business-humanrights.org/en/ngo-statement-alleges-that-alliance-for-bangladesh-worker-safety-led-by-gap-wal-mart-contains-empty-promises

Butler, Patrick, and Dominic Rushe. "UN Accuses Blackstone Group of Contributing to Global Housing Crisis." *The Guardian*, March 26, 2019, sec. US news. https://www.theguardian.com/us-news/2019/mar/26/blackstone-group-accused-global-housing-crisis-un

"By-Laws of the Museum of Modern Art," May 12, 1960. Reports and Pamphlets, 11.1. The Museum of Modern Art Archives, New York.

Cahan, Susan E. *Mounting Frustration: The Art Museum in the Age of Black Power*. Durham, NC: Duke University Press, 2016.

Callahan, David. *The Givers: Wealth, Power, and Philanthropy in a New Gilded Age*. New York: Vintage, 2018.

Carnegie, Andrew. "The Gospel of Wealth." Carnegie Corporation of New York. Accessed October 27, 2019. https://www.carnegie.org/about/our-history/gospelofwealth/

Carrier, David. "Why Were There No Public Art Museums in Renaissance Italy?" *Source: Notes in the History of Art* 22, no. 1 (October 1, 2002): 44–50. https://doi.org/10.1086/sou.22.1.23206822

Cedric Johnson. "The Panthers Can't Save Us Now." *Catalyst* 1, no. 1 (Spring 2017). https://catalyst-journal.com/vol1/no1/panthers-cant-save-us-cedric-johnson

Cherbo, Joni Maya, and Margaret Jane Wyszomirski, eds. *The Public Life of the Arts in America*. New Brunswick: Rutgers University Press, 2000.

Chesnais, François. *Finance Capital Today: Corporations and Banks in the Lasting Global Slump*. Historical Materialism Book Series: Volume 131. Leiden: Brill, 2016. https://doi.org/10.1163/9789004255487

Childs, Mary. "Auction Houses Hammer It out as Competition Heats Up." *Financial Times*, November 10, 2015. https://www.ft.com/content/8dba3e18-873e-11e5-9f8c-a8d619fa707c

Christie's. "Peter Doig (b. 1959), Pine House (Rooms for Rent)." Post-War & Contemporary Art Evening Sale, November 12, 2014. https://www.christies.com/lotfinder/lot_details.aspx?intObjectID=5846091

Cipolla, Carlo M. "The Changing Balance Of Economic Power." In *Before the Industrial Revolution: European Society and Economy, 1000-1700*, 182–214. New York: Routledge, 1993.

Citta di Firenze. "The 'Studiolo' of Francesco I." September 18, 2020. http://museicivicifiorentini.comune.fi.it/en/palazzovecchio/visitamuseo/studiolo_francesco_i.htm

Clark, Elias. "Charitable Trusts, the Fourteenth Amendment and the Will of Stephen Girard." *The Yale Law Journal* 66, no. 7 (1957): 979–1015. https://doi.org/10.2307/793871

Clark, T. J. "Gerhard Richter." *London Review of Books* 33, no. 22 (November 17, 2011): 3–7.

Clifford, James. *The Predicament of Culture: Twentieth-Century Ethnography, Literature, and Art.* Cambridge, MA: Harvard University Press, 2002.

Clotfelter, Charles T. "Government Policy Toward Art Museums in the United States." In *The Economics of Art Museums*, edited by Martin Feldstein, 237–69. A National Bureau of Economic Research Conference Report. Chicago: The University of Chicago Press, 1991. https://epdf.pub/the-economics-of-art-museums-national-bureau-of-economic-research-conference-rep.html

Cockcroft, Eva. "Abstract Expressionism, Weapon of the Cold War." *Artforum* 12, no. 10 (June 1974): 39–41.

Cocke, Dudley. "The Unreported Arts Recession of 1997." *Grantmakers in the Arts* 20, no. 2 (Summer 2011). https://www.giarts.org/article/unreported-arts-recession-1997

Cohen, Patricia. "Writing Off the Warhol Next Door." *The New York Times*, January 10, 2015, sec. Business. https://www.nytimes.com/2015/01/11/business/art-collectors-gain-tax-benefits-from-private-museums.html

Cohen, Rachel. *Bernard Berenson: A Life in the Picture Trade*. New Haven: Yale University Press, 2013.

Cole, Matt. "Exploring the Labour Processes of Hospitality Work." Conference paper, International Initiative for The Promotion Of Political Economy. Berlin, 2017.

College Art Association. "CAA Arts and Humanities Advocacy Toolkit." *CAA News Today*, March 2, 2017. http://www.collegeart.org/news/2017/03/02/caa-arts-and-humanities-advocacy-toolkit/

Collier, Peter, and David Horowitz. *The Rockefellers: An American Dynasty*. New York: Holt, Rinehart and Winston, 1976.

Collins, Chuck. "The Wealthy Kids Are All Right." *The American Prospect*, May 28, 2013. https://prospect.org/article/wealthy-kids-are-all-right

Collins, Maureen. "Pensions or Paintings?: The Detroit Institute of Arts from Bankruptcy to Grand Bargain." 24 U. Miami Bus. L. Rev. 1 (2015). https://repository.law.uic.edu/facpubs/613

Cooks, Bridget R. *Exhibiting Blackness: African Americans and the American Art Museum*. Amherst, MA: University of Massachusetts Press, 2011.

Coombes, Annie. "Museums and the Formation of National and Cultural Identities." *Oxford Art Journal* 11, no. 2 (1988): 57–68.

Cooper, Ryan. "The Rise and Fall of Clintonism." *The Nation*, February 14, 2018. https://www.thenation.com/article/the-rise-and-fall-of-clintonism/

Cox-Rearick, Janet. "Epilogue: Francesco de' Medici and Aries." In *Dynasty and Destiny in Medici Art: Pontomo, Leo X, and the Two Cosimos*, 283–91. Princeton: Princeton University Press, 1984.

Crenshaw, Kimberlé. "Demarginalizing the Intersection of Race and Sex: A Black Feminist Critique of Antidiscrimination Doctrine, Feminist Theory and Antiracist Politics." *University of Chicago Legal Forum* 1989, no. 1 (1989). https://chicagounbound.uchicago.edu/uclf/vol1989/iss1/8

Crimp, Douglas. "The Postmodern Museum." In *On the Museum's Ruins*, 282–325. Cambridge, MA: MIT Press, 1993.

Crow, Kelly. "The Top-Selling Living Artist." *The Wall Street Journal*, March 9, 2012. https://www.wsj.com/articles/SB10001424052970204781804577267770169368462

Crow, Thomas E. *Painters and Public Life in Eighteenth-Century Paris*. New Haven & London: Yale University Press, 1985.

Culleton Colwell, Mary Anna. "The Foundation Connection." In *Philanthropy and Cultural Imperialism: The Foundations at Home and Abroad*, edited by Robert F. Arnove, 416–32. Bloomington: Indiana University Press, 1982.

Curiel, Jonathan. "At SFMOMA, Donald Fisher's Art Collection Proves Surprisingly Diverse." *SF Weekly*, June 24, 2010, sec. All Shook Down. https://www.sfweekly.com/music/at-sfmoma-donald-fishers-art-collection-proves-surprisingly-diverse/

Cuyler, Antonio. "An Exploratory Study of Demographic Diversity in the Arts Management Workforce." *Grantmakers in the Arts* 26, no. 3 (Fall 2015). https://www.giarts.org/article/exploratory-study-demographic-diversity-arts-management-workforce

Cynthia Liu. "Weaponized Generosity: How L.A.'s 1% Disrupt Democracy and Dismantle the Public School System." *The Progressive*, September 25, 2015. https://progressive.org/public-school-shakedown/weaponized-generosity-l.a.-s-1-disrupt-democracy-dismantle-public-school-system/

Dabla-Norris, Era, Kalpana Kochhar, Nujin Suphaphiphat, Franto Ricka, and Evridiki Tsounta. "Causes and Consequences of Income Inequality: A Global Perspective." Staff Discussion Notes No. 15/13. International Monetary Fund, June 15, 2015. https://www.imf.org/en/Publications/Staff-Discussion-Notes/Issues/2016/12/31/Causes-and-Consequences-of-Income-Inequality-A-Global-Perspective-42986

DaCosta Kaufmann, Thomas. "Remarks on the Collections of Rudolf II: The Kunstkammer as a Form of Representatio." *Art Journal* 38, no. 1 (1978): 22–8. https://doi.org/10.2307/776251

Davis, Angela Yvonne. *Women, Race, and Class*. London: Vintage Books, 1983.

Davis, Ann E. "The New 'Voodoo Economics': Fetishism and the Public/Private Divide." *Review of Radical Political Economics* 45, no. 1 (March 1, 2013): 42–58. https://doi.org/10.1177/0486613412447057

Day, Gail. *Dialectical Passions: Negation in Postwar Art Theory*. New York: Columbia University Press, 2010.

Day, Meagan. "Working Hard, Hardly Working." *Jacobin*, March 5, 2018. https://jacobinmag.com/2018/03/labor-workforce-unemployment-overwork

De Marchi, Neil, and Hans J. Van Miegroet. "The History of Art Markets." In *Handbook of the Economics of Art and Culture*, edited by Victor A. Ginsburg and David Throsby, 69–122. London: Elsevier, 2006.

Dean, Jodi. "Neofeudalism: The End of Capitalism?" *Los Angeles Review of Books*, May 12, 2020. https://lareviewofbooks.org/article/neofeudalism-the-end-of-capitalism/

Dean, Jodi. *The Communist Horizon*. London: Verso, 2012.

Dempster, Anna M, ed. *Risk and Uncertainty in the Art World*. London: Bloomsbury, 2015.

Denemark, Robert A., and Kenneth P. Thomas. "The Brenner-Wallerstein Debate." *International Studies Quarterly* 32, no. 1 (March 1988): 47–65.

Desilver, Drew. "U.S. Income Inequality, on Rise for Decades, Is Now Highest since 1928." Factank. *Pew Research Center* (blog), December 5, 2013. https://www.pewresearch.org/fact-tank/2013/12/05/u-s-income-inequality-on-rise-for-decades-is-now-highest-since-1928/

Desmarais, Charles. "Unraveling SFMOMA's Deal for the Fisher Collection." *San Francisco Chronicle*, August 21, 2016. https://www.sfchronicle.com/art/article/Unraveling-SFMOMA-s-deal-for-the-Fisher-9175280.php

Di Liscia, Valentina. "Brooklyn Museum Employees Accuse Administration of Staff Mistreatment." *Hyperallergic*, September 17, 2020. https://hyperallergic.com/588184/brooklyn-museum-staff-open-letter/

Dimaggio, Paul, and Francie Ostrower. *Race, Ethnicity, and Participation in the Arts: Patterns of Participation by Hispanics, Whites, and African-Americans in Selected Activities*. Report / National Endowment for the Arts. Santa Ana: Seven Locks Press, 1992.

Dimitrakaki, Angela, and Kirsten Lloyd. "Social Reproduction Struggles and Art History." *Third Text* 31, no. 1 (January 2, 2017): 1–14. https://doi.org/10.1080/09528822.2017.1358963

Dobkin Hall, Peter. "Historical Perspectives on Nonprofit Organizations in the United States." In *The Jossey-Bass Handbook of Nonprofit Leadership and Management*, edited by David O. Renz, 3–38. Hoboken: John Wiley & Sons, 2005.

Dobrzynski, Judith H. "A Possible Conflict By Museums In Art Sales." *The New York Times*, February 21, 2000, sec. Arts. https://www.nytimes.com/2000/02/21/arts/a-possible-conflict-by-museums-in-art-sales.html

Dobrzynski, Judith H. "Sold Calder May Head To Museum In Bay Area." *The New York Times*, June 2, 1999, sec. Arts. https://www.nytimes.com/1999/06/02/arts/sold-calder-may-head-to-museum-in-bay-area.html

Dobrzynski, Judith H. "The Fisher Folly: SFMoMA's Bad Deal." *Arts Journal: Real Clear Arts* (blog), August 22, 2016. https://www.artsjournal.com/realcleararts/2016/08/the-fisher-folly-sfmomas-bad-deal.html

Dobrzynski, Judith H. "Whitney Gives Up a Gift, and Competitors Blanch." *The New York Times*, May 28, 1999, sec. Arts. https://www.nytimes.com/1999/05/28/arts/whitney-gives-up-a-gift-and-competitors-blanch.html

San Francisco Museum of Modern Art. "Donald Fisher on collecting art." *Interview July 25, 2007.* YouTube Video, 4:17. September 20, 2010. https://www.youtube.com/watch?v=490srFST-Ks

Donald Preziosi, and Claire Farago, eds. *Grasping the World: The Idea of the Museum.* Farnham: Ashgate, 2003.

Doris and Donald Fisher. *Calder to Warhol: Introducing the Fisher Collection.* Interview by Neal David Benezra. San Francisco: San Francisco Museum of Modern Art, 2010.

Douglas, Sarah. "Prior to Her Firing, Curator Helen Molesworth Made Public Statements Critical of Museum Practices, MOCA." *ARTnews*, March 21, 2018. https://www.artnews.com/art-news/news/prior-firing-curator-helen-molesworth-made-public-statements-critical-museum-practices-moca-10009/

Dowie, Mark. *American Foundations: An Investigative History.* Cambridge, MA: MIT Press, 2001.

Doyle, Jennifer, Jonathan Flatley, and Jose Esteban Munoz, eds. *Pop Out: Queer Warhol.* Durham, NC: Duke University Press, 1996.

D'Souza, Aruna. *Whitewalling: Art, Race & Protest in 3 Acts.* New York: Badlands Unlimited, 2018.

Duncan, Carol. *Civilizing Rituals: Inside Public Art Museums.* London: Routledge, 2006.

Duncan, Carol, and Alan Wallach. "The Museum of Modern Art as Late Capitalist Ritual: An Iconographic Analysis." *Marxist Perspectives* 1, no. 4 (1978): 28–51.

Duncan, Carol, and Alan Wallach. "The Universal Survey Museum." *Art History*, no. 3 (December 1980): 448–69.

Duncan, Sally Anne. "From Period Rooms to Public Trust: The Authority Debate and Art Museum Leadership in America." *Curator: The Museum Journal* 45, no. 2 (May 24, 2010): 93–108. https://doi.org/10.1111/j.2151-6952.2002.tb01184.x

Duncan, Sally Anne. "Paul J. Sachs and the Institutionalization of Museum Culture between the World Wars." PhD diss., Tufts University, 2001.

Duve, Thierry de. "Andy Warhol, or The Machine Perfected." *October* 48 (1989): 3–14. https://doi.org/10.2307/778945

Editorial. "Policing and Profit." *Harvard Law Review*, Developments in the Law, 128, no. 1723 (April 10, 2015). https://harvardlawreview.org/2015/04/policing-and-profit/

Elger, Dietmar, ed. *Gerhard Richter Catalogue Raisonné.* Vol. 5. Berlin: Hatje Cantz, 2011. https://www.hatjecantz.de/gerhard-richter-catalogue-raisonn-volume-5-3010-1.html

Ellegood, Anne, and Johanna Burton, eds. *Take It or Leave It: Institution, Image, Ideology.* Los Angeles: UCLA Hammer Museum, 2014.

Elson, Diane. "The Value Theory of Labour." In *Value: The Representation of Labour in Capitalism*, edited by Diane Elson, 115–80. London: CSE Books, 1979.

Esterow, Milton. "Are Museum Trustees Out of Step?" *ARTnews*, October 1, 2008. http://www.artnews.com/2008/10/01/are-museum-trustees-out-of-step/
Fabrikant, Geraldine. "European Museums Adapt to the American Way of Giving." *The New York Times*, March 15, 2016, sec. Arts. https://www.nytimes.com/2016/03/17/arts/design/european-museums-are-shifting-to-american-way-of-giving.html
Feldstein, Martin, ed. *The Economics of Art Museums*. A National Bureau of Economic Research Conference Report. Chicago: The University of Chicago Press, 1991. https://epdf.pub/the-economics-of-art-museums-national-bureau-of-economic-research-conference-rep.html
Ferro, Shane, and Rachel Corbett. "10 Former Stars The Art Market Left Behind." *HuffPost*, December 6, 2017, sec. BLOUIN ARTINFO. https://www.huffpost.com/entry/10-former-art-sensations-_b_2584507
Figueroa, Hector. "In the Name of Fashion: Exploitation in the Garment Industry." *North American Congress on Latin America*, September 25, 2007. https://nacla.org/article/name-fashion-exploitation-garment-industry
Findlen, Paula. "The Museum: Its Classical Etymology and Renaissance Genealogy." *Journal of the History of Collections* 1, no. 1 (1989): 59–78. https://doi.org/10.1093/jhc/1.1.59
Fink, Larry and The BlackRock Blog. "BlackRock CEO Larry Fink Tells the World's Biggest Business Leaders to Stop Worrying about Short-Term Results." *Business Insider*, April 14, 2015. https://www.businessinsider.com/larry-fink-letter-to-ceos-2015-4
Finkel, Jori. "SFMOMA Chooses Architect for $250-Million Expansion: Norwegian Firm Snøhetta." *Culture Monster* (blog), July 21, 2010. https://latimesblogs.latimes.com/culturemonster/2010/07/sfm.html
Fisher Art Foundation. "Form 1990-PF," 2014.
#ForTheCulture. "An Open Letter to New York City's Cultural Institutions," 2020. https://fortheculture2020.com/
Fox Business. "Charles Schwab on Trump's tariffs: There is really is no free trade." YouTube Video, 8:32. March 13, 2018. https://www.youtube.com/watch?v=S27O7nO1V4M
Frank, Robert. "Billionaire Collector Shares Secrets to Investing in Great Art." *CNBC*, October 22, 2018. https://www.cnbc.com/2018/10/22/billionaire-collector-shares-secrets-to-investing-in-great-art.html
Fraser, Andrea. "L'1% C'est Moi." *Texte Zur Kunst* 83 (September 2011): 114–27.
Fraser, Andrea. "There's No Place Like Home." In *Whitney Museum of American Art: Whitney Biennial*, 28–33. New Haven: Yale University Press, 2012.
Fraser, Nancy. "Why Two Karls Are Better than One: Integrating Polanyi and Marx in a Critical Theory of the Current Crisis." Jena, 2017. http://www.kolleg-postwachstum.de/sozwgmedia/dokumente/WorkingPaper/WP+1_2017+Fraser.pdf

Freeman, Nate. "The Next Must-Have Market Darling Has Emerged." *ARTnews*, September 21, 2017. https://www.artnews.com/art-news/market/if-another-person-asks-me-to-get-them-a-jen-guidi-i-think-i-might-just-vomit-in-my-bed-the-next-must-have-market-darling-has-emerged-9028/

Furness, Hannah. "Richter Breaks Record for Most Expensive Living Artist in Europe." *The Telegraph*, February 11, 2015. https://www.telegraph.co.uk/culture/art/artsales/11407110/Richter-breaks-record-for-most-expensive-living-artist-in-Europe.html

Gamerman, Ellen. "The New High-Tech Patrons." *The Wall Street Journal*, February 28, 2013. https://www.wsj.com/articles/SB10001424127887323384604578328121811415726

Gan, Anne Marie, Glenn Voss, and Zannie Giraud Voss. "Do Grants from the National Endowment for the Arts Represent a Wealth Transfer from Poorer to Wealthier Citizens?" National Center for Arts Research, July 2014. https://www.smu.edu/~/media/Site/Meadows/NCAR/NCAR%20NEA%20Study

Gee, Alastair. "San Francisco or Mumbai? UN Envoy Encounters Homeless Life in California." *The Guardian*, January 22, 2018, sec. US news. https://www.theguardian.com/us-news/2018/jan/22/un-rapporteur-homeless-san-francisco-california

Gelles, David. "Wooing a New Generation of Museum Patrons." *The New York Times*, March 19, 2014, sec. Arts. https://www.nytimes.com/2014/03/20/arts/artsspecial/wooing-a-new-generation-of-museum-patrons.html

Geltman, Nancy. "New Engines of Growth: Five Roles for Arts, Culture, and Design." National Governors Association, May 2012. https://www.americansforthearts.org/sites/default/files/NGANewEnginesofGrowth.pdf

Gennari-Santori, Flaminia. "An Art Collector and His Friends John Pierpont Morgan and the Globalization of Medieval Art." *Journal of the History of Collections* 27, no. 3 (November 1, 2015): 401–11. https://doi.org/10.1093/jhc/fhu039

Gilens, Martin, and Benjamin I. Page. "Testing Theories of American Politics: Elites, Interest Groups, and Average Citizens." *Perspectives on Politics* 12, no. 3 (September 2014): 564–81. https://doi.org/10.1017/S1537592714001595

Gilmore, Ruth Wilson. *Golden Gulag: Prisons, Surplus, Crisis, and Opposition in Globalizing California*. Berkeley: University of California Press, 2007.

Giridharadas, Anand. *Winners Take All: The Elite Charade of Changing the World*. New York: Knopf Doubleday, 2018.

Glueck, Grace. "MoMA Gets a Taste of Pasta." *The New York Times*, September 26, 1971, sec. Art Notes. https://www.nytimes.com/1971/09/26/archives/moma-gets-a-taste-of-pasta.html

Glueck, Grace. "San Francisco's Modern Museum Aims for the Top; West Coast Showcase Brightens Up the Lobby Revue About 30's Hollywood." *The New York Times*, September 15, 1980, sec. Archives. https://www.nytimes.com/1980/09/15/archives/san-franciscos-modern-museum-aims-for-the-top-west-coast-showcase.html

Godfrey, Mark, Dorothée Brill, and Achim Borchardt-Hume. *Gerhard Richter: Panorama: A Retrospective*. London: Tate Publishing, 2011.
Goetzmann, William, Elena Mamonova, and Christophe Spaenjers. "The Economics of Aesthetics and Three Centuries of Art Price Records." Working Paper. Working Paper Series. National Bureau of Economic Research, August 2014. https://doi.org/10.3386/w20440
Goetzmann, William N., Luc Renneboog, and Christophe Spaenjers. "Art and Money." Working Paper. National Bureau of Economic Research, April 28, 2010. DOI:10.3386/w15502
Goldstein, Andrew. "'We're Not Working in an ER': Dealer Esther Kim Varet on How to Run a Thriving Art Gallery Without Losing Your Mind." *Artnet News*, February 12, 2020, sec. People. https://news.artnet.com/art-world/various-small-fires-esther-kim-varet-interview-1773888
Goldthwaite, Richard A. *The Economy of Renaissance Florence*. Baltimore: Johns Hopkins University Press, 2009.
Goldthwaite, Richard A. "The Economy of Renaissance Italy: The Preconditions for Luxury Consumption." *I Tatti Studies in the Italian Renaissance* 2 (1987): 15–39. https://doi.org/10.2307/4603651
Goldthwaite, Richard A. *Wealth and the Demand for Art in Italy, 1300-1600*. Baltimore: Johns Hopkins University Press, 1993.
Goldthwaite, Richard, and Patricia Simons. "The Empire of Things: Consumer Demand in Renaissance Italy." In *Patronage, Art, and Society in Renaissance Italy*, edited by Francis William Kent and John Christopher Eade, 153–75. Oxford: Humanities Research Centre, 1987.
Gordon Kantor, Sybil. *Alfred H. Barr, Jr. and the Intellectual Origins of the Museum of Modern Art*. Cambridge, MA: MIT Press, 2002.
Graw, Isabelle. *High Price: Art Between the Market and Celebrity Culture*. Berlin: Sternberg Press, 2009.
Greenberger, Alex. "Do Exhibitions at U.S. Museums Reflect Calls for Diversity?" *ARTnews.Com*, August 5, 2019, sec. White Cubes. https://www.artnews.com/art-news/news/u-s-museums-exhibitions-diversity-survey-13065/
Greenberger, Alex. "Nan Goldin's P.A.I.N. Group Protests 'Proud' Support from Sackler Family at Victoria & Albert Museum in London." *ARTnews*, November 16, 2019. https://www.artnews.com/artnews/news/sackler-pain-protest-victoria-and-albert-museum-13589/
Greenblatt, Stephen Jay. "Marvelous Possessions." In *Marvelous Possessions: The Wonder of the New World*, 52–85. Chicago: The University of Chicago Press, 1992.
Grey, Barry. "The Rape of Detroit: Deindustrialization, Financialization and Parasitism." *World Socialist Web Site*, February 28, 2014. https://www.wsws.org/en/articles/2014/02/28/barr-f28.html
Guilbert, Kieran, and Amber Milne. "Big Clothes Brands Found to Fall Short of Own Fair Wage Promises." *Reuters*, May 30, 2019. https://www.reuters.com/article/global-garment-workers-pay-idUSL8N23540T

Gürcan, Efe Can. "The Nonprofit-Corporate Complex: An Integral Component and Driving Force of Imperialism in the Phase of Monopoly-Finance Capitalism." *Monthly Review* 66, no. 11 (April 1, 2015). https://monthlyreview.org/2015/04/01/the-nonprofit-corporate-complex/

Guthrie, Julian. "Why Gap Founder Fisher Decided to Build His Own Art Museum." *SFGate*, August 12, 2007. https://www.sfgate.com/news/article/Why-Gap-founder-Fisher-decided-to-build-his-own-3758499.php

Habermas, Jürgen. *The Structural Transformation of the Public Sphere: An Inquiry Into a Category of Bourgeois Society*. Translated by Thomas Burger. Cambridge, MA: MIT Press, 1991.

Hagan, Ariel. "Public Duty and Private Pursuits: Reconciling 21st Century Relationships Between Collectors and Art Museums." MA diss., University of Colorado, 2011. https://scholar.colorado.edu/concern/graduate_thesis_or_dissertations/wm117p34j

Halperin, Julia. "Almost One Third of Solo Shows in US Museums Go to Artists Represented by Five Galleries." *The Art Newspaper*, April 2, 2015, sec. Exhibitions. http://www.theartnewspaper.com/news/almost-one-third-of-solo-shows-in-us-museums-go-to-artists-represented-by-five-galleries

Halperin, Julia. "Clashing Visions, Simmering Tensions: How a Confluence of Forces Led to MOCA's Firing of Helen Molesworth." *Artnet News*, March 16, 2018. https://news.artnet.com/art-world/moca-helen-molesworth-tension-1246358

Halperin, Julia. "Contemporary Art Dominates US Museums, Our Visitor Surveys Confirm." *The Art Newspaper*, March 29, 2017, sec. News. http://www.theartnewspaper.com/news/contemporary-art-dominates-us-museums-our-visitor-surveys-confirm

Halperin, Julia. "MOCA Fires Chief Curator Helen Molesworth for 'Undermining the Museum,' According to Report." *Artnet News*, March 13, 2018. https://news.artnet.com/art-world/moca-fires-chief-curator-helen-molesworth-according-to-report-1243853

Halperin, Julia, and Javier Pes. "Can Museum Curators Ever Moonlight as Art Advisors Without Corrupting Themselves?" *Artnet News*, December 4, 2017. https://news.artnet.com/art-world/can-curators-give-advice-collectors-without-conflict-interest-1166267

d'Harnoncourt, Anne, Paul DiMaggio, Marilyn Perry, and James N. Wood. "The Museum and the Public." In *The Economics of Art Museums*, edited by Martin Feldstein, 35–60. A National Bureau of Economic Research Conference Report. Chicago: The University of Chicago Press, 1991.

Harvey, David. *A Brief History of Neoliberalism*. New York: Oxford University Press, 2007.

Haug, Wolfgang Fritz, and Joseph Fracchia. "Historical-Critical Dictionary of Marxism: Immaterial Labour." *Historical Materialism* 17, no. 4 (January 1, 2009): 177–85. https://doi.org/10.1163/146544609X12562798328251

Heinrich, Michael. *An Introduction to the Three Volumes of Karl Marx's Capital*. Translated by Alexander Locascio. New York: Monthly Review Press, 2012.

Hewison, Robert. "Contemporary Art Museums Can't Avoid Conflicts of Interest – but We Need to Trust Their Directors." *Apollo Magazine*, November 1, 2017. https://www.apollo-magazine.com/contemporary-art-museums-cant-avoid-conflicts-of-interest-but-we-need-to-trust-their-directors/

Higginbottom, Andy. "'Imperialist Rent' in Practice and Theory." *Globalizations* 11, no. 1 (January 2, 2014): 23–33. https://doi.org/10.1080/14747731.2014.860321

Hooper-Greenhill, Eilean. "The Museum in the Disciplinary Society." In *Museum Studies in Material Culture*, edited by Susan Pearce, 61–72. Leicester: Leicester University Press, 1989.

Horowitz, Noah. *Art of the Deal: Contemporary Art in a Global Financial Market*. Princeton: Princeton Univ. Press, 2014.

Horwitz, Andy. "Who Should Pay for the Arts in America?" *The Atlantic*, January 31, 2016. https://www.theatlantic.com/entertainment/archive/2016/01/the-state-of-public-funding-for-the-arts-in-america/424056/

Horwitz, Morton J. "History of the Public/Private Distinction." *University of Pennsylvania Law Review* 130, no. 6 (1982): 1423.

Horwitz, Morton J. *The Transformation of American Law, 1870–1960: The Crisis of Legal Orthodoxy*. New York: Oxford University Press, 1995.

Huckabee, Mike. "A Conservative Plea for the National Endowment for the Arts." *Washington Post*, March 22, 2017, sec. Opinions. https://www.washingtonpost.com/opinions/mike-huckabee-a-conservative-plea-for-the-national-endowment-of-the-arts/2017/03/22/8d6d746a-0d94-11e7-9d5a-a83e627dc120_story.html

Hulst, Titia, ed. *A History of the Western Art Market: A Sourcebook of Writings on Artists, Dealers, and Markets*. Oakland: University of California Press, 2017.

Huws, Ursula. "Crisis as Capitalist Opportunity: New Accumulation through Public Service Commodification." *The Socialist Register*. 48 (September 24, 2011): 64–84.

Ilyenkov, Evald V. *The Dialectics of the Abstract and the Concrete in Marx's Capital*. Translated by Sergei Kuzyakov. Moscow: Progress Publishers [1960], 1982.

INCITE!, ed. *The Revolution Will Not Be Funded Beyond the Non-Profit Industrial Complex*. Durham, NC: Duke University Press, 2017.

Internal Revenue Service. "Life Cycle of a Private Foundation Termination of Foundation Under State Law," June 5, 2019. https://www.irs.gov/charities-non-profits/private-foundations/life-cycle-of-a-private-foundation-termination-of-foundation-under-state-law

International Monetary Fund. "General Government Debt." Global Debt Database. Accessed October 21, 2020. https://www.imf.org/external/datamapper/GG_DEBT_GDP@GDD

Jacobs, Julia, and Zachary Small. "Whitney Cancels Show That Included Works Bought at Fund-Raisers." *The New York Times*, August 25, 2020, sec. Arts. https://www.nytimes.com/2020/08/25/arts/design/whitney-museum-exhibition-canceled.html

Jacqueline, Crispino. "Art-Wash: Regulations of Museums, Donors, and Board Members." *Center for Art Law*, July 8, 2019. https://itsartlaw.org/2019/07/08/art-wash-regulations-of-museums-donors-and-board-members/

Jarvik, Laurence. "Ten Good Reasons to Eliminate Funding for the National Endowment for the Arts." Budget and Spending. The Heritage Foundation, April 29, 1997. https://www.heritage.org/report/ten-good-reasons-eliminate-funding-the-national-endowment-orthe-arts

Jay, Martin. *Marxism and Totality: The Adventures of a Concept Form Lukács to Habermas*. Berkeley: University of California Press, 1992.

Jeffrey Deitch's Los Angeles. [Video]. Vol. 10, Episode 5. Artbound. KCET, 2019. https://www.pbs.org/video/jeffrey-deitchs-los-angeles-pomi9f/

Johnson, Cedric. "The Wages of Roediger: Why Three Decades of Whiteness Studies Has Not Produced the Left We Need." *Nonsite.Org*, no. 29 (September 9, 2019). https://nonsite.org/the-wages-of-roediger-why-three-decades-of-whiteness-studies-has-not-produced-the-left-we-need/

Jones-Rizzi, Joanne, and Stacey Mann. "Is That Hung White?" *American Alliance of Museums*, May 19, 2020. https://www.aam-us.org/2020/05/19/is-that-hung-white-a-conversation-on-the-state-of-museum-exhibitions-and-race/

Karp, Ivan. *Exhibiting Cultures: The Poetics and Politics of Museum Display*. Washington, D.C.: Smithsonian Institution, 1991.

Katz, Stanley N. "Philanthropy." In *Handbook of the Economics of Art and Culture*, edited by Victor A. Ginsburg and David Throsby, 1:1299–1321. London: Elsevier, 2006. https://doi.org/10.1016/S1574-0676(06)01037-4

Kazakina, Katya. "Advisers to the Ultra-Rich Try to Treat Art as Just Another Asset." *Bloomberg Businessweek*, April 27, 2017. https://www.bloomberg.com/news/articles/2017-04-27/advisors-to-the-ultra-rich-try-to-treat-art-as-just-another-asset

Kazanjian, Dodie. "Inside Yves Béhar and Sabrina Buell's High-Tech San Francisco Home." *Vogue*, May 30, 2016. https://www.vogue.com/article/sabrina-buell-yves-behar-san-francisco-home

Keats, Jonathon. "How Billionaire Charles Schwab Brokered San Francisco's New $610 Million Masterpiece." *Forbes*, June 21, 2016, sec. Arts. https://www.forbes.com/sites/jonathonkeats/2016/06/01/billionaire-charles-schwab-on-san-franciscos-new-610-million-masterpiece-sfmoma/#648197434378

Kirk, Alex E. "The Billionaire's Treasure Trove: A Call to Reform Private Art Museums and the Private Benefit Doctrine." *Fordham Intell. Prop. Media &Ent. L.J.* 27, no. 4 (May 15, 2017): 869–933.

Kliman, Andrew. *The Failure of Capitalist Production: Underlying Causes of the Great Recession*. London: Pluto Press, 2011.

Koch, Cynthia M. "The Contest for American Culture: A Leadership Case Study on The NEA and NEH Funding Crisis." *Public Talk*, 1998. http://www.upenn.edu/pnc/ptkoch.html

Koke, Judy, and Marianna Adams. "'Stuck' Is Where You Need to Pay Attention: Some Barriers to Creating Truly Inclusive Art Museums." In *Multiculturalism in Art Museums Today*, edited by J. B. Acuff and L. Evans, 3–18. London: Rowman & Littlefield, 2014.

Kreder, Jennifer. "The 'Public Trust.'" *University of Pennsylvania Journal of Constitutional Law* 18, no. 5 (January 1, 2016): 1425–78.

Krugman, Paul. "Debunking the Reagan Myth." *The New York Times*, January 21, 2008, sec. Opinion. https://www.nytimes.com/2008/01/21/opinion/21krugman.html

Kumar, Ashok, Dalia Gebrial, Adam Elliott-Cooper, and Shruti Iyer, eds. "Identity Politics." *Historical Materialism* 26, no. 2 (July 2018). http://www.historicalmaterialism.org/special-issue/issue-262-identity-politics

Kuttner, Robert, and Katherine V. Stone. "The Rise of Neo-Feudalism." *The American Prospect*, April 8, 2020. https://prospect.org/api/content/95e27c24-7931-11ea-a366-1244d5f7c7c6/

Laing, Justin. "What Does Culture Look Like When #BlackLivesMatter?" *Grantmakers in the Arts* 26, no. 3 (2015). https://www.giarts.org/article/what-does-culture-look-when-blacklivesmatter

Lane, John. "Letter to Mr. Mabry," June 12, 1935. Early Museum History: Administrative Records, IV.38.C. The Museum of Modern Art Archives, New York.

Larry's List Ltd and AMMA. "Private Art Museum Report." Modern Arts Publishing, January 2016. https://www.larryslist.com/art-collector-report

Laville, Helen, and Hugh Wilford. *The US Government, Citizen Groups and the Cold War: The State-Private Network*. London: Routledge, 2012.

Lawrence, Steven. "Arts Funding at Twenty-Five: What Data and Analysis Continue to Tell Funders about the Field." *Grantmakers in the Arts Reader* 29, no. 1 (Winter 2018): 16.

Lefebvre, Sam. "Senior SFMOMA Curator Resigns Amid Reckoning With Institutional Racism." *Hyperallergic*, July 13, 2020. https://hyperallergic.com/576369/gary-garrels-resigns-sfmoma/

Lefebvre, Sam. "Special Report: 'Toxic Donors' Are Coming under Fire at Art Museums — but Not in Liberal San Francisco. What Will SFMOMA Do?" *Mission Local* (blog), May 15, 2019. https://missionlocal.org/2019/05/toxic-donors-are-coming-under-fire-at-art-museums-but-not-in-liberal-san-francisco-what-will-sfmoma-do/

Legal Information Institute. "43 U.S. Code § 1311 - Rights of States." Cornell Law School. Accessed September 13, 2020. https://www.law.cornell.edu/uscode/text/43/1311

Lipsky, Michael, and Steven Rathgeb Smith. "Nonprofit Organizations, Government, and the Welfare State." *Political Science Quarterly* 104, no. 4 (Winter, 1989–1990): 625–48. https://doi.org/10.2307/2151102

Littlejohn, David. "SFMOMA Fills In Some Blanks." *The Wall Street Journal*, July 7, 2010, sec. Life and Style. https://www.wsj.com/articles/SB10001424052748704862404575350882558729198

Lloyd, Kirsten. "Shaping Collections: Globalisation and Contemporary Art." The University of Edinburgh, Edinburgh College of Art. The Fabric: Social Reproduction and the Art Field in History and Praxis, May 11, 2017. http://www.fabric.eca.ed.ac.uk/university-edinburgh-contemporary-art-research-collection/

Lonetree, Amy. *Decolonizing Museums: Representing Native America in National and Tribal Museums*. Chapel Hill: The University of North Carolina Press, 2012.

Lopez, Robert. "Hard Times and Investment in Culture." In *Social and Economic Foundations of the Italian Renaissance*, edited by Anthony Molho, 95–115. New York: John Wiley & Sons, 1969.

Lowry, Glenn D. "A Deontological Approach to Art Museums and the Public Trust." In *Whose Muse? Art Museums and the Public Trust*, edited by James Cuno, 129–50. Princeton: Princeton University Press, 2006.

Luxemburg, Rosa. *The Junius Pamphlet: The Crisis in the German Social Democracy*. Colombo: Young Socialist Publications, 1969. https://www.marxists.org/archive/luxemburg/1915/junius/index.htm

Lynes, Russell. *Good Old Modern: An Intimate Portrait of the Museum of Modern Art*. New York: Atheneum, 1973.

Macdonald, Sharon. *A Companion to Museum Studies*. Oxford: Blackwell, 2006.

MacGregor, Neil. "A Pentecost in Trafalgar Square." In *Whose Muse? Art Museums and the Public Trust*, edited by James Cuno, 27–8. Princeton: Princeton University Press, 2006.

Mack, Earle, Randall Bourscheidt, and Robert Lynch. "Funding the Arts Is More than Preserving Culture. It's Big Business." *The Hill*, February 19, 2017. https://thehill.com/blogs/pundits-blog/uncategorized/320235-funding-the-arts-is-more-than-preserving-culture-its-big

Malaro, Marie C., and Ildiko DeAngelis. *A Legal Primer on Managing Museum Collections*. 3rd ed. Washington, D.C.: Smithsonian Institution, 2012.

Maneker, Marion. "How Correlated Are Art Returns to Other Assets?" *Art Market Monitor*, April 28, 2016. https://www.artmarketmonitor.com/2016/04/28/how-correlated-are-art-returns-to-other-assets/

Mansoor, Jaleh. "Minima Moralia: Notes on Richter's Readymade Red in The Singer of 1965." In *Gerhard Richter: Colour Charts*, 29–38. London: Dominique Lévy, 2016.

Marshall, Alex. "Museums Cut Ties With Sacklers as Outrage Over Opioid Crisis Grows." *The New York Times*, March 25, 2019, sec. Arts. https://www.nytimes.com/2019/03/25/arts/design/sackler-museums-donations-oxycontin.html

Marx, Karl, and Friedrich Engels. *Capital, Volume 1*. Vol. 35. *Marx & Engels Collected Works*. London: Lawrence & Wishart, 2010.

May, Robert E. "Culture Wars: The U.S. Art Lobby and Congressional Tariff Legislation during the Gilded Age and Progressive Era." *The Journal of the Gilded Age and Progressive Era* 9, no. 1 (January 2010): 37–91. https://doi.org/10.1017/S1537781400003789

Mayer, Jane. "The Koch Brothers' Covert Ops." *The New Yorker*, August 23, 2010. https://www.newyorker.com/magazine/2010/08/30/covert-operations

McAndrew, Clare. *Fine Art and High Finance Expert Advice on the Economics of Ownership*. Hoboken: John Wiley & Sons, 2012.

McAndrew, Clare. "The Art Basel and UBS Global Art Market Report," March 11, 2019. https://d2u3kfwd92fzu7.cloudfront.net/The_Art_Market_2019-5.pdf

McCambridge, Ruth. "Museums So White: Survey Reveals Deep Lack of Diversity." *Nonprofit Quarterly*, May 9, 2017, sec. Non Profit News. https://nonprofitquarterly.org/museum-boards-directors-whitest-getting-whiter/

McClellan, Andrew. "A Brief History of the Art Museum Public." In *Art and Its Publics Museum Studies at the Millennium*, edited by Andrew McClellan, 1–50. Malden: Blackwell, 2003.

McClellan, Andrew. *Inventing the Louvre: Art, Politics, and the Origins of the Modern Museum in Eighteenth-Century Paris*. Berkeley: University of California Press, 2009.

McIntosh, Kriston, Emily Moss, Ryan Nunn, and Jay Shambaugh. "Examining the Black-White Wealth Gap." *Brookings Institute: Up Front* (blog), February 27, 2020. https://www.brookings.edu/blog/up-front/2020/02/27/examining-the-black-white-wealth-gap/

Meadow, Mark A. "Merchants and Marvels: Hans Jacob Fugger and the Origins of the Wunderhammer." In *Merchants and Marvels Commerce, Science, and Art in Early Modern Europe*, edited by Pamela Smith and Paula Findlen, 182–200. New York: Routledge, 2002.

Mediavilla, Juanjo, and Jorge Garcia-Arias. "Philanthrocapitalism as a Neoliberal (Development Agenda) Artefact: Philanthropic Discourse and Hegemony in (Financing for) International Development." *Globalizations* 16, no. 6 (September 19, 2019): 857–75. https://doi.org/10.1080/14747731.2018.1560187

Meiksins Wood, Ellen. *The Origin of Capitalism: A Longer View*. London: Verso, 2002.

Meislin, Richard J. "Gardner Quits Rockefeller Fund, Citing 'Special Status.'" *The New York Times*, August 24, 1977, sec. Archives. https://www.nytimes.com/1977/08/24/archives/gardner-quits-rockefeller-fund-citing-special-status-of-brothers.html

Mercer, Kobena. "Where the Streets Have No Name: A Democracy of Multiple Public Spheres." In *This Will Have Been: Art, Love & Politics in the 1980s*, edited by Helen Molesworth. New Haven: Yale University Press, 2012.

Meyer, Richard. "The Jesse Helms Theory of Art." *October* 104 (April 1, 2003): 131–48. https://doi.org/10.1162/016228703322031749

Miedema, Christie. "Five Years after Rana Plaza, the Need for the Bangladesh Accord Persists." News. Clean Clothes Campaign, April 18, 2018. https://cleanclothes.org/news/2018/04/18/five-years-after-rana-plaza-the-need-for-the-bangladesh-accord-persists

Miranda, Magally, and Kyle Lane-McKinley. "Artwashing, or, Between Social Practice and Social Reproduction." *A Blade of Grass*, February 1, 2017. https://www.abladeofgrass.org/fertile-ground/artwashing-social-practice-social-reproduction/

Mishel, Lawrence. "Vast Majority of Wage Earners Are Working Harder, and for Not Much More: Trends in U.S. Work Hours and Wages over 1979–2007." *Economic Policy Institute*, January 30, 2013. https://www.epi.org/publication/ib348-trends-us-work-hours-wages-1979-2007/

Molesworth, Helen. Andrea Fraser and Helen Molesworth. Interview by Andrea Fraser. *BOMB Magazine*, October 17, 2018. https://bombmagazine.org/articles/andrea-fraser-and-helen-molesworth/

Molesworth, Helen Anne, ed. *This Will Have Been: Art, Love & Politics in the 1980s*. Chicago: Museum of Contemporary Art Chicago, 2012.

Molho, Anthony. "Masaccio's Florence in Perspective: Crisis and Discipline in a Medieval Society." In *The Cambridge Companion to Masaccio*, edited by Diane Cole, 16–39. Cambridge: Cambridge University Press, 2002.

Molho, Anthony. "The State and Public Finance: A Hypothesis Based on the History of Late Medieval Florence." *The Journal of Modern History* 67 (1995): S97–135. https://doi.org/10.1086/245011

MoMA. "The 'Permanent' Collection," circa 1938. Alfred H. Barr, Jr. Papers, II.C.26. The Museum of Modern Art Archives, New York.

"MoMA Provisional Charter," September 19, 1929. Reports and Pamphlets, 11.1. The Museum of Modern Art Archives, New York.

Montabonel, Sébastien, and Diana Vives. "When Financial Products Shape Cultural Content." Alaska Editions. London: Institutions of the 21 Century, August 2018. http://www.artinstitutions.org/reports/when-financial-products-shape-cultural-content/

Moore, Porchia. "Cartography: A Black Woman's Response to Museums in the Time of Racial Uprising." *The Incluseum: Best Practices* (blog), June 10, 2020. https://incluseum.com/2020/06/10/cartography-a-black-womans-response-to-museums-in-the-time-of-racial-uprising/

Morgan, Kelli. "To Bear Witness: Real Talk about White Supremacy in Art Museums Today." *Burnaway*, June 24, 2020. https://burnaway.org/to-bear-witness/

Morrison, Sarah. "Bangladesh Factory Collapse: Gap Refuses to Back Safety Deal." *The Independent*, May 14, 2013. http://www.independent.co.uk/news/world/asia/bangladesh-factory-collapse-gap-refuses-to-back-safety-deal-8615599.html

Moskowitz, Peter E. *How to Kill a City: Gentrification, Inequality, and the Fight for the Neighborhood*. New York: Bold Type Books, 2017.

Mukherjee, Romi S. "Make America Great Again as White Political Theology." *Revue LISA/LISA e-Journal [En Ligne]*, vol. XVI, no. 2 (September 10, 2018). https://doi.org/10.4000/lisa.9887

Mullaney, Tom. "Museum Ethics: Still A Problem For The Profession And Contemporary Art." *New Art Examiner*, October 1981.

Murphy, Liam, and Thomas Nagel. *The Myth of Ownership: Taxes and Justice*. New York: Oxford University Press, 2002.

National Endowment for the Arts. "NEA Quick Facts 2018," 2018. https://www.arts.gov/sites/default/files/NEA_Quick_Facts_2018_V.1.pdf

National Gallery, London Press office. "'Diana and Actaeon' Is Secured for the Nation." Press Release, February 2009. https://www.nationalgallery.org.uk/about-us/press-and-media/press-releases/diana-and-actaeon-is-secured-for-the-nation

Neuendorf, Henri. "Georg Baselitz Makes Disgraceful Sexist Remarks on Women Painters, Again." *Artnet News*, May 21, 2015. https://news.artnet.com/art-world/georg-baselitz-women-painters-300663

Neuendorf, Henri. "Gerhard Richter Says He's Shocked by the State of the Art Market." *Artnet News*, December 23, 2015. https://news.artnet.com/market/gerhard-richter-criticizes-art-market-398694

Nightingale, Julie. "Cultivating Private Donors." *Museums Journal*, Museum Practice, no. 42 (Summer 2008): 60–2.

Norfield, Tony. "Index of Power." *Economics of Imperialism* (blog), February 12, 2018. https://economicsofimperialism.blogspot.com/2018/02/index-of-power.html

Norfield, Tony. *The City: London and the Global Power of Finance*. London: Verso, 2016.

Ober, Cara. "The BMA Spent $2.57 Million on Art by 49 Women in 2020. Guess How Many Are from Maryland?" *BmoreArt*, January 22, 2021. https://bmoreart.com/2021/01/the-bma-spent-2-57-million-on-art-by-49-women-in-2020-guess-how-many-are-from-maryland.html

O'Connor, Clare. "Report: Walmart Workers Cost Taxpayers $6.2 Billion In Public Assistance." *Forbes*, April 15, 2014. https://www.forbes.com/sites/clareoconnor/2014/04/15/report-walmart-workers-cost-taxpayers-6-2-billion-in-public-assistance/#293a2df3720b

OECD. "Chapter 3: Lifting Investment for Higher Sustainable Growth." *OECD Economic Outlook*, vol. 2015, no. 1. OECD Publishing, June 2015. https://doi.org/10.1787/eco_outlook-v2015-1-en

Olmi, Guiseppe. "Science-Honour-Metaphor. Italian Cabinets of the Sixteenth and Seventeenth Centuries." In *The Origins of Museums: The Cabinet of Curiosities in Sixteenth- and Seventeenth-Century Europe*, edited by O. R. Impey and Arthur MacGregor, 5–16. Oxford: Clarendon Press, 1985.

O'Malley, Michelle. *The Business of Art: Contracts and the Commissioning Process in Renaissance Italy*. New Haven: Yale University Press, 2005.

Ott, John. "Metropolitan, Inc.: Public Subsidy and Private Gain at the Genesis of the American Art Museum." In *New York, Cultural Capital of the Gilded*

Age, edited by Margaret R. Laster and Chelsea Bruner, 122–38. London: Routledge, 2018.

Parmar, Inderjeet. *Foundations of the American Century: The Ford, Carnegie, and Rockefeller Foundations in the Rise of American Power.* New York: Columbia University Press, 2014.

Piketty, Thomas, and Arthur Goldhammer. *Capital in the Twenty-First Century.* Cambridge, MA: The Belknap Press of Harvard University Press, 2017.

Pindell, Howardena. "Art World Surveys." pindell.mcachicago.org. Accessed May 9, 2021. https://pindell.mcachicago.org/art-world-surveys/

Pogash, Carol. "Its Top Curator Gone, SFMOMA Reviews Its Record on Race." *The New York Times*, July 22, 2020, sec. Arts. https://www.nytimes.com/2020/07/22/arts/design/sfmoma-gary-garrels-resignation.html

Pogrebin, Robin. "Art Galleries Face Pressure to Fund Museum Shows." *The New York Times*, March 7, 2016, sec. Arts. https://www.nytimes.com/2016/03/07/arts/design/art-galleries-face-pressure-to-fund-museum-shows.html

Pogrebin, Robin. "Curators Urge Guggenheim to Fix Culture That 'Enables Racism.'" *The New York Times*, June 22, 2020, sec. Arts. https://www.nytimes.com/2020/06/22/arts/design/guggenheim-curators-racism-sexism.html

Polanyi, Karl. *The Great Transformation: The Political and Economic Origins of Our Time.* Boston, MA: Beacon Press [1944], 2001.

Pomian, Krzysztof. "The Collection: Between the Visible and the Invisible." In *Interpreting Objects and Collections*, edited by Susan M. Pearce, 160–74. New York: Routledge, 1994.

Quaintance, Morgan. "The New Conservatism: Complicity and the UK Art World's Performance of Progression." *E-Flux Conversations.* (blog), October 2, 2017. https://conversations.e-flux.com/t/the-new-conservatism-complicity-and-the-uk-art-worlds-performance-of-progression/7200

Rectanus, Mark W. *Culture Incorporated: Museums, Artists, and Corporate Sponsorships.* Minneapolis: University of Minnesota Press, 2002.

Reich, Rob. *Just Giving: Why Philanthropy Is Failing Democracy and How It Can Do Better.* Princeton: Princeton University Press, 2018.

Reitlinger, Gerald. *The Economics of Taste: The Rise and Fall of the Picture Market 1760-1960.* New York: Holt, Rinehart and Winston, 1964.

Reuters. "Who Donated to President Trump's Gigantic Inauguration Fund." *Fortune*, April 20, 2017. https://fortune.com/2017/04/20/donald-trump-inauguration-donors/

Reyburn, Scott. "In a Tough Art Market, Auction Houses Are Seeking More From Less." *The New York Times*, November 4, 2016, sec. Art & Design. https://www.nytimes.com/2016/11/07/arts/design/in-a-tough-art-market-auction-houses-are-seeking-more-from-less.html

Richter, Gerhard. *Gerhard Richter: Catalogue Raisonné.* New York: Artbook D A P, 2015.

Richter, Gerhard. "Meet the world's most expensive painter." Interview by Nick Glass. *Print CNN*, October 16, 2014. https://www.cnn.com/2014/10/16/world/gerhard-richter-most-expensive-painter/index.html

Richter, Gerhard, Dietmar Elger, and Hans Ulrich Obrist. *Gerhard Richter. Text. Writings, Interviews and Letters. 1961-2007*. London: Thames & Hudson, 2009.
Richter, Gerhard, Stefan. Gronert, Hubertus. Butin, and Dallas Museum of Art. *Gerhard Richter, Editions 1965-2004: Catalogue Raisonné*. New York & Berlin: Hatje Cantz, 2004.
Rieff, David. "Philanthrocapitalism: A Self-Love Story: Why Do Super-Rich Activists Mock Their Critics Instead of Listening to Them?" *The Nation*, October 1, 2015. https://www.thenation.com/article/philanthrocapitalism-a-self-love-story/
Riley, Dylan. "Bourdieu's Class Theory." *Catalyst* 1, no. 2 (Summer 2017). https://catalyst-journal.com/vol1/no2/bourdieu-class-theory-riley
Roberts, David. "None of the World's Top Industries Would Be Profitable If They Paid for the Natural Capital They Use." *Grist*, April 17, 2013, sec. Business & Technology. https://grist.org/business-technology/none-of-the-worlds-top-industries-would-be-profitable-if-they-paid-for-the-natural-capital-they-use/
Roberts, Michael. "A World Rate of Profit: A New Approach." *Michael Roberts Blog* (blog), July 25, 2020. https://thenextrecession.wordpress.com/2020/07/25/a-world-rate-of-profit-a-new-approach/
Roberts, Scott, and Bianca Tylek. "Call to Remove Tom Gores from the LACMA Board," September 9, 2020. https://static1.squarespace.com/static/58e127cb1b10e31ed45b20f4/t/5f626fc9dbc5373a81461178/1600286667361/2020.09.09+-+LACMA+Letter+re+Tom+Gores.pdf
Robinson, Cedric J. *Black Marxism: The Making of the Black Radical Tradition*. London: Zed Press, 1983.
Roscigno, Vincent J., and George Wilson. "Privatization and Racial Inequality." *Contexts* 13, no. 1 (February 1, 2014): 72–74. https://doi.org/10.1177/1536504214522014
Rosenbaum, Lee. "BlogBack: Guggenheim President Jennifer Stockman on Trustees' Conflict-of-Interest." *CultureGrrl* (blog), November 19, 2008. https://www.artsjournal.com/culturegrrl/2008/11/blogback_guggenheim_president.html
Rosenbaum, Lee. "Conflicts of Interest: Museum Trustees Play the Market." *CultureGrrl* (blog), October 31, 2008. https://www.artsjournal.com/culturegrrl/2008/10/conflicts_of_interest_museum_t.html
Ross, Andrew S. "Schwab Office Opens in Style." *SFGate*, October 28, 2009. https://www.sfgate.com/business/article/Schwab-office-opens-in-style-3212015.php
Rotta, Tomás Nielsen. "Unproductive Accumulation in the USA: A New Analytical Framework." *Cambridge Journal of Economics* 42, no. 5 (August 18, 2018): 1367–92. https://doi.org/10.1093/cje/bex080
Rotta, Tomas Nielsen, and Rodrigo Alves Teixeira. "The Autonomisation of Abstract Wealth: New Insights on the Labour Theory of Value." *Cambridge Journal of Economics* 40, no. 4 (July 1, 2016): 1185–201. https://doi.org/10.1093/cje/bev028

Salamon, Lester M. "Partners in Public Service: The Scope and Theory of Government-Nonprofit Relations." In *The Nonprofit Sector: A Research Handbook*, edited by Walter W. Powell, 99–117. New Haven: Yale University Press, 1987.

Salamon, Lester M. "The Marketization of Welfare: Changing Nonprofit and For-Profit Roles in the American Welfare State." *Social Service Review* 67, no. 1 (March 1993): 16–39. https://doi.org/10.2307/30012181

Samels, Zoë. "A Tale of Two Cities: Contemporary Art and the American Museum c. 1940." Le musée face à l'art de son temps Bicentenaire du Musée du Luxembourg, 1818–2018, Archives Nationales, Centre Pompidou, Musée d'Orsay Paris, 2018.

San Francisco Museum of Modern Art. "SFMOMA Form I990." Schedule A; I.7, 2007.

San Francisco Museum of Modern Art. "SFMOMA Form I990." Schedule L, 2013.

Savran, Sungur, and Ahmet E. Tonak. "Productive and Unproductive Labour: An Attempt at Clarification and Classification." *Capital & Class* 23, no. 2 (July 1, 1999): 113–52. https://doi.org/10.1177/030981689906800107

Schneider, Tim. "What Happens When a Collector Promises to Donate an Artwork and Then Flips It at Auction Instead? It's Worse Than You Think." *Artnet News*, July 9, 2019. https://news.artnet.com/market/collectors-renege-promised-gifts-1593475

Schonfeld, Roger C., and Liam Sweeney. "Diversity in the New York City Department of Cultural Affairs Community." *Ithaka S+R*, April 21, 2016. https://doi.org/10.18665/sr.276381

Schonfeld, Roger, Mariët Westermann, and Liam Sweeney. "The Andrew W. Mellon Foundation: Art Museum Staff Demographic Survey." *The Andrew W. Mellon Foundation*, July 28, 2015. https://mellon.org/media/filer_public/ba/99/ba99e53a-48d5-4038-80e1-66f9ba1c020e/awmf_museum_diversity_report_aamd_7-28-15.pdf

Selvin, Claire. "Aiming to Diversify Collection, SFMOMA Purchases 11 Works with Profits from $50 M. Rothko Sale." *ARTnews*, June 26, 2019. http://www.artnews.com/2019/06/26/sfmoma-acquisitions-rothko-deaccession/

SFMOMA. "Application MA-10-15-0494-15." Project Category: Learning Experiences Funding Level: $25,001-$150,000. Museums for America, 2016. https://www.imls.gov/sites/default/files/ma-10-15-0494_-_san_francisco_museum_of_modern_art.pdf

SFMOMA Press Office. "SFMOMA Announces Deaccession to Benefit the Acquisitions Fund and Strategically Diversify the Collection." Press Release, February 15, 2019. https://www.sfmoma.org/press-release/rothko-deaccession-2019/

SFMOMA Press Office. "Nixon Peabody Congratulates the Fisher Family and SFMOMA as the Transformed and Expanded Museum Opens to the Public." Press Release. Nixon Peabody LLP, May 11, 2016. https://www.nixonpeabody.com/en/news/press-releases/2016/05/12/nixon-peabody-

congratulates-the-fisher-family-and-sfmoma-as-the-transformed-and-expanded-museum-ope
SFMOMA Press Office. "Nixon Peabody's Art & Cultural Institutions Team Plays Key Role in SFMOMA Expansion; San Francisco Museum of Modern Art to Expand; Museum Will Showcase Fisher Family's Renowned Art Collection." Press Release. Nixon Peabody LLP, March 15, 2010. https://www.nixonpeabody.com:443/en/news/press-releases/2010/03/15/nixon-peabodys-art-cultural-institutions-team-plays-key-role-in-sfmoma-expansion-san-f
SFMOMA Press Office. "SFMOMA Announces Pioneering Partnership to Share the Fisher Collection with the Public." Press Release, September 25, 2009. https://www.sfmoma.org/press-release/sfmoma-announces-pioneering-partnership-to-share/
Shaked, Nizan. "Getting to a Baseline on Identity Politics: The Marxist Debate." In *The Routledge Companion to African American Art History*, edited by Eddie Chambers, 209–18. New York: Routledge, 2019.
Shaked, Nizan. "Looking the Other Way: Art Philanthropy, Lean Government, and Econo-Fascism in the USA." *Third Text* 33, no. 3 (July 29, 2019): 375–95. https://doi.org/10.1080/09528822.2019.1628439
Shaked, Nizan. "Propositions to Politics: Adrian Piper's Conceptual Artwork." In *Adrian Piper: A Reader*, edited by Cornelia H. Butler and David Platzker, 68–101. New York: The Museum of Modern Art, 2018.
Shaked, Nizan. "So Much for Philanthropy: The Marciano and 'All the Usual Suspects' — A Los Angeles Perspective." *East of Borneo*, May 12, 2020. https://eastofborneo.org/articles/so-much-for-philanthropy/
Sheets, Hilarie M. "How The Gap's Founders Helped Shape the New SFMOMA." *Artsy*, April 28, 2016. https://www.artsy.net/article/artsy-editorial-how-the-gap-s-founders-helped-shape-the-new-sfmoma
Shelton, Anthony Alan. "Cabinets of Transgression: Renaissance Collections and the Incorporation of the New World." In *Cultures of Collecting*, edited by John Elsner and Roger Cardinal, 177–203. London: Reaktion Books, 1994.
Sholette, Gregory. *Dark Matter: Art and Politics in the Age of Enterprise Culture*. London: Pluto Press, 2011.
Smith, Adam. "Of the Accumulation of Capital, or of Productive and Unproductive Labour." In *The Wealth of Nations*, edited by Edwin Cannan. London: Modern Library, 1994: 360–380.
Smith, Craig N., Sean Ansett, and Lior Erez. "How Gap Inc. Engaged With Its Stakeholders." *MIT Sloan Management Review*, June 22, 2011. https://sloanreview.mit.edu/article/how-gap-inc-engaged-with-its-stakeholders/
Smith, John. *Imperialism in the Twenty-First Century: Globalization, Super-Exploitation, and Capitalism's Final Crisis*. New York: Monthly Review Press, 2016.
Smith, John. "The GDP Illusion." *Monthly Review*, July 1, 2012. https://monthlyreview.org/2012/07/01/the-gdp-illusion/

Smith, John. "The Global Economy - Crisis or Recovery?" April 12, 2017. DOI: 10.13140/RG.2.2.34812.54405

Smith, Matt. "Filling the Civic Gap." *SF Weekly*, June 21, 2006. http://www.sfweekly.com/news/filling-the-civic-gap/

Smith, Melissa. "Responding to Widespread Demands, Museums Are Acquiring More Works by Artists of Color. But How They Do So Matters More Than Ever." *Artnet News*, September 2, 2020, sec. Art World. https://news.artnet.com/art-world/museums-acquiring-works-artists-of-color-1905718

Soby, James Thrall. Microfilm. "Letter to Alfred Bar." Microfilm, April 12, 1958. Alfred H. Barr, Jr. Papers:2181;1200. The Museum of Modern Art Archives, New York.

Soby, James Thrall. "Report to the Trustees in Connection with a Review of the Museum Collection," January 1945. Alfred H. Barr, Jr. Papers, II.C.58. The Museum of Modern Art Archives, New York.

Solnit, Rebecca. "Get Off the Bus." *London Review of Books*, Diary, 36, no. 04 (February 20, 2014). https://www.lrb.co.uk/the-paper/v36/n04/rebecca-solnit/diary

Solnit, Rebecca. "Google Invades." *London Review of Books*, Diary, 35, no. 03 (February 7, 2013). https://www.lrb.co.uk/the-paper/v35/n03/rebecca-solnit/diary

Sonders, Liz Ann. "Trade Mistakes: Will a Trade Spat Turn Into a Trade War?" *Charles Schwab Corporation*, March 26, 2018. https://www.schwab.com/resource-center/insights/content/trade-mistakes-will-trade-spat-turn-into-trade-war

Soskis, Benjamin. "Giving Numbers: Reflections on Why, What, and How We Are Counting." *Nonprofit Quarterly*, November 1, 2017. https://nonprofitquarterly.org/giving-numbers-reflections-counting/

Sotheby's. "A Rare Rothko Represents the Artist at the Height of His Career." *Sothebys.com*, February 15, 2019. https://www.sothebys.com/en/articles/a-rare-rothko-represents-the-artist-at-the-height-of-his-career.

Spears, Dorothy. "An Unusual New Home for a San Francisco MoMA Collection." *The New York Times*, November 11, 2009, sec. Giving. https://www.nytimes.com/2009/11/12/giving/12FISHER.html

Staff. "Artiquette." *The Economist*, June 18, 2015, sec. Books & arts. https://www.economist.com/books-and-arts/2015/06/18/artiquette

Staff. "Gap Founders Transfer Assets." *Los Angeles Times*, August 7, 2004. https://www.latimes.com/archives/la-xpm-2004-aug-07-fi-gap7-story.html

Staff. "Going Public." *The Economist*, April 30, 2016, sec. Books & arts. https://www.economist.com/books-and-arts/2016/04/30/going-public

Staff. "'Monet Talks' as Mideast Art Investment Proves a Pretty Picture." *Al Arabiyah English*, September 19, 2013.

Staff. "National Galleries Pay Duke of Sutherland 45m Pounds for Second Titian." *HeraldScotland*, March 1, 2012. https://www.heraldscotland.com/

news/13048987.national-galleries-pay-duke-of-sutherland-45m-pounds-for-second-titian/

Stallabrass, Julian. "The Branding of the Museum." *Art History* 37, no. 1 (February 2014): 148–65. https://doi.org/10.1111/1467-8365.12060

"Statements and Notes." MoMA, May 8, 1939. Alfred H. Barr, Jr. Papers. II.C.76. The Museum of Modern Art Archives, New York.

Steinhauer, Jillian. "Art World's Wage Inequality Sparks Waves of Protests." *The Art Newspaper*, March 8, 2019, The Armory Show special edition. http://www.theartnewspaper.com/feature/art-world-wage-inequality-protests

Stenhouse, William. "Roman Antiquities and the Emergence of Renaissance Civic Collections." *Journal of the History of Collections* 26, no. 2 (July 1, 2014): 131–44. https://doi.org/10.1093/jhc/fht033

Steverman, Ben. "The Wealth Detective Who Finds the Hidden Money of the Super Rich." *Bloomberg Businessweek*, May 23, 2019. https://www.bloomberg.com/news/features/2019-05-23/the-wealth-detective-who-finds-the-hidden-money-of-the-super-rich

Stewart, Emily. "Republicans Said Their Tax Bill Would Go to Workers. Instead, It's Going to Wall Street." *Vox*, March 22, 2018. https://www.vox.com/policy-and-politics/2018/3/22/17144870/stock-buybacks-republican-tax-cuts

Stewart, Susan. "The Collection: Paradise of Consumption." In *On Longing: Narratives of the Miniature, the Gigantic, the Souvenir, the Collection*, 151–70. Durham, NC: Duke University Press, 1993.

Stiglitz, Joseph E. "Inequality and Economic Growth." In *Rethinking Capitalism*, 134–55. Wiley-Blackwell, 2016. https://doi.org/10.7916/d8-gjpw-1v31

Stiglitz, Joseph E., and Linda J. Bilmes. "The Book of Jobs." *Vanity Fair*, January 2012. https://www.vanityfair.com/news/2012/01/stiglitz-depression-201201

Stone, Christopher D. "Corporate Vices and Corporate Virtues: Do Public/Private Distinctions Matter?" *University of Pennsylvania Law Review* 130, no. 6 (June 1982): 1441. https://doi.org/10.2307/3311978

Stonor Saunders, Frances. *The Cultural Cold War the CIA and the World of Arts and Letters*. New York: The New Press, 2013.

Storr, Robert. "To Have and to Hold." In *Collecting the New*, edited by Bruce Altshuler, 29–40. Museums and Contemporary Art. Princeton: Princeton University Press, 2005.

Stringer, Scott. "Culture Shock: The Importance of National Arts Funding to New York City's Cultural Landscape," March 9, 2017. https://comptroller.nyc.gov/reports/culture-shock-the-importance-of-national-arts-funding-to-new-york-citys-cultural-landscape/

Stromberg, Matt. "Major Artists Demand LACMA Remove Board Member Who Owns Prison Telecom Company." *Hyperallergic*, September 16, 2020. https://hyperallergic.com/588856/open-letter-lacma-tom-gores/

Stubbs, Ryan. "Public Funding for the Arts: 2014 Update." Arts Funding Snapshot: GIA's Annual Research on Support for Arts and Culture. GIA Reader. Grantmakers in the Arts, Fall 2014. https://www.giarts.org/sites/default/files/25-3_Vital-Signs.pdf

Sullivan, Paul. "A Museum's Seal of Approval Can Add to Art's Value." *The New York Times*, October 14, 2016, sec. Your Money. https://www.nytimes.com/2016/10/15/your-money/a-museums-seal-of-approval-can-add-to-arts-value.html

Sweeney, James Johnson. "Report of the Committee on the Museum Collection," 1943. James Johnson Sweeney Papers,10. The Museum of Modern Art Archives, New York.

Sweeney, Liam. "Reflecting Los Angeles, Decentralized and Global: Los Angeles County Museum of Art." Case Study. *Ithaka S+R and the Andrew W. Mellon Foundation*, January 23, 2017. https://doi.org/10.18665/sr.309173

Sweeney, Liam, and Roger C. Schonfeld. "Interrogating Institutional Practices in Equity, Diversity, and Inclusion." *Ithaka S+R*, September 20, 2018. https://doi.org/10.18665/sr.309173

Tait, Allison. "Publicity Rules for Public Trusts." *Cardozo Arts & Entertainment Law Journal* 33, no. 2 (January 1, 2015): 421–71.

Taylor, Brandon. *Art for the Nation: Exhibitions and the London Public, 1747-2001*. New Brunswick: Rutgers University Press, 1999.

Taylor, Keeanga-Yamahtta. *From #BlackLivesMatter to Black Liberation*. Chicago: Haymarket Books, 2016.

Taylor, Keeanga-Yamahtta. *Race for Profit: How Banks and the Real Estate Industry Undermined Black Homeownership*. Chapel Hill: The University of North Carolina Press, 2019.

The DeVos Institute of Arts Management. "Diversity In The Arts: The Past, Present, and Future of African American and Latino Museums, Dance Companies, and Theater Companies." The University of Maryland, September 2015. http://devosinstitute.umd.edu/~/media/D6750176AEF94F918E8D774693C03E53.ashx

The NEA's Office of Research & Analysis. "NEA Guide to the U.S. Arts and Cultural Production Satellite Account." National Endowment for the Arts, December 2013. https://www.arts.gov/sites/default/files/nea_guide_white_paper.pdf

Thomasian, John. "Arts & the Economy: Using Arts and Culture to Stimulate States Economic Development." National Governor's Association, January 14, 2009. https://www.americansforthearts.org/sites/default/files/0901ARTSANDECONOMY.pdf

Thornton, Dora. *The Scholar in His Study: Ownership and Experience in Renaissance Italy*. New Haven: Yale University Press, 1998.

Thornton, Sarah. "Love and Money." *Artforum*, May 11, 2006. https://www.artforum.com/diary/sarah-thornton-on-sotheby-s-contemporary-evening-sale-10968

Thorstein, Veblen. *The Theory of the Leisure Class: An Economic Study of Institutions*. London: B. W. Huebsch [1899], 1912.

Tomba, Massimiliano. "Differentials of Surplus-Value in the Contemporary Forms of Exploitation." *The Commoner*, Summer 2007.

"Toolkit." MASS Action: Museum as Site for Social Action, 10/17. https://www.museumaction.org/s/TOOLKIT_10_2017.pdf

Topaz, Chad M., Bernhard Klingenberg, Daniel Turek, Brianna Heggeseth, Pamela E. Harris, Julie C. Blackwood, C. Ondine Chavoya, Steven Nelson, and Kevin M. Murphy. "Diversity of Artists in Major U.S. Museums." *PLoS ONE* 14, no. 3 (March 20, 2019). https://doi.org/10.1371/journal.pone.0212852

Tregenna, Fiona. "'Services' in Marxian Economic Thought." Cambridge Working Papers in Economics. Faculty of Economics, University of Cambridge, September 24, 2009. https://ideas.repec.org/p/cam/camdae/0935.html

Tuck, Eve, and K. Wayne Yang. "Decolonization Is Not a Metaphor." In *Decolonization: Indigeneity, Education & Society* 1, no. 1 (September 8, 2012).

Turpin, Adriana. "The Display of Exotica in the Uffizi Tribuna." In *Collecting East and West*, edited by Susan Bracken, Andrea M. Gáldy, and Adriana Turpin, 83–118. Cambridge: Cambridge Scholars Publishing, 2013.

Ullberg, Alan D., and Patricia Ullberg. *Museum Trusteeship*. Washington, D.C.: American Association of Museums, 1991.

Ultra Red. "Desarmando Desarrollismo: Listening to Anti-Gentrification in Boyle Heights." *FIELD*, no. 14 (Winter 2020). http://field-journal.com/issue-14/desarmando-desarrollismo

US Bureau of Economic Analysis. "Arts and Cultural Production Satellite Account, U.S. and States 2014," April 19, 2017. https://www.bea.gov/news/2017/arts-and-cultural-production-satellite-account-us-and-states-2014

Valentino-DeVries, Jennifer. "Service Meant to Monitor Inmates' Calls Could Track You, Too." *The New York Times*, May 11, 2018, sec. Technology. https://www.nytimes.com/2018/05/10/technology/cellphone-tracking-law-enforcement.html

Vance, Carole. "Reagan's Revenge: Restructuring the NEA." *Art in America* 78, no. 11 (1990): 49–55.

Velthuis, Olav. *Talking Prices: Symbolic Meanings of Prices on the Market for Contemporary Art*. Princeton: Princeton University Press, 2007.

Villarreal, Ignacio. "The Dealmaker behind the San Francisco Museum of Modern Art and Fisher Family Partnership." *Artdaily*, May 16, 2016. http://artdaily.com/news/87290/The-dealmaker-behind-the-San-Francisco-Museum-of-Modern-Art-and-Fisher-Family-partnership#.XRSxFnu-khs

Villette, Emilie. "Art & Wealth Management: A Win-Win Combination." Art & Finance Report 2017. Deloitte Luxembourg and ArtTactic, 2017. https://www2.deloitte.com/lu/en/pages/art-finance/articles/art-finance-report.html

Virginia, Richardson, and Francis Reilly John. "Public Charity or Private Foundation Status Issues under IRC 509(a)(1)-(4), 4942(j)(3), and 507." Exempt Organizations-Technical Instruction Program for FY 2003. IRS, 2003. https://www.irs.gov/pub/irs-tege/eotopicb03.pdf

Vogel, Carol. "Big New York Auction Houses Brace for a Slower Dance at the Fall Sales." *The New York Times*, October 29, 2008, sec. Art & Design. https://www.nytimes.com/2008/11/02/arts/design/02voge.html

Vogel, Susan, ed. *Art/Artifact: African Art in Anthropology Collections*. New York: Center for African Art, 1989.
Wake, John. "Why Isn't The Black Homeownership Rate Higher Today Than When The 1968 Fair Housing Act Became Law?" *Forbes*, May 16, 2019, sec. Consumer. https://www.forbes.com/sites/johnwake/2019/05/16/heres-why-the-black-homeownership-rate-is-the-same-50-years-after-1968-fair-housing-act/
Wallach, Alan. *Exhibiting Contradiction: Essays on the Art Museum in the United States*. Amherst, MA: University of Massachusetts Press, 1998.
Wallerstein, Immanuel. *The Modern World-System I: Capitalist Agriculture and the Origins of the European World-Economy in the Sixteenth Century*. New York: Academic Press, 1974.
Washington, Laura. "Latest Art Museum Staff Demographic Survey Shows Increases in African American Curators and Women in Leadership Roles." *The Andrew W. Mellon Foundation News* (blog), January 28, 2019. https://mellon.org/news-blog/articles/latest-art-museum-staff-demographic-survey-shows-increases-african-american-curators-and-women-leadership-roles/
Weber, Jasmine. "Almost 50 Whitney Biennal Artists Sign Letter Demanding Removal of Warren Kanders from Museum Board." *Hyperallergic*, April 29, 2019. https://hyperallergic.com/497515/almost-50-whitney-biennal-artists-sign-letter-demanding-removal-of-warren-kanders-from-museum-board/
Weitz, Yael. "Claim by Museums of Public Trusteeship and Their Response to Restitution Claims." *Art & Advocacy*, February 2013. http://www.herrick.com/art/publications/claim-by-museums-of-public-trusteeship-and-their-response-to-restitution-claims/
West, Cornel. "Pity the Sad Legacy of Barack Obama." *The Guardian*, January 9, 2017, sec. Opinion. https://www.theguardian.com/commentisfree/2017/jan/09/barack-obama-legacy-presidency
Westbrook, Lindsey. "Field Report from Yours, Mine, and Ours: Museum Models of Public-Private Partnership." SFMOMA, February 2017. https://www.sfmoma.org/read/field-report-yours-mine-and-ours-museum-models-public-private-partnership/
Westermann, Mariët, Roger Schonfeld, and Liam Sweeney. "Art Museum Staff Demographic Survey 2018." *The Andrew W. Mellon Foundation and Ithaka S+R*, January 28, 2019. https://mellon.org/news-blog/articles/art-museum-staff-demographic-survey-2018/
Wetherell, Sam. "Richard Florida Is Sorry." *Jacobin*, August 19, 2017. https://jacobinmag.com/2017/08/new-urban-crisis-review-richard-florida
Whitford, Emma. "MoMA Employees Protest 'Modern Art, Ancient Wages.'" *Gothamist*, June 3, 2015. https://gothamist.com/news/moma-employees-protest-modern-art-ancient-wages
Williams, Ben. "Art-secured lending." Interview by Victoria Kisseleva. Deloitte Luxembourg and ArtTactic: Art & Finance report 2017, 2017. https://www2.deloitte.com/lu/en/pages/art-finance/articles/art-finance-report.html

Williams, Jennifer, Dr. fari nzinga, Ifátùmínínú Bamgbàlà Arẹ̀sà, Jonathan Serrette, and Jane Kate Wood. "Open Letter to the New Orleans Museum of Art." Dismantle NOMA, June 24, 2020. https://sites.google.com/view/dismantlenoma/collective-statement

Wolch, Jennifer R. *The Shadow State: Government and Voluntary Sector in Transition*. New York: Foundation Center, 1990.

Wood, James N. "The Authorities of the American Art Museum." In *Whose Muse? Art Museums and the Public Trust*, edited by James Cuno, 103–28. Princeton: Princeton University Press, 2006.

Wu, Chin-Tao. *Privatising Culture: Corporate Art Intervention since the 1980s*. London; New York: Verso, 2003.

Wyszomirski, Margaret Jane. "Federal Cultural Support: Toward a New Paradigm?" *The Journal of Arts Management, Law, and Society* 25, no. 1 (March 1, 1995): 69–83. https://doi.org/10.1080/10632921.1995.9941788

Wyszomirski, Margaret Jane. "Philanthropy and Culture: Patterns, Context, and Change." In *Philanthropy and the Nonprofit Sector in a Changing America*, edited by Charles Thomas Clotfelter and Thomas Ehrlich, 461–80. Bloomington: Indiana University Press, 2005.

Wyszomirski, Margaret Jane. "Philanthropy, the Arts, and Public Policy." *Journal of Arts Management and Law* 16, no. 4 (January 1, 1987): 5–29. https://doi.org/10.1080/07335113.1987.9943084

xSFMoMA Workers. "We Are Calling for the Resignation of SFMOMA Senior Curator Gary Garrels." Petition. *Change.org*, July 7, 2020. https://www.change.org/p/we-are-calling-for-the-resignation-of-sfmoma-senior-curator-gary-garrels

INDEX

AAM (see: American Alliance of Museums)
AAMD (see: Association of Art Museum Directors)
abolition 6, 155,
absolutism 126, 150, 184
absolutist 4, 8, 103, 124, 127, 149, 150, 161, 184
accreditation 66
acquisition committee 166
acquisitions 54, 140, 148, 178, 187
activism 34, 36, 45, 135, 155
activists 36, 73, 117
advocacy 34, 36–38, 52, 74, 154, 184
African American 6
African Modernism 46
Alberts, Lindsay 106, 111, 115
Albrecht V (collections) 112
Aldrovandi, Ulisse 114
Althusser, Louis 85, 87
Altshuler, Bruce 147, 181
American Alliance of Museums 66, 144, 172
American Association of Museums 62
anthropological 102
anticapitalist 155
antiquities 109, 111, 181
antiracism 11
antiracist 14, 153, 154, 172, 176
Antwerp 119
arbitrage 31, 121, 161
architectural 117, 128
architecture 21, 119, 125, 132
archives 99, 139, 176, 180–82
aristocracy 13, 117, 118, 124, 125, 130, 157
Armani, Giorgio (show) 65
Arrighi, Giovanni 107, 115, 117, 157, 158
art
 collateral (see: loan collateral, art as)
 collateralization 41
 consulting (see: consulting (art))

 financialization (see: financialization of art)
 market 41, 186, 187
 world 27, 180, 183
Art Institute of Chicago 140
ascriptive 6, 154, 155
asset-class 16, 159
Association of Art Museum Directors 66, 172
auction house/s 3, 41, 53, 162, 184
Autry, LaTanya S. 153, 170
avant-garde 139, 147, 149, 162, 163

Bangladesh 28, 31
Barr, Alfred 146–49
Baselitz, Georg 39, 46, 47
Bay Area 16, 45
Bazin, Germaine 130
Beat culture 45
Beech, Dave 94, 95
Bellamy, John 70
Bellofiore, Richardo 58
Belvedere 108
Benedict, Anderson 126
Benezra, Neal 20–22, 24, 42, 44, 45
Bennett, Tony 125, 128
Berenson, Bernard 129, 132
Berman, Wallace 45
Best, Beverley 83, 87, 88, 91, 99
Biddle, Livingston 38
Bilmes, Linda 33
Bishop, Claire 140
Black and Indigenous People of Color (BIPOC) 6, 177
Black Lives Matter 6, 155
Black Panthers 45
Blackstone Group 1
Blue-chip art/ist 16, 61
Board member/s 3, 12, 55–57, 64, 145, 152, 153
Board of regents 143
Board of trustees 60, 141, 149, 177
Bocchi, Francesco 114

Bologna 114
Borghini, Vincenzo (Don) 110
Bourdieu, Pierre 84–87, 125
bourgeois economics 95, 96
bourgeois revolutions 124, 125
bourgeois society 8, 84, 103, 124–26, 128, 156
Boyle Heights, Los Angeles 27
branding 46, 89, 90
Brandon, Taylor 170
Braudel, Fernand 158
Bridgewater collection 20
Broad, the 19, 167
Broad Foundation 168
Brody, Evelyn 74–80, 82
Brooklyn Museum 152
Brown, Joan 45, 146, 170
Bruges 119
bubble (economic) 41, 58, 164
Buchloh, Benjamin 50
Bureau of Economic Analysis Arts and Cultural Production 32, 93
Burrell, Jane 174
Bush, George h. W. (President) 36

cabinet/s 110, 111, 113
Cabinets of Curiosity 107
California Clay 45
capital gains 4, 52, 98
capitalist economy 2, 25, 29, 91, 98, 107, 129, 158, 175
capitalist production 32, 90, 105
Captains of Industry (see also Robber Barons) 56, 129, 133, 169
Carnegie, Andrew 133, 135, 137, 138
Carnegie Corporation 137
Carnegie Foundation 138
Carrier, David 109, 110
Carter, Jimmy (president) 38
Casino di San Marco 104
Cellini's Perseus 108
censorship (McCarthy-era) 139
ceremonial objects 111
charitable 4, 54, 56, 71–74, 76, 80–82, 129, 134, 142, 143
 contributions/giving 74, 129, 135
 organizations 4, 19, 47, 56, 73–76, 80, 134, 143, 144, 171, 183
 sector 71, 73, 82
 tax deductions 71, 72, 81, 143
 trusts 4, 54, 140, 142–44
charter (corporate) 12, 75, 78–80, 129, 137, 139, 143, 145, 186
checks and balances 135, 161
Chesnais, Françoise 57, 58
Chicago, Judy 45
Christie's (auction house) 40, 54, 55
Cicero 113
Cipolla, Carlo 119
Citizens United v. Federal Election Commission (case) 80
city-state 109, 115, 118, 119, 122, 124, 160, 161
civic 12, 108, 113, 132, 136, 142, 154, 174
 collections 108
 institutions 136
 patrimony 12
 spaces 132, 142
civil rights 73, 153, 161, 168
civil society 2, 7, 11, 13, 29, 35, 56, 72, 97, 125, 126, 129, 134–36, 150
civil war, the 131, 136
Clark, T. J. 50
class, capitalist 4, 12, 56, 57, 157
class (creative) 4
classes 13, 19, 28, 30, 109, 125, 126, 128, 129, 134, 136, 139, 157, 183, 185, 186
 lower 109, 125
 middle 4, 19, 28, 38, 85, 127, 136, 139, 171, 185
 working (see: working class)
 ruling (see: ruling class)
Clinton, Bill (president) 37
Cockcroft, Eva 138, 139
collective asset 23, 56, 165
collector (art) 1, 3, 10, 12, 15, 17, 19, 21, 23, 24, 33, 38, 40, 43, 44, 51, 54–57, 60, 61, 64–66, 95, 97, 99, 106, 111, 112, 129, 130, 158, 162–66, 171
 board member 12, 57
 collector/trustees 55, 61
 group 3
 groups 57, 164
 patrons 17

College Art Association (CAA) 34, 138
Collins, Maureen 141
commercial revolution 120
Committee, Nolan 66
committee (trustee) 20, 21
commodity 8, 10, 30, 32, 33, 68, 82–84, 87–90, 92–94, 96, 98, 105, 120, 159, 160, 174, 183, 184
 commodity fetishism 10, 82
 commodity prices 158
 commodity production 8, 68, 82, 84, 120, 160
common law 69, 78, 134
commons 67
communities of color 161
community, art-collecting 64
community arts 38
community stakeholders 167
conceptualist (art/ist) 48, 49
conflict of interest 24, 41, 55, 61, 62, 65, 66
Congress 37, 143
Connolly, Kate 46
conservation (art) 22, 23, 141, 146, 170, 172
conservatism 27, 36, 46, 70
conspicuous consumption (see: consumption (conspicuous))
Constable, William George 177, 178
constellation 10, 97, 116, 175
constituencies 2, 27, 35, 37, 52, 85, 154, 170, 171
constitutional law 69
consulting (art) 41
consumption (conspicuous) 59, 94, 107, 115
consumption (luxury) 109, 115, 119
corporate charters 78, 79, 143, 145
Cosimo I 103, 104, 108, 117
cosmopolitanism 45
Costello, Mary 129
cottage industry 47, 49
creative economy 26–28, 32, 33, 50, 93, 174
Crenshaw, Kimberlé 171, 172
Creole Petroleum 138, 139
Crimp, Douglas 47
critics (art) 84, 170
Crystal Bridges Museum 28

cultural
 patrimony 54, 95, 98, 183
 production 27, 32, 93
 products 107, 115
 wars 36, 37

Dartmouth College v. Woodward (case) 78, 79, 134
Davis, Angela 6
Davis, Ann E. 82
deaccession 15, 17, 66, 98, 140–42, 148, 178
de-accredit 66
dealers (art) 1, 27, 39, 51, 53, 54, 56, 62, 119, 126, 129–31, 162, 178
Dean, Jodi 145, 160, 162
Decolonize This Place (organization) 153
DeFeo, Jay 45
Deitch, Jeffrey 53
Delaware 60
democratic
 ideals 25, 38, 102
 societies 87, 137
demographics 13, 16, 17, 22, 38, 47, 79, 99, 110, 115, 152–54, 159, 164, 167, 172, 176
depression, the (see: Great Depression)
deregulation 33, 70, 71, 162
Desmarais, Charles 19, 21
Detroit art collection 76
Detroit Institute of Art (DIA) 141
Diebenkorn, Richard 39
digital prints 48
Dimaggio, Paul 145, 170, 171
discrimination 19, 38, 47, 52, 73, 111, 151, 154, 169, 172, 176, 178
diversity (in collections) 1, 17, 18, 37, 43, 46, 52, 61, 74, 172, 173, 178
diversity (in museum workplace) 12, 18, 153, 154, 172, 173
Dobkins, Peter 134
Dobrzynski, Judith 24
Doig, Peter 53
donations 12, 17, 19, 24, 27, 28, 50, 52, 62, 67, 72, 81, 108, 130, 142, 149, 154
donor 12, 19, 24, 26, 39, 41, 64, 68, 101, 130, 132, 143, 167
dot.com boom 33

double-booking system 118, 121
Douglas, Emory 45, 47
Dowie, Mark 136
Du Bois, W. E. B. 157
Ducal Florence 102–5, 107, 116, 117, 132, 184
Duke of Sutherland 20
Duncan, Carol 125–27, 139, 140
Duncan, Sally Anne 137, 146
Duveen, Joseph 129, 130, 132
d'Harnoncourt, René 138

economic
 categories 85, 86, 96
 history 69, 160
 imperialism 139
 inequality 11, 47, 155
 justice 14, 52, 154, 170, 183
 order 6, 8, 51, 58, 68, 79, 97, 98, 102, 108, 115, 124, 127, 155, 160, 174, 185, 187
 policies 71, 105, 117
economic bubble 41, 58, 164
Edgell, George 177
educational institutions 25, 60, 127, 139, 172
egalitarian 2, 38, 124, 187
Egypt, ancient 127
Elson, Diane 90
England 31, 68, 69, 79, 120, 123, 125, 161
England (Tudor) 125
English law 67, 77
enlightenment, age of 9, 123, 125, 126, 185
equality 5, 6, 11, 14, 51, 73, 136, 141, 152, 154, 156, 165, 170, 174, 175, 177, 183, 186
 equality (social) 5
equal opportunity 25, 87
equitable (see: equality)
Esterow, Milton 62
ethics/al 3, 9, 46, 51, 62, 65, 66, 74, 142, 143, 152, 159
ethnic diversity 173
European art 132
European museums 4, 82, 129, 141, 186
excluded artists 16
excluded groups 4, 7, 37, 38, 161, 163, 174
exemptions (see: tax – exemptions)

externalization (of collections) 103, 104, 108, 112, 113, 116, 184

federal government 72, 73, 135, 138
federal tax 74, 143, 145
feminist 9, 56
fetishism 10, 49, 82–84, 88
feudalism 67, 68, 122, 123, 161
fictitious capital 86
fiduciary 61, 142, 143
Fields, Barbara 6
figurative (art) 17, 45, 48
finance industry 40, 41, 58, 61, 122, 160
financial crisis, 2008 1, 40, 53, 58
financialization of art 9, 39, 40, 46, 50, 58, 59, 61, 86, 87, 97–99, 150, 158, 159, 175
financial derivatives 161, 162
financial oligarchy 116
Findlen, Paula 111
fine-arts 104, 128
Fink, Larry 58
Fisher, Donald 16, 20, 21, 28, 29, 39
Fisher, Doris 15, 20
Fisher, Robert 15
Fisher (family) 16, 19–24, 28, 29, 42, 47
Fisher collections 11, 15–17, 19–21, 42, 44–46, 164
Fisher foundation 21–23, 28
Florence 102, 103, 105, 107, 108, 111, 114, 116–21, 132, 150, 184
Ford Foundation 135, 169
Fordism 89
foregone tax 7, 19, 35, 52, 54, 67, 74, 76, 81, 142, 167
for-profit corporations 80
Foster, John Bellamy 70
Foucault, Michel 47, 102
foundations, private operating 4, 19, 167
Fox News 26
Frampton, Meredith 46
France 127
Francesco I de' Medici 104, 106, 108, 110–12, 114, 115
Fraser, Andrea 63, 72
free market 30, 139, 161
Free-port 61, 117
French revolution 126, 127
Frick collection 43

Friedman, Milton 71
Fugger, Jacob 113
funding for the arts 33–36, 52

Gagosian, Larry 54
Galleria degli Antichi 112
Galleria della Mostra 112
Gap Inc. 15, 20–23, 28, 31
Gardner, Isabella Stewart 129
Garrels, Gary 151, 164
Gates, Bill and Melinda Foundation 168
Gennari-santori, Flaminia 131
George III (king of England) 79
Germaine, Bazin 130
Getty Museum 54
Gilded age 56
Gilmore Wilson, Ruth 6
globalization 12, 18, 30, 33, 70, 158, 179
global south 29, 52, 89
Goldthwaite, Richard 104, 105, 119, 120, 160, 161
Gores, Tom 152
governance 41, 51, 61, 68, 104, 107, 116, 127, 128, 130, 133
governmental arts policy 108
governmental institutions 82, 116
Grand Duke 103, 108, 109, 111, 114, 115
grassroots organization/s 137
Graw, Isabelle 84
Great Depression 33, 134
Great recession 70
Green, Brian 32
Green New Deal 175
Gross Domestic Product (GDP) 30, 32–34, 58, 91, 160
groups, collector 164
groups (excluded/underrepresented) 7, 37–39, 52, 163, 171
Guggenheim Foundation 53
Guggenheim Museum 54, 55, 64, 65, 152, 153
Guidi, Jennifer 165
guilds 103, 119, 120
Gund, Agnes 101

Habermas, Jürgen 124, 125
Habsburg (house) 160

Hall, Peter Dobkins 134
Hanks, Nancy 38
Harvard University 132
hedging, of art loans 59, 87, 158
hegemony 4, 13, 38, 126, 151, 157, 158, 185
Heinrich, Michael 88, 94
held in common, art 83, 187
hemisphere, northern 29, 30, 32
heritage, cultural 54
hierarchies, social/racial 7, 137, 156, 157, 164, 169
Higginbottom, Andy 31
high art 65
high price 30, 40, 42, 94, 98
high-stakes art market 159, 175, 176
Hill, Tomilson J. 1, 2
Hirshhorn Museum 1
historical works 20, 42, 48
Hodsoll, Frank 38
holding, (museum/s) 15, 16, 23, 39, 61, 141
Hopkins, Henry 45
Horwitz, Morton 67–70, 77–79
Huckabee, Mike 34
human labor 54, 88, 90, 91, 98

ideals, democratic 102
identity politics 6, 153
Ilyenkov, Evald 9
imperialism 10, 12, 18, 30, 32, 33, 71, 139
incorporation 8, 60, 121, 139
Indianapolis Museum of Art 170
industrial revolution/s 69, 109, 119, 120, 124, 183, 185
industries, tech/creative 26, 28, 33, 50
industry, financial 40, 41
inequality 7, 12, 17, 18, 28, 41, 47, 51, 60, 83, 87, 123, 150, 155, 158, 161, 163, 175, 187
infrastructure 8, 163, 169, 175, 186
insider, trading/knowledge 3, 166
institution
 nonprofit 12, 18, 42, 72, 167
 public/private 3–5, 7, 34, 40, 43, 55, 61, 78, 98, 99, 109, 121, 130, 131, 146, 149
 subsidized 16, 17, 41, 51, 54
insurance 9, 22, 41, 59, 77, 159, 175
interest, conflict of 24, 41, 55, 62, 65, 66

interest, public/private 4, 17, 22, 24, 34, 37, 41, 48, 51, 52, 70, 79, 80, 135, 142–44, 162, 163, 167, 186
interest-group 70, 124, 154
Internal Revenue Service (IRS) 19, 54, 74, 84, 87, 92, 94, 143
internationalism 46, 135
intersectionality 171, 172
investment asset/vehicle, art as an 16, 28, 59, 130, 158
investors 33, 40, 59, 120, 159
IRS (see: Internal Revenue Service (IRS))
Italian City-state 119, 161
Italy, renaissance 109, 110, 184
Ithaka s+r 172

Jay, Martin 10
jewel-box museum 167
John, Gwen 46
Johns, Jasper 50
Johnson, Lyndon 38, 134
Julius II (Pope) 108
jurisprudence, public 70, 161
justice 14, 52, 154, 170
 distributive 74, 186
 racial 14, 154, 183, 186
 social 5, 10, 35, 153, 176, 183

Kanders, Warren 153
Kantor, Sybil 148
Kelly, Ellsworth 39
Kennedy, Robert F 73
Kensington Museum, South (see: Victoria and Albert museum)
Kentridge, William 39
Keppel, Frederick 138
Kim Varet, Esther 165, 166
Koch, Cynthia 37
Kooning, Willem de 39
Kreder, Jennifer Anglim 142, 143, 145
Kuttner Robert 161

labor
 aristocracy 157
 law 28, 132, 161
 power 7, 29, 83, 86, 92, 94, 185, 186
 rights/relations 155, 175, 183
 social 187
 value 31

laborers 33, 98, 99, 101
Laing, Justin 73
landed gentry 125
Lane, John 145, 146
Lanzi, Luigi 112
late-renaissance 4, 8, 13, 158, 160, 184
law
 governing philanthropy 166
 law, torts 162
 laws, patrimony 98
 of trusts 137
 public 69, 70, 77, 143, 162
 tax 7, 24, 56, 76, 130
leaders (museum) (see: museum - leader/ship)
legal system 70, 77, 78, 131
lending, art 59–61, 87
libertarian 70, 73, 81
Lichtenstein, Roy 39
like-kind exchange 4
living artist/s 42, 44, 51, 56, 98, 159
Livingston, Biddle 38
Livorno 117
loan collateral, art as 9, 12, 41, 59–61, 83, 97, 158, 160, 175
Locke, John 68, 142
Loggia dei Lanzi 108
Lopez, Roberto 108, 116
Lorraine, house of 109
Los Angeles 2, 19, 27, 43, 56, 57, 64, 165
Los Angeles County Museum of Art Count (LACMA) 152, 166, 167, 174, 182
Los Angeles Museum of Contemporary Art (MoCA) 53, 64
Louvre 126, 127, 130, 147, 153
Lowry, Glenn D. 142
Lukács, György 11
luxury/ies 2, 95, 96, 102–5, 109, 113, 115–21, 128, 158–61, 165, 184

Mabry, Thomas Dabney 145
Mansoor, Jaleh 49
Marciano Foundation 2
Marden, Brice 39
Marini, Mauro 31
market art/ists 16

market for art 16, 40, 87, 98, 130, 159,
 167, 178
 high-stakes 159, 175, 176
Martin, Agnes 10
Marx, Karl 10, 29, 82, 86, 88–90, 96, 156
Marxist 5, 9, 12, 29, 32, 33, 70, 84, 87, 95,
 96, 122, 146, 156
MASS (Museums as sites of social
 change) 151, 176
masterpiece/s 24, 43, 48, 49, 59, 85, 105,
 147, 148, 177, 178
materials 24, 31, 32, 83, 91, 94, 106, 107,
 110, 111, 120, 138
McCarthy-era censorship 139
McClellan, Andrew 126, 128, 129
McCray, Porter A. 138
Meadow, Mark 112, 113
Medici 13, 102, 103, 105, 107, 109,
 111–13, 117, 132, 140
 Medici, Francesco I de' 104, 106, 108,
 110, 114
 Medici, Lorenzo de' 106
 Medici, Maria Luisa de' 109
Medici, Cosimo (see: Cosimo I, Duke)
megacollectors 167
Meiksins Wood, Ellen 121, 122, 160
Mellon Foundation 172, 174
Met (see: Metropolitan Museum of Art)
Metropolitan Museum of Art 1, 131, 136,
 147, 152, 153
Minimal Art 17
minimalist 49
Mitchel, Joan 20
MoCA (see: Los Angeles Museum of
 Contemporary Art (MoCA))
MoCA Cleveland 170
modern art 11, 139
modernism 46, 47, 107
Molesworth, Helen 63, 64
MoMA (see: Museum of Modern Art
 (MoMA))
monarch/ies 4, 67, 127, 128, 150
monopoly 29, 77, 85, 90, 121, 160–62
Montabonel, Sébastien 60
Moore, Porchia 153, 154, 171, 176
Morgan, John Pierpont 59, 130, 131
Morgan, Kelli 170, 177
movement, Black Lives Matter (see: Black
 Lives Matter)

movement, Civil Rights 73, 161
multiculturalism 6, 39, 153
Municipal museum 4, 139
Murakami, Haruki 63
Murphy, Liam 80, 81
Musée du Luxembourg 147, 178
museum
 acquisitions 43
 administration/ors 22, 144
 boards 1–4, 7, 27, 28, 35, 39, 57, 63, 66,
 140, 145, 152, 154, 162, 166
 collection/s 1, 3, 48, 95, 148, 156,
 165
 directors 44, 54, 57, 62, 65–67
 donors (protest against) 2, 42
 ethics 62
 exhibitions 53–55, 178
 funding 99
 history 8, 185
 law 142–44
 leader/ship 16, 67, 130, 138, 146, 154
 loans 23
 personnel/professionals 6, 18, 51, 57,
 146, 148, 153, 157, 170, 172,
 173, 176
 public 143, 145, 146
 trustees/ship 62, 136
Museum of Fine Arts Boston 177
Museum of Modern Art (MoMA) 13, 43,
 101, 102, 104, 137–39, 141,
 142, 145–47, 149, 152, 163,
 167, 178, 180, 181, 184

Nagel, Thomas 80, 81
naming rights 24, 67
National Endowment for the Arts (NEA)
 17, 19, 32, 34–36, 38
National Endowment for the Humanities
 (NEH) 36
National Gallery, London 20, 127
National Gallery of Art, Washington, D.C
 67
The National Gallery of Scotland 20
nationalism 47, 126
nationalization 71, 110
national patrimony 105, 107, 126, 183
nation-state/s 13, 30, 68, 97, 103, 109, 122,
 124, 126, 129, 161, 183, 185
Native American/s 152

Nauman, Bruce 45
neoliberal/ism 12, 27, 35, 47, 70–72, 105, 162, 167
Netherlands 125
New Deal 20, 135, 161, 175
New Hampshire 60, 78
New Orleans Museum of Art 152
Newsom, Gavin 20
New York 1, 26, 46, 97, 101, 129, 131, 136, 140, 143, 146, 149, 178
Nongovernmental agencies/
 organizations (NGOs) 6, 72, 133, 139, 155
nonproductive 29, 93, 98, 102, 160
nonprofit
 corporations 54, 80, 144
 institution/s 12, 18, 19, 42, 60, 72, 167
 Nonprofit Industrial Complex, 73
 organization/s 71, 143
 sector 70, 134, 159, 176, 185
 status 19, 143, 167
 system 1, 16, 20, 33, 35, 51, 52, 72–74, 93, 137, 150, 186
Norfield, Tony 18, 125, 128
Northern Hemisphere 29, 30, 32

Obama, Barack 71
object-based practices 99
Office of Inter-American Affairs 138
offshoring 28, 29, 76, 158
Old master/s (see: masterpiece/s)
Olmi, Guiseppe 108
Oregon 60
organized labor 169
Ossei-Mensah, Larry 170
Ostrower, Francie 145

Palazzo Ducale of Mantua 112
Palazzo Medici 106
Palazzo Vecchio 110, 111
Paris 124, 126
Parmar, Inderjeet 135, 136, 138
patrimony 12, 13, 54, 95, 98, 105, 107, 126, 127, 183
patronage 4, 106, 107, 109, 117, 126, 131, 149, 184
Peel, Sir Robert 127
Pennsylvania 134

permanent collection 45, 46, 140, 147, 148, 178
pharmaceutical industry 161
philanthrocapitalism 168, 170
philanthrocrats 168
philanthropy 4, 5, 12, 19, 24, 28, 35, 37, 51, 52, 56, 61, 71, 73–75, 82, 101, 129, 130, 132–38, 142, 146, 149, 165–69, 173, 183, 186, 187
Piper, Adrian 101
pluralism 70, 72–74, 136
Polanyi, Karl 8, 68, 69
policies 5, 24, 65, 71–74, 134, 135, 151, 153, 176
political
 economy 5, 7, 12, 18, 29, 51, 69, 81, 130, 156
 power 102, 116, 119, 161, 186
 strategy 4, 6, 155
 system 79, 80
Pop (art) 17, 49
populism 43, 51, 128
portfolio diversification 158, 160
postmodernism 47, 49
power structure 30, 102
precapitalist 8, 33
preindustrial capitalism 120
price arbitrage 121
price markups 30
Prince, Richard 55, 65
princely collections 110, 113, 126
prints 48–50, 97, 119, 126
private
 collection/s/ing 1, 2, 8, 12, 13, 15–18, 39, 42, 43, 45, 46, 48, 52, 55, 64, 103, 123, 148, 173
 collectors 3, 21, 23, 57, 64, 163
 corporations 54, 79, 134
 donors 11, 22, 165
 foundation/s 12, 19, 138, 167
 institution 78, 149, 186
 interest/s 4, 6, 17, 24, 34, 37, 48, 51, 52, 77, 80, 163, 167
 investment 72, 77, 78
 law 69, 161, 162
 museum/s 2, 20, 150
 nonprofit museum 11, 186

philanthropy 4, 9, 11, 12, 19, 35, 71, 74, 129, 134
property 10, 12, 67, 68, 81, 82, 91, 114, 125, 142
sector 12, 34, 70, 133, 149
private/public distinction 5, 7, 12, 13, 67–70, 77, 79, 82, 140, 187
privatization 4, 8, 9, 13, 27, 34, 35, 70, 73, 76, 77, 124, 151, 160–63, 167–69, 173
profiteering 2, 152
profit extraction 28
profit maximization 121, 174
progressive tax 135
promissory notes 54, 58, 87, 97, 98, 184
propaganda 39, 103, 109, 128, 139
protectionism 25
protomercantilist 117
proto-public 107, 110
provenance cases 142
public
 art 2, 41, 109, 126
 collections 2, 5, 44, 103, 113, 129, 131, 187
 funding 35
 museum/s 109, 126, 187
 benefit museums 19, 61
 charitie/s 19, 47, 76, 183
 display 23, 66, 105
 domain 20, 124
 economy 38, 186
 entities 12, 76, 106, 135
 funding 4, 12, 17, 33–35, 37, 52, 54, 117, 140, 143, 167, 174
 galleries 114, 130
 good 19, 55, 69, 77, 79, 95, 126, 150
 institution/s 1–5, 7, 24, 40, 43, 44, 61, 97–99, 109, 130, 131, 146
 interest/s 11, 15, 22, 70, 117, 143
 law 69, 77, 161, 162
 money 2, 18, 34, 52, 76, 140
 municipal museum 139
 museum/s 16, 22, 61, 110, 165, 187
 officials 20, 68, 116, 122, 142
 partnership museums 5
 policy 59, 185
 public/private distinction 5, 27, 67, 68, 70, 82, 142

public/private divide 82, 187
realm/s 7, 67, 69, 77, 140, 184
resources 22, 52, 56, 76, 99, 116
royal collections 127
sector 51, 187
services 35, 40
sphere 2, 8, 51, 124, 125
subsidy 1, 16–18, 22, 38, 41, 48, 50, 51, 57, 64
support 18, 19, 34, 36, 37
tax 52
trust 3, 13, 76, 127, 141–45, 149, 152
Puryear, Martin 20
Putting-out system 120

quasi-state 162, 169
queer 28, 45, 49
Quiccheberg, Samuel 112, 113

race 47, 155, 157, 169, 171, 175, 176, 185
racial
 capitalism 5, 6, 8, 156
 hierarchies 157, 169
 inequality 163, 186
 justice 14, 154, 161, 183
 racial/ethnic diversity 173
racism 6, 7, 47, 87, 151, 156, 157, 172, 186
racist 6, 26, 151, 164, 175
radicalism 73, 156
Raphael 20
Reagan, Ronald (president) 34–36, 38, 70, 71, 161
reformist initiatives 73
reformist outcomes 136
reformist suggestions 173
reform policy 6
regulation 30, 120, 125, 142–44, 162
regulatory 69, 176
Reich, Rob 81
relations 2, 6, 8, 9, 11, 19, 30, 32, 41, 67, 68, 72, 82, 86–88, 93, 95, 96, 98, 119–22, 124, 125, 138, 149, 154, 156, 159, 170, 175, 183, 185, 186
relations, social 68, 183, 186
relations of production 11, 72, 122, 185
religious artwork 119
Rembrandt 20, 130

Renaissance 8, 13, 101, 102, 105, 106, 109–11, 113, 116, 120, 121, 127, 132, 149, 158, 160
reprivatization 4, 105, 107
revisionist perspectives 45
Ricardo, David 5, 90
Richter, Gerhard 15, 16, 39, 47–51, 59
right-wing 6, 34, 35, 137
Riley, Dylan 84–86
Robber Barons (see also Captains of Industry) 13, 56, 132, 133
Robinson, Cedric 6, 8, 156, 157
Rockefeller, Nelson 137, 138, 183
Rockefeller Brothers 137
Rockefeller Center 132
Rockefeller family 137
Rockefeller Foundation 136–38
Rodríguez, Dylan 73
Rome 103, 108, 109, 112, 114, 119, 126, 127
Roosevelt, Franklin 134, 135, 146
De Roover, Raymond 120
Rosenbaum, Lee 55, 62, 64
Rothko, Mark 15, 180
Rotta, Tomás 93
royal collections 109, 126, 127
ruling class 13, 14, 27, 85, 103, 107, 116, 123, 127, 129, 150, 152, 157, 165, 183, 185
rural pauperism 68
Russia 26

Sachs, Paul 43, 132, 137, 138, 146
Sackler family 153
Samels, Zoë 177
Satersmoen, Laura 23, 45
Savran, Sungur 92
Schwab, Charles 24–26, 40, 44, 180
secondary market 51
securities 27, 41, 58, 162
self-dealing 66
self-governance 71
self-regulation 128, 162, 167
semiprivate 72
semipublic 8, 72
Serra, Richard 39
SFMOMA (San Francisco Museum of Modern Art) 11, 12, 15–29, 33, 39, 41, 42, 45–47, 51, 151, 164, 167, 170

shadow state 12, 70, 72, 97
Shelton, Anthony 114
Sholette, Gregory 93
Silicon Valley 16, 27, 28, 33, 45
Sixtus IV (Pope) 108
Smith, Adam 5, 25, 29, 30, 32, 90, 96
Smith, John 30, 33
Smithsonian Institution 1
SNCC (see: Student Nonviolent Coordinating Committee)
Soby, James 43, 44, 148
social
 change 72, 84, 151
 conditions 86, 164
 control 110, 127, 157, 161, 185
 hierarchies 2, 7, 83, 109, 117, 137, 156, 187
 justice 5, 10, 35, 153, 176
 media 152, 170
 production 10, 82, 83
 relations 6, 8, 9, 68, 86–88, 92, 93, 95, 96, 98, 120, 124, 154, 156, 159, 175, 183, 186
 reproduction 33, 72, 92, 93, 96, 122
 structures 2, 4, 10, 11, 56, 85, 97, 98, 110, 115, 126, 136, 142, 146, 156, 168, 173
 system 83, 183, 186
 wealth 94
 welfare 4, 38, 86, 132
socialism 70, 71, 123, 155, 175
socially 2, 5, 12, 31, 54, 83, 85, 89–91, 97, 98, 128
 allocated labor 90
 conscious museums 128
 created wealth 2
 necessary labor 31
soft power 13, 63, 101, 104, 115, 116, 149, 150, 184
Solnit, Rebecca 27, 28
Solomon R. Guggenheim Foundation 53
Sotheby's 15
sovereignty 5, 13, 68, 97, 107, 110, 115, 116, 127
Spanish empire 119
Spector, Nancy 152
speculative market 178
stabilizing art prices 41, 159, 165

staff demographics (museum) 172
stakeholder groups 60
standard commodity 8, 95
state
 actors 75
 apparatuses 85
 chartered 54
 functions 12, 72
 funded 128
 funding 130
 ideology 4
 interest 79, 186
 ownership 141
 patronage 109
 policy 77, 119
 regulation 125
 replacing 75, 133
 structure 19, 30, 74, 149, 183-186
 welfare 134
statistics 152, 164, 171
statutory law 69
stewardship 22, 126, 141
Stiglitz, Joseph 33
Stockholm 126
Stockman, Jennifer 53–55, 64, 65, 74
Stone, Christopher 75
Stone, Katherine 161
Storr, Robert 163, 164
Story (Justice) 79
stratified social order 7, 85, 127, 153
structure of museums 11, 18, 51
structure of philanthropy 56
Student Nonviolent Coordinating Committee 24, 43, 73, 146
Studiolo 108, 110, 111
submuseum 170, 171
subsidy 1, 3, 23, 35, 37, 38, 54, 74
superexploitation 31, 52
supply-side 35, 72
Supreme Court 78–80
surplus capital 108
surplus value 10, 30, 31, 83, 84, 86, 89–94, 96, 123, 161
Sweeney, James Johnson 148
symbolic
 capital 84, 86, 87, 98
 symbolic power 83, 84, 97
 value 2, 3, 7, 8, 12, 54, 55, 61, 82–84, 87, 94, 98, 105

systemic change 7, 93
systemic inequality 60

Tate Britain 53
Tate Modern 46
tax
 advantages 35, 143
 breaks 60, 130, 162
 code 72, 131, 167
 deduction 3, 19, 51, 52, 55, 71, 76, 81, 143, 167
 exempt (organization) 2, 19, 22, 54, 66, 71, 80, 143, 166, 167
 exemptions 73, 130, 142, 143, 167
 laws 7, 24, 56, 76, 130, 142
 marginal 52
 money/ies 7, 12, 35, 52, 54, 67, 71, 74, 76, 81, 142
 planning 4
 returns 19, 22, 24
 sales 4, 60
taxes 4, 19, 32, 68, 71, 81, 98, 116, 161, 164, 167
taxing 3, 51, 52, 60, 71, 78, 98
Taylor, Keeanga-Yamahtta 6, 155, 169
Taylorism 89
Tech-world 26–28, 33, 161, 162
television 51, 94, 171
temporary-loan 20
textiles 119
Thatcher, Margaret 70, 71, 161
Thornton, Dora 113
Toledo, Ohio 43
Tomilson J. Hill 1, 2
Tonak, Ahmet 92
totalitarianism 70
totalizing 9–11, 29, 49
transaction 3, 58, 62, 68, 69, 118, 119, 125, 165, 186
transnational corporations 30
treasury/ies 81, 102, 116, 117, 158, 184
Tregenna, Fiona 95
trickle-down Economy 51
trustee-collectors 3
trustee-owned 140
trustees 2–4, 16, 21, 22, 24, 27, 42, 43, 55, 57, 60–67, 78, 136, 139–41, 145–49, 177
trusts 4, 54, 137, 142

Turpin, Adriana 112
Twombly, Cy 39
Tyler, John 74–80, 82

Uffizi Gallery 102, 104, 106, 108–10, 112, 114, 115
ultrawealthy 2, 34, 61
undemocratic 1, 16, 28, 80, 107, 175, 186
underrepresented 6, 38, 39, 47, 52
unions 71, 101, 128, 152, 183
United Kingdom 20
United States 4, 16, 56, 58, 74, 79, 142, 146
universalism 9
universalist 9, 39
universalization 172
University of New York 139
unproductive 30, 32, 84, 89, 91–93, 96, 160

valorized (valorization) 94
value
 added 32, 90
 creating 91, 183, 184, 186
 form 2, 6, 12, 94, 175, 186
 market 61, 84, 131
 monetary 7, 12, 85, 105, 131
 use 92
 values 32, 88, 92, 96, 114, 137, 174
Vance, Carol 35, 36
Vasari, Giorgio 104, 110, 112
Veblen good 94, 95
Venice 108
Versailles 104
Victoria and Albert Museum 129, 131, 153

Vives, Diana 60
Vogel, Carol 53, 55, 62

Walker, John 67
Wallach, Alan 127
Wallerstein, Immanuel 8, 31, 122, 125, 156, 157
Wall Street 162
Walmart 28, 168
Wal-Mart 31
Walsh, John 54
Walton (family) 168
Warhol, Andy 39, 49
wealth management 9, 39, 41, 50, 59, 60
western-centric 39
white supremacy 2, 6, 7, 17, 151, 155, 163, 170, 174, 175
Whitney Museum 20, 41, 152, 153
winner-take-all 16, 25, 98, 99, 152, 175
Wire, The 51
Wittmann, Otto 43
Wolch, Jennifer R. 72, 73
Wood, James N. 140
working class 4, 11, 13, 35, 85, 110, 126–28, 134, 157, 169, 171, 185, 186
World-systems 8, 104, 123, 156, 184
Wright, Shevaun 144
Wu, Chin-tao 3
Wyszomirski, Margaret Jane 75

Xenophobia 47

Yossifor, Liat 48